Politics, Transgression, and Representation at the Court of Charles II

Studies in British Art 18

Politics, Transgression, and Representation at the Court of Charles II

Edited by Julia Marciari Alexander
and Catharine MacLeod

Published by
The Yale Center for British Art
The Paul Mellon Centre for Studies in British Art

Distributed by
Yale University Press, New Haven & London

Published by

The Yale Center for British Art
P. O. Box 208280
1080 Chapel Street
New Haven, CT 06520-8280
www.yale.edu/ycba

and

The Paul Mellon Centre for Studies in British Art
16 Bedford Square
London WC1B 3JA
United Kingdom
www.paul-mellon-centre.ac.uk

Distributed by

Yale University Press
P. O. Box 209040
302 Temple Street
New Haven, CT 06520-9040
www.yalebooks.com

Volume edited by Julia Marciari Alexander and Catharine MacLeod
Publication coordinated by Julia Marciari Alexander, Anna Magliaro,
and Kristin Swan at the Yale Center for British Art
Copyedited by Richard Slovak
Index by Enid Zafran

Designed by Miko McGinty
Set in Garamond by Tina Henderson
Printed in Canada by Friesens

Library of Congress Control Number: 2007936884

ISBN: 978-0-300-11656-4

A catalogue record for this book is available from the British Library.

10 9 8 7 6 5 4 3 2 1

This is the eighteenth in a series of occasional volumes devoted to studies in British art, published by the
Yale Center for British Art and the Paul Mellon Centre for Studies in British Art.

Jacket illustration: Peter Lely, *Barbara Villiers, Countess of Castlemaine (later Duchess of Cleveland), with Her
Son, Charles Fitzroy, as Madonna and Child* (detail), oil on canvas (ca. 1664), 49⅛ x 40⅛ in. (124.7 x 102 cm).
National Portrait Gallery, London.

IN MEMORY OF OLIVER MILLAR

1923–2007

Contents

Acknowledgments

THIS VOLUME IS THE RESULT of an ongoing collaboration among three institutions and colleagues at those institutions: the Paul Mellon Centre for Studies in British Art, London; the National Portrait Gallery, London; and the Yale Center for British Art, New Haven, Connecticut. Both our scholarly collaboration and our friendship, dating back many years, have been supported and facilitated by the generosity of these three institutions. The National Portrait Gallery and the Yale Center, our places of employment, were the venues for our collaborative exhibition, *Painted Ladies: Women at the Court of Charles II* (2001–2), and it was in that context that the contributors to this volume were originally brought together. The two conferences held in conjunction with the exhibition, one in London and one in New Haven, were jointly sponsored by the Paul Mellon Centre and the host institutions. We are indebted to Charles Saumarez Smith, former Director of the National Portrait Gallery, London; Patrick McCaughey, former Director of the Yale Center; and Brian Allen, Director of Studies at the Paul Mellon Centre, for their support of the exhibition and especially of the conferences, which were the inspiration for this volume.

More recently, this project has greatly benefited from the unfailing and generous support of Amy Meyers, Director of the Yale Center for British Art, who, along with Brian Allen, enthusiastically encouraged the editors to produce this book as part of the series *Studies in British Art*, jointly published by the Yale Center and the Paul Mellon Centre. We could not be more grateful to them. The National Portrait Gallery, likewise, has been a generous partner in the project by allowing Catharine MacLeod to work on the volume as part of her curatorial responsibilities. We hope that all who have provided financial, academic, or emotional support— including our families—will find the product both worthwhile and enjoyable.

The book is the result of a very happy collaboration between authors, editors, and production team. Richard Slovak has copyedited the volume with great skill and aplomb, extraordinary energy, and extremely good humor. Anna Magliaro and Kristin Swan have masterfully assembled the illustration program and aided in

manuscript preparation; they have received invaluable help with regard to photography from Melissa Gold Fournier and Richard Caspole at the Yale Center. The series is now designed by Miko McGinty, who with her team has produced yet another splendid volume.

Most importantly, however, we owe our greatest debt of gratitude to our authors, all of whom have waited patiently—for five years—for us to finish this book. The spirit of Barbara Villiers, mother of five of Charles II's children (produced in as many years), seems to have swooped down upon us to delay the volume: four children have been born, in successive years, to the editors since the conferences. We are, consequently, especially grateful to the authors whose work, effectively, went on maternity leave with us. We hope, however, that they are as pleased as we are with the volume. As a result of this book, we are more convinced than ever that the collaborative model of scholarship provides the richest results, and we thank all our colleagues for their continued insights, cooperation, and friendship.

Introduction

Catharine MacLeod and Julia Marciari Alexander

THIS VOLUME HAS ITS ORIGINS in two conferences held in conjunction with the exhibition *Painted Ladies: Women at the Court of Charles II*. The exhibition (at the National Portrait Gallery, London, in the fall of 2001 and at the Yale Center for British Art, New Haven, in the winter of 2002) examined portraits of a variety of women—from royal brides to mistresses to actresses—in order to assess the roles both of portraiture and of women at the court of Charles II. *Painted Ladies* and its associated conferences provided the first major reassessment of Restoration portraiture since various monographic studies (mainly in the form of exhibitions and related publications) had appeared more than twenty years earlier.

The two conferences associated with *Painted Ladies*—the first of which took place in London and the second in New Haven—brought together two distinguished international groups of Restoration scholars. Both events explored the wider cultural, social, and political contexts for the women and portraits in the exhibition, and, exceptionally for the field of Restoration studies, they included scholars from a variety of disciplines in order to examine how visual culture intersected with literature, politics, and other cultural forms in the years following Charles II's restoration to the throne. While interdisciplinary study had become the normative model for many fields of scholarship, Restoration studies had remained relatively compartmentalized, particularly with regard to the visual arts, and the exhibition seemed to present the ideal opportunity to stimulate thinking across traditional disciplinary boundaries.

The true legacies of such events often become apparent in scholarly output only after the passage of time. Many of the conversations begun at the events have remained ongoing, and this volume is the direct result of such continued dialogues among colleagues and friends. Although this book grew out of the conferences, it is not a simple record of the conference papers, assembled commemoratively. Rather, the essays published here include some based on papers given at those conferences, others adapted from papers presented at other venues, and some that were written specifically for this volume. We intend that this book should stand

independently of *Painted Ladies* (both the exhibition and the catalogue); however, many of the issues discussed and themes examined here arose from the experience of putting together, viewing, thinking about, discussing, and even reviewing the exhibition and its associated publication. Nevertheless, the range of issues addressed in the present volume is much broader than that on which we were able to focus in the context of the exhibition and catalogue.

For a variety of reasons, not all the participants in the symposia were able to contribute to this volume. We are particularly grateful to Annabel Patterson, Sterling Professor Emeritus, Department of English, Yale University, and Paulina Kewes, Fellow and Tutor of English Literature, Jesus College, Oxford University, for their excellent and thought-provoking papers, respectively, "'Colors That Will Hold': Figuring and Disfiguring Barbara Villiers" (conference in New Haven) and "Ancient Romans on the Restoration Stage" (conference in London). Both speakers added further depth to our exploration of the construction and reception of "representation" during the Restoration; their contributions, though not marked by the presence of essays printed here, are nonetheless manifest in the evolution and refinement of ideas presented by a number of authors in the present volume.

One participant of the London conference whose paper is also not included here made a contribution to the study of the visual arts in seventeenth-century England—and, through this, to most of the papers in this book—the significance of which is difficult to estimate adequately. This is the late Sir Oliver Millar, to whom we have dedicated this volume. At the conference, Sir Oliver gave a paper about Sir Peter Lely, which he subsequently decided not to adapt for inclusion here as he was working on the final stages of the monumental catalogue raisonné of paintings by Sir Anthony Van Dyck.[1] The debt owed to him by the editors of this book in particular—and indeed by anyone working on the visual arts of the Restoration period—is immense. A traditional art historian in the best sense, Sir Oliver had an unrivaled knowledge of painting in England in the seventeenth century and of the social and historical context in which it was produced; he added to this an unwavering (and untiring) pursuit of new information. His method combined analysis of the aesthetic qualities and characteristics of a broad range of art and artists with a thorough investigation of the patronage and political patterns and networks of seventeenth-century Europe. His work thus provides the foundation for all those studying the visual arts of this period in Britain, including those whose approach is more theoretical. His substantial published output represents only a small part of the information he had at his disposal, but he always readily shared his knowledge with others. His support of younger scholars was unstinting, and, because of his generosity toward those following him, his continuing legacy to the field is assured. When he died he was working in collaboration with

Diana Dethloff, Lecturer and Academic Administrator at University College, London, on a catalogue raisonné of the works of Sir Peter Lely; this will now be continued by Dethloff with Catharine MacLeod. Sir Oliver was a true pioneer in the field of seventeenth-century English art history, one of those who helped to turn the study of art into a scholarly discipline in Britain, and his influence will continue to be felt for generations to come.

The range of historiographical approaches exemplified in this volume reflects something of the diversity of scholarship now present in the broader academic world. Precisely because—as Joseph Roach so eloquently makes clear in his essay in this book—the Restoration "moment" was one in which the visual, the literary, the political, and the theatrical merged to create a thoroughly modern mode of "presentation" and "representation," as they do in our own twenty-first-century world, this volume aims to redress the compartmentalization of disciplines and methods. Consequently, the scholarship in this volume ranges from the type of document- and object-based empirical history and art history of which Sir Oliver was such a notable exponent, to more theoretical analyses that reflect developments in recent decades (particularly in the fields of literary criticism and of what we now designate as visual culture). These approaches are not mutually exclusive, and a cross-disciplinary study of the Restoration (especially one that probes its subjects from a variety of methodologies) allows the scholar of this period to unravel in new ways the complex cultural and political fabric of life in later Stuart England.

The history of the later seventeenth century in Britain is now a growing field, particularly when it is construed as part of the "long eighteenth century"; in this construction, the Restoration is posited as a sort of preface to political and cultural developments that came to fruition in the succeeding century. Although this approach has much to offer, the present volume aims to locate the Restoration squarely in the seventeenth century, with its legacies (cultural, political, economic) of the age of Charles I, the civil wars, and the interregnum. The authors of the essays in this volume have not all restricted themselves solely to the years 1660–85, but it is these years, and the distinctive cultural and political milieu brought about by the circumstances and personality of the monarch, that are the main focus of this book.

The return of Charles II to the throne in 1660 marked a moment of political and cultural change that must have seemed to many almost as dramatic as the change brought about by his father's execution eleven years before. Throughout society, people responded and reacted to the new king and his court: rejoicing or disapproving, looking forward to or fearing what was to come. Representations of kings and courtiers, in words and in visual imagery, reflected the range of responses, but the king also harnessed visual and verbal imagery to his own ends. His challenge was to bring his people together in support of his rule and to maintain that

support, fulfilling the expectations of his followers but also reassuring the doubters, and representation was to play an important role in this. After the repressions of the interregnum and the uncertainties and poverty of the exiled court, there was an appetite for exuberance, indulgence, and transgression—of written and unwritten rules alike—an appetite that the king, and especially the women at his court, came to symbolize.

This new visibility of women, particularly in London, was the subject of much of the verbal and visual imagery produced both by supporters and by detractors of the regime, and it is the complex interplay among such representation, the behaviors that were its subjects, and the political exigencies of the time that is the theme of this volume.[2] Looking to women and their representation—in a variety of media and formats—allows us to understand some of the specific ways in which, in this period, culture and politics depended on what were construed as "transgressive" modes of behavior.

The book begins with an essay in which Kevin Sharpe explores the political implications of the new, unabashed sexuality that, from the beginning of his reign, characterized Charles II's court. In a context in which the king had mistresses who were openly acknowledged and some of whom bore him numerous children (unlike his barren queen), Sharpe demonstrates that the king's behavior and self-representation disrupted traditional models and discourses of the family, marriage, and morality, of gender itself, and even of religion. The fact that these women included actresses—working-class women performing for the first time on the public stage—and the physical accessibility of the king to the people, by comparison with his father and grandfather, also threatened the traditional class structures of aristocratic England. Sharpe provides a new interpretation of Charles's personal political strategies, arguing that the king came to personify a new "politics of pleasure," in which conventional hierarchies were overturned and boundaries were transgressed. He explores how both verbal and visual imagery (including the poetry of John Wilmot, second Earl of Rochester, and the paintings of Sir Peter Lely) reinforced this personification. As Sharpe argues, the king was, for the first half of the 1660s, a popular monarch, and his depiction as a sexually potent, fertile man both reinforced and sustained this popularity. Sharpe carefully exposes, however, the ways in which, by the end of the decade, a succession of disasters—the plague, the Great Fire of London, and the Dutch invasion of the Medway—had changed the attitude of the people toward their king, and he examines why and how Charles's new discourses of sex and love were turned against him. The great literary response to this succession of events was Andrew Marvell's *Last Instructions to a Painter*, and this poem marks the point at which, Sharpe argues, sexual slander became the dominant language of opposition to the king.

Following Sharpe's examination of the roles that both sex itself and sexual language played for or against the king's political strategies primarily within court circles, Tim Harris expands our understanding of how such behavior and discourse affected politics outside the court. Through his examination of the origins, extent, and nature of popular opposition to the court in Restoration England, Harris explodes the traditional image of the popular reception to the Restoration as simply one of celebration and deliverance from Puritan tyranny. He pays particular attention to the public concern over sexual conduct at court and the extent to which women, notably the king's mistresses, were considered responsible for the nation's political troubles. Focusing on the seditious words, sermons, and poems on affairs of state, as well as other evidence of popular unrest, Harris assesses whether this growing popular opposition to the court mattered, asking what sort of impact it had and if it ever posed a serious threat to the stability of the Restoration regime.

Similarly, in spheres that extended beyond the court, but were largely based in the metropolis, Sheila O'Connell probes the views of ordinary people by examining the visual culture that most people saw on an everyday basis. O'Connell's essay deals with what most art historians and others view as the very bottom of the seventeenth-century art market: prints and illustrated ballads that were sold cheaply in the streets. These prints formed part of a common experience of daily life, and although they are usually assumed to be objects specifically designed for an "uneducated" audience and discussed as such, O'Connell identifies these works as of interest to a broad range of readers, including those who could well appreciate more sophisticated prints. Through her examination of the ways in which women are depicted—both pictorially and verbally—in such prints, she reveals the inexorably male viewpoint of such works: in this medium, women are stereotyped as, in the author's words, "willing wenches" or "shrewish adulteresses." She also explores the emblematic nature of the visual language deployed, highlighting the ways in which the sophistication of popular visual culture lagged behind its verbal equivalent at this time.

As both a parallel and a counterpoint to the ways in which women were portrayed and perceived in the reproductive media of "popular" print culture during the Restoration, our essay explores the ways in which a specific aspect of painted portraiture, the "beauties series," operated in elite society. Through a study of the group of paintings known as the "Windsor Beauties," we argue that such groups reflected the varying concerns of their owners (in this case, courtiers and the royal family) and also contributed to the perception of women—whether seen as ideal or transgressive, or both—as emblems of the court. We examine the phenomenon of compiling groups of pictures of "beautiful" women, both at Charles II's court and elsewhere in Europe, and we question traditional assumptions about how and

why such groups were put together. The essay explores the ways in which both the individual portraits themselves and the groups, collectively displayed, might have been understood by contemporary viewers. In so doing, it seeks to provide a more fully nuanced context for paintings that have come to be seen as the ultimate representation of the values of the Restoration court, and it provides further evidence for the importance of sexual politics as a crucial site for political discourse during the first part of Charles's reign.

Through his examination of Andrew Marvell's great verse satire *Last Instructions to a Painter*, Steven N. Zwicker forcefully exposes the dependence of the visual and verbal arts upon each other during the Restoration period. Zwicker analyzes Marvell's highly sexualized, satiric verse portraits embedded within the poem, notably that of Charles II's most notorious mistress, Barbara Villiers, Countess of Castlemaine (later Duchess of Cleveland). He shows how the poet used images of ugliness and revulsion, in a context of religious parody, to counterpoint the idealization of Lely's painted portraits of the same sitter. In so doing, he demonstrates how Marvell deployed the language of sex as a devastating critique of Charles's reign at this time, thus expanding on Sharpe's identification of this poem as central to the wave of sexual slander used against the king from the late 1660s. Zwicker also highlights the way in which Marvell linked insatiable sexual appetite and social leveling, supporting the proposition that indiscriminate sexual behavior—notably on the part of the king—was a threat to social order and hierarchy. In the microcosm of Marvell's poem, Zwicker identifies many of the same concerns that Sharpe considers in the wider political arena: concerns about representation of the body and the body politic, as well as the role of the visual and literary arts in this context.

This phenomenon of construing the portrait—both painted and literary—as a richly connotative mode of political and personal discourse during the years of Charles's reign is further examined in Susan Shifrin's essay about Hortense Mancini, Duchess Mazarin. Mazarin came to England in the mid-1670s and soon became one of Charles II's more notorious mistresses (albeit only for a short while). Shifrin's analysis of Mazarin's portraits reveals the various ways in which she both was viewed by her contemporaries—as a "foreigner," an "Amazon," a woman of great "beauty, quality and adroictnesse"—and constructed her own visual identity. Further, Shifrin demonstrates that Mazarin, along with a few of her contemporaries, depended on her richly meaningful portraits to convey the complex patterns of self-representation that would allow her to move freely, as a "notorious" woman, throughout the courts of Europe. Like Charles II, as Shifrin posits, Mazarin used transgressive behavior and representation itself to negotiate an independence from societal norms. Sexuality was, for Charles and Hortense, a dangerously liberating

tool, one that could be fully manipulated only in the world of the Restoration, of a monarchy and aristocracy tenuously "restored."

The question of whether a woman could be independent or wield any kind of real "power"—political or otherwise—is the subject of Rachel Weil's essay, which takes us to the liminal years of the seventeenth and eighteenth centuries (after the "Glorious Revolution" of 1688–89 and before the death of the last Stuart monarch, Queen Anne, in 1714). Weil questions the shift in historiographical approach that has occurred in recent years, away from a lamentation of women's exclusion from politics toward a celebration of their behind-the-scenes, informal, and hidden influence. She posits that historians' recent emphasis on what is hidden does not take into account what was highly visible: that is, the ubiquitous representations, both positive and negative, of women perceived to have influence in politics, all of which made "invisible power" extremely visible. Her essay compares the cases of Louise de Kéroualle, Duchess of Portsmouth, in the reign of Charles II and Sarah Jennings, Duchess of Marlborough, in the reign of Queen Anne, and it explores how the representation of a woman's political power both constitutes power itself and creates constraints on the exercise of power. Weil demonstrates that the perception that a particular woman had influence did give her a degree of influence, but of a type and extent over which the woman herself had little control. Her comparative study provides a necessary corrective to overstatements about the freedoms and power available to women at the Restoration court and highlights the importance of representation as a necessary but complicating factor in the construction of women's history.

One form of cultural production that has traditionally been seen as presenting an entirely uncritical view of the reigning monarch is the court masque. Andrew R. Walkling's essay on absolutist imagery in three late-seventeenth-century masques demonstrates how these productions could be understood as a critique of policy and of the monarch himself at the late Stuart courts. Like their more famous predecessors in the reigns of James I and Charles I, the court masques of Restoration England were, at least on one level, the ultimate propagandistic expressions of royal majesty and power. Looking at three theatrical productions that contained masques within them—masques within masques—Walkling explores the phenomenon of the "interrupted masque" in Restoration courtly theater. He examines how the sudden and unexpected intrusion of external forces brings the internal masque to a premature halt, reversing the expected movement from disorder to order and thereby exposing the foundations of royal authority to questioning and subversion. His study of the interrupted masque and its implications, both for the theatrical work in which it appears and in relation to the political ambitions of Charles II and James II, provides a new perspective on reactions to the policies

of the Restoration court. The disruption of this most stable and conventional of art forms echoes the ways in which other kinds of cultural production, including poetry and court painting, operated in the face of the uncertainties and shifting values of the time. In this respect, the masque can be regarded as a barometer of politics and the life of the court in late-seventeenth-century England.

Finally, Joseph Roach also posits performance as one of the key modes within the Restoration arsenal of representation, be that political, historical, cultural, or simply personal. For Roach, the Restoration is the moment when modern "celebrity" culture emerged, and, as such, understanding how the modes of representation functioned within this emergent culture (one necessarily dependent on performance of all types) allows us to understand not only Restoration politics and culture, but also aspects of our own celebrity-obsessed world. His essay takes as its starting point the funeral effigies—images of deceased monarchs sculpted from wood or wax and dressed in their own clothes—that accompanied the corpses of English kings to their places of rest. Although this particular kind of "performance" lapsed with the burial of Charles II, other means of circulating personal images in the absence of the persons themselves proliferated during his reign. Roach analyzes various types of performance and representation described by Samuel Pepys in his *Diary*, including Pepys's extraordinary private "performance" with the body of Catherine de Valois, his viewing of "role portraits" of women at court and prints after these portraits, and the emergence of actors and actresses as living effigies. In so doing, Roach reveals how closely our own interactions with and uses of "representations" derive from and rely on those of our Restoration peers; in exploring the beginnings of celebrity as a concept in the later seventeenth century, he both draws together various themes discussed by other authors in this volume and uses them as a way of understanding the present.

From the perspective of the Western world in the early twenty-first century, Restoration England seems to have much in common with our own visually dense cultural and political landscape, with its shifting values and new definitions of morality. Perhaps this is one reason that increasing numbers of young scholars are drawn to that era. Every essay in this volume demonstrates the extent to which, in Restoration England, pleasure was considered to be a universal language that was understood and manipulated to suit the needs—or desires—of each constituent. But this pleasure was negotiated in a context of anxiety, about what it meant, how it might be represented, what its value might be. Traditional boundaries were transgressed, but that transgression was not without consequences, both personal and political. Representation, whether in the "high" arts or in other forms of discourse, was a slippery concept, never completely under the control of either the individual (or group) depicted or the creator of the image, or indeed the viewer.

In the new political world of Restoration England, it appears that most forms of creative discourse—political language, visual and verbal imagery—were stimulated by a pervading uncertainty and an anxious desire to create new order. Ultimately, of course, that new order collapsed and was replaced by a very different political and social landscape after the Revolution of 1688–89, but the responses to the particular nature of the Restoration period make it, in our view, one of the richest for the study of the intersection of politics and culture. We have been exceptionally fortunate in being able to draw on such a range of high-quality essays for this volume, and for that we will be eternally grateful to our authors, but we recognize that this volume is only one small contribution to a field that deserves— and, we hope, will continue to receive—much more scholarly and interdisciplinary attention.

1. Susan J. Barnes, Nora De Poorter, Oliver Millar, and Horst Vey, *Van Dyck: A Complete Catalogue of the Paintings* (New Haven and London: Yale Univ. Press for The Paul Mellon Centre for Studies in British Art, 2004).

2. For the purposes of this volume we have had to limit ourselves mainly to the English court, with some excursions more widely into London and the surrounding areas. It is important, however, to recognize that what was happening during this period at court was not necessarily a reflection of the world outside, nor was England necessarily representative of the other kingdoms (Scotland and Ireland) of what was to become Great Britain.

"Thy Longing Country's Darling and Desire": Aesthetics, Sex, and Politics in the England of Charles II

Kevin Sharpe

I WANT TO BEGIN by returning to the paintings, principally the portraits by Peter Lely that were the center of the exhibition that inspired our conference and volume, *Painted Ladies: Women at the Court of Charles II* (fig. 1). And I want to ask a simple question: as we peruse these canvases, what do we see? As a historian my instinct is to ask, too, what did contemporaries see and how did these paintings perform, convey meaning, in the environment of the court and, through copies and engravings, beyond in Restoration England? More particularly, as a scholar engaged in a study of images of power in early-modern England, I want to explore the ways in which these portraits, some of which hung at Whitehall, represented, and were seen to represent, the court and the monarchy—how they contributed to the royal image and responses to the royal image in Charles II's reign.

The question "what do we see?" takes us to the essential characteristic of the Restoration: its ambiguity, its evocation of tradition and convention, and yet its radical novelty and difference from the past. When, as a historian of politics, I walked through the exhibition rooms at the National Portrait Gallery, London, and the Yale Center for British Art, New Haven,[1] my first impression was of a familiar group of princes and aristocrats, a display of dynasty and privilege. That sense of familiarity, however, though deliberate—indeed, strategic—is superficial, if not illusory. In the first place, most of the canvases are portraits of women; although ladies were, of course, the chosen focus of the exhibition, it remains the case that Lely's female portraits are his best work and eclipse any picture of the king. Second, several are of royal mistresses, a class of women never before so publicly represented and displayed—and not only aristocratic mistresses but, in the cases of Moll Davis and Nell Gwyn, common actresses who were often taken in seventeenth-century England to be common whores. Third, the children in these canvases are not the usual subjects of the royal publicizing of dynasty and succession; they are bastards, the illegitimate offspring of a monarch who had a barren marriage and no legitimate heir. Again, with names like Fitzroy (son of the king) and ducal titles (reserved for those of the royal blood) as well as their

representation by Lely, these bastards are, novelly, publicized as royal, as representations of the king.

Fourth, and to me strikingly, the female portraits, for all their gestures to Sir Anthony Van Dyck's, exhibit a revolutionary sexuality. The exhibition catalogue is surely guilty of coy understatement in describing Lely as moving away from the "delicate lyricism" of earlier portraits.[2] His Restoration females are, in their settings and dishabille, with their languid poses and direct gaze toward the viewer, sexual women. Rather than complex Neoplatonic conceits alluding to the beauties of the mind, it is the female sexual body these paintings figure and advertise, and it is the newly sexualized female body to which contemporaries, most famously Samuel Pepys, so readily (if at times guiltily) responded.[3] Indeed, as we look again, even the conventions and traditions to which these paintings gesture no longer carry their original symbolic freight. Rather than again presenting Neoplatonic and Christian conceits, these portraits play with them, and in the process they signal a dissociation from an older world of ideas and forms and a skepticism about their authority. In Lely's portraits of court whores with the symbolic attributes of chastity, conventional meaning gives way to mere witty playfulness, while the figuring of mistresses as saints—or, in the notorious case of Barbara Villiers, Countess of Castlemaine (later Duchess of Cleveland), with her son Charles Fitzroy (later second Duke of Cleveland and first Duke of Southampton), as Madonna and Child (fig. 2)—entirely disrupts the association between the sacred symbol and the sitter. As with much of the literature and political discourse of the Restoration, these texts discover and negotiate the disruption of traditional symbols and codes that was one of the (as-yet-unstudied) legacies of civil war and revolution.

Dynasty, family, lineage, the sacred, sex, and the body are not only the motifs and subjects of these paintings; they were also the principal political sites and discourses of early-modern England. My purpose in this essay is to sketch the early-modern history of these languages, the radical transformation of them effected by civil war, and their very different ideological performance in 1660. I want to suggest that the images displayed in *Painted Ladies* belong to a specific and brief period when the discourses of gender and sex, religion and dynasty, politics and power, were being renegotiated and rewritten, along with the script of monarchy itself, and that the paintings, as well as responding, contribute to that refashioning of social and political arrangements. For a decade or so after Restoration, I will argue, revolutionary representations loosened traditional codes and transgressed conventional boundaries, before changed political circumstances dictated a return to moral as well as political norms. Most of all, pleasure—sexual pleasure—for a brief moment became a novel mode of royal representation: of a king who was, in the wake of revolution, feeling his way toward a new relationship with subjects and a

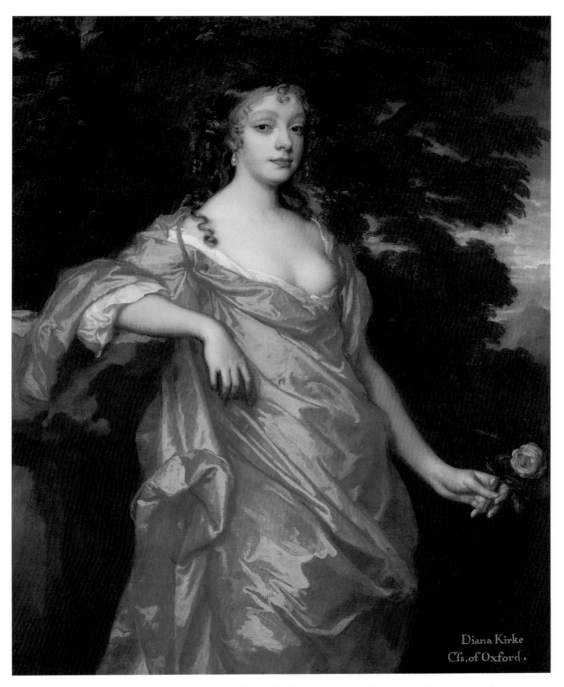

1. Peter Lely, *Diana Kirke (later Countess of Oxford)*, oil on canvas (ca. 1665), 52 x 41 in. (132.1 x 104.1 cm). Yale Center for British Art, Paul Mellon Collection.

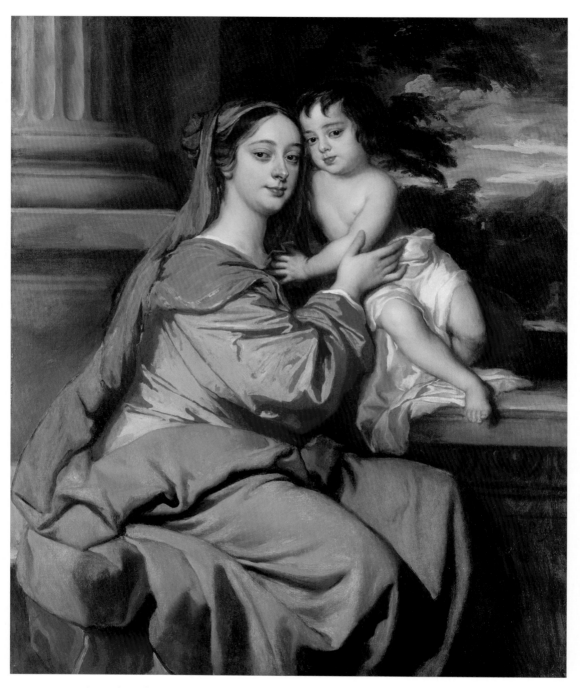

2. Peter Lely, *Barbara Villiers, Countess of Castlemaine (later Duchess of Cleveland), with Her Son, Charles Fitzroy, as Madonna and Child*, oil on canvas (ca. 1664), 49⅛ x 40⅛ in. (124.7 x 102 cm). National Portrait Gallery, London.

new monarchical style. "The Merry Monarchy," we must come to see, was serious political business.

Family and patriarchy had been the dominant languages of royal representation and formed some of the most powerful images of early-modern rulers.[4] Not least because his tenure was new and precarious, Henry VIII commissioned from Hans Holbein a mural of the Tudor royal family (fig. 3)—his father, Henry VII; his mother, Elizabeth of York; himself; and his third wife and only mother of a son, Jane Seymour—and patronized him and other artists for family portraits that initiated a new style of royal representation.[5] In Holbein's mural and the portraits of the king based on it, Henry—full face, standing akimbo, and with a large codpiece—is, as well as the sire of a dynasty, the patriarch of the realm. So important were this image and the language of patriarchal sway that, for all their very different circumstances, Henry's successors felt the need to redeploy them. Even at age nine (probably just before his succession), Prince Edward was painted very much in the style of his father;[6] later, Edward VI's sister Elizabeth ubiquitously used the language of nursing father as well as mother to represent her relationship with and care for her people.[7] Succession, family, was the central political issue—and anxiety—in Tudor England. Although the Stuarts did not initially face the problem that beset all Henry's children—lack of an heir—family and paternity remained dominant motifs of royal discourse. James I persistently used the language of the father, famously calling himself "dear dad" when addressing George Villiers, first Duke of Buckingham, making his favorite a part of an affective royal family.[8] In the case of Charles I, as I have argued elsewhere, family was the principal conceit of the king's representation of his monarchy.[9] Van Dyck's paintings of Charles with his children (fig. 4), or of the royal children together, transforming the royal family portrait, figure the king as loving father of his people—an image he also bequeathed to the realm in the pages of the *Eikon Basilike*, with his final address to his son.

If the civil war strained the discourse of polity as affective family, regicide killed the father as well as the ruler of the nation. Many of the elegies on Charles speak of a nation orphaned.[10] Yet the transference to Oliver Cromwell, especially after he became Lord Protector, of these tropes of the father figure underpins the embeddedness of this language as much as it suggests a psychology of power.[11] To royalists, however, Cromwell could be nothing other than a stepfather; it is in 1660 that a flood of panegyrics greeted the restored Charles II as the fertile future father of dynasty and nation who could reunite the fractured family of the realm.[12] Despite its promise, Charles's marriage to Catherine of Braganza was barren. But unlike Henry VIII, Charles did not divorce his queen and marry a mistress to secure a legitimate heir. He paraded his mistresses as mistresses and publicized his fertility not, for the most part, within a conventional representation of family but through

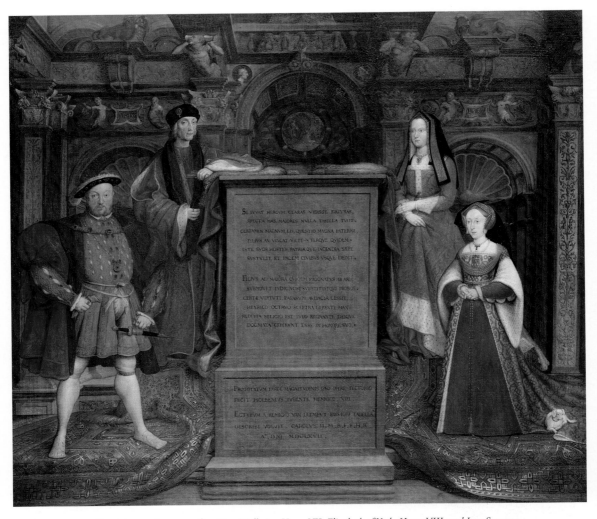

3. Remigius van Leemput after Hans Holbein, *Henry VII, Elizabeth of York, Henry VIII, and Jane Seymour,* oil on canvas (1537), 35 x 38⅞ in. (88.9 x 98.7 cm). The Royal Collection, Her Majesty Queen Elizabeth II.

his illegitimate offspring—the first in England elevated to form a ducal caste like that in France.[13] Was Charles seeking to lay the blame for the failure of issue publicly on the queen, or did his expansion through representation of what constituted a royal family (a monarchy) signal a broader political move? Certainly the king's critics sought to counter his attempt to abnegate responsibility for failure to provide an heir, claiming that it was Charles's sexual profligacy which had wasted a national as well as personal bodily resource. In the lines of John Lacy's poem on Nell Gwyn:

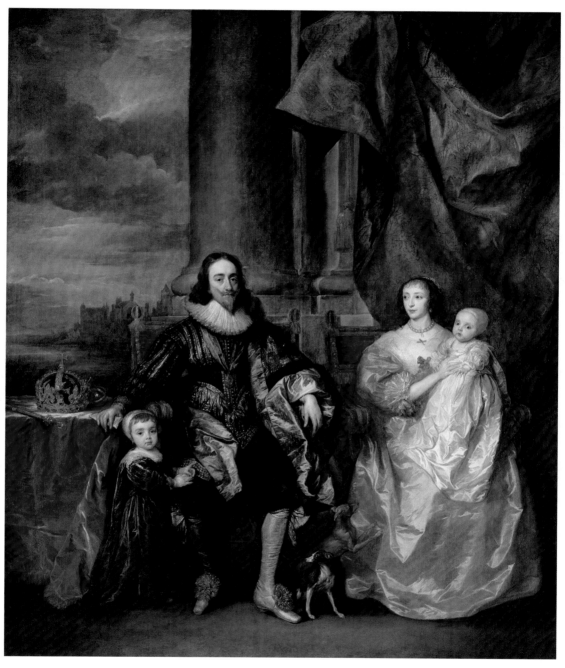

4. Sir Anthony van Dyck, *Charles I and Henrietta Maria with Their Two Eldest Children, Prince Charles and Princess Mary*, oil on canvas (1632), 146 x 108 in. (370.8 x 274.3 cm). The Royal Collection, Her Majesty Queen Elizabeth II.

How poorly squander'st thou thy seed away
which should get kings for nations to obey![14]

And John Milton, using a term with regal as well as familial freight, praised "house-hold society" and, in his critique of Restoration promiscuity in *Paradise Lost*, celebrated marital union.[15] Charles's supporters responded, however, by claiming patriarchal language for the king, in one case in a revealing new way. At the height of the political crisis of the Popish Plot, when once again the nation teetered on the brink of civil war, Robert Filmer's *Patriarcha; or, The Natural Power of Kings* was published, with an engraved portrait of Charles II. The next year, famously, in "Absalom and Achitophel," John Dryden presented the king as an Old Testament patriarch in an age of polygamy, "scatter[ing] his Maker's image through the land."[16] It may be that Dryden, like Charles himself, was making the best of a difficult situation. But if there is something in our sense that Charles was rewriting patriarchy (as I will argue he was to rewrite desire), as a public representation in changed circumstances, Lely's canvases are important documents of that new presentation of a royal family larger than the traditional understanding.

Central to the conventional Christian family was marriage, another vital discourse and symbol of early-modern monarchy. At the coronation service, the placing of the ring on the monarch's finger symbolized not only the sovereign's faith and priestly function (bishops wore a ring), but also marriage to the realm.[17] Henry attributed so much importance to holy matrimony that he married six times, not least out of conviction that God had not favored or sanctified his earlier unions. Although she was "the Virgin Queen," Elizabeth made much of her politic marriage with her people, on one occasion dramatically breaking off a speech to hold out to Parliament her ring, as she told them, "I am married already to the realm of England when I was crowned [*sic*] with this ring, which I bear continually in token thereof."[18] James I, in words that were echoed in several other speeches, told his Commons: "I am the husband and the whole isle is my lawful wife."[19] It was Charles I and Henrietta Maria, however, who, not least on account of enjoying the first happy royal marriage in early-modern England, made their marital union the central motif of monarchical representation (fig. 5). On canvases, as in masques (in *Coelum Britannicum* they were figured as one, "Carlomaria"), the royal marriage was represented as a platonic union of higher rational souls, a symbol of the king's qualification to rule and of the mystical union with his people.[20] Civil war and regicide ruptured that union. Poets and pamphleteers wrote of a nation "widowed" by the death of the king,[21] and it may be no mere coincidence that both advocacy of divorce and the Civil Marriage Act of 1653 followed soon after civil conflict and the death of a sacred king.[22]

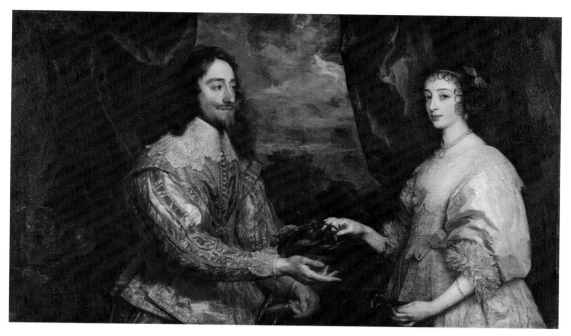

5. Sir Anthony van Dyck, *Charles I and Queen Henrietta Maria,* oil on canvas (1632), 44¾ x 64⅛ in. (113.5 x 163 cm). Archiepiscopal Museum, Kroměříž, Czech Republic.

In 1660, then, the royal marriage in the narrower and larger, personal and political, senses—as Charles II himself recognized when he acknowledged public desire for his early betrothal—was part of the process of resettling the kingdom.[23] Yet, whatever its popularity in the public eye, Charles's marriage turned out to be a personal failure. Although—and his reasons for this require exploration—Charles never seriously entertained divorcing Catherine, and on occasion stood by her at some political risk to himself, the couple were not close.[24] Describing her as looking more like a bat than a woman, Charles almost immediately separated himself from his wife and publicly distanced himself from his marriage.[25] Literally. The king spent most of his evenings apart from Catherine, provocatively appointed his mistress the Countess of Castlemaine to a post in the queen's bedchamber, and set her up—and later Louise de Kéroualle, Duchess of Portsmouth, as well—in apartments more lavish than the queen's, where Charles dined and spent most of his leisure time.[26] Not only did Portsmouth become, in many respects, an "alternative queen," but Charles was rumored to have undergone a mock marriage with her— a mockery indeed of the sacred bonds of his lawful union.[27] Marriage, then, was no easy discourse of representation for Charles II, and it is notable that his speeches

do not deploy it. Marriage remained central to Restoration politics: Edward Hyde, first Earl of Clarendon, was charged with arranging a barren marriage to advance his daughter Anne to the throne as the Duchess of York, and the question of whether the king had married Lucy Walter, the Duke of Monmouth's mother, became vital to the politics of Exclusion.[28] But Charles's self-presentation was less that of the husband than of the lover, the man not confined by conventional codes or boundaries, the monarch who reconstituted the royal household by instituting the mistress as a recognized figure. While in so doing the king, as we shall see, surrendered the discourse of marriage to his critics and opponents, he appears to have willingly publicized different amorous—and therefore political—relationships.

In early-modern England the most common analogue (a contemporary term of more force than our metaphor) for the state was the body. As Ernst Kantorowicz expounded in his classic study, the theory, or political theology as he termed it, of the king's natural and politic bodies was devised to reconcile the humanity and mystery of kingship, to conjoin the man and the polity.[29] In the case of Henry VIII we are again led back to Holbein, whose portraits render the royal body as the body of the realm, no less than Reformation apologia depict Henry as head of the Church as well as the state. In an age of dynastic politics, disputed successions, and foreign threats, the royal body needed to be strong, fertile, procreative; by contrast, the female royal body needed to be a marital and maternal body. Two childless queens therefore added to their difficulties as women a major problem of representation as well as rule. In the case of Elizabeth, while remaining, and persistently proclaiming herself, a virgin, the queen endeavored to make her public body the body of the realm. The "Ditchley" portrait (fig. 6) literally superimposes the queen's body on a map of Britain on which she stands, while another engraving shapes the very coastline of the realm to the figure of the queen.[30] Elizabeth erased her personal sexual body—she is nearly always alone in portraits—but successfully represented her iconicized body as the body politic. As is infamous, James I's sexual body was at the core of his problems and especially undermined the image of monarchy. Effeminate and homosexual, the king's body signified not the strong Protestant nation but corruption and Catholicism, sodomy being long associated with monks and Jesuits. Revealingly it was the martial body of James's son Prince Henry that came to embody the hopes of the realm, but these hopes would be dashed by Henry's untimely death in 1612.[31] After the damage done by his father to the representation of the king's two bodies, it would seem as though Charles I sought consciously to re-sacralize the royal body. Although in his case the body was fertile and procreative, Charles mystified his person through distance and ritual, while on canvas Van Dyck reconstituted the king's body personal as the body politic.[32]

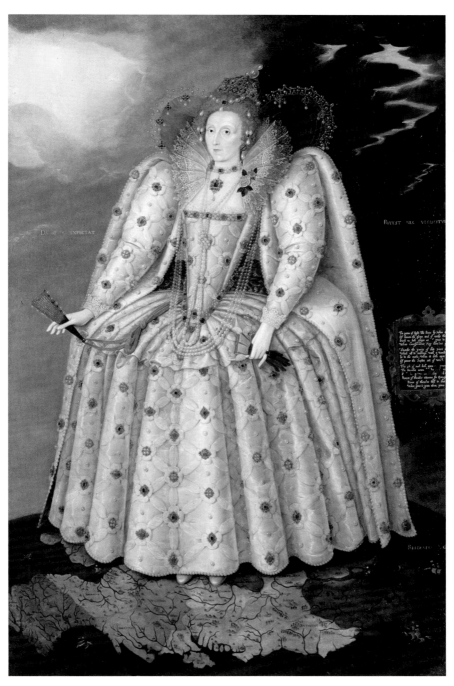

6. Marcus Gheeraerts the Younger, *Elizabeth I*, called the "Ditchley" portrait, oil on canvas (ca. 1592), 95 x 60 in. (241.3 x 152.4 cm). National Portrait Gallery, London.

Ironically, Charles's success in conjoining the king's two bodies necessitated republic as well as regicide. I have remarked elsewhere—and it remains striking—that, even in death, the royal body of Charles I was not cartooned; it retained its mystery.[33] The same could not be said of the republic or even the Lord Protector, both ubiquitously represented in doggerel verse, ballads, and woodcuts as grotesque and deformed: as not a body politic at all but in Cromwell's case a nose, in that of the Commonwealth a stinking part, a rump.[34] In 1660, then, there was "an unresolved relationship between the king's body and the body politic."[35] While the mystical body of Charles I offered the most recent model, the republic and Hobbesian political theory had refigured the state as a monster, as artificial and anatomized.

Charles II's body had already been represented to his subjects before he returned to his throne: narratives of his flight after the battle of Worcester described him as dirty and disguised, and tales spread of his sexual escapades.[36] As has recently been brilliantly argued, an early series of paintings he probably commissioned depict Charles as anything but mystical, rather as a humble figure of folklore (see, for example, fig. 7).[37] Here again I would suggest that Charles skillfully accommodated and embodied the ambiguities of Restoration. No monarch touched more people to cure what was called the king's evil (scrofula)—the ultimate expression of sacred kingship. On the other hand, Charles rejected his father's ceremonial: in contrast to the towel the king had touched being raised aloft as a sacred object, he laughed at the court customs of Spain (often the model for his father's) where, as he put it, the king could not piss without someone holding the pot.[38] Charles II made his body public: he walked in St. James's Park, often with no attendants; he stood grimy amid the flames of the Great Fire of London, manning a water pump. As several commentators from Pepys onward observed, Charles appeared as much an ordinary man as a monarch.[39] Most of all he revolutionized the representation of the royal sexual body. Charles openly conducted his sexual affairs and publicly fondled his mistresses; his sexual life and even his genitalia were the subjects of public interest and conversation.[40] In every sense Charles's reign rendered the royal body a public sight as well as site. In so doing it may be that, as critics have argued, he demystified monarchy and damaged royal authority. Yet this publicizing of his affairs (his brother was far more discreet) was partly a royal choice and possibly a strategy. Rachel Weil suggests, and I will return to the suggestion, that his sexual body was Charles II's blazon.[41] Did he recognize that, for all the sacred discourse and ritual of state, the regicide had destroyed for all time the sacred body of the king? Was the representation of his public sexual body a refiguring, a humanizing, of a trope for changed times? John Dryden, for one, was doubting the valence of the old political theology: "if," he prefaced "Absalom and Achitophel," "the body politic have any analogy to the natural. . . ."[42] A few decades later Bernard Mandeville,

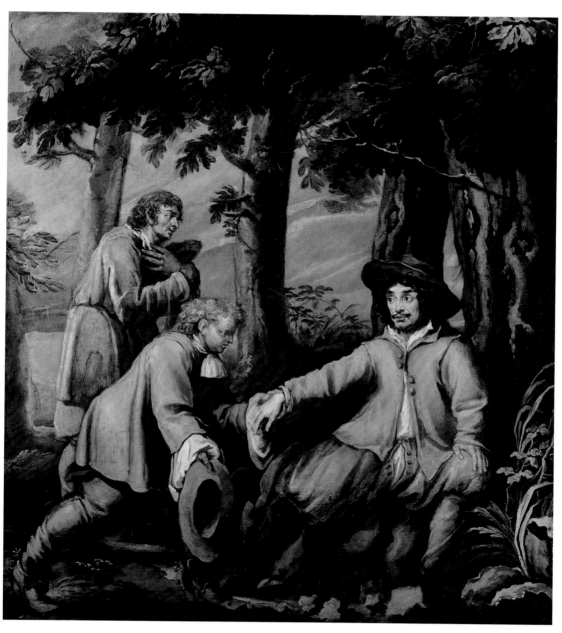

7. Isaac Fuller, *King Charles II in Boscobel Wood*, oil on canvas (?1660s), 84⅛ x 74 in. (213.7 x 188 cm). National Portrait Gallery, London.

accepting the demise of the theory and the legacy of Hobbesian atomism, replaced the king's two bodies with the hive as the analogy for the state.[43] If there is something in my suggestion that Charles's sexual body was refigured to represent the body of the people, then along with diaries, newsletters, and verse, along with (as I will argue elsewhere) portraits of the king that owe a debt to Holbein, these canvases of mistresses and bastards perform in that process—even though they do not directly depict Charles himself.[44]

Discussion of the royal body leads us swiftly to the subject of intimacy, significantly a word with both sexual and political meaning, especially in the personal monarchy of early-modern England. The king's body servants were those closest to him, his intimates, who, as David Starkey has shown, could often wield more influence than major officers of state.[45] Henry VIII's minions and Gentlemen of the Privy Chamber were suspected and feared by powerful ministers. Under Mary and Elizabeth, courtiers were wary of the potential influence that might be exercised by the queen's female body servants; they coveted the seemingly unimportant positions, such as Master of the Horse, because such posts licensed close and frequent personal attendance on the queen—not coincidentally were there rumors about Elizabeth's sexual affairs with the earls of Leicester and Essex, both Masters of the Horse. Intimacy was inseparable from that cynosure of early-modern monarchy: counsel. That is why James I's personal favorites led him into such political trouble. By transgressing the normal rules of intimacy—by having male lovers—James was open to the charge of being improperly advised and corruptly influenced, indeed (given the signification of homosexuality) popishly counseled. Key, therefore, to Charles I's reform of monarchy was a reconstitution of the politics of intimacy. Charles had no favorite; he took advice from his Privy Council; he kept a distance from his ministers and officers. Although his wife was increasingly suspected of exercising inappropriate (in other words, Catholic) influence through intimacy, at least her place in his bed was legitimate and his expulsion of the Ganymedes who had attended his father was welcomed.[46]

Once again Charles II fundamentally transformed the politics of intimacy. Those closest to the king were not, for the most part, men but women—mistresses—with whom, away from public affairs, Charles spent most of his time. Not only was intimacy again dangerously connected with illicit sex (John Wilmot, second Earl of Rochester, shared Jane Roberts with Charles), but Charles's behavior raised the specter of influential, powerful women.[47] Although Sonya Wynne and others have rightly downplayed the women's actual influence over policy as out of all proportion to what was feared, Charles's mistresses were widely suspected of corrupt influence and Portsmouth was directly blamed for the dissolution of Parliament and a pro-French foreign policy.[48] Revealingly Nell Gwyn escaped most of the

opprobrium, not just because she was Protestant (and of low birth) but because she showed little interest in politics or power:

> She hath got a trick to handle his p[rick]
> But never lays hands on his sceptre
> All matter of state from her soul she does hate,
> and leave to the politic bitches.[49]

For all their differences, Charles followed his father in keeping a personal distance from his ministers and withholding real power from his intimates who were not only women but sometimes commoners. Moreover, his relationships with his mistresses were fickle and founded more on fancy and lust than any enduring bond of love. After the fall of the Earl of Clarendon, Charles had no obvious close political confidant. Amid the circles of his ministers and his mistresses, he was free to take all counsels and ultimately to follow his own.

Whatever the extent of their influence, the appearance of women at court who had the place and potential to influence the king should not pass unremarked. For much of the early-modern period the powerful woman was but a contradiction in terms. Countless courtesy manuals, prescribing that they remain chaste, silent, and obedient, sought to confine women to housewifery and the household and to deny them a place in the public sphere.[50] If right authority was founded on reason, it was argued, women could not rule; governed by appetite, their leaky, lusty bodies symbolized their sex's failure at self-regulation, that quality essential for government over others. Female power was, in this society, illegitimate, illicit, and demonized as witchcraft or seduction. Although such prescriptions were by no means uncontested—their repetition betrays nervous anxiety that they were not heeded—women rarely performed on the public stage of theater or state. The civil war, however, transformed the role of women and the discourse of gender, that is to say, of politics.

During the 1640s and 1650s women emerged as petitioners and lobbyists to Parliament, as fighters and preachers.[51] Although such transgressions continued to be condemned, they slowly effected a change in attitudes that may be reflected in the decline of witchcraft trials from mid-century on as well as in a mounting literature advocating female spiritual equality. An important legacy of civil war and revolution was the emergence in 1660 of women in a myriad of public places and roles: among other things, as writers, actresses, and as mistresses at court. The virulent misogyny of some Restoration texts offers testimony enough of a male ambivalence regarding such changes, and there is a debate about whether a new libertinism further confined or emancipated women.[52] Yet what is unquestionable is that such literature acknowledged female sexual desire and the force that female

sexuality—what the poet and playwright George Etherege graphically terms "the powerful cunt"—could exert.[53] More positively, women also published and publicized their sexuality. Where female publishing had been regarded as akin to prostitution, Aphra Behn not only made a career in letters but legitimized female sexual desire and wrote a female heroic not scripted by chastity.[54] The royalist Katherine Philips even valorized same-sex female relations.[55]

Milton intuited these important social changes. Uncoupling female virtue from what in *Comus* he had described as "the sage and serious doctrine of virginity," at the close of *Paradise Lost*, in James Turner's words, Milton "promotes the female as a paradigm of the new heroism."[56] *Paradise Lost*, as we have come to see, is an intensely political poem, and the new representation of women had important political implications for a commonwealth structured around gender norms, one that Andrew Marvell was now calling "our Lady State."[57] To many "the powerful cunt" represented the subversion of politics as well as gender politics. Castlemaine's desire to be publicly recognized as a royal mistress epitomized the dangers of a new female sexual presence.[58] Those who criticized Charles II for advancing these women to title and place presented him as effeminized, weakened by them. The Whig theorist John Locke, in his treatises on government, was to reinscribe the household and family as the fittest domains of female agency and restate chastity and fidelity as the vital feminine virtues, not least because they guaranteed the legitimate patrimonial descent of property. The king himself, however, celebrated and licensed female sexuality and in so doing transformed a gendered discourse of state. It may be that, often more swiftly than his subjects, he sensed the changes effected during his exile, and he recognized the new role of women in the public sphere and, though not without ambivalence, the benefits of acknowledging, not contesting, it. The royal mistresses of Lely's canvases have an agency as well as a sexuality that is part of a changed social and political world, one in which the business of kingship would be conducted.

In sixteenth- and seventeenth-century England the tropes of gender and sex were inseparable from religious language and polemic. As I have noted, in Reformation literature sodomy is most often associated with monks, and of course the biblical Whore of Babylon was identified by Protestant exegetes as the papacy. Represented as the Virgin, one of the few positive female symbols, Elizabeth I was often contrasted with the Whore, her Catholic cousin Mary Queen of Scots— whose relations, it has to be said, did nothing to discountenance the association. In sixteenth-century England, whoredom was figured as popish. On the other hand, and again from the Reformation, the charge of sexual promiscuity was leveled also against the radical Protestant sects, in particular the Anabaptists, who threatened all social order. Sexual slander, then, was frequently deployed to vilify

religious opponents (that is, also political opponents); in the British civil wars religio-sexual languages wrote the pamphlet polemics of charge and countercharge.[59] It has long been argued, even if latterly it has been disputed, that after the religious conflicts of civil war, the Restoration witnessed a greater reluctance to speak and write the scripts of state in the language of the sacred.[60] For all his invocation of Providence in 1660, the languages, speeches, and ceremonies of Charles II's early years often sound novelly secular. Less often observed, however, is the blatant uncoupling of religion, morality, and sex. Of course, the Church courts, which had endeavored to regulate lay sexual behavior, were restored in 1660, but the story of the following years was one of their "declining business and shrinking authority" in a more Erastian Church.[61] In that story, the role of the head of the Church played no small part. Whatever Charles's private religious faith, his behavior was perceived as unsettling not just the moral authority but the authority of the Church of England. Gilbert Burnet, bishop of Salisbury, was later to claim that Charles, without conscience, went right from his mistresses to church.[62] And contemporary verse connects the king's immorality with possible irreligion. As "The King's Vows" satirized him in 1670:

> I will have a religion then all my own,
> Where Papist from Protestant shall not be known,
> But if it grow troublesome, I will have none. . . .
> But whatever it cost I will have a fine whore.[63]

Worse in the eyes of some, Rochester, a poet close to the king, portrayed not love but sex itself—fucking—in sacral language, as if mocking the Church's teaching on sin, in the same manner that some of Lely's canvases audaciously toyed with sacred conceits (see, for example, fig. 2). The established religion and Church were, of course, central in the politics of Charles II's reign, and from the 1670s opponents of the king, not least Marvell in the *Growth of Popery*, directly associated royal lust with debauchery and Catholicism.[64] Charles's position, however, may not have simply been dictated by his sexual urges. In the first place, the king was anxious to signal the end of Puritanism, with its unpopular agenda of policing lay morality. Even in the late 1670s, long after the memories of those ayatollahs of moral behavior, the Cromwellian major generals, Rochester told Burnet that strict moral regulation smacked of "enthusiasm or canting."[65] In addition, Charles's embrace of a more secular approach to sex, like his plans for toleration, was an "indulgence," an appropriation by a Protestant ruler of a remission of punishment and a grant of "freedom." In *Some Passages of the Life and Death of . . . Rochester*, Burnet related how the poet, using loaded political language, described

the restraint of men from women as "unreasonable impositions on the freedom of mankind."[66] Charles II wished to dissociate himself from Puritanism and to free himself from an Anglican stranglehold. When he gambled on indulgence being popular, albeit not to the liking of the Church, he may have been thinking of a laity freed from a variety of strictures.

In disrupting the conventional discourses of family, marriage, and gender, and of morality and religion, Charles II represented and personified what I want to call a new politics of pleasure. As well as a religious matter, in a Christian commonwealth sex had been a social and political concern and an analogue for social and political arrangements. Sex was a matter for, and a symbol of, regulation. The sexual impulse stood for the appetites, and control of the passions was what distinguished men—and it was only men—from beasts, and equipped them for rational self-governance. Those who could not govern themselves had to be ruled by others: women by men, the libidinous rabble by virtuous governors. The regulation of sexual behavior was inseparable from the foundations and principles of government itself. Indeed, during the interregnum, the most often cited sign of an entire world turned upside down was unbridled sexual activity: free love signaled not only the rejection of religious authority but political anarchy. It was not least the alleged promiscuity of the radical sects that led the gentry to the restoration of old political forms. Ironically, however, Charles II himself overturned the traditional paradigm through what amounted to an official sanctioning of sex and promiscuity. Given the ties between sexual regulation and sound government, we must endeavor to understand why.

The king's own appetites scarcely begin to solve the puzzle. As we have seen, Charles did little to keep his promiscuous behavior or that of his court from the public eye; on the contrary, he paraded it. Rachel Weil suggestively describes the public sexual display as a parodic "form of royal ceremonial," and she is supported by John Oldham's satirizing a monarch with arms "Priapus Rampant"—perhaps another reference to the well-publicized size of the royal penis.[67] Sexual indulgence and pleasure were, and were seen to be, new forms of royal representation. Again, this representation may have been intended as an antidote to an unpopular Puritanism and as the replacement of a repressive and sterile regime by a monarchy of liberality and abundance. But the priapic was also a mode of assertion, and Rochester may have been right to discern in Charles's sexual self-proclamation a broader assertion of royal will. Directly associating sexual appetite with unbridled royal prerogative, the poet wrote of his master:

> What ere religion and the laws say on't
> He'll break though all to come at any cunt[68]

There had long been an identification made, not least from observation of the Turkish polity, between libertinism and tyranny; many less well disposed toward the king than Rochester would deploy it against Charles. But the attacks, I think, also manifest a nervousness that the pleasure the king embodied might, too, be the pleasure of the nation, and that their indulgence might form an affective bond between the king and his subjects. During the 1690s the Whigs were to accuse Charles II of using debauchery as a means of gaining popularity. In 1694, for example, *The Portraicture of . . . King Charles II* presents the king as articulating that "debauchees . . . will never be enemies to a reign that allows them in it," and that debauchery would assist his quest to restore arbitrary government and popery.[69] Such concerns were not only articulated from hindsight. Milton, for one, did not allow the court to claim a monopoly on sexual pleasure. *Paradise Lost*, unlike *Comus*, is a text that celebrates, in Adam and Eve, the erotic and sensual, even borrowing in the process from Cavalier lyric.[70] To be sure, it is marital sex, but the change of tone is striking. And the larger cultural change that it may reflect may be witnessed in a very different way by the behavior of Pepys. As a good civil servant of the interregnum regime, Pepys could be critical of Restoration extravagance and indecency, but he was obsessively drawn to the royal mistresses, especially Castlemaine (whose picture he acquired and fetishized); one might say that he was vicariously involved in the king's sex life, which his own replicated in some ways.[71] As today, the sexual lives of great figures attracted and repelled; they made authority itself a site of desire as well as disgust; and in the post-Hobbesian universe in which Charles ruled, desire may have been a crucial bond now that chivalry and platonic love had fallen victim to civil conflict.

Charles admired his old tutor Thomas Hobbes, whom he protected at the Restoration, while the king's friend Rochester, in his defense of sexual freedom, reprised a Hobbesian theory of the appetites.[72] It is Rochester, famously, who connected the royal prick and scepter, Charles's sexuality and government—but he is not alone. Charles is the Stuart most fondly remembered in popular histories, in which his nickname "Old Rowley," after his racing stud at Newmarket, preserves an image of the king that had currency at the time. As often it may be the poets who best discerned a transition in the cultures of sex and power. In his "Instructions to a Painter," Edmund Waller describes the beauties of the court inspiring sailors to great deeds.[73] More interestingly, Dryden figures the might of Charles II in overtly sexual language, drawing attention to his "new cast canons" and "big corned powder."[74] Already in 1672 Dryden is figuring sexual power as power, and presenting Charles as what he was to call "Thy longing country's darling and desire."[75]

That the enduring popular image of Charles II, as Ronald Hutton points out, is at odds with the academic evaluations of the king and man may helpfully direct

us to the issue of class.[76] In early-modern England, pleasure, festivity, and promiscuity were associated with popular culture. Puritanism, it has long been argued, appealed to the middling sort, not least as a movement for regulation of the unruly festivities (and costly illegitimate offspring) of the lower orders.[77] In the reigns of James I and Charles I, though by no means condoning immorality, the monarchs had sanctioned popular games and festivities in their Books of Sports of 1618 and 1633 that had alienated Puritan magistrates. Not only were popular games celebrated in the verse of Robert Herrick and the Cavalier poets, but the sensual and erotic charge of May dances and festivities was fully embraced too. Timothy Raylor and James Loxley have persuasively argued a closer link between court poets and popular culture, by tracing the participation of poets such as William Davenant and Sir John Suckling in the taverns and revelry of Stuart London.[78] For all the remote hauteur of Charles I, the court reached into popular culture, and there can be no doubt that the abolition of the monarchy was deeply unpopular. During the interregnum, the closure of the theaters and the prohibition on the celebration of Christmas and other festivals drew stark attention to a connection between monarchy and popular pleasure—not the least of the reasons the Restoration was heralded with popular joy. With the restoration of kingship many hoped for the return of festival culture; in this regard at least, Charles II did not disappoint. The king's public entry into his capital on his birthday, the 29th of May, was perhaps the most dazzling spectacle staged for an early-modern sovereign, and Charles did not fail to mark other state occasions with stunning fireworks displays for the people.[79] The royal style was also more accessible and popular; as we have seen, Charles walked so freely in St. James's Park that it was possible for a humble commoner to accost him.[80]

But what I most wish to remark is the relationship of Restoration sex to class— or, more exactly, the transgression of class lines by Restoration courtiers and even the king himself. In "A Ramble in St. James's Park," Rochester paints a graphic portrait of the sexual as well as social miscegenation of the classes, describing a mistress as

> Full gorged at another time
> With a vast *Meal* of Nasty slime
> Which your devouring *Cunt* had drawn
> From *Porters' Backs and Footmen's-Brawn.*[81]

A host of other verses, some hardly less graphic, make the same point. Indeed, their language radically breaks from courtly sensibilities and refashions them to the style of the street. Sex is indeed a leveler. The "poor whores" who petitioned Castlemaine in a pamphlet address her as one of them, "concerned with us," a

gesture the countess reciprocates in her supposed response to her "sisterhood in Dog and Bitch Yard."[82] In the cases of Moll Davis and Nell Gwyn, of course, Charles took as mistresses commoners of dubious reputation, the latter already a prostitute and perhaps one of the many Charles patronized casually alongside his more established affairs. Not only was Charles's sex life common knowledge; some of his women were common subjects. At a time when novels about Henry VIII sitting down to drink with a humble cobbler were being published, this may have contributed to Charles's popularity.[83] Nell certainly seems to have been popular—and perhaps for her humble origins as well as her Protestantism. Although respectable society, including the London apprentices in 1668, manifested their disapproval of immorality, to humble folk the down-to-earth Charles with his orange seller may have had an appeal that predominantly middle-class historians have missed.[84] When one rereads G. M. Trevelyan's famous description of a king with "thick sensuous lips, dark hair and a face of the type more common in Southern Europe," one can almost see the net curtains twitching.[85] At several points in his reign, however, Charles appealed to his people over the heads of his Parliament; in 1680 he gambled on popular loyalty—and won. During the last years of his reign, Old Rowley helped to take the Stuart monarchy to its height of popularity and power.

Although it is the subject of another, more expert, contribution to this collection, in my discussion of sex and politics I must glance briefly at the Restoration stage. After the closure of the theaters in 1642, following a long Puritan antipathy to the stage, the monarchy was regarded as the champion of the players—and, reciprocally, some argued, monarchy was supported by play.[86] If not always uncritically supported by theater, the monarchy was certainly represented in and by it. The impresarios and managers of the Restoration stage, William Davenant and Thomas Killigrew, for example, had long-standing connections with the Stuart court and cause, and in 1660 they received a patent to erect a new playhouse, performances in which were to be independent of the censorship of the Master of the Revels. If the Restoration stage represented the monarchy, its most common subject was sex. For all the treatment of sex and commodification in Jacobean city comedies, it was on the Restoration stage where sex outside marriage was ubiquitously staged and stripped of moral opprobrium.[87] Moreover, Restoration drama introduced a popular new character antagonistic toward marriage and any social restraint on his appetites: the rake. As Harold Weber, Susan Owen, and others have observed, the rake was a Hobbesian figure who represented a new world of loosened social bonds and obligations.[88] As other critics have argued, the Restoration theater was engaged in generic experimentation, as with broader social and political changes: with the legacy of civil war to honor, allegiance, and community, and with its consequences for the nature of monarchy itself.[89] Plays about marriage and sex were

part of that process of negotiation with change. The rake, writes Susan Owen, "is a Machiavellian and Hobbesian figure"; in *The Country Wife*, the predatory deceiver Horner describes himself as "a Machiavel in love."[90] The new, unrestrained sexuality figured the new politics of interest, calculation, and guile, just as platonic love had symbolized Renaissance ideals of social and political relations. On the stage of the Restoration years, love was a politic universe; no less the new polity, and "politics" (a term slowly emerging from opprobrium) was negotiated, represented, and perhaps even valorized through a new discourse of sex and love.[91] Quite simply, the affection of subjects could no longer be assumed; it had to be won. The bonds of love in the state as on the stage were giving way to more fickle interest and desire. In his re-rendering of the *carpe diem* genre in at times provocatively brutal lines, as well as in his less often cited tender love lyrics, Rochester seems to be experimenting with a new politics of love, sex, and state. *Poems on Affairs of State* are dominated by just that—sexual affairs that were also matters of state. And, I would suggest, Charles II was, as well as indulging his appetites, experimenting: with a new monarchy founded not on the old assumptions of patriarchy and love, but on calculation, interest, and desire.

The suggestion that Charles II's novel sexual representation was also a political representation gains support, I believe, from the discourses and modes of opposition to the regime. The charges of promiscuity and debauchery had been common oppositionist languages in early-modern England, in the village as well as at court. In James I's reign, the Overbury affair prompted libels vilifying a court that was politically as well as morally bankrupt;[92] during the interregnum the republican Henry Marten was the object of coruscating verse about his libertinism, which was taken as a manifestation of his politics.[93] In 1660 promiscuity appeared to be officially licensed and validated—not unequivocally (not even in Rochester's case), but validated nonetheless. While this radical move might have exposed Charles to a powerful language of opposition, however, for all the mutterings, the king's sexual activities—public from soon after his restoration—did not immediately draw public attack. It appears to have been a series of events, following in rapid succession, that revived sexual slander as a dominant trope of opposition. The plague, the Great Fire of London, and the Dutch invasion of the Medway all could be, and in some circles were, read as signs of God's hand of judgment on Sodom, on an England mired in debauchery. We cannot know when Milton, who published *Paradise Lost* in the wake of these disasters, composed particular lines, but the poem's celebration of "wedded love" as "mysterious law" and condemnation of "the bought smile of harlots" redeploy familiar conceits in highly topical circumstances.[94] "Wedded love," once a predominant motif of royal representation, was now turned against a king who had publicly flouted its mysteries.

8. Jan Roettier, *The Peace of Breda*, gold medal (1667),
diameter 2¼ in. (5.6 cm). The British Museum, Department of
Coins and Medals.

Topicality and specific sexual reference were combined in the devastating critique
that initiated a new stage and form in the literature of opposition to Charles II.
Andrew Marvell's *The Last Instructions to a Painter* not only appropriates for oppo-
sition a genre Waller had created for royal encomium; it totally subverts the new
representation of royal sexuality as liberality, abundance, and national desire. In
Marvell's poem it is the republican Dutch, not the king, who, while invading, appear
to woo and caress a willing people. Painting a languid pastoral vision (pastoral was
a conventional genre of anti-court literature), Marvell describes how the "Belgic
navy glides / And at Sheerness unloads its stormy sides."[95] Once the feeble chain
across the Medway is easily broken (as easily as virginity is lost at court?), the pas-
sage is open and the fleet penetrates the realm. While England is taken, the courtly
gallants, weak and effeminate, "a race of drunkards, pimps and fools," looks on
helpless.[96] As for the king, in his bedroom, he has a dream of a helpless, naked,
blindfolded, and bound Britannia (the medallic figure for which his desired Frances
Teresa Stuart had sat as a model; fig. 8) standing before him. Rather than perform-
ing a chivalric rescue, he dreams of raping her. Here is a king whose subversion of
traditional sexual codes is not a reconstitution of kingship, but an abnegation of
it. The longing details of Marvell's description of the royal mistress parodies royal
duties diverted to pleasures as it also satirizes courtly sacrilege. Charles II is figured
here not with mighty cannons but as unmanned, as much as unkinged, by sex: "He
only thunders when he lies in bed"—and even there, the poem hints, the action
may be onanistic, an impotent self-pleasuring.[97] Although sexual-political critique
could hardly come sharper than that, Marvell's poem opened the way to other

satires that turned the royal image against the king. In "The Fourth Advice to a Painter," the anonymous author starkly contrasts kingly duties and sex, portraying Charles, in an allusion to Nero, as fornicating while the English ships burned. The verse continues:

> So kind was he in our extremest need,
> He would those flames extinguish with his seed
> But against Fate all human aid is vain:
> His pr— then prov'd as useless as his chain.[98]

Here not only are profligacy and its pretension to kindness exposed, but it is itself a sham—impotent and flaccid.

Rather than the roistering rake or Old Rowley, in opposition satires Charles is depicted as feminized and dominated by women. "The Fifth Advice to a Painter" posits that women have "snared the wisest prince."[99] In "The Haymarket Hector" the Duchess of Cleveland is "the prerogative whore."[100] When the French Catholic Duchess of Portsmouth replaced her as Charles's favorite, "The Royal Buss" has the French mistress effecting the dissolution of Parliament.[101] Not the manly sexual philanderer, the rake on the throne, Charles in opposition satires may think only of fucking the nation, but he does not even have the parts for that. In attacking Charles's government, these texts revive traditional sexual tropes of opposition, and they also invert the king's own public representation to reveal the failures of both prick and scepter.

Those who sought to defend Charles from such critiques were faced with the difficulty that it was the king's own radical refashioning of these languages that had provided the opposition with such an opportunity. One tactic was to divert attention from Charles II and revert to more suitable models of propriety. In his play *The Conspiracy*, the Tory dramatist William Whitaker portrays an exemplary married couple who resemble Charles I and Henrietta Maria.[102] The late 1670s and 1680s saw a big revival of literature on Charles I, presenting him as husband and father as well as martyr; it may be that the engravings of the royal family sold by Moses Pitt from 1682 to 1684 were an attempt at re-branding Charles II as his father's son and as a husband more than a libertine.[103] The publication in 1680 of *Patriarcha*—a text written in the reign of Charles I—with Charles II's portrait image may have been part of the same strategy.[104] Dryden pursued a very different course. Where others erased Charles or again presented him traditionally, he took up the king's reputation for promiscuity and sought, daringly, to sacralize it. In "Absalom and Achitophel," there is no place or sympathy for Queen Catherine; her infertility licenses the king's promiscuity, which in this poem becomes the

performance of kingly duty as well as sacred rite. Charles, like the biblical King David, "scatter'd his Maker's image through the land," and in so doing, like "Israel's monarch," he "his vigorous warmth did variously impart . . . wide as his command."[105] Let us return to Dryden's eroticizing of Charles's relations with his subjects—to the king as "thy longing country's darling and desire." Even in the crisis of 1680 Dryden, like Charles, intuiting a new psychology of authority in a post-Hobbesian world, boldly endeavors to render promiscuity, as do so many of Lely's female portraits, as a new family romance of the nation. It was not, however, to become a new script of state. Charles triumphed over his Whig enemies, but he did so by returning to the fold of the Tories and the Church. Already by 1680, too, despite Dryden's daring, the old moral codes, and with them traditional modes of royal representation, had regained the ascendancy.

If Rochester can be taken as the poet of the new sexuality and politics, his biography and the posthumous fate of his works reveal much about shifting values. In 1680, the year of his death, the first edition of Rochester's *Poems* was published, purportedly in Antwerp but in fact in London, with a prefatory epistolary essay anticipating a critical reception.[106] The same year, as if to neutralize the effects of the poems' public circulation, Bishop Burnet published his *Some Passages of the Life and Death of . . . Rochester*, in which he presented the poet as a deathbed penitent. Burnet's Rochester is a talented, brave nobleman (Burnet narrates Rochester's service in the fleets in 1665 and 1666) whose "natural propensities to . . . virtue" were corrupted by the court.[107] In his account of his discussions with Rochester, Burnet argues powerfully against the poet's philosophy, skepticism, and morality. Accordingly, Rochester's final conversion reads as a full acceptance of those arguments, as well as a conversion to belief in God. Burnet's concern to assert that Wilmot was not deranged but converted of his own free will demonstrates the bishop's wider purpose and the importance he attached to Rochester as a representative of court, and royal, morality. The year 1685 saw another deathbed conversion—or at least the public announcement by Charles II of his Catholicism as he called upon Father Huddleston to administer the last rites—although one story, that his last words were "Let not poor Nellie starve," evokes more ungodly priorities.[108] In 1685, too, a second edition of Rochester's verse was published. This time, *Poems on Several Occasions. Written by a Late Person of Honour* was publicly printed in London and "to be sold by most booksellers."[109] The edition was a sanitized version of the 1680 text, with the more obscene poems omitted and indecent passages revised.[110] Perhaps not coincidentally, as Rochester was being cleansed and newly presented, James II—though he continued to conduct affairs as king—took pains after succeeding to the throne to keep his extramarital relations discreet and to present himself very much as a monarch in a loving marriage to Mary of

Modena. As even Burnet, his leading critic, was to acknowledge, at James's court promiscuous sex was not condoned, or at least not practiced with an "open avowing."[111] It was, however, William III who proclaimed himself a champion of not only Protestantism but what contemporaries related to it, moral reformation. From 1688 William and Mary set out to promote an image of their marriage and their court as models of godly union and royal virtue, in contrast to the debauched popery of their Stuart relatives and predecessors.[112] In 1691 a third edition of Rochester was published by Jacob Tonson. A preface to the reader explained that Rochester had entered a court characterized by "ribaldry and debauch" in which poetry had no "good aspect."[113] But Rochester, it continued, was at least a poet of "manly vigour," in contrast to his French contemporaries, now the enemies of England, and he was a talent worthy of national preservation. The publisher presented the poet in this edition having "taken exceeding care that every block of offence should be removed." Tonson, secretary of the Whig Kit-Cat Club, who also purchased the rights to Milton's *Paradise Lost*, gave Whig England a Rochester collection of "such pieces only as may be received in a virtuous court and not unbecome the cabinet of the severest matron."[114] It was an edition from which the irreligious as well as the indecent verses were excised.

While Rochester was being repackaged as, at heart, a good Englishman, in sermons and tracts the Stuart monarchy was being vilified for its debauchery, popery, and tyranny. The poet's relations with his king, never properly explored, were complicated and by no means unambiguous, but the two were close. In 1670, in his published "Advice to the Painter's Adviser," Rochester viciously attacked the king's critics and presented Charles as not just "tender of his subjects good" but as Christlike, a "Vice God." "King's failings," he argued, "ought not lie / An open prospect for the Vulgar Eye."[115] As opposition to Charles had grown, the easygoing atmosphere in which Rochester himself had satirized the king was passing. From the later 1670s we sense from the poet's correspondence with Henry Savile that an age of free sexual pleasure was passing too.[116] The editor of *Poems on Affairs of State* sees the decade as one in which the king was increasingly the target of satiric fire.[117] A decade before Rochester's death, a more sober mood had overtaken the nation—one we may also sense from Lely's later style as well as the work of other artists.[118]

For all the rhetoric of restoral, the Restoration was a period of novel experimentation—and not only in science, the arts, and social customs. After experiences very different from those of his predecessors, Charles II experimented with a new style of kingship and self-representation: a style less sacralized, more familiar, more open.[119] The indulgence of pleasure was a powerful antidote to Puritanism: it acknowledged a new world of appetite and interest; it had popular

appeal. And a new acceptance of sexual pleasure responded to changed gender relations and the new place of women in society. If the 1660s, not least Lely's canvases, suggest a demystifying of the female sex, the same was true (though not in either case simply so) of Charles's monarchy—and, some feared, of religion itself. Like the female bodies of the actresses newly set, often in undress, on the stage, the royal body was a site of public voyeurism.[120] Charles promiscuously mingled with his citizens as well as his mistresses. After the disasters of the 1660s, the fall of Clarendon, and then the crisis over the king's declaration of toleration, much changed. Indeed, this declaration was not the only royal indulgence rescinded. As Charles's relations with his Parliaments deteriorated and he drew closer to France, the subjects' ardor for the king cooled. Charles's withdrawal and planned retreat away from London, at Winchester, signaled the end of a happy liaison.[121] Even after his triumph over the Whigs, he spent the last years of his reign in greater seclusion, while panegyrists—quite unlike Rochester—reclothed his monarchy in mystery. Rewedded to the Church and the Tories, Charles ended his promiscuous flirtations with Presbyterians and Dissenters.

By Charles II's death, a new aesthetic in literature and the arts was beginning the process that would condemn Lely's "painted ladies," along with the king's court, as decadent. Lely's portraits capture many of the ambiguities of Restoration: though they reprise traditional subjects, they subvert them; though they figure the holy, they come close to the sacrilegious; though their subjects are dynasty and lineage, they are portraits of women; though the king is not figured, he is, in some respects, the subject of them all—he is the sire, yet not the legitimate father. And though the head and reason of the realm, it is his body and his appetites that are here implicitly represented. Lely depicted Charles as a monarch of sex and pleasure, and in doing so he exposed his paintings not only to differences of sensibility and taste, but also to party conflict and ultimately Whig disapproval. As the exhibition gave us an opportunity to view them again free of that moral judgment, we should also take the occasion to study these paintings as testimonies to the artist's brilliance and, like Rochester's and Dryden's poems, as texts of a new politics of pleasure.

1. The different viewing experiences of the two venues are worthy of record. In London the rooms were laid out in a manner evocative of a boudoir; in New Haven the space was more generous, less intimate, and more austere.

2. Catharine MacLeod and Julia Marciari Alexander, eds., *Painted Ladies: Women at the Court of Charles II*, exh. cat. (London: National Portrait Gallery, London, in association with the Yale Center for British Art, 2001), 72.

3. See, for example, entry for 15 Aug. 1665 in *The Diary of Samuel Pepys*, ed. R. C. Latham and W. Matthews, 11 vols. (London: HarperCollins, 1995), 6:191, and James Grantham Turner, "Pepys and the Private Parts of Monarchy," in *Culture and Society in the Stuart Restoration: Literature, Drama, History*, ed. Gerald M. MacLean (Cambridge and New York: Cambridge Univ. Press, 1995), 95–110.

4. The classic study of patriarchy as political discourse is Gordon J. Schochet, *Patriarchalism in Political Thought: The Authoritarian Family and Political Speculation and Attitudes, Especially in Seventeenth-Century England* (Oxford: Blackwell, 1975).

5. The mural was destroyed, but a copy was painted by Remigius van Leemput. See Oliver Millar, *The Tudor, Stuart and Early Georgian Pictures in the Collection of Her Majesty the Queen*, 2 vols. (London: Phaidon Press, 1963), 1:152, no. 216.

6. See Karen Hearn, *Dynasties: Painting in Tudor and Jacobean England, 1530–1630*, exh. cat. (London: Tate Pub., 1995), 49–50, no. 13.

7. See, for example, *Elizabeth I: Collected Works*, ed. Leah S. Marcus, Janel M. Mueller, and Mary Beth Rose (Chicago and London: Univ. of Chicago Press, 2000), 72, 151, 198, 314–15, 325–26, 329, 331, 339, 342. See also Helen Hackett, *Virgin Mother, Maiden Queen: Elizabeth I and the Cult of the Virgin Mary* (New York: St. Martin's Press, 1995), and Carole Levin, *The Heart and Stomach of a King: Elizabeth I and the Politics of Sex and Power* (Philadelphia: Univ. of Pennsylvania Press, 1994), esp. chap. 6.

8. See *Letters of King James VI and I*, ed. G. P. V. Akrigg (Berkeley: Univ. of California Press, 1984), 374, 386–87, 418–19, 431–32, 440–41, and David Moore Bergeron, *Royal Family, Royal Lovers: King James of England and Scotland* (Columbia: Univ. of Missouri Press, 1991).

9. Kevin Sharpe, *The Personal Rule of Charles I* (New Haven and London: Yale Univ. Press, 1992), 184–90.

10. See, for example, Kevin Sharpe, "'An Image Doting Rabble': The Failure of Republican Culture in Seventeenth-Century England Rewritings," in *Remapping Early Modern England: The Culture of Seventeenth-Century Politics* (Cambridge and New York: Cambridge Univ. Press, 2000), 238–40.

11. Sharpe, "'Image Doting Rabble,'" 250–53.

12. See, for example, Martin Lluelyn, *To the Kings Most Excellent Majesty* (London: Printed for J. Martin, J. Allestry, T. Dicas, 1660); John Dryden, H. Herringman, and James MacDonald, *To His Sacred Majesty* (London: Printed for H. Herringman, 1661); and John Dryden, *Astraea Redux* (London: Printed for H. Herringman, 1660).

13. I am grateful to John Adamson for this point.

14. George de Forest Lord, ed., *Poems on Affairs of State: Augustan Satirical Verse, 1660–1714*, 7 vols. (New Haven and London: Yale Univ. Press, 1963–75), 1:426.

15. Quoted in *One Flesh: Paradisal Marriage and Sexual Relations in the Age of Milton*, by James Turner (Oxford: Clarendon Press, 1987), 206.

16. "Absalom and Achitophel," line 10, in *John Dryden: Selected Poems*, ed. Steven N. Zwicker and David Bywaters (London: Penguin Books, 2001), 114.

17. L. G. Wickham Legg, ed., *English Coronation Records* (Westminster: A. Constable, 1901), xlviii–li.

18. Marcus, Mueller, and Rose, *Elizabeth I*, 59, 65.

19. Charles Howard McIlwain, ed., *The Political Works of James I* (Cambridge, Mass.: Harvard Univ. Press, 1918), 272.

20. Kevin Sharpe, *Criticism and Compliment: The Politics of Literature in the England of Charles I* (Cambridge and New York: Cambridge Univ. Press, 1987), chap. 5.

21. See, for example, *Jeremias Redivivus; or, An Elegiacall Lamentation on the Death of Our English Josias, Charles the First, King of Great Britaine, &c. Publiquely Murdered by His Calvino-Judaicall Subjects* ([London?], 1649), 2.

22. See Susan Staves, *Players' Scepters: Fictions of Authority in the Restoration* (Lincoln: Univ. of Nebraska Press, 1979), 115.

23. *The Letters, Speeches and Declarations of King Charles II*, ed. Arthur Bryant (London: Cassell and Company, 1935), 111–12.

24. Ronald Hutton, *Charles the Second, King of England, Scotland, and Ireland* (Oxford: Clarendon Press; New York: Oxford Univ. Press, 1989), 362–63, 373, 377–78, 402.

25. MacLeod and Marciari Alexander, *Painted Ladies*, 83.

26. Hutton, *Charles the Second*, 186–87; Sonya Wynne, "'The Brightest Glories of the British Sphere': Women at the Court of Charles II," in MacLeod and Marciari Alexander, *Painted Ladies*, 44–45.

27. Hutton, *Charles the Second*, 416; MacLeod and Marciari Alexander, *Painted Ladies*, 136.

28. Steven N. Zwicker, "Virgins and Whores: The Politics of Sexual Misconduct in the 1660s," in *The Political Identity of Andrew Marvell*, ed. Conal Condren and A. D. Cousins (Aldershot, UK: Scolar Press, 1990), 85–110, esp. 94.

29. Ernst Hartwig Kantorowicz, *The King's Two Bodies: A Study in Mediaeval Political Theology* (Princeton: Princeton Univ. Press, 1957).

30. As well as the famous "Ditchley" portrait, see the engraving reproduced in Winfried Schleiner, "Divina Virago: Queen Elizabeth as Amazon," *Studies in Philology* 75 (1978): 165. I owe this reference to the kindness of Alexandra Lumbers.

31. See Roy Strong, *Henry, Prince of Wales, and England's Lost Renaissance* (New York: Thames and Hudson, 1986), esp. 63–70.

32. Kevin Sharpe, "The Image of Virtue: The Court and Household of Charles I, 1625–1642," in *The English Court: From the Wars of the Roses to the Civil War*, ed. David Starkey (London and New York: Longman, 1987), 226–60.

33. Kevin Sharpe, "'An Image Doting Rabble': The Failure of Republican Culture in Seventeenth-Century England," in *Refiguring Revolutions: Aesthetics and Politics from the English Revolution to the Romantic Revolution*, ed. Kevin Sharpe and Steven Zwicker (Berkeley: Univ. of California Press, 1998), 25–57, esp. 39–42.

34. On Cromwell, see Laura Lunger Knoppers, *Constructing Cromwell: Ceremony, Portrait and Print, 1645–1661* (Cambridge and New York: Cambridge Univ. Press, 2000), 46–50, 87, 149, 185–87.

35. Rachel Weil, "Sometimes a Scepter Is Only a Scepter: Pornography and Politics in Restoration England," in *The Invention of Pornography: Obscenity and the Origins of Modernity, 1500–1800*, ed. Lynn Avery Hunt (New York: Zone Books, 1993), 152.

36. See Alexander Meyrick Broadley, ed., *The Royal Miracle: A Collection of Rare Tracts, Broadsides, Letters, Prints, and Ballads Concerning the Wanderings of Charles II after the Battle of Worcester* (London: S. Paul & Co., 1912).

37. David H. Solkin, "Isaac Fuller's *Escape of Charles II*: A Restoration Tragicomedy," *Journal of the Warburg and Courtauld Institutes* 62 (1999): 199–240.

38. Sharpe, "Image of Virtue," 243; Paul Hammond, "The King's Two Bodies: Representations of Charles II," in *Culture, Politics and Society in Britain, 1660–1800*, ed. Jeremy Black and Jeremy Gregory (Manchester: Manchester Univ. Press, 1991), 22.

39. See, for example, entry for 25 May 1660, Pepys, *Diary*, 1:158.

40. In addition to the Earl of Rochester's famous line "His sceptre and his prick are of a length," there are other references to the size of the royal penis. See entry for 15 May 1663, Pepys, *Diary*, 4:136–38.

41. Weil, "Sometimes a Scepter," 130; compare with 136.

42. "Absalom and Achitophel," lines 78–79.

43. Bernard Mandeville, *The Fable of the Bees; or, Private Vices, Publick Benefits* (London: Printed for J. Roberts, 1714).

44. On the debt to Holbein of John Michael Wright's portrait of Charles, see Millar, *Tudor, Stuart and Early Georgian Pictures*, 1:129, no. 285. I shall develop this point in my study of representations of late-seventeenth-century monarchy.

45. David Starkey, "Representation Through Intimacy," in *Symbols and Sentiments: Cross-Cultural Studies in Symbolism*, ed. I. M. Lewis (London and New York: Academic Press, 1977); Starkey, "Intimacy and Innovation: The Rise of the Privy Chamber, 1485–1547," in Starkey, *English Court*, 71–118.

46. Sharpe, *Personal Rule of Charles I*, esp. 131–53, 212.

47. *The Letters of John Wilmot, Earl of Rochester*, ed. Jeremy Treglown (Oxford: Basil Blackwell, 1980), 34.

48. Sonya Wynne, "The Mistresses of Charles II and Restoration Court Politics," in *The Stuart Courts*, ed. Eveline Cruickshanks (Stroud, UK: Sutton, 2000), 171–90; Nancy Klein Maguire, "The Duchess of Portsmouth: English Royal Consort and French Politician, 1670–85," in *The Stuart Court and Europe: Essays in Politics and Political Culture*, ed. R. Malcolm Smuts (Cambridge: Cambridge Univ. Press, 1996), 247–73.

49. "On Nell Gwynne," in Lord, *Poems on Affairs of State*, 1:420. See, however, for a complicating of this contrast, James Turner, *Libertines and Radicals in Early Modern London: Sexuality, Politics, and Literary Culture, 1630–1685* (Cambridge: Cambridge Univ. Press, 2002), 256–58.

50. For a classic study of this literature, see Suzanne W. Hull, *Chaste, Silent and Obedient: English Books for Women, 1475–1640* (San Marino, Calif.: Huntington Library, 1982).

51. See A. M. McEntee, "'The [Un]civill-sisterhood of Oranges and Lemons': Female Petitioners and Demonstrators, 1642–1653," in *Pamphlet Wars: Prose in the English Revolution*, ed. James Holstun (London and Portland, Ore.: F. Cass, 1992), 92–111; Ann Hughes, "Gender and Politics in Leveller Literature," in *Political Culture and Cultural Politics in Early Modern England: Essays Presented to David Underdown*, ed. Susan Amussen and Mark Kishlansky (Manchester and New York: Manchester Univ. Press, 1995), 162–88; Keith Thomas, "Women and the Civil War Sects," *Past and Present*, no. 13 (April 1958): 42–62; and Christopher Hill, *The World Turned Upside Down: Radical Ideas during the English Revolution* (New York: Viking Press, 1972).

52. Susan Owen, *Restoration Theatre and Crisis* (Oxford: Clarendon Press, 1996), 159; Warren Chernaik, *Sexual Freedom in Restoration Literature* (Cambridge: Cambridge Univ. Press, 1995).

53. "So Soft and Amorously You Write," in *The Poems of Sir George Etherege*, ed. James Ernest Thorpe (Princeton: Princeton Univ. Press, 1963), 43.

54. Pat Gill, *Interpreting Ladies: Women, Wit, and Morality in the Restoration Comedy of Manners* (Athens, Ga.: Univ. of Georgia Press, 1994), 142. On Behn, see Janet M. Todd, *The Secret Life of Aphra Behn* (London: Andre Deutsch, 1996).

55. *The Collected Works of Katherine Philips, the Matchless Orinda*, vol. 1, *The Poems*, ed. Patrick Thomas (Stump Cross, UK: Stump Cross Books, 1990), esp. poems to Lucasia.

56. *Comus*, lines 785–86, in *John Milton: The Complete Poems*, ed. Gordon Campbell (London: Dent, 1980); Turner, *One Flesh*, 307.

57. *The Last Instructions to a Painter*, line 1, in *Andrew Marvell: The Complete Poems*, ed. Elizabeth Story Donno (Harmondsworth, UK: Penguin Books, 1985), 157.

58. Wynne, "'Brightest Glories,'" 44.

59. I am grateful to Alexandra Lumbers for permission to read "The Discourses of Whoredom in Seventeenth-Century England" (PhD diss., Oxford Univ., 2005).

60. For the challenge, see J. C. D. Clark, *English Society, 1688–1832: Ideology, Social Structure, and Political Practice during the Ancient Regime* (Cambridge: Cambridge Univ. Press, 1985).

61. John Spurr, *The Restoration Church of England, 1646–1689* (New Haven and London: Yale Univ. Press, 1991), 209–19, quotation at 209.

62. MacLeod and Marciari Alexander, *Painted Ladies*, 222.

63. "The King's Vows," lines 7–9, 37, in Lord, *Poems on Affairs of State*, 1:159, 161.

64. Andrew Marvell, *An Account of the Growth of Popery and Arbitrary Government in England* (Amsterdam, 1677).

65. Quoted in *Earl of Rochester: The Critical Heritage*, by David Farley-Hills (New York: Routledge, 1972), 59.

66. Farley-Hills, *Earl of Rochester*, 72.

67. Weil, "Sometimes a Scepter," 130–36.

68. *The Works of John Wilmot, Earl of Rochester*, ed. Harold Love (Oxford: Oxford Univ. Press, 1999), 88; compare with variants, 87–89.

69. *Eikon Basilike Deutera, The Pourtraicture of His Sacred Majesty, King Charles II, with His Reasons for Turning Roman Catholick* (London: Published by King James, 1694), 82. The full quotation reads: "Debauchery is looked upon by me as the best test of loyalty . . . for sure I am that debauchees as foolish men call those that indulge the innocent appetites of Nature, will never be enemies to a reign that allows them in it; but, on the contrary, will be my surest defence against all the attempts of the Puritanical Precisians." During the 1690s there was a ubiquitous literature associating royal debauchery with tyranny. See, for example, John Phillips, *The Secret History of the Reigns of K. Charles II and K. James II* ([London], 1690), esp. 23, 25–26, 85. Rochester was one of the first to make the connection; see Chernaik, *Sexual Freedom*, 9–60.

70. Turner, *One Flesh*, esp. 248–49.

71. See the excellent essay by Turner, "Pepys and the Private Parts of Monarchy," 95–110.

72. See Gilbert Burnet, *Some Passages of the Life and Death of . . . Rochester* (London: Printed for Richard Chiswel, 1680), and Chernaik, *Sexual Freedom*, chap. 2.

73. Edmund Waller, "Instructions to a Painter," lines 85–90, in Lord, *Poems on Affairs of State*, 1:25.

74. "Annus Mirabilis," lines 593–96, in Zwicker and Bywaters, *John Dryden*.

75. "Absalom and Achitophel," line 232.

76. Ronald Hutton, "Charles II," in *Debates in Stuart History*, ed. Ronald Hutton (Houndmills, UK: Palgrave Macmillan, 2004), chap. 5, esp. 135–42. I am most grateful to Ronald Hutton for his (typical) kindness in letting me read this valuable essay in advance of its publication and for our subsequent stimulating discussions of this subject.

77. See Keith Wrightson and David Levine, *Poverty and Piety in an English Village: Terling, 1525–1700* (New York: Academic Press, 1979).

78. Timothy Raylor, *Cavaliers, Clubs and Literary Culture: Sir John Mennes, James Smith and the Order of the Fancy* (Newark, Del.: Univ. of Delaware Press, 1994); James Loxley, *Royalism and Poetry in the English Civil Wars: The Drawn Sword* (Basingstoke, UK: Macmillan, 1997).

79. See John Ogilby, *The Entertainment of His Most Excellent Majestie Charles II in His Passage through the City of London to His Coronation*, ed. R. Knowles (Binghamton, N.Y.: Medieval & Renaissance Texts & Studies, 1988; orig. pub. 1662). A fireworks display also was staged for the 1668 investiture of the king of Sweden. See Elias Ashmole, *The Institution, Laws and Ceremonies of the Most Noble Order of the Garter* (London: Printed by J. Macock for Nathanael Brooke, 1672), 421.

80. Hutton, *Charles the Second*, 134, 359.

81. "A Ramble in St. James's Park," lines 119–20, in Love, *Works of John Wilmot*, 79.

82. *The Poor-Whores Petition* (London, 1668); *The Gracious Answer of the Most Illustrious Lady of Pleasure, the Countess of Castlem—— to the Poor-Whores Petition* (London, 1668).

83. *The Cobbler Turned Courtier, Being a Pleasant Humour between King Henry the Eighth and a Cobbler* (London: F. Haley, 1680).

84. On apprentice riots against brothels in 1668, see T. J. G. Harris, "The Bawdy House Riots of 1668," *Historical Journal* 29, no. 3 (Sept. 1986): 537–56, and Turner, *Libertines and Radicals*, chap. 5.

85. Quoted in Hutton, "Charles II," 136.

86. See *The Unfortunate Usurper: A Tragedy* (London, 1663), 71, and Kevin Sharpe, "Restoration and Reconstitution: Politics, Society and Culture in the England of Charles II," in MacLeod and Marciari Alexander, *Painted Ladies*, 19–20.

87. As Harold Weber observes, city comedies were more about money than sex; see Weber, *The Restoration Rake-Hero: Transformations in Sexual Understanding in Seventeenth-Century England* (Madison: Univ. of Wisconsin Press, 1986), 14–16.

88. See also David Foxon, *Libertine Literature in Enand, 1660–1745* (New Hyde Park, N.Y.: University Books, 1965).

89. Nancy Klein Maguire, *Regicide and Restoration: English Tragicomedy, 1660–1671* (Cambridge: Cambridge Univ. Press, 1992). I am grateful for discussions with Marjorie Huntley, who recently completed a PhD on concepts of honor in Restoration drama.

90. Owen, *Restoration Theatre*, 159; William Wycherly, *The Country Wife*, act 4, scene 3, in *Restoration Plays*, ed. Robert Gilford Lawrence (London: J. M. Dent; Rutland, Vt.: C. E. Tuttle, 1994), 72.

91. See Kevin Sharpe and Steven Zwicker, *Politics of Discourse: The Literature and History of Seventeenth-Century England* (Berkeley: Univ. of California Press, 1987), introduction.

92. For an excellent study, see Alastair James Bellany, *The Politics of Court Scandal in Early Modern England: News Culture and the Overbury Affair, 1603–1660* (Cambridge: Cambridge Univ. Press, 2002).

93. S. Wiseman, "'Adam, the Father of All Flesh': Porno-Political Rhetoric and Political Theory in and after the English Civil War," in Holstun, *Pamphlet Wars*, 134–57.

94. Milton, *Paradise Lost*, bk. 4, lines 750, 765–66.

95. *Last Instructions to a Painter*, lines 559–60, in Donno, *Andrew Marvell*, 171.

96. *Last Instructions to a Painter*, line 12, in Donno, *Andrew Marvell*, 157.

97. *Last Instructions to a Painter*, lines 885–906, in Donno, *Andrew Marvell*, 180–81.

98. "The Fourth Advice to a Painter," line 136, in Lord, *Poems on Affairs of State*, 1:146.

99. "The Fifth Advice to a Painter," line 135, in Lord, *Poems on Affairs of State*, 1:152.

100. "The Haymarket Hector," line 53, in Lord, *Poems on Affairs of State*, 1:171.

101. "And so, red hot with wine and whore, / He kick'd the Parliament out of door"; "The Royal Buss," in Lord, *Poems on Affairs of State*, 1:265.

102. Owen, *Restoration Theatre*, 162.

103. See, for example, *The Pious Politician or Remains of the Royal Martyr* (London: Printed by Tho. James for Benj. Harris, 1684), and John Gauden, *Aurea Dicta: The Gratious Words of King Charles I. of Glorious Memory* (Oxford: Printed by L. Lichfield for John Barksdale, 1682). Lives of Charles I and of Henrietta Maria were published in 1684 and 1685; *The Famous Tragedy of King Charles I* was acted in 1680. On the engravings sold by Moses Pitt, see MacLeod and Marciari Alexander, *Painted Ladies*, 195.

104. *Patriarcha and Other Political Works of Sir Robert Filmer*, ed. Peter Laslett (Oxford: Basil Blackwell, 1949).

105. "Absalom and Achitophel," lines 7–9. After writing this essay, I came across James Grantham Turner's helpful phrase "eroticised loyalism"; see Turner, *Libertines and Radicals*, 171.

106. *Poems on Several Occasions by the Right Honourable the E. of R——* (London, 1680).

107. Farley-Hills, *Earl of Rochester*, 50, 54.

108. Hutton, *Charles the Second*, 443–45.

109. [Earl of Rochester], *Poems on Several Occasions. Written by a Late Person of Honour* (London, 1685). We note the removal of Rochester's name from the title page.

110. Love, *Works of John Wilmot*, xxxvi.

111. Quoted in *Papers of Devotion of James II*, by Godfrey Davies (Oxford: Printed for presentation to the members of The Roxburghe Club, 1925), xxv. I will discuss the image of James II in a study of representations of authority, 1500 to 1700.

112. See Tony Claydon, *William III and The Godly Revolution* (Cambridge: Cambridge Univ. Press, 1996), and Dudley W. R. Bahlman, *The Moral Revolution of 1688* (New Haven and London: Yale Univ. Press, 1957).

113. Earl of Rochester, *Poems, &c. on Several Occasions: With Valentinian, a Tragedy* (1691), sig. A3v.

114. Earl of Rochester, *Poems &c.* , sig. B2v.

115. "Advice to the Painter's Adviser" (1670), assigned to Rochester in Wing: *Short-Title Catalogue of Books Printed in England, Scotland & Ireland and of English Books Printed Abroad, 1475–1640*, comp. Donald Wing, John J. Morrison, Carolyn Nelson, and Alfred W. Pollard, 2nd ed. (New York: Modern Language Association of America, 1972–98); however, Love does not include this as Rochester's work.

116. Treglown, *Letters of . . . Rochester*; John Harold Wilson, ed., *The Rochester–Savile Letters, 1671–1680* (Columbus: Ohio State Univ. Press, 1941).

117. Lord, *Poems on Affairs of State*, 1:xxx.

118. MacLeod and Marciari Alexander, *Painted Ladies*, 58–59.

119. For Charles's strategic manipulation of access and openness, see Brian Weiser, *Charles II and the Politics of Access* (Woodbridge, UK: Boydell Press, 2003).

120. Elizabeth Howe, *The First English Actresses: Women and Drama, 1660–1700* (Cambridge: Cambridge Univ. Press, 1992).

121. See Simon Thurley, "A Country Seat Fit for a King: Charles II, Greenwich and Winchester," in Cruickshanks, *Stuart Courts*, 214–39.

"There Is None That Loves Him but Drunk Whores and Whoremongers": Popular Criticisms of the Restoration Court

Tim Harris

T HE ENGLISH CONVENTION'S DECISION in the spring of 1660 to restore the Stuart monarchy, after eleven years of failed republican experimentation in government, is normally seen as being welcome to most people across the British Isles. Not, however, to a woman named Margaret Dixon from Newcastle upon Tyne. On 13 May, shortly after Charles II's proclamation as king but some two weeks before he was to make his triumphant return from exile, she heatedly exclaimed: "What! can they finde noe other man to bring in then a Scotsman? What! is there not some Englishman more fit to make a King then a Scott?" Margaret clearly did not have a very high opinion of Charles Stuart. "There is none that loves him," she averred, "but drunk whores and whoremongers. I hope he will never come into England, for that hee will sett on fire the three kingdoms as his father before him has done. God's curse light on him. I hope to see his bones hanged at a horse tayle, and the dogs runn through his puddins."[1]

Her speech has an obvious fascination: aggressively opinionated and in some respects quite articulate, despite the unmistakably plebeian and uncultured idiom, it provides a precious insight into the views of the types of people who so often remain hidden from history. There are several things about what she said that give pause for reflection. One is that, despite her hostility toward Charles II, Margaret does not appear to have been an out-and-out republican; it was the restoration of the Stuarts that she resented. Another is Margaret's Scotophobia, although again this was perhaps less a generalized hatred of the Scots than a dislike of the Scottish Stuart dynasty.[2] A third is Margaret's contempt for Charles's whoremongering, and this before "the Merry Monarch" had even come back into England and had the chance to set up his "bawdy court" at Whitehall. Finally, there is Margaret's fear that Charles II, like Charles I, would stir up a hornet's nest of trouble within his three kingdoms of England, Scotland, and Ireland. In this she proved remarkably prescient.[3]

Four years later a Quaker by the name of John Brown turned up at a Quaker meeting at the Bull and Mouth Inn just off St. Martin's le Grand in London, with

his hair cropped, completely covered in dust, and totally naked except for a loin-cloth. He was making a political statement. God "will cut the locks of the head, and shave the Crowne," Brown predicted. "Woe to Charles and James [Duke of York, the king's brother], destruction draweth Nye."[4] Bad puns were something that radical dissenters went in for at this time. We have stories of sectarians urinating from the belfry to express their disgust at the restoration of the old order in the Church—"pissing," as they said, "on the 'piscopal congregation below."[5] Most modern-day readers will cringe; the congregation likewise also must have cringed, albeit for very different reasons. One suspects there was not a great deal of humor intended: the stakes were too high and the issues deadly serious.

Our traditional image of the reaction to the Restoration is of crowds reveling in the streets in delight, toasting the king's health and dancing around maypoles to celebrate the return of monarchy and deliverance from Puritan tyranny.[6] The examples just cited remind us that the mood of celebratory optimism was neither universal nor long-lived: some never wanted the Stuarts back in the first place; many more were soon to regret the fact that the Stuarts had been restored. The purpose of this essay is to explore the nature of popular opposition to the Stuart monarchy in the early years of the Restoration in England. Where did it come from, and how extensive was it? Was it limited to a few radical extremists (a "lunatic fringe," perhaps, to judge from their antics), or was it more widespread? I shall examine the economic, religious, and political causes of disaffection, and how such disaffection found expression in talk, print, and deed. In particular, I shall focus attention on the public concern over the depravity of the court and the extent to which Charles II's whoremongering was seen as responsible for the political ills that seemed to be befalling England. In the process, I hope to offer a "thick description" of the speech and gestures with which I opened this essay—that is to say, a suitably contextualized analysis enabling us to unravel the conceptual structures that informed the words and deeds of Dixon and Brown and the meaning(s) that their acts held within the society in which they lived.[7]

Christopher Hill reminded us years ago that not everyone in 1660 supported the restoration of monarchy, and he pointed to the survival of a radical underground tradition that was opposed to hierarchy in both Church and state.[8] A perusal of the state papers and extant court records, to be sure, reveals numerous examples of people speaking out against the restored Stuarts. On hearing of the king's return, a Carlisle man decided to make haste for London, laying his hand on his sword and announcing before he left: "This is the sword shall run Charles Stuart through the heart blood."[9] A Puritan divine from rural south Yorkshire predicted on 13 May that "the man . . . the Parliament were about to bring in, would bring in superstition

and Popery" and urged his congregation to "feare the King of heaven and worship Him, and bee not so desirous of an earthly King."[10] About the same time a Hampshire tanner was charged with saying that the king "kept lewd company and was a bastard"; toward the end of the month a Portsmouth innkeeper was accused of having said the previous December "that rather than a King should come in he would fight up to the knees in blood."[11] In some parts of the country, die-hard local republicans took it upon themselves to extinguish neighborhood bonfires made to celebrate the proclaiming of Charles II king; in Herefordshire a Commonwealth justice of the peace even wrote down the names of all those who made bonfires for the king's return and threatened them with punishment.[12]

London provides most examples of popular hostility to the restoration of Charles II, as might be expected given the density of population in the metropolitan area and the authorities' natural desire to be tough on suspected disaffection in the nation's seat of government. On 11 May a Wapping glazier promised that "if hee mett the King hee would run his knife into him to kill him, and that hee did not care though he were hanged for it himselfe, and did wish that the King and Generall Monk [the architect of the Restoration] were hanged together."[13] In August a carpenter from St. Martin's-in-the-Fields claimed that "our sovereign Lord King Charles the second is a bastard and not worthy to inherit the Crowne of England," while on 1 October a man from the same neighborhood supposedly said, "King Charles is noe King and had no power."[14] Some Londoners would have preferred an alternative monarch: one asserted in May that "Lord Lambert deserved the Crowne and to bee King better then King Charles the Second." Others hoped that power would soon revert to the people: "it was the King's time now to reigne," proclaimed a shoemaker's wife from Westminster on 22 May, "but it was upon sufferance for a little time, and it would be theirs agine before itt be long."[15]

The examples could easily be multiplied—and perhaps they should, since it is too easy to lose sight of the dissentient voices at the time of the Restoration in the face of all the accounts of reveling crowds. The sources are patchy—the quarter sessions records do not survive for many counties, while most of the sessions records for the City of London itself were destroyed in the Great Fire of 1666—so what we have is probably just the tip of the iceberg. Yet at the same time we need to ask ourselves why the cases we know about came to court in the first place. Increased vigilance at a time of heightened anxiety over political security in the face of a regime change undoubtedly explains why more people were prosecuted for disaffection than was typically the case in more settled times.[16] On the other hand, the fact that we find so many ordinary people—who did not have an official policing responsibility—willing to inform against those who spoke out against the restoration of monarchy means the seditious speeches that have left a trace in the

historical record might hint as much at popular monarchism as they do of popular republicanism. On balance, as I have argued elsewhere, the evidence seems to point to the inescapable conclusion that the restoration of monarchy was welcome to most—though certainly not all—people in 1660, and that many of these were enthusiastic in their support, not least because they expected so much from the restored monarchy. Even Separatists, such as Quakers and Baptists, were initially prepared to acquiesce peaceably and accept the inevitable if they could be guaranteed certain basic liberties, the most important of which being liberty of conscience. What is clear, however, is that different people expected different things from the Restoration. Once the reality of what the restored polity would actually be like began to sink in, various groups grew increasingly disillusioned.[17]

Those who welcomed the return of monarchy expected things to get better economically. High taxes and a trade slump had helped turn large numbers against the republic by late 1659. However, it took a while for the economy to improve after 1660, and in the short term the situation for many—especially at the lower rungs of society—seemed only to get worse, with the continuation of regressive taxes such as the excise (retained on beer and liquor) and the introduction of a new tax on fireplaces in 1662.[18] As one London merchant tailor put it in July 1663: "Wee were made to believe when the King came in That we should never pay any more taxes. If wee had thought that he would have taxed us thus, hee should never have come in."[19] Similarly, an inebriated Portsmouth man bemoaned over his brandy wine in February 1665: "If I cannot subsist, I had as good serve the Divell as serve the King."[20] The early years of the Restoration saw numerous conflicts over tax collection. There were riots against the hearth tax in 1666–67 in Hackney, Hereford, Marlborough, St. Neots, the North Riding, Weymouth, Winchcombe, Pewsey, Banbury, and Taunton, and more minor disturbances at Lynn and Newcastle.[21] At Bridport in February 1668, "the collectors of the hearth money . . . were followed about town by men, women, and children, who threw stones at them"; the local magistrates apparently did little to quell the tumult, and one of the collectors was hit on the head—twice—and subsequently died of his wounds.[22] In Derby that year excise collectors were violently set upon by an angry gang led by a local innkeeper; one of the collectors was "run through with a sword," though seemingly not fatally. Again the local constables refused to come to the assistance of the excise collectors when they were being attacked.[23]

The bitterest source of contention in Restoration England was religion. In his Declaration of Breda of April 1660, Charles II, recognizing that religious animosities had been the main source of "the continued Distractions" and "great Revolutions" of the last two decades, had promised "a Liberty to tender Consciences" (for those who did not "disturb the Peace of the Kingdom") so as to encourage men to

"unite in a Freedom of Conversation" and to reach a better mutual understanding.[24] The trouble was that Charles was frustrated in his irenic intentions by his own Cavalier Parliament, which sat from 1661. This proceeded to restore the prewar Church of bishops and Prayer Book and enacted a stern penal code designed to uphold the Anglican monopoly of worship, education, and office-holding and punish all forms of dissent: the Corporation Act (1661), the Act of Uniformity (1662), the Quaker Act (1662), two Conventicle Acts (1664, 1670), and the Five Mile Act (1665). Members of Parliament who favored such legislation would have claimed that it was designed to deal with those who aimed to "disturb the peace of the kingdom"; indeed, much of it emerged in response to various sectarian plots against the government in the early years of the Restoration.[25] The problem was that the government's response only served to exacerbate existing religious tensions and make a disturbing of the peace of the kingdom even more likely. Although the laws against dissenters were not always rigorously enforced, when they were—and there were a series of waves of persecution in the 1660s, 1670s, and 1680s—the effects could be devastating: heavy fines, distraint of goods, imprisonment, and even death (for those unlucky enough to spend too much time in Restoration jails). Excommunication (in the Church courts) seemed mild by comparison. Dissenters quite rightly came to complain that they were suffering in their lives, liberties, and estates.[26]

To be sure, there were large numbers of devout Anglicans who welcomed the return of the old order. However, moderate Puritans, Presbyterians, and Independents (who had hoped for a more comprehensive Church settlement), as well as Separatists (who had expected some degree of toleration), felt betrayed. Court records reveal that for some people support for the Restoration had clearly been conditional. As one Londoner put it in August 1662, "if the King did side with the Bishopps, the Divell take King and Bishops too."[27] Revived episcopacy caused others to give voice to deep-seated republican sympathies that had perhaps never been abandoned. In November 1662 a Worcester gentleman, talking to a local cleric about the reintroduction of the Book of Common Prayer, said "he hoped soon to see the wicked King's head cut off, when there would be no King, no Bishop, no Common Prayer."[28] In December 1666 Joseph Williamson, undersecretary of state, received a report that there were "many disaffected persons and Nonconformists" in Aldborough, Norfolk; one, who had been a soldier and exciseman under the Protectorate, "was clapped up in gaol for saying the King was as much an usurper as Cromwell," while "another of his gang . . . a great independent, spoke against the discipline of the Church and Bishops."[29] Not that religious and economic issues were separate. One Kent man had already concluded by January 1661 "that the Bishopp had the King's meanes, and that the King had nothing to live upon

but sesses [taxes], and that whatsoever the Bishoppe and his Councell made hee was faine to sett his hand to it." Finishing on a more optimistic note, he predicted "that in the end they would serve him as they did his Father."[30]

England's economic and religious woes might not have seemed so bad if there had been something else to cheer about. The trouble was that there was not. The new regime's foreign policy appeared disastrous compared to what Oliver Cromwell had been able to achieve in the 1650s. A war of 1664–67 fought against the Dutch (and also, from the beginning of 1666, against the French) went humiliatingly badly: in June 1667 came the ultimate disgrace, when the Dutch fleet managed to sale up the Medway to Chatham and destroy four of the English navy's biggest vessels and capture the flagship, the *Royal Charles*.[31] On top of this, there was a recurrence of the plague, with the mass outbreak occurring in London in 1665. People, it was said, fell "as thick as leaves from the Trees in Autumn"; by the end of the year as many as one hundred thousand of the capital's inhabitants had died.[32] Then, in September 1666, the Great Fire of London broke out, destroying most of the built-up area of the City proper and causing damage to property estimated at some £10 million. Although the fire started by natural causes in a baker's shop in Pudding Lane, the instinct was to blame the tragedy on the perceived enemies of the state: radical sectarians (such as the Fifth Monarchists) or, better still, the Catholics. Indeed, a Catholic watchmaker named Robert Hubert confessed to having started the fire, as part of a conspiracy hatched in Paris, and was hanged as a result, although he was almost certainly deranged.[33]

Why were things going so badly wrong? To many, the sudden collapse of the republican regime in 1659–60 and the fact that Charles II had been restored peacefully had appeared miraculous, a sure sign of the workings of divine Providence. Indeed, an act of 1660 ordaining the perpetual commemoration of Restoration Day (29 May) affirmed that Charles's restoration had been brought about by God's "all swaying providence and power"—an interpretation that the Anglican clergy were all too willing to endorse from the pulpit.[34] As affairs took a turn for the worse in the 1660s, some reached the conclusion that the Restoration regime must have forfeited divine favor. There were two interlocking concerns: the apparent rise of popery and the all-too-apparent moral depravity of court. Let us address them in turn.

There is little evidence that Catholicism was actually on the increase in England in the 1660s; whatever reconciliations to the Roman Catholic faith did occur were approximately canceled out by apostasies and the extinction of old Catholic families.[35] Yet there were many powerful figures at the Restoration court—including both Charles himself and his brother the Duke of York—who were sympathetic to Catholicism. Indeed, Charles made an unsuccessful attempt to extend

greater religious freedom to both Catholics and Protestant Nonconformists with his Declaration of Indulgence of December 1662. York himself was to convert to Catholicism in the late 1660s, though his true religious sympathies were already suspected in the early years of the Restoration.[36] Then there was the king's mother, Henrietta Maria, a French Catholic and the infamous wife of Charles I, whom many of the parliamentary opposition of 1641–42 had believed responsible for promoting a "popish plot" to subvert Protestant liberties across the three kingdoms. Her return to England in October 1660, Samuel Pepys tells us, pleased "very few."[37] It certainly displeased a leather seller's wife from Whitechapel, who in January 1661 complained that "the Queene is the Great Whore of Babilon and the King is the son of a whore."[38] Her words might seem mere crude abuse. Certainly there is a sense in which this woman was just venting her spleen and unleashing her prejudices in the heat of the moment; attempts to overintellectualize run the risk of detracting from the force and anger contained in a visceral lashing out at unpalatable political figures expressed in the typical plebeian idiom of the day. Nevertheless, the charge was more loaded than might appear to modern readers. Specifically it alluded to Henrietta Maria's Catholicism, the "Whore of Babylon" from the book of Revelation—"The Mother of Harlots and Abominations of the Earth"[39]—being firmly associated in most Protestants' minds with the Roman Catholic Church. Furthermore, the vocabulary of sexual insult, and especially that of "whore," which was the most common defamatory term applied to females, possessed multiple resonances in this culture. As Laura Gowing has taught us, very rarely was the word "whore" used to mean an actual prostitute; rather, it conveyed "a collection of images that explored and condemned women's unchastity" and carried with it powerful connotations of corruption and dishonesty.[40] Moreover, in condemning the Queen Mother in this way, our leather seller's wife was offering a particularly powerful condemnation of the king. For just as Charles II was Henrietta Maria's son in a literal (biological) sense, so too he was "the son of a whore" (indeed, *the* whore) by dint of his own corrupt and dishonest nature and his sympathies for Catholicism.

A late-seventeenth-century writer was to lay a large proportion of the blame for "the Miscarriages" of Charles II on Henrietta Maria, specifically for her having "infused into him" the "Principle of Revenge," "not so much for the loss of her Husband, but out of her inbred Malice to the Protestant Religion."[41] Yet Henrietta Maria was not to be a powerful player in Restoration politics; in fact, she was to leave England for good in 1665. It was the other Catholic women at court who were more a cause for concern. In 1662 Charles married Catherine of Braganza, another Catholic—a match condemned by many for bringing England into the French orbit, implying, as it did, support for the Portuguese in their struggle for

independence from France's rival, Spain. Then there were Charles's mistresses. From 1660 to 1668 the most influential was Barbara Villiers, Countess of Castlemaine (later Duchess of Cleveland), who converted to Catholicism in 1663 and had at least five children by Charles. One of Pepys's associates in July 1667 referred to Charles II as being "a Tom Otter . . . to my Lady Castlemayne"—Tom Otter being the henpecked husband in Ben Jonson's comedy *Epicoene*. From about 1663 Charles developed a passion for Frances Teresa Stuart, the daughter of a Scottish Catholic royalist, although it is unclear whether they ever actually became lovers. From the early 1670s the king's most influential mistress was Louise de Kéroualle (whose name was typically Anglicized as Carwell by contemporaries), created Duchess of Portsmouth, a French Catholic who was to bear Charles a son—Charles Lennox, first Duke of Richmond and Lennox—in July 1672. Nell Gwyn, the orange girl and actress who became Charles's mistress in the late 1660s, was conspicuous for being "the Protestant whore," as Nell herself famously quipped.[42]

If the court seemed a center of popery, it soon became notorious as a site of licentiousness. In the summer of 1661 Pepys commented on the prevalence of the "vices of swearing, drinking and whoring" at court and noted that "the pox [was] as common there . . . as eating and swearing."[43] In the 1670s one poet rhymed:

> Not thicker are the Starrs in the milky way
> Or Summer Insects on a Sun-shine day,
> Than Whores and Bawds
> Throughout our English Coast,

adding that most of these whores and bawds were to be found at St. James's and Whitehall, "Where mighty Letchery is all in all."[44] Retrospective Whig accounts, written by those who knew how things were ultimately to play themselves out, were predictably highly censorious. "From the first hour of his Arrival into these Kingdoms," one author maintained a couple of years after the Glorious Revolution, it seemed that Charles "set himself . . . to withdraw both Men and Women from the Laws of Nature and Morality: Execrable Oaths were the chief Court Acknowledgments of a Deity, Fornications and Adulteries the Principal Tests of the People's Loyalty and Obedience."[45] Gilbert Burnet, who had briefly been a royal chaplain in the 1670s, went so far as to claim in his *History* that "the ruin of [Charles's] reign, and of all his affairs, was occasioned chiefly by his delivering himself up at his first coming over to a mad range of pleasure."[46] Yet many contemporaries were just as outraged at the time. In 1664 one weaver from Whitechapel complained that Charles II was "a vagabond and a rogue" and "keeps whores," and he sarcastically proceeded to drink "a Health to the King and all Whores."[47] Ten

years later a laborer from St. Giles-in-the-Fields charged, "Our King keepeth nothing but whores and . . . is a scourge to the nation."[48] Charles II's whoring was a particular source of anxiety because it seemed to be one of the few things he was good at. As Sir James Johnson of Yarmouth allegedly said in June 1681, "the King of France could whore well and govern well," but "our King could whore well but not govern."[49]

Contemporary criticisms of the court were expressed in a variety of different media, beyond street talk: sermons, print, and manuscript verse (much of which was passed around from hand to hand or else circulated via the coffeehouses). A certain caution is needed with the evidence. Clergymen were supposed to preach morality; it was part of their job description. It is thus hardly surprising that sermons condemned the sins of the age; sermons had always condemned the sins of the age. Some of the satiric verse that circulated in manuscript was produced by Restoration rakes who were as much celebrating as condemning the activities they were purporting to describe. For example, when the Earl of Rochester claimed that "the Isle of Britain" was "long since famous grown / For breeding the best cunts in Christendom" and described Charles as "the sauciest one that e'er did swive," he was perhaps as much boasting as denouncing.[50] Yet not all sermons offered conventionalized condemnations of immorality, even those preached by clergy who enjoyed favor at court. Furthermore, even Rochester's satires worked—to the extent that they did—only because they played on anxieties that were widely shared in his society, if not necessarily by the Restoration rakes themselves; his verse, in other words, can tell us what worried others, if not what worried him. Besides, at times even Charles II found Rochester more scathing than witty—too close to the bone, perhaps. Finally, these types of sources would not be particularly interesting if they merely told us that some people were upset about the immorality of the court. But they tell us much more. Scrutinized more closely, they reveal the *range* of concerns that the depravity of the court aroused. There were a series of overlapping anxieties—anxieties that stemmed from a more generalized growing disillusionment with the Restoration regime that we have already documented. There was, to be sure, a concern about moral degeneration in the aftermath of a failed Puritan revolution. But beyond this there were concerns over economics (the expense of government), Church politics (and particularly the politics of religious persecution), the rise of popery, and the threat to national—that is, *English*—interests posed by foreigners.

Manuscript verse frequently linked England's economic woes with the vices at court. Charles's mistresses, after all, cost a lot of money. During the 1670s the duchesses of Cleveland and Portsmouth and their children were in receipt of permanent grants worth more than £45,000 per year.[51] In one of his most notorious poems, Rochester referred to Charles as "scandalous and poor" and rolling "about

from whore to whore."[52] It was an often-made accusation. One anonymous rhymester has "Old Rowley the King" recall, "The making my Bastards so great / And Dutchessing every Whore" had cheated the treasury and "made me so wonderfull poor."[53] Another asked, "Why art thou poore O King?" and concluded it was the "imbezzling C—t, / That wide moth'd, greedy Monster that has don't."[54] Other versifiers bemoaned, "We have rais'd a Legion of lusty young Wenches / Enough to confound the King's Treasure and senses" and "all the coin by harras't subjects lent / Must through your [Charles II's] conduit pipe be spent."[55] A satiric royal speech has Charles II bewail: "I am under incumbrances, For besides my Harlotts in Service, my Reformado Concubines lye heavy upon Me. . . . All my money design'd for next Summer's Guards must of necessity be applied to the next yeare's Cradles, and swaddling Cloths: What shall wee doe for Ships then?"[56] Such complaints continued throughout the reign. "An Essay of Scandal," a poem from about 1681, attributed the king's poverty to his whores having taken all his money. The rhymester's advice? "Remove that costly dunghill [Portsmouth] from thy doors; / If thou must have 'em, use cheap, wholesome whores."[57]

Attacks on the court were also linked to a condemnation of the intolerance of the Restoration Church. In the immediate aftermath of the Restoration, one still encounters a millenarian expectancy in the writings of the more radical sectaries (notably Quakers), predicting that God would visit his judgment on the land for the iniquities of the nation and for the persecution of the saints.[58] For example, in a letter to the king of September 1663, the Quaker Charles Bayley warned Charles II:

> The Whirlwind of the Lord God is coming on the Nation, and Wo is ready
> to be poured forth upon all the workers of Iniquity: so that all are to meet
> the Lord in Judgment; and thou amongst the rest, O King, wilt not be
> exempted; but naked must thou appear before the King of kings, who is
> come, and risen to take to himself the Possession, and sole Rule of all the
> Kingdoms of this World.

Bayley's list of the iniquities that had thus provoked God's wrath was quite specific: "The great Rioting and excess of Eating and Drinking . . . within thy Courts," "The great Chambering and Wantoness, and the making provision for the flesh, to fulfil the lusts thereof," "The great and grievous Oppressions which are within thy dwelling-place," and "The many and grievous Injuries which the Lord's People," he said, had made "the Lord of Truth . . . highly displeased."[59]

Bayley represents a dying breed; this type of millenarian language did not survive long after the return of monarchy, the dissenters instead coming to accept that their lot was to suffer peaceably in this world and await their reward in the next.[60]

Nevertheless, the calamities of the plague and the Great Fire inevitably invited a recourse to the language of providentialism and divine retribution. Nonconformist clergy became very active once again in London in the plague year of 1665, taking over the pulpits left deserted by Anglican clerics who had fled to the countryside, and preaching "with very good success," Burnet tells us, though "not without reflecting on the sins of the court, and on the ill usage they themselves had met with."[61] We can obtain a clearer sense of the sorts of arguments they might have made by looking at what Nonconformist divines chose to say in print. In 1667 the ejected Presbyterian divine Thomas Doolittle published a lengthy treatise in which he wrote of "the Judgement of the Plague . . . and of the Fire" and warned readers that, through both, God had declared his "Anger and great displeasure against you for your sin." Among the sins that had provoked "God to be very angry," Doolittle enumerated, were those of "Adultery, Fornication, Uncleanness, [and] Lasciviousness."[62] That same year the Quaker preacher and author James Parke warned the "Nation of England" that "a great Destruction and Calamity is begun in thee, because of thy Oaths, Drunkenness, Covetousness and Lying, Cursed speaking and Whoredoms," and also for the "Persecuting of an innocent People," namely the Quakers. Sparing no one, he called on "Rulers, Priests and People" to "consider your wayes and your doings," and he reminded people how they had been "cheated by those you call your Ministers and Leaders," since how could such men be likely "to beget you out of pride and covetousness . . . to beget you out of Whoredom and Swearing, who are in it themselves?"[63] In 1666 Roger Hough, who described himself simply as "a Lover of the Truth," reminded his readers of 1 Corinthians 6:9–10: "Know you not that the unrighteous shall not inherit the kingdome of God? Be not deceived, neither Fornicators, nor Idolaters, nor Effeminate, nor abusers of themselves with mankind, nor Thieves, nor Covetous, nor Drunkards, nor Revilers, nor Extortioners, shall inherit the Kingdome of God." Hough appears in particular to have been targeting the enemies of Protestant dissent, since he wrote elsewhere in the same work: "There is a principal of Irreligion in wicked men; rather then they will condemn themselves they will condemn all the wayes of God's people; nay, rather then they will condemn their own sins, they condemne the ways of holiness."[64] Toward the end of 1666 a Quaker—whom we know only as "J.C."—claimed to have had a vision when he was traveling near Windsor, in which "a bright cloud came about him, and a shrill child's voice said, 'They [the inhabitants of London] have had the pestilence and fire, and other calamities, and yet are not amended, but a worse plague has yet to come on them and the nation.'"[65]

This is not to say that Nonconformists were the only ones who were critical of the court. The Anglican clergy could also be outspoken in their criticism. For

Dr. Thomas Plume, preaching at Greenwich on 10 September 1665, the plague showed "how our sinns had drawne downe Gods Judgements"; in a sermon on the anniversary of the regicide in 1671, he was more specific as to who had committed these sins, proclaiming how "the leudnesse of our greatest ones, & universal luxurie, seemed to menace some yet more dreadfull vengeance," and recalling how England had "had a plague, a Warr, & such a fire, as never was the like in any nation since the overthrow of *Sodome*."[66] Some Anglican divines were prepared to preach their censures in front of the king. On Christmas Day 1662, for example, the bishop of Winchester delivered a sermon at Whitehall against the sins of the court; according to Pepys, he was laughed at for his pains.[67] In July 1667 the anti-Nonconformist zealot Dr. Robert Creighton, dean of Wells, preached a "strange bold sermon" before the king "against the sins of the Court, and perticulary against adultery, over and over instancing how for that single sin in David, the whole nation was undone," before proceeding to make a pointed connection with the Medway disaster.[68] Royal chaplain Richard Allestree delivered a series of sermons before the king in the 1660s in which he condemned adultery, fornication, uncleanness, lasciviousness, drunkenness, and reveling.[69] Clearly it would be wrong to posit a dichotomy between a censorious Puritanism and an overly indulgent Anglicanism.

Allestree's sermons, however, are revealing in that they hint at the extent to which the public condemnation of the immorality of the court was particularly associated in the contemporary mind with the political and religious enemies of the restored monarchy. Preaching at Whitehall on 20 October 1661 about the "uncleanness" of the age, Allestree noted that "we may find Purity of several forms, but 'tis either pure Fraud, or pure Impiety" or even "pure Corruption," and he concluded that "thus is the world, we do not onely see men serve some one peculiar vicious inclinations, and cherish their own wickednesse, but they make every vice their own, as if the Root of bitterness branch't out in each sort of Impiety in them, such fertile soyls of sin they are." He recalled how, when Israel had sinned in like manner, "Then did God execute a Vengeance . . . fit to be mistaken for . . . the Day of Judgment"; however, Allestree held back from making his point explicit. "But I will make no parallels, publique clamors do that too loud," he proclaimed, hinting at the complaints of those hostile to the Restoration regime; "these do display the factions of iniquity among us, and muster up the several parties of our vices too; and each man is as perfect in the guilts of all sides that he is not of."[70] In a Lenten sermon of 1664 Allestree lashed out at the erstwhile supporters of the republic and how they claimed that "as we had been delivered to commit Abominations, they are grown confident God is engag'd against us" and "that we . . . have been Fatted for a Sacrifice and are ripe to bleed"; he attributed "this Confidence

of theirs . . . on the non-execution of the Laws" against Protestant dissenters.[71] Moreover, the public reputation of the Anglican Church—and its episcopal leadership—suffered as a result of association with the court. One anonymous poet alleged that "the Parsons all Keep Whores" and "the Bishops bugger up and down."[72] Pepys heard rumors that the archbishop of Canterbury himself, Gilbert Sheldon, "doth keep a wench," while Andrew Marvell, in his *Last Instructions to a Painter*, accused Sheldon of having several mistresses. In reality, the mores of Charles II's court were deeply offensive to Sheldon.[73]

It seemed particularly galling to many that the godly should suffer persecution for worshipping God not only when all sorts of sins and vices were left unpunished but also when Catholics were largely free from molestation and popery was seemingly openly encouraged at court. Thus a third element of the public criticism of the court centered around the indulgence of a false religion. Again it was a concern that was shared by some Protestants of the established Church. For example, Robert Elborough, in his sermon on the Great Fire of London, listed among the sins for which God was punishing London those of "Popery and Idolatry." "The great quarrel God hath with his people," Elborough bemoaned, "is their being an apostatising people. . . . I could wish that what of Popery and Idolatry there hath been and is, were suppressed; it may be we should then not have been destroyed: How much better it is to stub up those bryers and thorns, which if let alone, may set on fire the tallest Cedars in our Lebanon." Significantly, Elborough also condemned "Remissness in the Ministry"—"when those that are Angels in their Function and Profession, are far from being Angels in their Lives and Conversation"—and the "oppression and cruelty" of the times for provoking God's wrath (although he seems to have been thinking mainly of economic oppression).[74]

Yet the concern about the rise of popery was one that had a particularly biting Nonconformist slant. The author of *Tydings from Rome* of 1667, ominously subtitled *England's Alarm*, pointed out that the Catholics had already obtained "two considerable advantages": the first was "the removal of so many able and Godly Ministers out of the way," an allusion to the ejections that followed upon the Act of Uniformity of 1662; the second was "the destruction of our Famous City, the strength and glory of the Nation, which they have laid in the dust," an allusion to the widespread belief that Catholics were responsible for starting the Great Fire. It was "an old and true observation," this author continued, "That whosoever will attempt the overthrow of Religion, must begin with the Ministry first." Thus, "When so many pious Ministers went off the Stage, it was apparent enough what an opportunity these men [Catholics] had to ascend it and act their part." The "cause and interest" of the Catholics had since been "revived and warmed" by the Great Fire, and they were further greatly encouraged by the fact "that the Ceremonies of

their Religion find such acceptation among us," an allusion to the supposedly "popish" ceremonies still retained by the Church of England. The author then proceeded to lament how "we are at this day persecuting and suppressing the faithful in the Land." And to what end?

> Ah! How little do our bold informers think whose work they are doing! Little do Constables think they are breaking down of the Walls and Gates of the Nation; when breaking up the peaceable Meetings of God's people. Poor men! did you but see how the Papists laugh among themselves, to see their work so industriously performed by your hands.

Turning to direct his comments to the members of the Cavalier Parliament, this author then warned: "Rome is a nettle, the more gently it's handled, the more it stings . . . here is an Enemy that deserves your hottest zeale and greatest vigilance, much better then honest loyal Nonconformists."[75]

Finally, the goings-on at court seemed to be working against England's national interest. Anxiety here was of course intricately bound up with the concerns identified above. Neither bleeding the country dry in order to support the king's illicit love affairs nor provoking God to send judgments of plague and fire could be seen as being in the nation's interest. Nor, for many, was prosecuting Protestant dissenters from the established Church while letting Catholics off scot-free. But the concern went beyond this. There was the worry that Charles's "whoring" was distracting him from the real business of running the country—preventing him from paying enough attention to those affairs that were truly important. There was also the worry that foreign—mainly French—interests were doing the distracting, and deliberately so, in order to weaken England. Hence the Medway disaster, at a time when the English were involved in a war against both the Dutch and the French. As one poet rhymed:

> So our great Prince, when the Dutch fleet arriv'd,
> Saw his ships burn'd and, as they burn'd, he swiv'd.
> So kind was he in our extremest need,
> He would those flames extinguish with his seed.[76]

It was a powerful indictment of royal incompetence—of inattention to business. Another critic argued that the mismanagement of the Dutch war was a direct consequence of the "debauchery and drunkenness at court" and alleged that "no better could be expected when the Popish and profane party [were] in such credit."[77] Pepys recalled how "people do cry out in the streets . . . that we are bought and

sold and governed by Papists and that we are betrayed by people about the King and shall be delivered up to the French."[78] Besides, how could it be in England's national interest to be at war with the Protestant Dutch? In mid-August 1666 Williamson, the undersecretary of state, was informed from Walmer, Kent, that "Our common people cry out for peace with Holland and war with France."[79]

Charles II was back fighting the Dutch in 1672, this time with France on his side. To many, for England to ally with a Catholic country to fight a Protestant one was the wrong way around—and this even without people knowing the terms of the secret Treaty of Dover of 1670, in which Charles II had promised Louis XIV that he would announce his own conversion to Catholicism at the next opportune moment.[80] A mock advertisement for a public sale at the Royal Coffee House near Charing Cross, which circulated about 1673, proclaimed that the following items were for sale:

> One whole peece of the Duchess of Cleveland's honesty . . . Two Ells of Nell Gwin's Virginity . . . Two whole peeces of new fashioned paradoxes, the one to suppress popery by the Suppression of the Protestant interest abroad, the other to maintain libertie by the raiseing of a standing Army at home . . . Two dozen of French wenches, the one half paid by his Majesty to keep him right to the Protestant religion, the other to incline him to the Catholicks.[81]

About 1674–75 the radical Whig poet John Ayloffe bemoaned, "A colony of French possess the court" and Charles's "fair soul, transform'd by that French dame [the Duchess of Portsmouth], / Had lost all sense of honor, justice, fame."[82] One abusive poem from the Exclusion Crisis referred to Portsmouth as "that pockey Bitch / A Damn'd papisticall Drab, / An ugly deformed Witch / Eaten up with the Mange and Scab," and added, "This French Hagg's Pockey Bum" had become "so powerfull . . . of late" that "It rules both Church and State."[83]

By now, of course, other issues had arisen to provoke further cause for concern. Charles's second Declaration of Indulgence (an attempt in 1672 to suspend the penal laws by dint of the royal prerogative), the Duke of York's public acknowledgment of his conversion to Catholicism in 1673, and the duke's marriage to a Catholic princess that same year (which, given that York was Charles's heir, opened up the possibility of a never-ending succession of Catholic monarchs should York's second wife give him a son)—all confirmed suspicions about the threat of popery and arbitrary government. Although Thomas Osborne, first Earl of Danby, endeavored to take England out of the French orbit in the mid-1670s, his attempt to "manage" Parliament through patronage and clientage networks seemed to offer further "proof" that the royal administration was determined to prevent either

Lords or Commons from providing any independent check on the Crown. Moreover, Danby also sought to appeal to the sensibilities of hard-line Anglicans by taking a tougher stance on dissent. Long before the revelations of the Popish Plot in 1678 and the subsequent crisis over the succession, it seemed to many that Protestant liberties in England were under serious threat. Hence, from the mid-1670s we see in underground political verse explicit calls for a return to a republic. One poem of 1674, which circulated in the coffeehouses, claimed that the miracle of the king's restoration had now become England's "curse and punishment" and expressed the hope that the English would send Charles back to Breda and reestablish a commonwealth.[84] In another poem from the same time, Ayloffe pleads for the erection of a Venetian-style republic.[85]

What has usually been missed is that this republican literature often evinced a marked anti-Scottish bias. It was not just that the Stuarts were corrupt, amoral, pro-Catholic, and pro-French (although they were, in the minds of their opponents, all these things). They were also "this stinking Scottish brood," as Ayloffe put it. The prevalence of Scotophobia in seventeenth-century England is a topic that deserves closer examination. Certainly it can be seen quite powerfully at the time of the accession of James VI of Scotland to the English crown in 1603.[86] History's view of James VI and I, as is well known, has for a long time been colored by a scathing contemporary critique by the disillusioned courtier Sir Anthony Weldon, a man dismissed from royal service for writing a "humorous" *Description . . . of Scotland* in 1617, which James found far from funny. Less well known is that Weldon's diatribe was republished in 1659, on the very eve of the Restoration. The tract is deeply offensive and racist. It opens with these lines:

> First for the Country, I must confess, it is too good for those that possess it, and too bad for others, to be at the charge to conquer it. The aire might be wholesome, but for the stinking people that inhabit it. The ground might be fruitfull, had they the wit to manure it.

Weldon then proceeds to pun how Scotland possessed a "great store of Fowl . . . as foul-houses, foul-sheets, foul-linnen, foul-dishes and pots. . . ."[87] How many people read Weldon's tract is impossible to say. It seems highly likely, however—given that Weldon does not appear to have possessed a particularly imaginative wit—that his work reflected anti-Scottish stereotypes that were commonplace in England, at least at the time he wrote and arguably still at the time of subsequent publication. Indeed, mutual resentments between the English and the Scots had grown worse as the seventeenth century had progressed, having been exacerbated by the experiences of the civil wars and the Cromwellian Union of the 1640s and 1650s.

Hence we return to Margaret Dixon in the spring of 1660, asking why they can "finde noe other man to bring in then a Scotsman" and whether there was "not some Englishman more fit to make a King then a Scott?" Charles II himself, unlike his father, had not, of course, been born in Scotland; he had, however, been proclaimed and then crowned king by the Scots after the regicide and the refusal of the Scots to accept the abolition of the monarchy. And hence we arrive at Ayloffe, who, like Weldon, thought of the Scots as "stinking." For Ayloffe, the stench was political: Britannia had tried "too long in vain" to divide "the Stuart from the tyrant."[88] Another poem from 1676 (possibly also by Ayloffe) alleged that tyranny would "be our case / Under all that shall reign of the false Scottish race" and boldly proclaimed that he was "for old Noll [Cromwell]," for "Though his government did a tyrant's resemble, / He made England great and its enemies tremble."[89] "The Isle was well reform'd, and gain'd renown," another rhymester asserted:

> Whilst the brave Tudors wore th'Imperial Crown,
> But since the race of Stewarts came [note the Scottish spelling]
> It has recoil'd to Popery and shame.

"Let Cromwell's Ghost smile with Contempt to see," this poet therefore concluded, "Old England struggling under Slavery."[90]

So far we have concentrated on written or spoken expressions of discontent with the Restoration court. Let us now move from words to action. Concern over what was widely believed to be the degeneracy of a crypto-Catholic court that was enforcing a policy of religious persecution against godly Protestants was to provoke serious rioting in the capital in Easter Week 1668.[91] The riots began on 23 March, Easter Monday, when a crowd demolished bawdy houses in Poplar, in London's east end. The following day, gangs of about five hundred attacked similar establishments in Moorfields, East Smithfield, Shoreditch, and Holborn, and there was further rioting on the Wednesday, with one report claiming there were now forty thousand rioters (presumably an exaggeration, but nevertheless suggesting that extraordinarily large numbers of people were involved). The government had to send in the Life Guards to put down the disturbances—but when some of the rioters were arrested and brought into custody, the crowds turned their attention to besieging the prisons where their associates were being detained—Finsbury jail and New Prison at Clerkenwell on the Tuesday, New Prison again on the Friday. What is notable about the disturbances are the political slogans chanted by the rioters. On Tuesday crowds demanded "that if the King did not give them liberty of conscience, that May-day must be a bloody day" and threatened that they

would "go and pull down the great bawdy house at White hall." On Wednesday the slogan was "Reformation and Reducement." Hardly surprising then, as Pepys observed, that "the courtiers" were said to be "ill at ease to see this spirit among people." The Duke of York was especially upset; he later complained that he lost "two tenants by their houses being pulled down," who paid him £15 per year for their wine licenses.[92] The riots, it appears, were as much an attack on the court as they were against the London "stews" (brothels). The government was sufficiently alarmed to proceed against the ringleaders for high treason.

The key to deciphering the logic behind the riots appears to lie in the rioters' demand for "liberty of conscience." Since the plague of 1665 and the Great Fire of 1666, the laws against Nonconformists had rarely been enforced. Furthermore, after the fall of Edward Hyde, first Earl of Clarendon, in 1667, following the failures of the Dutch war, hopes were raised that some form of religious toleration might be introduced. The first move came in the autumn of 1667, when a bill for the comprehension (inclusion in the Church of England) of Presbyterians was drawn up—though, lacking sufficient political backing, it was never introduced. But in January 1668 more promising moves were initiated by the new Lord Keeper, Sir Orlando Bridgemen, in consultation with moderate Anglican ecclesiastics and leading Nonconformist divines, for comprehension of Presbyterians and religious toleration for Separatists, and two such bills were prepared for introduction into Parliament when it reassembled in February. However, instead of being sympathetic to the king's plea at the opening of the session to "find some way to unite his subjects in matter of Religion," the Cavalier Parliament complained about the "insolent carryage and conventicles of nonconformists and sectaries" in recent months and called upon Charles to issue a proclamation calling for the strict enforcement of all the penal laws against those who dissented from the Church. Under pressure, and in need of money, Charles gave in and issued a proclamation to such an effect on 10 March.[93] The result was predictable: rioting on the next public holiday. There seemed to be a double standard at work: the godly would be punished for violating the law (even though they were only worshipping God), but not the ungodly (even though they were sinning against God). Thus the rioters of Easter Week 1668 appear to have been telling the court that if the laws against dissenters were going to be enforced, they would see to it that the laws against brothels were also enforced—holding out the threat of further action, against Whitehall, on a future date should the king not give them liberty of conscience. This interpretation is backed up by the little we know about the composition of the crowds—most of those rioters for whom we have information came from the same sort of occupational and geographic background as those who had suffered most for religious dissent during the 1660s.

A number of satires appeared at the time of the disturbances linking the riots with grievances against the court.[94] The first, dated 25 March, took the form of a petition from the "undone company of poor distressed whores, bawds, pimps, and panders" to Lady Castlemaine asking for protection from the "rude and ill-bred Boys" who threatened their ruin and destruction. Warning Castlemaine that the youths must be stopped "before they come to your Honours Pallace, and bring contempt upon your worshiping of Venus," it concluded with a swipe at the Catholicism of the "painted ladies" of the court.[95] More revealing are two replies allegedly from Castlemaine to the *Poor-Whores Petition*—one in manuscript, the other printed—which combine the lampoon of Castlemaine with an attack on the Church of England and the Anglican clergy. In the manuscript response, Castlemaine justifies her indulgence in "all Venereall delights" as having "Episcopall allowance . . . according to the principles of Seer Sheldon." This, she claims, had kept her loyal to the Church of England for some time; but Sheldon had revealed his cowardice "in fearing to declare the Church of Rome to be the true Ancient, Uniforme, Universall, and most Holy Mother Church," and therefore she had left the Church of England, which was "but like a Brazon Bason tyed to a Barbours wooden pole (vizt) Protestant Doctrine and Order tyed by parliamentary power to Roman Catholique foundations, Constitutions, and Rights." Castlemaine acknowledges that the rabble "by depauperating you"—the poor whores—"aymed at us the Soveraigne of your Order," and she adds that because "the most exquisite whores" were "the onely persons" fit to be "the bosome freinds of Kings and Archbishops" the rioters were guilty of high treason, since they "levell[ed] at the roote of the Government as now established." Castlemaine then promises to get the king to order the bishops to inquire "after all those sacrilegious Robbers and despoylers of the Temples and Synagoges of Venus, and to proceed by way of Excommunication against all," as well as to employ her interest with the House of Commons to have a bill enacted "that all such inhumane and barbarous Rascalls, that shall be convicted of the like Offences, bee deprived of their Testicles, as unworthy to wear them."[96] (The modern-day reader will perhaps cringe again; four of the rioters, it should be pointed out, were ultimately executed for treason, a punishment that did involve testicular removal of the most unpleasant kind.) The printed version of Castlemaine's supposed reply rehearses the same charges against Sheldon, but then changes tack and pleads that a parliamentary committee be appointed "to bring in a Bill . . . for a full Toleration of all Bawdy-houses, Play-houses, Whore-houses, etc.," with the proviso "That all Preaching, Printing, Private Meetings, Conventicles, etc, may be forthwith suppressed; except those that are Connived at, as Members of Holy Mother Church." Indeed, "for the increase of our Practice," the "Master of our Revels" (presumably the king) should

"give License for the setting up as many Play-houses as his Holiness the Pope hath Holidays in his Kalendar, that the Civil Youth of the City may be Debauched and trained up in looseness and Ignorance, whereby the Roman Religion may with ease be establish't in court, Church, City, and Nation."[97]

We have come a long way from the remarks and activities of Margaret Dixon and John Brown with which we opened this essay. We have come a lot closer, I would suggest, to understanding the meaning of what they said and did—to appreciating the significance of popular criticisms of Charles II, the condemnation of his whoremongering, the resentment at his Scottishness, the disgust at the restoration of the episcopal order, and the belief that "destruction draweth Nye." It is not my intention to suggest that most—or even a majority of—English people felt like Dixon and Brown; as I have shown elsewhere, public opinion was divided at this time.[98] But there were many who were alienated, and more who became alienated over time, and this essay has sought to shed light on these types of people—on their concerns, their gripes, their anxieties. They were not a lunatic fringe. In the first place, their alienation stemmed from quite rational feelings of resentment toward a religious and political establishment whose policies threatened the well-being and violated the liberties of many people. In the second place, this was no mere fringe—as evidenced by the thousands of people who took to the streets in protest in Easter Week 1668. The types of concerns identified here were to feed into "Country" grievances of the mid-1670s and ultimately into the Whig platform of the Exclusion era—augmented, to be sure, by new issues and sources of grievance that developed during the middle part of Charles II's reign, although the old concerns (as we have seen) undoubtedly remained alive. It is in this sense in particular, then, that the types of utterance with which we opened this essay cannot be dismissed as irrelevant. Margaret Dixon and John Brown might never have posed a serious threat to the security of the Restoration regime. However, the criticisms they voiced—shared, in varying ways, by a wide variety of people in the 1660s and 1670s—did. Hence, in part, why Charles II was to "sett on fire the three kingdoms as his father before him [had] done." Exactly how he managed to do this is more complicated than I have had time to explore here.[99] Nevertheless, the ways that have been explored are an important part of the story.

1. James Raine, Jr., ed., *Depositions from the Castle of York*, vol. 40 (Durham: Pub. for the Surtees Society by F. Andrews, 1861), 83–84.

2. For reasons why Scotophobia might have been more intense in the far north of England, however, see David Scott, "Motives for King-Killing," in *The Regicides and the Execution of Charles I*, ed. Jason Peacey (Basingstoke, UK: Palgrave, 2001), 138–60.

3. For which see Tim Harris, *Restoration: Charles II and His Kingdoms, 1660–1685* (London: Allen Lane, 2005).

4. Barry Reay, *The Quakers and the English Revolution* (New York: St. Martin's Press, 1985), 109.

5. Martin Ingram, "From Reformation to Toleration: Popular Religious Cultures in England, 1540–1690," in *Popular Culture in England, c. 1500–1850*, ed. Tim Harris (Basingstoke and London: Macmillan, 2005), 120.

6. David Underdown, *Revel, Riot, and Rebellion: Popular Politics and Culture in England, 1603–1660* (Oxford: Clarendon Press, 1985), 271–75.

7. Clifford Geertz, "Thick Description: Toward an Interpretive Theory of Culture," in *The Interpretation of Cultures: Selected Essays* (New York: Basic Books, 1973), 3–30 (esp. 27).

8. Christopher Hill, *The World Turned Upside Down: Radical Ideas during the English Revolution* (Harmondsworth, UK: Penguin, 1975), 354.

9. *Calendar of State Papers Preserved in the Public Record Office, Domestic Series* (hereafter *CSPD*), *1660–61*, ed. M. A. E. Green et al. (1860–1938), 37, 39.

10. Raine, *Depositions*, 40:83–84.

11. M. J. Hoad, ed., *Portsmouth Record Series: Borough Sessions Papers, 1653–1688: A Calendar* (Chichester: Phillimore for the City of Portsmouth, 1971), 14, 15.

12. *CSPD, 1660–61*, 59, 109.

13. John Cordy Jeaffreson, ed., *Middlesex County Records*, 4 vols. (London: Middlesex County Records Society, 1888–92), 3:303.

14. London Metropolitan Archives (hereafter LMA), WJ/SR/1216, indictment 28; LMA, WJ/SR/1219, recognizance 24.

15. LMA, MJ/SR/1214, recognizance 48; LMA, WJ/SR/1216, recognizance 30; Jeaffreson, *Middlesex County Records*, 3:304.

16. Compare with Paul Kléber Monod, *Jacobitism and the English People, 1688–1788* (Cambridge: Cambridge Univ. Press, 1989), 245–46, which shows how greater vigilance at times of invasion or rebellion scares affected the prosecution rates for Jacobite seditious words in the period from 1689 to 1751.

17. See Tim Harris, *London Crowds in the Reign of Charles II: Propaganda and Politics from the Restoration until the Exclusion Crisis* (Cambridge: Cambridge Univ. Press, 1987), chaps. 3, 4.

18. Michael J. Braddick, *State Formation in Early Modern England, c. 1550–1700* (Cambridge: Cambridge Univ. Press, 2000), 255–56. Compare with Gary S. De Krey, *London and the Restoration, 1659–1683* (Cambridge: Cambridge Univ. Press, 2005), 74, 80, 81, 82.

19. Harris, *London Crowds*, 61.

20. Hoad, *Portsmouth Record Series*, 33.

21. L. M. Marshall, "The Levying of the Hearth Tax, 1662–88," *English Historical Review* 51 (1936): 632; David Underdown, *A Freeborn People: Politics and the Nation in Seventeenth-Century England* (Oxford: Clarendon Press, 1996), 123; *CSPD, 1666–67*, 48, 285, 299, 307, 313, 321, 597–98.

22. *CSPD, 1667–68*, 222, 224; National Archives, Kew (hereafter NA), PC 2/60/199.

23. NA, PC 2/60/380, 411, 418–19, 433, 441–42, 447.

24. *Lords Journals*, 11:7.

25. Richard L. Greaves, *Enemies under His Feet: Radicals and Nonconformists in Britain, 1664–1677* (Stanford, Calif.: Stanford Univ. Press, 1990).

26. Tim Harris, "'Lives, Liberties and Estates': Rhetorics of Liberty in the Reign of Charles II," in *The Politics of Religion in Restoration England*, ed. Tim Harris, Paul Seaward, and Mark Goldie (Oxford: Basil Blackwell, 1990), 217–24.

27. LMA, WJ/SR/1257, recognizance 5; Jeaffreson, *Middlesex County Records*, 3:327.

28. *CSPD, 1661–62*, 143.

29. *CSPD, 1666–67*, 307.

30. Centre for Kentish Studies, Maidstone, Q/SB, fol. 7.

31. Steven C. A. Pincus, *Protestantism and Patriotism: Ideologies and the Making of English Foreign Policy, 1650–1668* (Cambridge: Cambridge Univ. Press, 1996); J. R. Jones, *The Anglo-Dutch Wars of the Seventeenth Century* (London: Longman, 1996).

32. Thomas Vincent, *God's Terrible Voice in the City*, 5th ed. (London, 1667), 30–31; N. H. Keeble, *The Restoration: England in the 1660s* (Oxford: Basil Blackwell, 2002), 159–60.

33. Keeble, *Restoration*, 162–64; John Bedford, *London's Burning* (London: Abelard-Schuman, 1966), 149–76; Harris, *London Crowds*, 79; John Miller, *Popery and Politics in England, 1660–1688* (Cambridge: Cambridge Univ. Press, 1973), 103.

34. A. Luders, T. Edlyn Tomlins, J. France, W. E. Tauton, and J. Raithby, eds., *The Statutes of the Realm . . . From Original Records, etc. (1101–1713)*, 12 vols. (London: 1810–28), 5:237; Tim Harris, *Politics under the Later Stuarts: Party Conflict in a Divided Society, 1660–1715* (London: Longman, 1993), 36.

35. Miller, *Popery and Politics*, 50.

36. Entry for 18 Feb. 1661, in *The Diary of Samuel Pepys*, ed. R. C. Latham and W. Matthews, 11 vols. (London: HarperCollins, 1995), 2:38, 2:38 n. 2.

37. Entry for 2 Nov. 1660, Pepys, *Diary*, 1:282.

38. LMA, MJ/SR/1222, recognizance 4 (to prosecute); Jeaffreson, *Middlesex County Records*, 3:309.

39. Revelation 17:5.

40. Laura Gowing, *Domestic Dangers: Women, Words, and Sex in Early Modern London* (Oxford: Clarendon Press, 1996), 1, 59–110.

41. [Nathaniel Crouch], *The Secret History of the Four Last Monarchs of Great-Britain, viz. James I, Charles I, Charles II, James II* (London, 1691), 45.

42. Entry for 30 July 1667, Pepys, *Diary*, 8:368; Catharine MacLeod and Julia Marciari Alexander, eds., *Painted Ladies: Women at the Court of Charles II*, exh. cat. (London: National Portrait Gallery, London, in association with the Yale Center for British Art, 2001), 94–96, 98, 136, 166–68; Sonya Wynne, "The Mistresses of Charles II and Restoration Court Politics," in *The Stuart Courts*, ed. Eveline Cruickshanks (Stroud, UK: Sutton, 2000), 171–90.

43. Entries for 31 Aug. 1661, 2 Sept. 1661, Pepys, *Diary*, 2:167, 170.

44. British Library (hereafter BL), Harleian MS 7317, fol. 11.

45. [Crouch], *Secret History*, 49.

46. Gilbert Burnet, *History of His Own Time: From the Restoration of King Charles the Second to the Treaty of Peace at Utrecht, in the Reign of Queen Anne* (London: William S. Orr and Co., 1850), 61.

47. LMA, MJ/SR/1289, recognizance 11; Jeaffreson, *Middlesex County Records*, 3:339.

48. LMA, MJ/SR/1479, indictment 5; Jeaffreson, *Middlesex County Records*, 4:54.

49. BL, Add. MSS 27,488, fols. 22, 25.

50. BL, Harleian MS 7317, fol. 68; George de Forest Lord, ed., *Poems on Affairs of State: Augustan Satirical Verse, 1660–1714*, 7 vols. (New Haven and London: Yale Univ. Press, 1963–75), 1:424.

51. John Spurr, *England in the 1670s: "This Masquerading Age"* (Oxford and Malden, Mass.: Blackwell Publishers, 2000), 204.

52. BL, Harleian MS 7317, fol. 68; Lord, *Poems on Affairs of State*, 1:424.

53. Bodleian Library, Oxford Univ., MS Douce 375, fol. 124.

54. BL, Add. MSS 27,407, fol. 120.

55. BL, Harleian MS 7317, fols. 57v, 67v.

56. BL, Harleian MS 7315, fol. 99r–v.

57. "An Essay of Scandal," cited in *Court Satires of the Restoration*, by John Harold Wilson (Columbus: Ohio State Univ. Press, 1976), 63–64. Also BL, Add. MSS 27,407, fol. 120; BL, Harleian MS 7319, fols. 68–70.

58. N. H. Keeble, *The Literary Culture of Nonconformity in Later Seventeenth-Century England* (Athens, Ga.: Univ. of Georgia Press, 1987), 197–98.

59. Charles Bayley, *The Causes of God's Wrath against England, and a Faithfull Warning from the Lord to Speedy Repentance, Fore-told by, and Delivered in, a Letter to the King, Dated the 4th of the 7th Month, 1663* (London, 1665), 3. Compare with Charles Bayley, *A True and Faithful Warning Sounded Forth through a True Prophet of the Lord unto all the Inhabitants of the Earth* (London, 1663), esp. 4.

60. Keeble, *Literary Culture*, 198–204. See, more generally, Christopher Hill, *The Experience of Defeat: Milton and Some Contemporaries* (London: Faber and Faber, 1984).

61. Burnet, *History*, 151.

62. T[homas] D[oolittle], *Rebukes for Sin by God's Burning Anger, by the Burning of London, by the Burning of the World, by the Burning of the Wicked in Hell-fire* (London: Dorman Newman, 1667), sigs. A4r–v and 95–96.

63. James Parke, *Another Trumpet Sounded in the Ears of the Inhabitants of England: Rulers, Priests and People* (London, 1667), 6, 7, 9.

64. Roger Hough, *A Wonder of Wonders: or, God's People the Worlds Wonder* (London: Printed for T. Passenger, 1666), sigs. A6v, Bv.

65. *CSPD, 1666–67*, 313.

66. *The Diary of John Evelyn*, ed. E. S. de Beer, 6 vols. (Oxford: Clarendon Press, 1955), 3:418, 569.

67. Entry for 25 Dec. 1662, Pepys, *Diary*, 3:292–93.

68. Entry for 29 July 1667, Pepys, *Diary*, 8:362–63.

69. Richard Allestree, *Eighteen Sermons, Whereof Fifteen Preached before the King, the Rest upon Publick Occasions* (London: Printed by T. Roycroft for J. Allestry, 1669), 13.

70. Allestree, *Eighteen Sermons*, 33, 35.

71. Allestree, *Eighteen Sermons*, 117.

72. BL, Harleian MS 6914, fol. 1.

73. Entry for 29 July 1667, Pepys, *Diary*, 8:364; Andrew Marvell, *The Last Instructions to a Painter*, in Lord, *Poems on Affairs of State*, 1:133; John Spurr, "Sheldon, Gilbert (1598–1677)," in *Oxford Dictionary of National Biography*, ed. H. C. G. Matthew and Brian Howard Harrison (Oxford: Oxford Univ. Press, 2004).

74. Robert Elborough, *London's Calamity by Fire Bewailed and Improved in a Sermon Preached at St. James Dukes-Place* (London: Printed by M.S. for Dorman Newman, 1666), 10, 14–15.

75. *Tydings from Rome: or, England's Alarm* (London, 1667), 6, 8, 10, 15.

76. "The Fourth Advice to a Painter," in Lord, *Poems on Affairs of State*, 1:146.

77. *CSPD, 1667*, 196.

78. Entry for 14 June 1667, Pepys, *Diary*, 8:269–70.

79. *CSPD, 1666–67*, 48. See, more generally, Pincus, *Protestantism and Patriotism*, chaps. 22, 23; Steven C. A. Pincus, "From Butterboxes to Wooden Shoes: The Shift in English Popular Sentiment from Anti-Dutch to Anti-French in the 1670s," *Historical Journal* 38 (1995): 333–61.

80. Ronald Hutton, "The Making of the Secret Treaty of Dover, 1668–1670," *Historical Journal* 29, no. 2 (1986): 297–318.

81. Lady Newton, ed., *Lyme Letters, 1660–1760* (London: W. Heinemann, 1925), 85–90.

82. John Ayloffe, "Britannia and Raleigh," lines 25, 117–20, in Lord, *Poems on Affairs of State*, 1:230, 233.

83. BL, Harleian MS 7317, fol. 21.

84. "The History of Insipids" (1674), in Lord, *Poems on Affairs of State*, 1:243–51 (esp. stanzas 1 and 23).

85. Ayloffe, "Britannia and Raleigh," lines 156–57, in Lord, *Poems on Affairs of State*, 1:235.

86. Roger Lockyer, *James VI and I* (London: Longman, 1998), 60; Brian P. Levack, *The Formation of the British State: England, Scotland, and the Union, 1603–1707* (Oxford: Clarendon Press, 1987), 193–97, 200–201, 204; Bruce Galloway, *The Union of England and Scotland, 1603–1608* (Edinburgh: John Donald, 1986), esp. 11, 170; R. C. Munden, "James I and 'the Growth of Mutual Distrust': King, Commons, and Reform, 1603–1604," in *Faction and Parliament: Essays on Early Stuart History*, ed. Kevin Sharpe (Oxford: Clarendon Press, 1978), 43–72; Jenny Wormald, "James VI and I: Two Kings or One?" *History* 68, no. 223 (1983): 187–209; Wormald, "Gunpowder, Treason, and Scots," *Journal of British Studies* 24, no. 2 (1985): 157–60.

87. Sir Anthony Weldon, *A Perfect Description of the People and Country of Scotland* (London: Printed for J. S., 1659), 1–2.

88. Ayloffe, "Britannia and Raleigh," lines 141–42, 153, in Lord, *Poems on Affairs of State*, 1:234.

89. "A Dialogue between the Two Horses," lines 135–56, 138–40, in Lord, *Poems on Affairs of State*, 1:281.

90. BL, Harleian MS 7317, fols. 41, 42v.

91. For a fuller discussion of these riots, see T. J. G. Harris, "The Bawdy House Riots of 1668," *Historical Journal* 29, no. 3 (Sept. 1986): 537–56; Harris, *London Crowds*, 82–91.

92. NA, SP 29/237, no. 59; LMA, MJ/GSR/1351, indictments 3, 38, 40, 43; T. B. Howell, ed., *Complete Collection of State Trials*, 33 vols. (London: T. C. Hansard, 1809–26), vol. 6, fols. 880–88; Jeaffreson, *Middlesex County Records*, 4:8–11; entry for 25 March 1668, Pepys, *Diary*, 9:132.

93. *Commons Journals*, 9:44; *London Gazette*, no. 242, 9–12 March 1667[/68].

94. Elizabeth Hamilton, *The Illustrious Lady: A Biography of Barbara Villiers, Countess of Castlemaine and Duchess of Cleveland* (London: H. Hamilton, 1980), 119–21.

95. *The Poor-Whores Petition* (London, 1668).

96. Bodleian Library, Oxford Univ., MS Don b. 8, 190–93. For Sheldon's wenching, see entry for 29 July 1667, Pepys, *Diary*, 8:364.

97. *The Gracious Answer of the Most Illustrious Lady of Pleasure, the Countess of Castlem—— to the Poor-Whores Petition* (London, 1668).

98. See, for example, Harris, *London Crowds* and *Politics under the Later Stuarts*.

99. For which see Harris, *Restoration*.

Love Pleasant, Love Unfortunate:
Women in Seventeenth-Century Popular Prints

Sheila O'Connell

THIS ESSAY EXAMINES the very bottom of the seventeenth-century visual-arts market in England: prints and illustrated ballads sold in the street for a penny or so. They are usually described as popular prints, but it should be understood that these prints were not only of interest to those who were unable to appreciate more sophisticated prints. The term "popular" is a Romantic one, invented in the late eighteenth century, and it misleadingly suggests an aspect of culture exclusive to the uneducated. The printed images discussed here were the mass media of their day. They would have formed part of a common experience of everyday life, offered for sale in the street or at fairs, as well as displayed on tavern walls. The audience was broad. Ronald Paulson's definition of popular printed material is a useful one: "read or seen by almost everybody; [therefore,] part of the consciousness of the learned, or educated, as well as the uneducated."[1]

The most common category of cheap print in England before the nineteenth century was the ballad illustrated with simple woodcuts. During the seventeenth century, ballads were normally printed horizontally on a half-broadside or "pot" sheet (more or less the modern British A4 size). As we will see, the style was conservative, and until about 1700 ballads were printed in "black-letter" (Gothic) type, though modern "white-letter" type was already in use for other sorts of printing. Even at the bottom of the market, purely pictorial images might be printed from copperplates, but woodcut was used as the medium for ballad illustration so that type and image could be printed in one operation.

There is a long history of ballad collecting; many examples survive, and the literature is extensive. But survival alone does not make the case for the predominance of the ballad in English popular print production. This is confirmed by visual evidence: ballads appear frequently in contemporary views of cottage or tavern interiors. They are also the subject of many literary references: for instance, in Izaak Walton's *Compleat Angler* (1653), Piscator takes his friend to an "honest ale-house, where we shall find a cleanly room, lavender in the windows, and twenty ballads stuck about the wall."[2]

The majority of popular prints in England were produced to accompany text. This was not the case in continental Europe, where cheap images (such as vast numbers of prints of saints in Roman Catholic Europe) appeared with little or no text. The explanation for the contrast must be the comparatively high levels of literacy at all strata of English society. Research in the last few decades makes it clear that literacy in Britain was much higher than has often been thought: the remarkable level of nearly 40 percent adult male literacy was reached in the third quarter of the seventeenth century—women, of course, were not so well educated.[3]

Many of the woodcuts used to illustrate ballads also appeared in chapbooks. These were little books of sixteen or twenty-four pages, made by folding a sheet or a sheet and a half of poor-quality paper and simply sewn together without covers. They sold for about 2d. or 3d.—roughly one-quarter of a day's pay for a laborer.

Evidence of the enormous amount of cheap printed material sold in the Restoration period appears in an inventory made at the death of the publisher Charles Tias in 1664.[4] The inventory gives details of stock in Tias's warehouse awaiting distribution: thirty-five thousand ballad sheets—roughly one for every ten Londoners, or one for every 140 people in the country; reams (bundles of five hundred each) of what are described as "pictures," presumably large pictorial prints; hundreds of titles of chapbooks, the most popular titles appearing also as broadsides, as well as in the form of books in several formats; more than nine thousand copies of books ready for sale for under 6d. (most under 4d.); and a further eighty thousand copies awaiting binding. Such figures give an indication of the scale of the trade in popular prints and cheap illustrated texts.

Ballad sheets were sold on the streets by "chanters," who drew attention to themselves by singing the ballads. Passersby would join in singing—and, perhaps with purse strings loosened by a few pints of beer, would part with a penny to purchase the sheet. It would be stuffed into a pocket or pinned or pasted onto a wall. Before too long it would have disintegrated or been used in some other way, such as to block a broken window, mend a hole in a shoe, or serve as lavatory paper. The result is that, although print runs would have been large, the vast majority of cheap prints have been lost. But fortunately for posterity there were those who preserved examples with care. Samuel Pepys owned nearly eighteen hundred ballads.[5] The collection of Pepys's contemporary and Oxford historian Anthony à Wood, now in the Bodleian Library, includes nearly three hundred ballads, numerous chapbooks, and more than five hundred broadsides. The most comprehensive collection of everyday prints of the later part of Charles II's reign was assembled by Narcissus Luttrell, who used this ephemeral material in compiling his daily chronicle of contemporary events, published more than a hundred years after his death in 1732 as *A Brief Historical Relation of State Affairs from September 1678 to April 1714*.[6]

Pepys's organization of his ballad collection provides a useful indication of popular subject matter. Women are a major theme. They appear chiefly under such headings as "Love Pleasant," "Love Unfortunate," "Marriage, Cuckoldry, &c.," and "Love Gallantry" related to the navy.[7] Whether Love is Pleasant or Unfortunate, the point of view is always male; women are stereotyped as willing wenches or shrewish adulteresses.

The prevailing attitude is summed up in the emblematic image known in England as "Bulchin and Thingut" or "Fill Gut and Pinch Belly,"[8] where one creature has grown fat because his diet consists of good husbands and they are plentiful, while the emaciated other creature is able to eat only good women and so she starves. These creatures had been known since the Middle Ages, not just in England but throughout Europe. The starving creature who eats good women is referred to as "Chichevache" in Chaucer's tale of Patient Griselda. The poet tells wives that they must not "let humility nail their tongues" and must not gain reputations for kindness or patience—for a woman to develop such uncharacteristic qualities would simply be inviting Chichevache to swallow her.[9] The attitude that engendered such images had not decreased by the late seventeenth century; Kevin Sharpe points out that lustful, shrewish women were "a stock in trade of early modern misogyny."[10]

The Happy Marriage (fig. 9) is an image of domestic harmony from about 1690. The marital relationship shown is a model one—but the image originally appeared as a pair with *The Unhappy Marriage*, in which, according to the accompanying verse, death is the only escape for the man "yoked with a brawling shrew."[11] The idea of the embattled couple was so familiar that it could be stereotyped both visually and verbally as "the fight for the breeches," a seventeenth-century version of the conflict over which one of a couple is "wearing the trousers." The standard image was a literal interpretation with a man and a woman tugging at a large pair of breeches. It appears in the form of a woodcut illustrating a ballad entitled "The Jolly Widdower" (fig. 10), from the "Love Unfortunate" section of Pepys's collection, which tells the story of a man who rejoices at the death of his unfaithful scold of a wife. Adulteresses were usually shown as scolds, and scolds as adulteresses; bad temper and sexual promiscuity appear to have been closely allied in the seventeenth-century mind. Women seen as guilty of such behaviors were condemned, and their husbands were despised as henpecked cuckolds.

Prints like these relate to such popular manifestations as the Skimmington, an English version of the French Charivari, where those who contravened the social norms were punished by raucous processions. They might be forced to ride backward on an ass, accompanied by "rough music" played on bones with butchers' cleavers.[12] The crowd would hold up horns, symbolizing cuckoldry, and petticoats

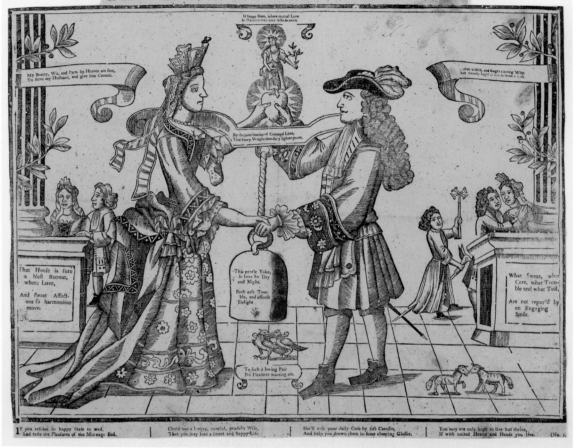

The HAPPY MARRIAGE.

9. Anonymous, *The Happy Marriage*, woodcut and letterpress (ca. 1690), 16½ x 19½ in. (41.9 x 49.5 cm).
The British Museum, Department of Prints and Drawings.

waved aloft like banners symbolized female domination. *Hudibras*, Samuel But-
ler's satire written in the 1660s and 1670s, has the eponymous narrow-minded
Puritan objecting to a Skimmington, calling it a "Devil's Procession" and "an Anti-
Christian Opera." The robust citizens pelt him with eggs for trying to spoil their
sport. Pepys recorded a real-life Skimmington on 10 June 1667: ". . . down to
Greenwich, where I find the stairs full of people, there being a great Riding there
today for a man, the constable of the town, whose wife beat him."[13]

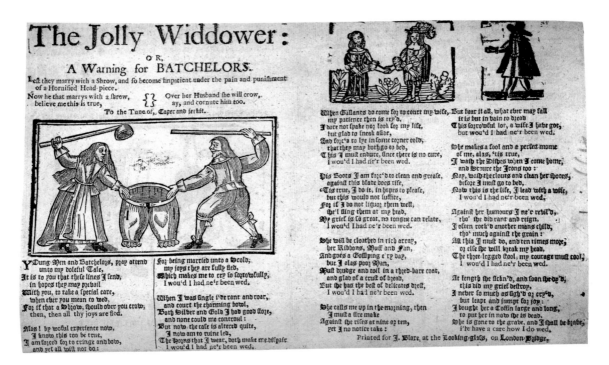

10. Anonymous, *The Jolly Widdower*, woodcut and letterpress (ca. 1690), 7½ x 11⅞ in. (19 x 30.2 cm). The Pepys Library, Magdalene College, Cambridge.

The difficulties and anxieties of life are much easier to cope with when distanced by emblematic representation of one kind or another. Unhappy cuckolds were mocked and depicted wearing horns to identify them as figures of fun. Many images of cuckoldry diminish the husband further by showing him as complacent. An example is a cheap etching entitled *The Contented Cuckold* (fig. 11), in which a husband is shown sorting pieces of jewelry and counting piles of money acquired from his wife's lovers; he is content "to weare such precious, profitable hornes."

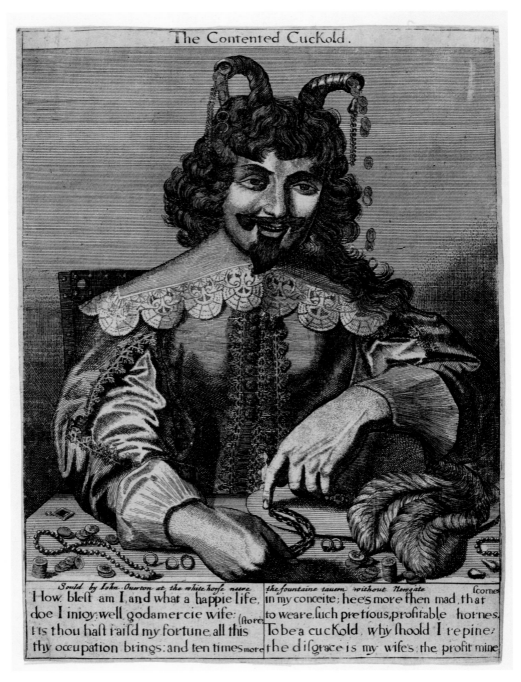

The Contented Cuckold.

Sould by Iohn Ouerton at the white horse neere — the fountaine tauern without Newgate (corne

How. blest am I, and what a happie life, in my conceite; hee's more then mad, that
doe I inioy: well godamercie wife: (ftore to weare.fuch pretious, profitable horne,
tis thou haft raif'd my fortune, all this To bea cuckold, why fhoold I repine:
thy occupation brings: and ten times more the difgrace is my wife's, the profit mine

11. Anonymous, *The Contented Cuckold*, etching (ca. 1660), 10 x 7¾ in. (25.4 x 18.5 cm). The British Museum, Department of Prints and Drawings.

66 *O'Connell*

What may be this print or a version of it was advertised as "The Silly Contented Cuckold" by Peter Stent in 1662 and by his successor John Overton in 1673.[14] Like many English prints, the etching is based on a Continental prototype, in this case a contemporary French print, *Le Cornard Contant*,[15] the title of which is a pun, describing the cuckold as both content and counting. The image appears also in the form of a small woodcut illustrating a ballad entitled "The Dyers Destiny" (fig. 12). The wife in this case justifies taking lovers because their money compensates for her husband's poor earnings. There was a traditional association between cuckoldry and the trade of the dyer, perhaps because the unpleasant smells of dyestuffs clinging to his person were thought likely to drive a wife away.

Punning—a favorite form of early-modern humor—appears again in an illustration to the ballad "Rocke the Cradle John" (fig. 13), in which a horned cuckold holds up a hornbook.[16] Versions of this woodcut were used to illustrate a whole series of ballads from about 1635 to the end of the century. By the 1680s the blocks were worm-eaten and damaged; the hornbook and the top part of the cuckold's horns disappeared, and eventually he appears alone.[17]

Publishers of cheap prints and ballads clearly did not set great store by originality. Woodblocks were reused for as long as they held together and copperplates for as long as the faintest image could still be printed from worn metal. Old plates would be reworked and old blocks copied, rather than any effort being put into making new designs. If images did not quite fit the subject, publishers—and presumably buyers—did not seem to be too concerned.

To illustrate bawdy ballads entitled "Love in a Mist" and "The Jovial Maypole Dancers,"[18] the publisher Jonah Deacon used a woodcut that was surprisingly incongruous even by the careless standards of cheap publishers: a small fifteenth-century woodcut of the Visitation. This is no cunning attempt to import Roman Catholic visual propaganda; a century and a half after the Reformation, the iconography of the Life of the Virgin was so unfamiliar in Protestant England that the image could be read simply as two figures embracing, and it would serve to illustrate a bawdy text. One verse from "Love in a Mist" will demonstrate just how inappropriate the image was:

> She put this youngster to his trumps
> till he began to blow,
> But up and down she briskly jumps,
> for sometimes 'twill be so:
> Quoth she, I'll never after miss,
> such opportunities,
> For this is perfect Lovers bliss,
> with a mist before mine eyes.

The DYERS Destiny

OR, The Loving Wife's Help in time of Need.

Two Trades is better far than one,
sweet Husband, then, said she;

Then if thou wilt let me alone,
I'll be a help to thee.

To the Tune of, *Why are my Eyes still flowing*, &c.

This may be Printed, R. P.

A Dyers Wife she was a dainty curious Doe,
But with her Friend she a Gadding would go,
Alas he could not keep his handsome wife at home,
For with her Gallant abroad she would roam,
And when she came to her Husband each night,
Then like two Tygers together they'd fight,
And at each blow she would often reply,
 Thou art a Cuckold and so thou shalt dye.

You know full well I take the greatest care of all,
Or else your substance would soon be but small,
For why should I depend upon your Trade alone,
Is not two Callings far better than one;

Therefore i'de have thee be contented still,
For I protest I will have my own will,
'Tis but a folly the same to deny,
 Thou art a Cuckold and so thou shalt dye.

Huswife, said he, and have you now the wanton play,
So that your Husband is a Cuckold made,
What flesh and blood is able for to bear with this?
You shall, quoth she, tho ugh you take it amiss:
For I declare it is nothing but true,
Which I have oftentimes hinted to you,
Nay I do dare to be sound in a lye,
 thou art a Cuckold and so thou shalt dye.

A Shoe-maker I own to be my chiefest friend,
There does the most of my hopes still depend,
Against we meet he is a Man that does provide,
Not only Money, but something beside:
Therefore you have no great cause to complain,
Because to you I still bring home the gain,
As for your Art, I still do do, &c.
 Being a Cuckold and so thou shalt dye.

The Dyer then, alas was in a cruel rage,
That nothing scarce could his anger asswage,
Do not I bring to you my Wages e'ry week,
What need have you any Gallants to seek;
At this his Wife she was straight in a huff,
Saying your Wages is not half enough,
Therefore be patient, said she, do not cry,
 For thou'rt a Cuckold and so thou shalt dye.

It is well known our Cloaths were all at pawn of late,
And we reduc'd to a very mean state,
But now you see we make a very handsome shift,
Thus I was fore'd to help at a dead lift;
I brought home Coin by my industry,
The which I gave you all pawns to set free,
The truth of this sure you cannot deny,
 As you are a Cuckold, and so you shall dye.

Pray now did you e're flourish so in all your Life,
As now you do by the help of your Wife,
Therefore my Crime you may very well here excuse
Tell me I pray, do you ever want shooes?
Yet know you not the price of those you wear,
I get them by my industrious care,
The truth of this sure you cannot deny,
 As you are a Cuckold and so you shall dye.

A Country-Man of mine you sent me with one day,
Who in Apparel was gallant and gay,
To me he gave a Golden Guinea and two besst,
But yet for what I will leave you to guess:
But for your comfort take this by the way,
You shall big Gravel the next Horn-Fair-day,
Basket and Pit-Are I reckon to buy,
 For you are a Cuckold, and so you shall dye.

Printed for J. Blare, at the Looking-Glass on London Bridge.

13. Anonymous, *Rocke the Cradle John*, woodcut and letterpress (ca. 1650), 6 x 10⅞ in. (15.3 x 27.6 cm). The Pepys Library, Magdalene College, Cambridge.

OPPOSITE

12. Anonymous, *The Dyers Destiny*, woodcut and letterpress (ca. 1690), 7¼ x 11½ in. (18.5 x 29 cm). British Library.

Woodcuts of soberly dressed men and women are the norm for illustrations of bawdy ballads, however immodest the text. Erotic prints appeared only at the upper end of the market in the seventeenth century, and the most suggestive cheap ballad illustrations are woodcuts of fully clothed couples embracing, whether on a bed or in the countryside.[19] An example is the illustration to the ballad entitled "The Ranting Whores Resolution" (fig. 14), where the verses are in the words of a so-called "Lady of pleasure" who moves from man to man in the London taverns:

> When this Gallant's broke,
> I've another bespoke,
> And he hath my protection,
> I call him my Love,
> My Jewel, my Dove,
> And swear by my reputation,
> That I never did know,
> What Love was till now,
> Though I have had men beyond measure.

The same woodcut was used to illustrate two other Pepys ballads, "The Jovial Lass, or Doll and Roger" and "The Mourning Conquest,"[20] in both of which eager country girls seduce naive young men. The notion of naïveté in young women does not appear in English popular visual culture until late in the eighteenth century.

The rare occasions when women who are guilty of sexual transgression are treated sympathetically involve the abused mistresses of powerful men—in particular, Jane Shore and Fair Rosamond. Jane Shore, mistress of Edward IV, was, according to legend, made to parade in public penance after his death and became a figure of popular mythology. In one ballad of 1682—unfortunately not illustrated—Charles II's notorious mistresses Nell Gwyn and Barbara Villiers, Duchess of Cleveland, are visited by Jane Shore's ghost, who warns them that kings' mistresses can come to sorry ends. Fair Rosamond, Henry II's mistress, was allegedly murdered by Queen Eleanor. Her story engendered its own iconography in a number of illustrations to ballads and chapbooks, extending over several scenes set in the house at Woodstock, Oxfordshire, where she was kept: in the first scene the king arrives at the house in full regalia; in a later scene the queen forces Rosamond to her knees and makes her drink a cup of poison (fig. 15). The familiarity of this latter composition is attested by its clear echo in William Hogarth's *Henry VIII and Anne Boleyn* of the 1720s.[21]

Seventeenth-century popular prints of women tend to concentrate on sexual misbehavior, but women also are sometimes shown critically as wasting their time

14. Anonymous, *The Ranting Whores Resolution*, woodcut and letterpress (1672), 7⅞ x 11⅞ in. (20 x 30.2 cm). The Pepys Library, Magdalene College, Cambridge.

with gossiping, drinking, and fashion. One particularly long-lived image went through several incarnations. It was published in France about 1560 as an etching with the title *Le Caquet des Femmes*,[22] and as two early-seventeenth-century German etchings, one by Wenceslaus Hollar and both illustrating broadsides entitled *Schaw Platz*.[23] A woodcut, which was probably cut in Holland about 1600, appears in two English versions: one, entitled *The Severall Places Where You May Hear News* (fig. 16), would have been published toward the end of the seventeenth century; the other, entitled *Tittle Tattle; or, the Several Branches of Gossipping*,[24] dates from several decades later, by which time the block had sustained considerable damage. Gossip is the female vice that is exposed here: groups of women are shown gossiping while attending church, fetching water at the conduit, drinking at the alehouse, washing clothes, and so on; gossiping leads to arguing, then to physical fighting both at the conduit and by the river.

The Unfortunate Concubines:

The History of Fair ROSAMOND,

Mistress to *Henry* the Second;

And *JANE SHORE*, Concubine to *Edward* the fourth; King of *ENGLAND*.

Shewing how they came to be so. With their Lives, Remarkable Actions, and Unhappy Ends.

Extracted from Eminent Records.

Fair *Rosamond* and the King. — Q. *Ellinor* and *Rosamond*

...er giving *Jane Shore* Bread. — The Parentage of *Jane Shore*.

LONDON; Printed for *J. Smith*, in *Fetter-Lane*.

15.　Anonymous, title page to *The Unfortunate Concubines: The History of Fair Rosamond*, woodcut and letterpress (ca. 1700), 7½ x 4⅝ in. (19 x 11.7 cm). Beinecke Rare Book and Manuscript Library, Yale University.

16. Anonymous, *The Severall Places Where You May Hear News*, woodcut and letterpress (late-seventeenth-century impression from a block of ca. 1600), 14⅜ x 19¾ in. (36.5 x 50.1 cm). The Pepys Library, Magdalene College, Cambridge.

A fondness for fashion is another popularly described female weakness.[25] An example is a ballad entitled "Prides Fall," surviving in several editions,[26] which tells the story of the birth of a child with two heads and strangely shaped hands—a warning from God to women against vanity and loose morals. The illustration, however, is another example of a publisher failing to find a woodcut that properly illustrates the text: it shows a naked woman with two heads, not a two-headed child.

Fashion-conscious women can be shown as simply vain, silly, and, of course, wanton. But there is often the added anxiety that fashionable dress can disguise a woman's social class. There were many comments toward the end of the century about the fashion for extravagant headdresses—the high *fontange* or "Top-Knot." The ballad "Advice to the Maidens of London" complains that "Every Draggel-tayl'd Country Girl" is dressing up her hair with expensive ribbons, so that "you scarce can know Joan from my Lady."[27]

Another London ballad, entitled "The White-Chappel Maids Lamentation,"[28] was published at a time of political tension and bears the imprimatur of the government censor. English governments recognized early the subversive potential of print, and from the mid-sixteenth century they used the Stationers' Company to police publications through compulsory registration of all printed material. Control was particularly stringent in the late seventeenth century, when—between 1662 and 1679, and again between 1685 and 1694—the censor's approval was required in advance of publication.[29] The date of the censor's annotation—24 June 1685—tells us that the soldiers for whom the "maids" lamented were off to fight the Duke of Monmouth's rebels. A bawdy ballad is here being put to political purpose. The delights promised to those who support the king are quite explicit:

> At parting I gave Sweet William a kiss,
> And bid him remember his Mistress by this,
> I gave him a present too large for to name,
> A present desired by the Cocks of the Game.

The refrain continues with a military swing: "No Nation can shew us such Youths as are here, / Such Warlike brave Heros, such hearts void of fear."

Although bawdy ballads were obviously popular, it is as well to remember that Puritanism was still a powerful force in the late seventeenth century. *The Young-Mans Conquest over the Powers of Darkness* (fig. 17), a broadside purchased by Narcissus

OPPOSITE

17. Anonymous, *The Young-Mans Conquest over the Powers of Darkness*, woodcut and letterpress (1684), 18⅛ x 11⅞ in. (46 x 30 cm). British Library.

The YOUNG-MANS Conquest

Over the POWERS of DARKNESS.

In a DIALOGUE, Between a Virtuous Young-Man, and the Subtile Insinuating Tempter; Discovering the Baits of *SATAN*, and the Strength of TEMPTATION: With the Christians Fortitude, and only means of Overcoming, which is by Faith in Christ, and unwearied Perseverance.

Eph. 6. chap. 11. *Put on the whole Armour of God, that you may withstand the wiles of the Devil.*

5 *March.* 1683. Necessary to be set up in all Houses.

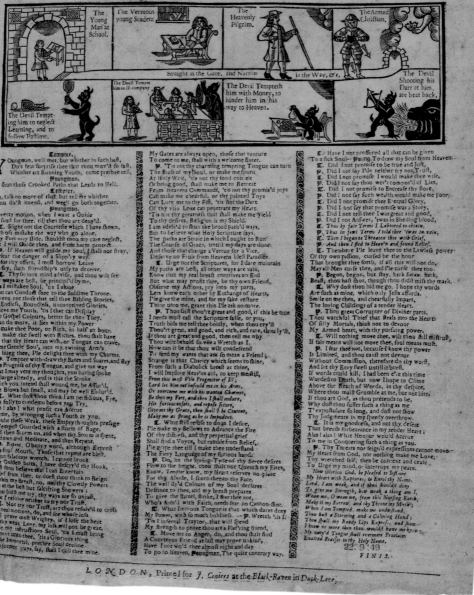

The Young Man at School. | The Vertuous young Student | The Heavenly Pilgrim. | The Armed Christian.

Straight is the Gate, and Narrow is the Way, &c.

The Devil Tempts him to ill company | The Devil Tempteth him with Money, to hinder him in his way to Heaven. | The Devil Shooting his Dart at him, are beat back.

The Devil Tempting him to neglect Learning, and to follow Pastime.

Tempter.

Youngman, well met, but whither in such haste,
Do's fear surprise thee that thou mov'st so fast,
Whither art Running Youth, come prethee tell,
To shun those Crooked Paths that Leads to Hell.

Youngman.

Fish, talk no more of that, but tell me whither
Thou do'st intend, and wee'l go both together.

Tempter.

A pretty motion, when I want a Guide
I'le send for thee, till then thou art deny'd.

Ch. Slight not the Courtesie which I have shown,
Such oft mistake the way who go alone,
Thy Feet may slide, shouldst thou my care neglect,
But I will Guide thee, and from harm protect.

Y. If Heaven will guide my Soul, I shall not stray,
Or fear the danger of a Slipp'ry way.
As for thy offers, I must borrow Leave
To say, such friendship's only to deceive.

Ch. Thy serious mind advise, and thou wilt see
My ways are best, be principl'd by me,
'Tis I mistaken Soul, 'tis I alone
That can Conduct thee to the Sublime Throne.
Believe not those that tell thee Babling Stories,
Of Endless, Boundless, unconceived Glories,
Believe the Youth, 'tis I that can Display
The Gospel Colours, better far then They.
I can do more, it lies within my Power
To make thee Poor, or Rich, in half an hour.
I'le make thee swell with Riches, thou shalt have
All that thy Heart can wish, or Tongue can crave,
Come Gentle Soul, into my twining Arm's
I'le hugg thee, I'le delight thee with my Charms.

Y. Tempter with-draw thy Baits and Snares, and stay
The Progress of thy Tongue, and give me way
That I may vent my thoughts, you having spoke
At large already, and is this the Stroke
Which you intend shall wound me, be Assur'd,
The Blows but small, and may be well Endur'd.

Ch. Dost thou think I am perfidious, Eye,
'Tis folly to condemn before you Try.
Alas! alas! what profit can Accrue
To me, by wronging such a Youth as you,
I doubt these Weak, these Empty-thoughts presage
A Tempest Guarded with a storm of Rage,
Well then Storm on, and when thy Storm is spent,
Sit down and Meditate, and then Repent.

Y. Repent, O happy word, although Express'd
By a soul Mouth, Those that repent are blest,
confalacious wretch, I cannot brook
thy Golden baits, I have descry'd thy Hook,
Wilt thou believe that I can Entertain
Belief from thee, or dost thou think to Reign
Within my Breast, no, no, thy Clowdy Powers
Are at the best but falsifying Showers;
Thou bidst me try, thy ways are so unjust,
That I resolve neither to try nor Trust.

Ch. Not try nor Trust, art thou resolv'd to cross
My real motions, do, and for whose loss
Will prove most Weighty, if I lose the heat
Of thy weak Love, my loss will not be great.
Take my instructions Soul, 'tis I must bring
Content to thee, 'tis a Glorious thing
To be Immortal, prethee Soul decline
Thy former ways, say, shall I call thee mine.

My Gates are always open, those that venture
To come to me, shall with a welcome Enter.

Y. 'Tis not thy charming tempting Tongue can turn
The Baits of my Soul, or make me spurn
At Holy Writ, 'tis not thy fond conceit
Of being good, shall make me to Retreat
From Heavens Commands, 'tis not thy promis'd joys
Can make me chearful, or thy painted Toys
Can Lure me to thy Fist, 'tis not the Dart
Of thy vain Love can penetrate my Heart.
'Tis not thy greatness that shall make me yield
To thy desires, Religion is my Shield.
I am advis'd to shun the broad path'd ways,
But to believe what Holy Scripture says,
The paths are Strait in which I ought to Run
The Course of Grace, until my days are done.
And those that change a Vertue for a Vice,
Deserve no Fruit from Heavens blest Paradice.

Ch. Urge not the Scriptures, for I dare maintain
My paths are best, all other ways are vain,
Know that my real breast contrives no End
But what may profit thee, be thy own Friend,
Observe my Actions, pry into my parts,
Lets know each other by Exchange of Hearts,
I'le give the mine, and for my sake restore
Thine unto me, grant this I'le ask no more.

Y. Thou fast thou'rt great and good, if this be true
I needs must call the Scripture false, or you,
Truth bids me tell thee boldly, when thou cry'st
Thou'rt great, and good, and rich, and rare, thou ly'st,
If thou art great and good, then tell me why
Thou wilt behold so vile a Wretch as I,
How can it be that thou wilt condescend
To feed my wants that am so mean a Friend;
Strange is that Charity which seems to shine,
From such a Diabolick breast as thine,
I will implore Heav'ns aid, to keep me still,
From this most Vile Progenitor of Ill;
Lord let him not infould me in his Arm,
Or overcome me with his wanton Charms,
Be thou my Fort, and then I shall endure,
His furious onsets, and repose secure,
Give me thy Grace, then shall I be Content,
Make me as strong as he is Impudent.

Ch. What still resist to do as I desire,
I'le make my Bellows to Advance the Fire
Of thy distress, and thy perpetual grief
Shall find a Voyce, but ramble from Relief,
I'le gripe thee till I make thee understand
The Fiery Language of my furious hands.

Y. Do, let the Spring-Tyde of thy fierce desires
Flow to the height, thou shalt not Quench my Fires,
Know, Tempter know, my Heart reserves no place
For thy Abode, I scorn thee to thy Face.
The well dy'd Colours of my Soul declares
Defiance to thee, and my breast prepares
To give the Battel, strike, I fear thee not,
Who's Arm'd with Faith, needs fear no Cannon-shot.

Ch. What Imvious Tongue is that which dares deny
My Power, with so much boldness. **Y.** Wretch 'tis I;
'Tis I internal Traytor, that will spend
My strength to prove thou art a Flatt'ring friend,

Y. Move me to Anger, do, and thou shalt find
A Courteous Friend at last may prove unkind,
Have I not wo'd thee almost night and day
To go to Heaven, Youngman, The quite contrary way.

Ch. Have I not proffered all that can be given
To a sick Soul— **Young.** To draw my Soul from Heaven.
Ch. Did I not promise to be true and Just,
Y. Did I not say Pale neither try not Trust,
Ch. Did I not promise I would make thee wife,
Y. Did I not say thou wer't compos'd of Lies,
Ch. Did I not promise to Encrease thy store,
Y. Did I not say such wealth would make me poor,
Ch. Did I not promise thee Eternal Glory,
Y. Did I not say that promise was a Story,
Ch. Did I not tell thee I was great and good,
Y. Did I not Answer, 'twas in Shedding blood,
Ch. Thus by fair Terms I Laboured to obtain,
Y. Thus in foul Terms I told thee 'twas in vain,
Ch. Then I began to Threaten thee with Grief,
Y. And then I fled to Heav'n and found Relief.
Ch. Therefore I'le leave thee to the Lawless power
Of thy own passion, cursed be the hour
That brought thee forth, if all this will not do,
May all Men curse thee, and I'le curse thee too.

Y. Begon, begon, but stay, hark Satan, hark,
Boast, thou hast shot, though thou didst miss thy mark.
Ch. Why dost thou bid me go, I hope thy words
Are such as mine, which only Jests affords.
Smile on me then, and chearfully Impart,
The loving Childings of a tender Heart.

Y. Thou grecie Corrupter of Diviner parts,
Thou watchful Thief that steals into the Hearts
Of silly Mortals, think not to devour
My Armed heart, with thy pursuing power.
Ch. Will nothing move thee, wilt thou still mistrust,
If fair means will not move thee, foul means must.
Y. I fear thee not, because I know thy power
Is Limited, and thou canst not devour
Without Commission, therefore do thy worst,
And let thy Envy swell untill it burst.
If words could kill, I had been e're this time
Worded to Death, but now I hope to Clime
Above the Reach of Words, in thy despite,
Where thou maist Grumble at me, but not bite;
If thou art God, as thou pretends to be,
Why dost thou suffer such a thing as me
T'expostulate so long, and dost not show
Thy Judgments in my speedy overthrow.
Ch. It is my goodness, and not thy desert
That breeds forbearance in my tender Heart;
Alas! alas! What Honour would Accrue
To me in Conquering such a thing as you.
Y. Thy Threats nor feign'd expressions cannot move
My Heart from God, nor nothing make me Love,
Thy wretched self, then be content and cease
To urge my mind, or interrupt my peace.
Now Glorious God, be pleased to Inflame
My Heart with Raptures, to Extol thy Name,
Lord, I am weak, and if thou shouldst deny
To give me Strength, how weak a thing am I,
Wean me, O wean me, from this Nursing Earth,
Make it my Sorrow, and thy Throne my Mirth,
When I am Tempted, make me understood,
Thou hast a Storming and a Calming Hand;
I know no more then thou wouldst have me know;
My unty'd Tongue shall evermore Proclaim
Exalted Praises to thy Holy Name.

FINIS.

Luttrell for 2d. on 5 March 1684, is a schematic illustration of the choice between the paths leading to heaven or hell. The heading "Necessary to be set up in all Houses" indicates that it was aimed at God-fearing families. The lengthy text—"a Dialogue, Between a Virtuous Young-Man, and the [Devil]"—avoids explicit descriptions of temptation. Serious moralists realized the risk of describing—let alone portraying—the vices they warned against; women appear here only as tiny figures among the "bad company" into which the Devil can tempt a young man. Naturalistic representation is avoided; just as in the bawdy ballads we see only symbols of cuckoldry, and as in the prints of Bulchin and Thingut, male virtue and female vice are portrayed emblematically.

The emblematic approach to imagery is a major distinction between the art of the streets of later-seventeenth-century London and the art of the court. By this time naturalism was the norm at the top end of the art market, but the popular audience maintained a conservative preference for the emblematic. This is partly a continuation of medieval modes of expression and partly a result of Reformation anxiety about the use of religious imagery, which had a far-reaching effect on print-making in England. In the German Protestant states, printmakers were able to switch their production from Catholic to Protestant imagery: Lucas Cranach's largely naturalistic woodcuts, for instance, were used to elucidate Martin Luther's works. The English print trade was not so well developed as its German counter-part—there was no Cranach, let alone a Dürer, able to adapt to new circumstances. Printed images became mere adjuncts to text, whether in religious contexts or in popular ballads. They were used emblematically to reinforce the word or to visu-alize abstract ideas. A well-known image might draw attention to the godly dis-tinction between the paths to heaven and hell (see fig. 17), or it might signal a tale of marital disharmony as in "the fight for the breeches" (see fig. 10). In neither case was naturalism required. If naturalism was irrelevant, then less discrimination might be needed in the choice of image. Consumers of these prints saw illustra-tions simply as signifiers. As we have seen, images might not relate precisely to tex-tual narrative; they could be printed from blocks that were worm-eaten and cracked—clearly decades old, and with characters wearing the fashions of an ear-lier generation. Such inconsistency between image and word was irrelevant in the seventeenth-century popular context, and the demand for naturalism was to emerge only gradually in successive decades.[30]

1. Ronald Paulson, *Popular and Polite Art in the Age of Hogarth and Fielding* (Notre Dame, Ind.: Univ. of Notre Dame Press, 1979), x.

2. For further literary references to popular prints, see Morris Martin, "The Case of the Missing Woodcuts," *Print Quarterly* 4, no. 4 (Dec. 1987): 342–61.

3. Lawrence Stone, "Literacy and Education in England 1640–1900," *Past and Present*, no. 42 (Feb. 1969): 69–139.

4. Margaret Spufford, *Small Books and Pleasant Histories: Popular Fiction and Its Readership in Seventeenth-Century England* (London: Methuen, 1981), 91–110.

5. Helen Weinstein, ed., *Ballads*, vol. 2 (bks. 1 and 2) of *Catalogue of the Pepys Library at Magdalene College, Cambridge*, ed. Robert Latham (Woodbridge, UK: D. S. Brewer, 1992–94); W. Geoffrey Day, ed., *The Pepys Ballads: Facsimile Volume*, 5 vols. (Cambridge: D. S. Brewer, 1987).

6. Luttrell's collection was sold by his descendants in 1786 and is now dispersed. Large numbers of the sheets are to be found in the British Library, the British Museum, and major American libraries, including the Beinecke Rare Book and Manuscript Library at Yale University; they are easily identifiable from Luttrell's annotations. See Stephen Parks, "The Luttrell File," *Yale University Library Gazette*, Occasional Supplement 3 (Dec. 1999).

7. Pepys's categories, listed at the beginning of the first volume of his ballad collection (see note 5 above), are: "1 - Devotion & Morality / 2 - History - True & Fabulous / 3 - Tragedy - vizt. Murd[e]rs, Execut[io]ns Judgm[en]ts of God &c. / 4 - State & Times / 5 - Love - Pleasant / 6 - D[itt]o . . . Unfortunate / 7 - Marriage, Cuckoldry, &c. / 8 - Sea - Love, Gallantry, & Actions / 9 - Drinking & Good Fellowshipp / 10 - Humour, Frollicks, &c. mixt."

8. Two English prints of the subject are known: an etching in the Morgan Library and Museum, New York (see Sheila O'Connell, "The Peel Collection in New York," *Print Quarterly* 16, no. 1 [March 1998]: 67), and a woodcut in the Society of Antiquaries, London (see Sheila O'Connell, *The Popular Print in England: 1550–1850* [London: British Museum Press, 1999], 48).

9. Author's modernization of Geoffrey Chaucer, "The Clerk's Tale," *The Canterbury Tales*, lines 1183–88.

10. Kevin Sharpe, "Restoration and Reconstitution: Politics, Society and Culture in the England of Charles II," in *Painted Ladies: Women at the Court of Charles II*, ed. Catharine MacLeod and Julia Marciari Alexander, exh. cat. (London: National Portrait Gallery, London, in association with the Yale Center for British Art, 2001), 19.

11. Reproduced in O'Connell, *Popular Print*, 110.

12. Violet Alford, "Rough Music or Charivari," *Folklore* 70, no. 4 (Dec. 1959): 505–18.

13. Samuel Butler, *Hudibras: The Second Part; by the Author of the First* (London: John Martyn and James Allestry, 1664), 121, 122; *The Diary of Samuel Pepys*, ed. R. C. Latham and W. Matthews, 11 vols. (London: HarperCollins, 1995), 8:257.

14. Alexander Globe, *Peter Stent, London Printseller, circa 1642–1665: Being a Catalogue Raisonné of His Engraved Prints and Books with an Historical and Bibliographical Introduction* (Vancouver: Univ. of British Columbia Press, 1985): 123, no. 52.

15. Reproduced in O'Connell, *Popular Print*, 112.

16. A hornbook was an early educational aid: a printed alphabet was mounted on a tablet of wood with a handle and protected by a thin sheet of transparent animal horn.

17. Examples of later uses of the same block include "Advice to Batchelors," "Hen-peckt Cuckold," "The Poor Contented Cuckold," and "My Wife Will Be My Master," in Day, *Pepys Ballads*, 4:103, 129, 133, 143.

18. British Library, London, C.22.f.6/56, 57. For an illustration of "Love in a Mist," see O'Connell, *Popular Print*, 117.

19. See, for example, "The Wheel-Wrights Huy-and-Cry after His Wife," in Day, *Pepys Ballads*, 4:115.

20. Day, *Pepys Ballads*, 3:116, 139.

21. A group of ballads and other popular materials illustrating the story of Fair Rosamond is kept in the Beinecke Rare Book and Manuscript Library, Yale University, pressmark Ib 57 + t4; for Hogarth's echo of the traditional iconography, see Ronald Paulson, *Hogarth's Graphic Works*, 3rd ed. (London: Print Room, 1989), 72–73, 282, no. 113.

22. André Linzeler and Jean Adhémar, *Inventaire du Fonds Français: Graveurs du Seizième Siècle*, 2 vols. (Paris: Bibliothèque Nationale, 1967–71), 2:193–94, inv. Tf.2, fol. 49.

23. Richard Pennington, *A Descriptive Catalogue of the Etched Work of Wenceslaus Hollar, 1607–1677* (Cambridge: Cambridge Univ. Press, 1982), 95, no. 596; Wolfgang Harms and Michael Schilling, *Deutsche Illustrierte Flugblätter des 16. und 17. Jahrhunderts*, 7 vols. (Tübingen: Max Niemeyer Verlag, 1985–2005), 1:300–301, no. I. 145.

24. Frederic George Stephens and M. Dorothy George, *Catalogue of Political and Personal Satires Preserved in the Dept. of Prints and Drawings in the British Museum*, 11 vols. (London: British Museum, 1870–1954), 1:31–32, no. 61.

25. Men are also mocked at times when fashion is particularly extravagant. The elaborate male clothing of the late 1620s was satirized in a number of prints of "Monsieur A-la-Mode," which include a surviving English example, *The Funeral Obsequies of Sir All-in-New Fashions*, published by Thomas Geele (Ashmolean Museum, Oxford Univ., Douce Prints, Portfolio 138, no. 89); "macaronis," "*incroyables*," and dandies from the 1770s to 1820s were the subject of much satire.

26. British Library, London, "Roxburghe Ballads," 3:64–65, 806–7; Day, *Pepys Ballads*, 2:66; Chetham's Library, Manchester, Halliwell-Phillipps Collection, cat. 28, http://www.chethams.org.uk (accessed Sept. 2007).

27. Day, *Pepys Ballads*, 4:365.

28. Day, *Pepys Ballads*, 3:338.

29. A. Griffiths, *The Print in Stuart Britain* (London: British Museum Press, 1998), 24.

30. For an account of the effect of Reformation iconoclasm on English art, see Margaret Aston, *The King's Bedpost: Reformation and Iconography in a Tudor Group Portrait* (Cambridge: Cambridge Univ. Press, 1993).

The "Windsor Beauties" and the Beauties Series in Restoration England

Catharine MacLeod and Julia Marciari Alexander

THE PORTRAITS OF WOMEN by Peter Lely that are known collectively as the "Windsor Beauties" (fig. 18) have been described as "the most familiar and vulnerable aspect of Lely's achievement."[1] These paintings, which hang in the Communications Gallery at Hampton Court Palace today, apparently formed the heart of Lely's work for his important royal patrons, the Duke and Duchess of York, in the years just following the Restoration. Since the early eighteenth century, tradition has held that the Duchess of York commissioned them as a coherent "series" intended to constitute a "beauties gallery" of the type found in Continental collections from the sixteenth century on.[2] In this assumed context critics and art historians have admired the group, mined it for Neoplatonic symbolism, criticized it for depicting "professional beauties" or "kept-mistresses," and denounced it for both its moral tone and its artistic and technical qualities.[3] Through an examination of the evidence for the paintings both individually and collectively, this essay aims to determine in what sense they might be regarded as a "beauties series" and to reassess their significance as artistic and cultural productions of their time.

With the help of early descriptions, royal inventories, and other, securely identified portraits of women at the Restoration court, it is possible to identify the sitters in the "Windsor Beauties" with a degree of certainty. The first mention of the paintings, in Samuel Pepys's *Diary* entry for 21 August 1668, identifies them collectively, but not individually: "This day I did first see the Duke of York's room of pictures of some Maids of Honour, done by Lilly; good, but not like."[4] The individual identities of the women in the portraits are given for the first time in the second contemporary document to record the group. This inventory of the possessions of James, Duke of York, dates from 1674 and lists eleven sitters:[5] Frances Teresa Stuart, Duchess of Richmond and Lennox (fig. 19); Elizabeth Hamilton, Countess of Gramont (fig. 20); Jane Needham, Mrs. Myddelton (fig. 21); Margaret Brooke, Lady Denham (fig. 22); Barbara Villiers, Countess of Castlemaine, and by 1674 Duchess of Cleveland (fig. 23); Mary Bagot, Countess of Falmouth and Dorset

(fig. 24); Frances Brooke, Lady Whitmore (fig. 25); Henrietta Boyle, Countess of Rochester (fig. 26); Elizabeth Wriothesley, Countess of Northumberland, later Duchess of Montagu (fig. 27); Anne Digby, Countess of Sunderland (fig. 28); and Lady Frances Hyde, sister of the Duchess of York.[6] All but the latter (the portrait of whom has apparently disappeared from the Royal Collection) correspond with the identities attached to the portraits in the group today. The inventory gives the location of the portraits as the White Room, which in the past was thought to be at Whitehall Palace but more recently has been identified as a room in St. James's Palace.[7] They were clearly displayed as a group, on walls "hunge wth white sarsanett, and over it blew Mohair with silk fringe." Below them hung six "narrow long pictures," believed to have been biblical or mythological paintings by Andrea Schiavone.[8]

The sitters' identities are again given in an inventory of the possessions of James (by then King James II) taken in 1688. By this time the pictures had been moved to the Princess's Dressing Room at Windsor Castle, and the inventory lists the sitters as "Dutchess of Cleveland, Dutchess of Richmond, Mrs. Middleton, Lady Northumberland, Lady Sunderland, Lady Falmouth, Lady Denham, Lady Denham's sister, Lady Rochester, Lady Grammont."[9] Frances Hyde has disappeared from the list, but a portrait of Henrietta Anne, duchesse d'Orléans (the youngest sibling of James and Charles II, married to Louis XIV's younger brother, Philippe d'Anjou, duc d'Orléans), is listed after "Lady Grammont," implying that it hung with the group. Sometime in the eighteenth century the ten pictures that currently make up the group (see figs. 19–28), along with other portraits of women that had been added during the reign of Queen Anne, were moved to the State Bedchamber at Windsor; by 1835 they had been transported to Hampton Court, where they hang today (see fig. 18).[10]

Recent research has confirmed that the majority of the paintings in the surviving group have been correctly linked with names in the inventory lists. Many of these women now have extensive and well-established iconographies, and, in spite of Pepys's comment that the portraits were "not like," the appearances of these sitters correspond closely to their other securely identified portraits.[11] The following portraits can be identified with confidence: Frances Stuart, Duchess of Richmond and Lennox (see fig. 19); Elizabeth Hamilton, Countess of Gramont (see fig. 20); Jane Needham, Mrs. Myddelton (see fig. 21); Barbara Villiers, Countess of Castlemaine, later Duchess of Cleveland (see fig. 23); Henrietta Boyle, Countess of Rochester (see fig. 26); Elizabeth Wriothesley, Countess of Northumberland (see fig. 27); and Anne Digby, Countess of Sunderland (see fig. 28).[12] There are less secure iconographies for the sitters currently—and traditionally—identified as Margaret Brooke, Lady Denham (see fig. 22); Mary Bagot, Countess of Falmouth and Dorset (see fig. 24); and Frances Brooke, Lady Whitmore (the

18. View of the Communications Gallery at Hampton Court Palace.

sister of Margaret Brooke, Lady Denham; see fig. 25).[13] In spite of the uncertainty over the definite identification of the latter three paintings, it does seem likely, given the well-recorded history of the portraits, the security of the other identities, and the consistency between the two early inventories, that the three women named in the lists of 1674 and 1688 are those depicted in the paintings now hanging at Hampton Court.[14]

So, what of Pepys's comment that the portraits represented "some Maids of Honour"? Much has been done in recent years, particularly by Sonya Wynne, to identify women who held official positions at the court of Charles II. Wynne has discussed, at length, the makeup of the two sets of maids of honor at court during the 1660s: those appointed to the queen's household and those to the Duchess of York's. An authoritative list has been compiled for the queen's maids of honor during this period, but the lists of women appointed to this position in the duchess's household are less secure.[15] Among all the names of women known or thought to have held this office in either household, in fact, only two correspond to sitters among the "Windsor Beauties": Frances Stuart, who became a maid of honor to the queen in 1662, and Mary Bagot, who was later identified—probably mistakenly—as a maid of honor to the duchess.[16] Pepys's assertion about the status of the sitters, therefore, is evidently incorrect, and it reminds us that, though an astute observer, he operated on the fringes of the court. His work as a naval

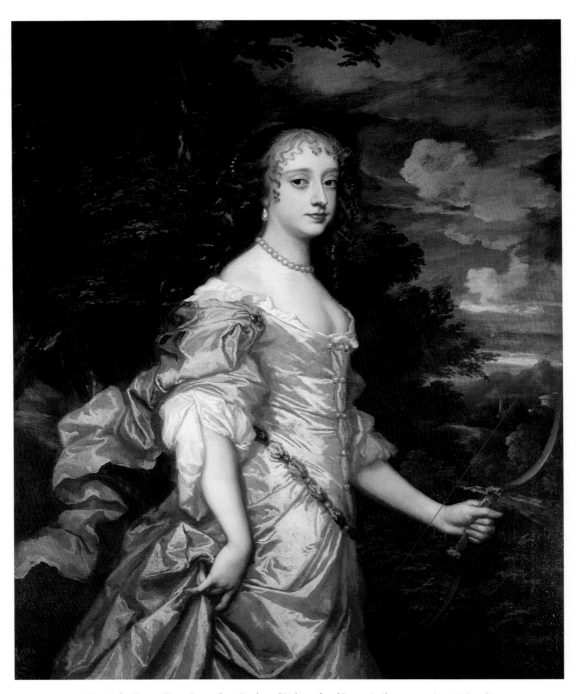

19. Peter Lely, *Frances Teresa Stuart (later Duchess of Richmond and Lennox)*, oil on canvas (ca. 1662), 49½ x 40⅜ in. (125.8 x 102.7 cm). The Royal Collection, Her Majesty Queen Elizabeth II.

20.　Peter Lely, *Elizabeth Hamilton, Countess of Gramont*, oil on canvas (ca. 1663), 49¼ x 40 in. (125.1 x 101.6 cm). The Royal Collection, Her Majesty Queen Elizabeth II.

21. Peter Lely, *Jane Needham, Mrs. Myddelton*, oil on canvas (1663–65), 48⅞ x 40 in. (124.1 x 101.6 cm).
The Royal Collection, Her Majesty Queen Elizabeth II.

22. Peter Lely and studio, *Margaret Brooke, Lady Denham*, oil on canvas (1663–65), 49 x 39¾ in.
(124.5 x 101 cm). The Royal Collection, Her Majesty Queen Elizabeth II.

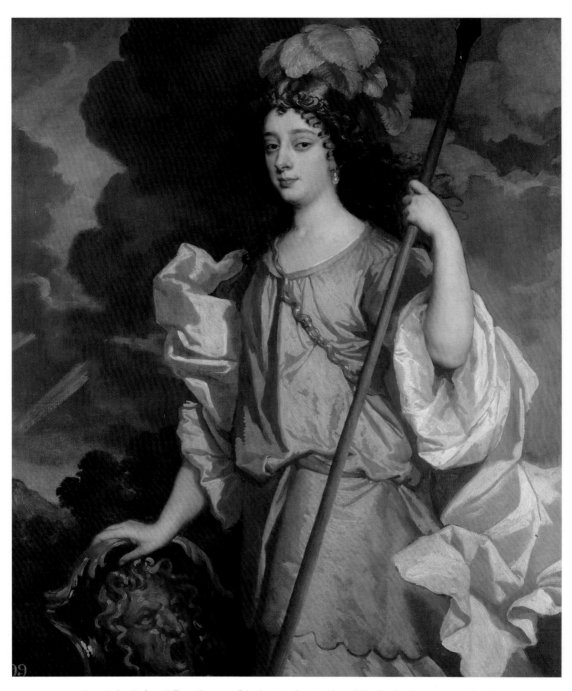

23. Peter Lely, *Barbara Villiers, Countess of Castlemaine (later Duchess of Cleveland)*, oil on canvas (1663–65), 49 x 40 in. (124.5 x 101.6 cm). The Royal Collection, Her Majesty Queen Elizabeth II.

24. Peter Lely, *Mary Bagot, Countess of Falmouth and Dorset*, oil on canvas (1664–65), 48⅞ x 40 in. (124.1 x 101.6 cm). The Royal Collection, Her Majesty Queen Elizabeth II.

25. Peter Lely, *Frances Brooke, Lady Whitmore*, oil on canvas (ca. 1665), 49 x 40 in. (124.5 x 101.6 cm). The
Royal Collection, Her Majesty Queen Elizabeth II.

26. Peter Lely, *Henrietta Boyle (later Countess of Rochester)*, oil on canvas (ca. 1665), 49 x 40 in. (124.5 x 101.6 cm). The Royal Collection, Her Majesty Queen Elizabeth II.

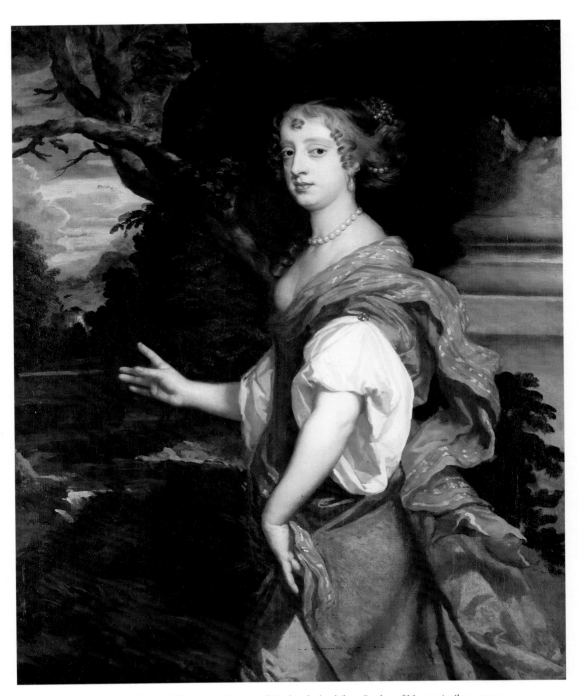

27. Peter Lely, *Elizabeth Wriothesley, Countess of Northumberland (later Duchess of Montagu)*, oil on canvas
(1665 or later), 49½ x 40¾ in. (125.7 x 103.5 cm). The Royal Collection, Her Majesty Queen Elizabeth II.

28. Peter Lely and studio, *Anne Digby, Countess of Sunderland,* oil on canvas (ca. 1666), 49¼ x 40¼ in. (125.1 x 102.2 cm). The Royal Collection, Her Majesty Queen Elizabeth II.

administrator from the 1660s did bring him into regular contact with the Duke of York, but largely in the context of external business; he was not part of the inner circles of court society and was unlikely to have had accurate knowledge of the latest female appointments to the queen's and Duchess of York's households. Indeed, it is questionable whether Pepys knew who some of the women depicted in these portraits were, and his description of them as a group rather than as individuals is quite revealing. Perhaps it is precisely his inaccuracy that is most telling: even if the paintings were not a set of portraits of maids of honor, does Pepys's instinct to identify them as a set with a single unifying theme suggest that they might have been considered at this time—as their traditional name implies—a beauties series, and intentionally constituted as such?

They appear to have been considered a beauties series by the early years of the eighteenth century, when in 1704 Anthony Hamilton, brother-in-law of Philibert de Gramont, comte de Gramont, wrote his *Mémoires de la Vie du Comte de Grammont: Contenant Particuliérement l'Histoire Amoureuse de la Cour d'Angleterre, sous le Regne de Charles II* (probably widely circulated in manuscript form before its initial publication in French in 1713).[17] Hamilton describes the genesis of the group thus:

> There was in London, at that time, a celebrated portrait-painter called Lely. . . . Of all the moderns, it is Lely whose works have come nearest to and best imitated Van Dyck. The Duchess of York wished to have a gallery of the fairest persons at Court; Lely painted them for her. In this commission he expended all his art; and there is no doubt that he could scarcely have had more beautiful sitters. Every picture seemed a masterpiece; but his portrait of Miss Hamilton was the most successful of them all. Lely admitted that he had enjoyed painting it; the Duke of York enjoyed looking at it, and once again began ogling the original. But in that quarter he could not hope for success.[18]

As the notes to Cyril Hughes Hartmann's 1930 English edition make clear, however, Hamilton was not always an accurate commentator, frequently adapting historical facts to fit his particular narrative agenda. The bias of the above passage in favor of his sister Elizabeth Hamilton (who married the eponymous comte de Gramont in December 1663) is evident, but this account—which proved highly influential on later commentators on the Lely portraits—nonetheless deserves serious consideration.

Although Hamilton's assertion that the women portrayed were "the fairest persons at Court" will forever remain unsubstantiated, contemporary and near-

contemporary written accounts provide the modern scholar with a record of women who were regarded at the time as "beautiful"—and this despite the fact that, inevitably, every writer brought his or her particular interests and prejudices to the task of citing "beauties."[19] Comparison of these sources indicates that there is a degree of consistency in identifying women generally regarded as particularly beautiful, and from them we can infer that most of the "Windsor Beauties" did indeed have reputations as beautiful women during their lifetimes. Four of the sitters, however, did not: Mary Bagot, Countess of Falmouth and Dorset (although Hamilton allows her "some semblance of virtue and beauty");[20] Lady Frances Hyde (if indeed her lost portrait should be considered part of the group); Elizabeth Wriothesley, Countess of Northumberland; and Anne Digby, Countess of Sunderland. By contrast, a number of women who were at court in the 1660s and were especially famous for their beauty were not included in the series, notable among them Frances Jennings (later Duchess of Tyrconnel), who was in fact a maid of honor to the Duchess of York and whose beauty Hamilton described at length; Anna Maria Brudenell, Countess of Shrewsbury, another famous—indeed, notorious—beauty; and Elizabeth Butler, Countess of Chesterfield (fig. 29), who was particularly admired by James, Duke of York.[21] If Lely, prompted by his patron, was really trying to produce a series of the most beautiful women at court, it is difficult to explain why women such as these, well known for their appearances, would have been omitted and others, not noted for their looks, such as the Countess of Sunderland, would have been included. But even if there were consensus among contemporary commentators as to the physical "beauty" of the sitters, the designation of particular women as "the most beautiful" can never be regarded as an objective exercise; as Hamilton's biases demonstrate, it was always one heavily vested with the author's particular political and social interests.

A more telling indicator as to the status of the group as a beauties series is its relationship to other such series that were put together both in England and on the Continent. Groups of portraits of women hung together and designated "beauties" were much more well established as a genre of painting, and of display, in continental Europe than in England by the seventeenth century. The only type of series found in England with any frequency before the second half of the seventeenth century was the series of kings and queens of England, which, by its very nature, largely comprised copies of earlier paintings (and indeed entirely fanciful paintings) and necessarily represented sitters almost entirely unknown personally to the patrons.[22] On the Continent, by contrast—and perhaps especially in Italy—groups of contemporary "beauties" had been collected since at least the mid-fifteenth century.[23] One of the earliest such sets was that of Galeazzo Maria Sforza, Duke of Milan, who commissioned portraits of beautiful and eligible women in

29. Peter Lely, *Elizabeth Butler, Countess of Chesterfield*, oil on canvas (ca. 1660), 48¾ x 40¼ in. (123.8 x 102.2 cm). The Board of Trustees of the Chevening Estate.

his duchy, perhaps for a beauties gallery.[24] Similarly, Ferdinand von Tirol apparently had a collection of "beauties" at his castle at Ruhelust.[25] In the early seventeenth century Vincenzo Gonzaga, Duke of Mantua, assembled a collection of portraits of the most beautiful women in the world,[26] and Louis XIV of France, too, apparently intended to have a beauties gallery among the rooms he renovated at Versailles in the early 1660s. Although there is no evidence that such a gallery was ever put together, Louis did have a set of portraits of the princesses of Europe painted by Charles and Henri Beaubrun, which was assembled by 1665.[27]

Two prominent Continental series, both dating to the late 1660s and early 1670s, provide the most useful comparisons with the "Windsor Beauties": the set assembled by Roger de Rabutin, comte de Bussy, at his Château de Bussy-Rabutin

in Burgundy, and the one assembled by Cardinal Flavio Chigi, now at the Palazzo Chigi in Ariccia. For these two series, more than for others compiled at the time, we have a relatively substantial amount of information, particularly about how and why these groups of portraits were acquired and displayed. Consequently, they reveal some of the ways in which the phenomenon of the beauties series had begun to function in the visual culture of the later decades of the seventeenth century.

In 1665 Roger de Bussy-Rabutin (or simply Rabutin), comte de Bussy, was first imprisoned and then exiled from the French court by Louis XIV for circulating in manuscript form and then publishing his scandalous *Histoire Amoureuse des Gaules* (a *roman à clef* that created shock waves throughout the court).[28] By assembling painted allegorical emblems and groups of portraits in complex programs displayed on the walls of his château in Burgundy, he continued in exile to create "histories" that expressed his opinions—political and personal. The portraits represented mainly groups of different types of historical figures—kings of France; statesmen and men of letters; illustrious men of war; and mistresses and favorites of past French kings—and he intended his display, which included painted epithets under some portraits, to be understood as indicative of his various opinions about history, politics, and court life.[29]

In addition to the more traditional sets of portraits listed above, he ended his instructive circuit in la Tour Dorée, with a set of what he described as "the most beautiful women of the court, who have given me their portraits"(fig. 30).[30] The comte de Bussy explicitly stated that he had acquired these sets of portraits not only for decorative and historical purposes but also for the education of his children. His location of the portraits of "the most beautiful women of the court"—at the end of a suite of rooms, separated from his other groups by a room containing portraits of his family—suggests that he regarded the "beauties" as having a closer connection to family than to historical figures. Furthermore, the way in which he acquired this group, by gift from the sitters, reinforces a sense of his personal affiliation with the individual women portrayed. The manner of his acquisition of these paintings also opens up the possibility that these were not necessarily the most beautiful women at all but rather the most generous women, the most vain, or simply those most closely associated with Bussy himself.

Bussy's display of his portraits of contemporary women derives most explicitly from the tradition of *recueils*, albums into which portrait drawings of contemporary members of court society were pasted and labeled with descriptions that were often malicious or salacious. These compendiums of written and drawn portraits were particularly associated with women, and most famously with the intellectually minded group called Les Précieuses. They were especially popular in early-seventeenth-century France, but their origins lay in court culture of the previous

30. La Tour Dorée, Château de Bussy-Rabutin, Burgundy, France.

century. Bussy's gathering of portraits also would have been understood in the context of the *portrait littéraire*, an enormously popular genre in France in the mid-seventeenth century, the greatest proponent of which was Louis XIV's first cousin Anne-Marie-Louise (princesse d'Orléans), duchesse de Montpensier, most commonly known as "La Grande Mademoiselle," who published a collection of these verbal portraits "done" in her chambers.[31] The kind of scandalous "history" of contemporary court life written by Bussy and subsequently by Hamilton provided further literary parallels to the *recueils* and the *portraits littéraires*.

Whether scandalous or not, all these types of portraiture—literary and pictorial—depended on the ability of their audiences to identify the individuals represented, through a synthesis of the specific and the general. Written descriptions coupled with the drawn portraits, and increasingly with the painted portraits,

relied on conventions of rhetoric and style that stressed particular models of beauty (much as our fashion magazines today employ a language of "beauty" that makes all the models seem cut from the same cloth). These generalizing patterns inevitably led to the stereotyping of individuals into categories such as "Beauty" or "Wit," especially in the case of the women. Yet, no matter how generalized, these portraits failed unless the viewer was able to make the transition from type to individual; in other words, the identifying phrases pasted alongside the portraits or the physical depiction of women in painted portraits depended on the specific connections made in the mind and eye of the viewer between the representation and an actual person.[32] Bussy was careful to make that transition possible for his audience—a necessarily select one during his lifetime, given his exile—by adding an inscription below each portrait; these not only helped individuate each sitter, they also expressed his opinions—sometimes sharp—about the subjects. For example, the inscription below the portrait of Catherine-Henriette d'Angennes, comtesse d'Olonne, referred to her as "the most beautiful woman of her time, less famous for her beauty than for what she did with it."[33] Clearly his ties to the sitters were not ones of uncomplicated admiration or affection, and certainly the combination of portrait and inscription was intended to stimulate a variety of responses, including comment, comparison, amusement, and admiration, on the part of its viewers. That Bussy compiled them individually but expressly displayed them as an "annotated" group within the context of the carefully laid-out program of his home reveals both that the beauties gallery could be much more than a simple aesthetic display and that it could be constructed and understood as a complex portrait of the owner as well.

Equally instructive to our understanding of the ways in which the beauties gallery or series functioned in the 1670s is the set of portraits of women commissioned by Cardinal Chigi. Compiled in Rome and now in Ariccia (fig. 31), this set was to prove immensely influential in Italy very shortly after its execution. The core of the group was a series of twenty portraits for which the Flemish artist Ferdinand Voet was paid in August 1672; a further seventeen portraits were added at some point between 1673 and 1678.[34] The portraits, which Francesco Petrucci has argued were largely based on existing images, rather than painted from life, are of sitters who were prominent Roman women and women temporarily resident in Rome, where Voet was working at that time; many of them had ties of friendship or blood to the Chigi family.[35] Notable among the women in this first group of paintings were the two most celebrated of Cardinal Mazarin's famously beautiful nieces: Marie Mancini, wife of Lorenzo Onofrio Colonna, Constable Colonna, and Hortense Mancini, Duchess Mazarin, estranged wife of Armand de la Meilleraye de la Porte, Duke Mazarin.[36]

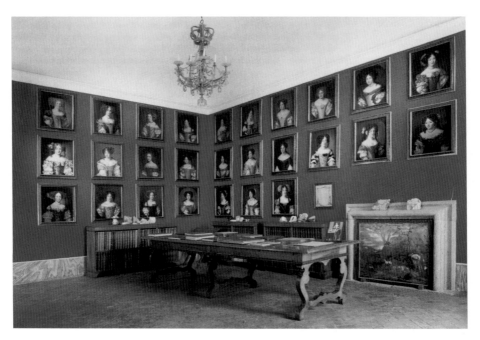

31. Beauties' Room, Palazzo Chigi, Ariccia, Italy.

In his recent book on Voet, Petrucci argues that the Mancini sisters' beauty and charm were the initial inspiration for the Chigi series. On 29 May 1672, before the first group of portraits had been paid for, the two sisters had scandalously fled Rome: Marie left her husband, Colonna, and Hortense continued her periodic travels around Europe (which were to end eventually in England). From this point on, as Petrucci points out, the Mancini sisters would have been regarded not just as models of beauty and elegance, but also, especially given the widely known circumstances of Hortense's marriage to a man generally regarded as extremely eccentric (if not lunatic), as emblems of independence and possibly even emancipation.[37] Whether or not individual viewers put such a positive interpretation on the sisters' actions, it would have been impossible to separate their reputations for beauty from their reputations for transgressive behavior.

The sets created in the wake of the Chigi series, including one commissioned by Colonna, by then Marie Mancini's estranged husband, must all be seen as marking—and perhaps indeed celebrating—not just the beauty but also, variously, the notoriety and charisma of both the Mancini sisters and the other women depicted.[38] These sets all included some copies from the Chigi set plus additional

portraits of other women; their distinct compositions reflected the interests and particularities of their patrons. The gathering together of a beauties series can be seen in this context to be an exercise that was not comprehensive; no set was ever the definitive group of beauties. Rather, it is apparent, through comparison of such sets, that for the courtier in late-seventeenth-century Europe, to commission, purchase, or simply display a beauties series was an act of self-expression that could be interpreted on a number of different levels.

Although the Bussy and Chigi galleries cannot have influenced Lely's group (as they were both assembled slightly later), they nevertheless provide a useful framework against which the "Windsor Beauties" can be measured, since they reveal a pattern for series of this kind. Indeed, understanding how the Bussy and Chigi sets were both compiled—reflecting personal taste, opinion, and, perhaps to a lesser extent, aesthetic merit—informs our understanding of how the "Windsor Beauties" would have been regarded by their viewers, even if we have little evidence of the circumstances in which they were acquired.

Little is known about the how the group of paintings by Lely came to be in the Duke and Duchess of York's possession. As we have seen, the tradition that the Duchess of York commissioned the pictures stems from the passage in Hamilton's *Memoirs*, which dates to the early years of the eighteenth century.[39] Recently Michael Wenzel has argued that the circumstances of their display, in the White Room at St. James's Palace above the Schiavone panels, support the idea of a "feminine" commission, paralleling the "masculine" series of portraits of naval flag officers painted by Lely and his studio for the Duke of York from 1666, some of which were hung at Culford Hall by 1671.[40] The subjects of the Schiavone panels, which Wenzel claims reinforce this feminine context, are a matter of some uncertainty, however, and cannot be regarded as substantially strengthening the original claim by Hamilton that the Lely portraits were commissioned by the duchess.[41] Providing further confusion as to the circumstances of the pictures' initial commission and display, Pepys describes them as hanging in the duke's room when he saw them in 1668, but Diana Dethloff has pointed out that this may have been a temporary arrangement.[42] She has persuasively argued that the duchess's precarious reputation at court; the precedent set by her father, Edward Hyde, first Earl of Clarendon, in collecting portraits of famous men; and her frequent patronage of Lely all support the idea that she was the patron of the "Windsor Beauties." This argument might also be supported by the fact that the duchess's daughter, Mary II, later commissioned, perhaps in imitation of her mother, a series of portraits of court beauties by Godfrey Kneller (which will be discussed at greater length below). Although it seems probable that the duchess was behind the acquisition of the portraits, it is not possible to rule out the involvement of the duke in assembling the group, and indeed the inclusion of many

of the sitters seems likely to have been at his behest rather than hers. In the absence of any substantial documentary evidence for the paintings' commission, then, can we look to the portraits themselves to reveal something about the genesis of the group?

None of the portraits is dated, but stylistically they all belong to the 1660s and could have all been painted before 1668, when Pepys saw them—or at least some of them—in the "Duke of York's room." The portraits of Frances Stuart, later Duchess of Richmond and Lennox (see fig. 19), and Elizabeth Hamilton, Countess of Gramont (see fig. 20), appear to be the earliest works of the group. Both paintings are of exceptionally high quality throughout, and their beautifully painted draperies show none of the abbreviated technique that Lely began to employ as he became increasingly busy after the first two or three years of the 1660s.[43] Frances Stuart arrived at the court in 1662 and became a maid of honor to the queen shortly after her arrival. Her portrait may have been painted to commemorate that event; it appears to show her as a very young woman, which would accord well with a date of about 1662. Likewise, Lely almost certainly painted the portrait of Elizabeth Hamilton during the first years of the Restoration period since, in addition to the stylistic evidence, she was only briefly at the English court. She came with her family to England from France at the Restoration, married the comte de Gramont in 1663, and left England for France with him in 1664. The iconography of her portrait, which shows her in the guise of Saint Catherine holding a martyr's palm and sitting in front of a broken, spiked wheel, suggests that it was painted in or about 1663 to commemorate her marriage.[44]

The other paintings in the group have been dated by Oliver Millar on stylistic grounds to the years between 1663 and 1665, or slightly later.[45] Millar identified the portraits of the Countess of Rochester (see fig. 26) and the Countess of Northumberland (see fig. 27) as the latest of the group, painted in or after 1665, but the portrait of Anne Digby, Countess of Sunderland (see fig. 28), is likely to be later still. Unlike the others in the group, which seem to be largely or wholly autograph works, this portrait is a studio version of a painting of which the prime original by Lely was in the collection of the sitter and her husband at Althorp. The Althorp portrait (still at the house, in the collection of the Spencer family) is dated 1666, and it is probably correctly associated with a payment to Lely in October of that year, giving the "Windsor" portrait a *terminus post quem* of late 1666.[46]

The portraits in the Royal Collection clearly range in date from about 1662 to 1666 or later, and, if the ten paintings were commissioned as a set, four years is a remarkably long time for a painter as productive as Lely to have been working on them. Here, Lely's method in painting the "Flagmen" for the Duke of York provides a telling contrast; when Pepys visited Lely's studio on 18 April 1666 he saw "the heads, some finished and all begun," of twelve of the thirteen portraits of the flag officers.[47]

The heads were all done by Lely himself, evidently in rapid succession, before the rest of the paintings were subsequently completed by his studio assistants. Given this indicator of his practice in painting a set of portraits and what is known of his efficient studio practices more generally, Lely would have been unlikely to have made an exception for a female series commissioned as a set by one of his most important patrons, painting them slowly over a number of years.[48] This, perhaps more than any other factor, indicates that the group was not commissioned at once as a set.

Moreover, although the "Windsor Beauties" visually form a superficially coherent group, this coherence is largely due to the prevailing style of the artist, to the languorous court "look" he gave all his young female sitters (which has been much commented on), and to the consistency in the size and framing of the paintings.[49] Lely painted all the portraits on canvases measuring approximately fifty by forty inches, a size that from 1660 onward became almost ubiquitous for his— and most other English artists'—three-quarter-length portraits. By contrast, the iconographies, poses, costumes, and settings provide little visual unity among the portraits. The women variously sit, stand, or walk in wooded landscapes, in interiors, on rocky crags. Four of the sitters play roles in their portraits: Frances Stuart is shown in the role of the goddess Diana; Barbara Villiers appears as Minerva; Jane Needham carries the cornucopia of Plenty (or Ceres); and Elizabeth Hamilton, as we have noted, is in the guise of Saint Catherine. The other women appear simply as themselves, although Mary Bagot is holding what may be a shepherdess's "houlette" (an archaic agricultural implement), a popular accessory in Restoration portraiture. Viewed as a group, the portrait of Barbara Villiers stands out particularly from the other nine. With her plumed helmet and Gorgon's-head shield she fills the canvas in a way that the others do not, and the martial theme, emphasized by the stormy sky behind, contrasts markedly with the twilit pastoral landscapes of the other outdoor settings. The women's costumes vary from simplified versions of formal dresses of the period (those of Frances Stuart and Anne Digby) to loose silk gowns that expose much of the white linen shifts—and flesh—beneath.

If Lely's portrait practice as well as visual aspects of the paintings themselves are to be seen as evidence that the portraits were not commissioned as a group (in the way that Chigi appears to have commissioned his initial set from Voet), it is possible that the "Windsor Beauties" may have been assembled through a combination of commissions, gifts from the sitters (like Bussy's "beauties"), and purchases from Lely's studio stock, which we know was an important part of the painter's business.[50] Such various methods of acquisition would explain the disparate nature of the appearance and dates of the portraits. Yet, once assembled, they soon would have come to be considered as a group through their display, hung together in matching frames in the White Room at St. James's.

The beauty, notoriety, or personal connections (or some combination thereof) that justified the inclusion of sitters in the Bussy and Chigi groups must surely also have been the stimulus for the selection of the Windsor sitters. We have seen that many of the group were famous beauties, including, notably, Frances Stuart, who was pursued shamelessly and openly by the king, but apparently never succumbed to his advances; the king's admiration of her was such that she was chosen to be the model for the figure of Britannia on the coinage and contemporary medals (see fig. 42).[51] Frances Brooke, Lady Whitmore, was also considered a great beauty.[52] Barbara Villiers was the king's most prominent mistress during the first part of his reign, a woman with an unmatched reputation in Charles's court for both beauty and immorality; she is also known to have been admired by James as well as by his brother.[53] Indeed, the admiration of James is a common thread running through the histories of several of the other sitters in the group. We have seen that Elizabeth Hamilton was particularly admired and pursued by him, her picture in the group inciting the duke to begin, in the words of Hamilton, once again "ogling the original."[54] Jane Needham, similarly, was rumored to be the duke's mistress, and, although Pepys later stated that this was untrue, the duke eventually gave her a pension, a fact that rather supports the rumors.[55] The Duke of York publicly acknowledged Margaret Brooke, Lady Denham, as his mistress by June 1666.[56] Elizabeth Wriothesley, Countess of Northumberland, and Mary Bagot, Countess of Falmouth and Dorset, were both talked of as possible brides for the duke after the death of the duchess, Anne Hyde, in 1671. Henrietta Boyle, Countess of Rochester, was the duchess's sister-in-law. Finally, Robert Spencer, second Earl of Sunderland, the husband of Anne Digby, was a close associate of the duke, and the couple lavishly entertained the duke and duchess, as well as fellow courtiers, at Althorp, Sunderland's newly refurbished country house in Northamptonshire.[57]

As was the case with the Bussy and Chigi groups, then, what the patron or patrons of the Windsor paintings compiled was a group of portraits that illustrated their personal affiliations and interests, but also flattered the sitters and no doubt satisfied the patron's own notions of fashionable aesthetics by overlaying the sitters' individuality with an approximation of contemporary courtly beauty. Although seemingly paradoxical, this combination of the generalized look with the particularization of the individual sitter—through attributes, and through individualized facial features articulated through a common stylistic and aesthetic language—made these groups especially interesting. Beautiful, decorative, fashionable, and hung harmoniously together, the portraits of these women must have provoked comment, admiration and awe, gossip and nudges, and even, perhaps, smirks and giggles from their audiences. Such portraits would have marked their owners as court insiders, among those most "in the know."

With their rich and striking appearance, and their strong individual and collective visual—and social—impact, it is not surprising that, as in the case of the Chigi paintings, the "Windsor Beauties" seem to have inspired the assemblage of numerous other groups of female portraits by Lely. It is instructive to consider these groups, as the ways in which they were assembled, displayed, and viewed have corroborative bearing on how the one acquired by the Yorks in the 1660s should be understood.

Most impressive of the beauties series inspired or at least influenced by the Windsor group—and perhaps qualitatively its equal—was that assembled by the Earl of Sunderland to decorate Althorp. Little documentary information survives about the way in which Sunderland acquired these works; although today at Althorp there are at least eighteen female portraits by Lely and his studio that could have belonged to Sunderland (among them, figs. 32 and 33), only three of these can be linked to payment records. These all date to 1666 and are for portraits of Sunderland himself, of Anne Digby, and of Jane Needham, Mrs. Myddelton (see fig. 33).[58] As was probably the case with the paintings for the Yorks, the Althorp group was put together over a period of time: the majority of the remainder of the paintings can be dated fairly reliably from the late 1660s until the mid-1670s.[59] Unfortunately, no early and reliable list exists to aid in identifying the sitters in Sunderland's paintings, and many of the identities traditionally affixed to the paintings are clearly incorrect. The securely identified paintings, nevertheless, indicate that the group comprised a mixture of famous beauties, relations, prominent aristocratic women, and members of the royal family. Some are autograph Lelys, some are studio works, and some are copies by lesser hands. It seems likely that, as suggested by the rather disparate quality, range of dates, and variety of types of subjects, they came into Sunderland's possession by a variety of means: some commissioned, some given, and some perhaps bought from Lely's studio stock. The most remarkable thing about Sunderland's collection of Lely portraits is its sheer size and the great preponderance of portraits of women. In common with the Windsor portraits, then, it seems that the display of at least a large part of the group in the long gallery at Althorp—however and on whatever basis the group had initially been assembled—was intended not only to make a striking aesthetic impression, implying a conventional analogy between the women's beauty and that of the paintings (and trumpeting the patron's aesthetic judgment, of artists and women), but also to elicit recognition of and comments about the sitters from the viewer.

At about the same time, Cosimo de' Medici, Archduke and later Grand Duke of Tuscany, commissioned a set of paintings from Lely. His father, Grand Duke Ferdinando II, had been told in 1667 by the diplomat Sir Bernard Gascoigne (a

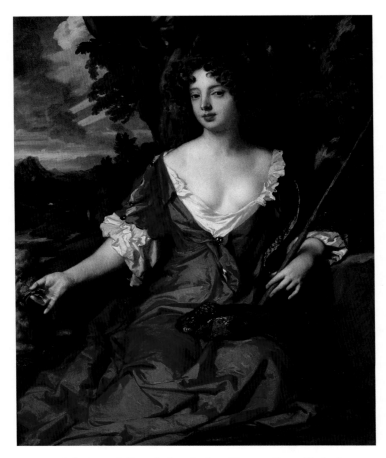

32. Peter Lely, *Louise de Kéroualle (later Duchess of Portsmouth), as a Shepherdess,* oil on canvas (ca. 1671), 50 x 40⅛ in. (127 x 102 cm). The Collection at Althorp.

Florentine who spent most of his life in England) that paintings by Lely made "a wonderful collection for decorating a room, with rich gilded frames," and it was perhaps with this advice in mind that Cosimo visited Lely's studio when he was in London in 1669.[60] Unusually, a substantial amount of material survives recording the circumstances of this commission, in the form of letters between various agents and employees of the Medicis.[61] Cosimo commissioned five portraits from Lely: the king; the Duke of York; the Duchess of York; Barbara Villiers, Duchess of Cleveland; and "Mistress Russell," probably Laetitia Russell, wife of Colonel Thomas Cheke. Cosimo's agent in London, Francesco Terriesi, was left to oversee the completion of the paintings and the shipping of them to Italy. By early 1672

33.　Peter Lely and studio, *Jane Needham, Mrs. Myddelton*, oil on canvas (1666), 50 x 40⅛ in. (127 x 102 cm). The Collection at Althorp.

they were still not finished, and Cosimo wrote to Terriesi urging him to press Lely to complete them. Finally dispatched by ship in September 1672, their delivery was delayed again when the ship was waylaid by pirates, but eventually they arrived with Cosimo in Florence.

Evidently, at some point, a change had been made to the commission, as Terriesi confirmed that instead of a portrait of the Duchess of York, the set now included one of a "Lady Cavendish," probably Lady Mary Butler, daughter of James Butler, first Duke of Ormond; she had married William Cavendish (later first Duke of Devonshire) in 1662. This change may have been connected to the fact that the Duchess of York had died in 1671. Cosimo added another female portrait from

Lely's studio—of Elizabeth Wriothesley, Countess of Northumberland—to the set in 1674. He also bought male portraits of military and naval heroes and friends.[62] In addition, he negotiated through Terriesi to buy portrait miniatures from the widow of the miniaturist Samuel Cooper, selecting these on the basis of price, identity of the sitter, and Terriesi's recommendations as to quality.[63]

As with all the other groups, Cosimo's portraits of women seem to have been chosen for a variety of reasons; they represented the famous, the beautiful, and possibly those from families with whom he had personal connections (as was perhaps the case with the images of Laetitia Russell and Lady Cavendish). Unlike the Windsor and the Althorp sets, all four paintings appear to be studio rather than autograph works. Hung together, however, they no doubt bore out Gascoigne's judgment of the merits of Lely's work as decoration for a room.

The display of the portraits together seems inevitably to have led its audiences to label and classify the paintings as a "set." In the eighteenth century Edward Wright, who saw Cosimo's paintings in Italy, described them as "copies of Sir Peter Lely's English beauties at Windsor, which his highness procur'd to be copied when he was in England."[64] In fact, none are copies of the Windsor paintings, although two of the sitters, the Countess of Northumberland and the Duchess of Cleveland, feature in both groups. The compulsion, among viewers, to label and codify the paintings reinforced the conventional association of both paintings and women with beauty and contributed to the veiling of the individuality both of the pictures and of their sitters. That Cosimo's portraits left England, where the identities of their sitters would have best been appreciated, further complicated the history of this particular group and its relationship with others of its kind. On the other hand, that Cosimo assembled a set of "beauties" provides us with yet another instance of how these groups were compiled, considered, and understood in a broad court culture that extended throughout Europe.

Probably in the 1670s, and therefore after the Sunderland and Medici portraits, a group of paintings by Lely and his studio was assembled by Baptist May, Keeper of the Privy Purse to Charles II and a confidant of the king. According to Gilbert Burnet, writing in the early eighteenth century, May gained power by "serving the King in his vices"; Samuel Pepys, usually a much less moralizing commentator than Burnet, referred to him as "Court pimp."[65] Charles Beale, husband of the painter Mary Beale, saw ten portraits in May's lodgings in Whitehall in April 1677. Two of these were of men: "the King's picture in Buff" and "Mr William Finch a head by Mr Hales." The other eight portraits were all of women, and all what he called half-lengths (what would be described today as three-quarter-lengths), painted on standard fifty-by-forty-inch canvases. The women depicted were Anne Hyde, Duchess of York; Louise de Kéroualle, Duchess of Portsmouth;

Nell Gwyn, with a lamb; the actress and singer Mary "Moll" Davis, with a gold pot; "Mrs Roberts"; the Duchess of Cleveland, "being as a Madonna & a babe"; someone described as "Mrs May's sister"; and finally, Frances Stuart, Duchess of Richmond and Lennox (this last was the only painting not by Lely, but rather by the obscure artist Henry Anderton).[66] The duchesses of Portsmouth and Cleveland, Nell Gwyn, and Mary Davis were all mistresses of the king—an appropriate theme, perhaps, for a set of portraits owned by a man with May's reputation. Mrs. Roberts may be the obscure Jane Roberts, a clergyman's daughter, with whom the king had a brief relationship, or perhaps more likely is Lady Robartes, a fairly prominent court beauty. Frances Stuart, openly pursued by the king, seems to have resisted becoming his mistress, so she does not fit into what might otherwise be perceived as a theme of this set, although her reputation for beauty was legendary in her lifetime. Anne Hyde, Duchess of York, had a reputation neither as a beauty nor, of course, as a mistress, but her status at court might have been a reason for her inclusion in this group of pictures. May was not married, and so "Mrs May's sister" is assumed to have been a portrait of one of May's own sisters, either Isabella Hervey or Margaret Lee, or perhaps one of their sisters-in-law. Again, we have a group composed of family members, friends, and associates (and into this category must come the king's mistresses, whom May was responsible for paying) as well as famous beauties.

Before it was dispersed, this set may have descended to the de Saumarez family, in whose collection there were formerly portraits of a number of the sitters listed by Beale. In spite of Beale's identification of the artist of the majority of the set as Lely (or perhaps against the claim that the de Saumarez portraits were those owned by May), the paintings of the four mistresses of the king all appear to be rather ordinary copy portraits from the Lely studio, perhaps even copies made outside the studio.[67] There were, in fact, many groups of paintings rather like this one: poorish-quality versions of paintings of well-known sitters, hung with often better portraits of family members, the former probably bought from the artist's studio stock, the latter commissioned. May's set exemplifies the ways in which such sets were assembled not only by important courtiers but also by other members of court, in emulation of the higher-quality groups put together by wealthier and more prominent individuals.[68]

The portraits in all these series would have inevitably conveyed, to those who knew the sitters best, information about the particularities of the individual women that is now lost to us as the distance between the life of the woman and the life of the "beauty" has expanded. Particularly instructive in helping us to understand how this phenomenon of "distancing" can occur with regard to portrait sets is the history of the series known as the "Northumberland Beauties." Painted by Sir Anthony Van Dyck for Algernon Percy, tenth Earl of Northumberland, this

34. Sir Anthony van Dyck, *Anne Carr, Lady Russell (later Countess of Bedford)*, oil on canvas (ca. 1638), 53⅜ x 43¼ in. (136.2 x 109.9 cm). Lord Egremont, Petworth House, Sussex.

group of portraits originally hung at Northumberland House in London (until at least 1671) and now can be seen at Petworth House (figs. 34 and 35). These paintings by Van Dyck may have influenced both the manner in which the Lely portraits were assembled and the way in which they were perceived by viewers, at the time and subsequently. Certainly, Van Dyck as a painter was a major influence on Lely,

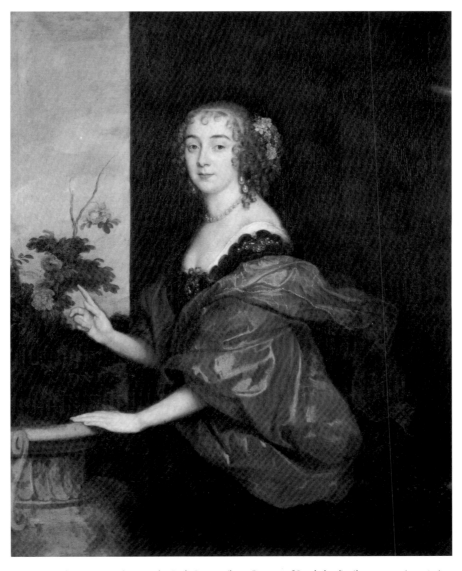

35. Sir Anthony van Dyck, *Dorothy, Lady Spencer (later Countess of Sunderland)*, oil on canvas (ca. 1639), 53⅛ x 43 in. (136.2 x 109.2 cm). Lord Egremont, Petworth House, Sussex.

and the latter even used an adapted version of the pose of one of the Northumberland paintings, that of the Countess of Sunderland, for his portrait of the Countess of Northumberland in the Windsor group (see fig. 27).[69]

As in the case of the "Windsor Beauties," little is known of the circumstances in which the Van Dyck paintings were acquired, and most of the portraits are in fact of

Northumberland's relations. Christopher Rowell has suggested that while some of the pictures were commissioned, others may simply have been acquired as fine examples of Van Dyck's paintings, and others inherited.[70] The Van Dyck set, then, like the Lely set, appears to have been, in fact, an assemblage of images perhaps acquired haphazardly, but then hung together, and soon seen as a beauties gallery. As four of the sitters were countesses, the group soon also became known by this title.

It is clear, however, that a particularly influential factor in fixing the perception of Northumberland's group as a beauties series, in which the individual sitters' identities were far less important than that of the group as a whole, was the production of sets of copies, on a small scale, of female portraits by Van Dyck, which included copies of some of Northumberland's portraits. At least four such sets are known, plausibly attributed to Remigius van Leemput. The most well known of these is one painted in 1638–39 that originally belonged to Amalia von Solms, wife of the stadtholder of the Netherlands.[71] In the form of copies painted as a set, the individual associations between the sitters and owners of the originals necessarily disappeared for all but a few viewers. With a new, head-and-shoulders format (the originals had been three-quarter-lengths), and executed in the bland and formulaic hand of the copyist, compositional and physiognomic differences were largely smoothed away. The copy portraits became relatively anonymous "beauties," valued primarily for decorative purposes and for the association with Van Dyck. In addition to these small oils, a series of engravings after portraits by Van Dyck was produced by Pierre Lombart about 1660; this comprised two depictions of earls and ten of countesses, including four of Northumberland's paintings. Once again, at an even further remove from the circumstances and purposes of the original paintings, this engraved series encouraged the perception that the painted portraits had been simply a set of "beauties," rather than a group of portraits of individuals with particular relationships among themselves and with the patron.

The full range of specific reasons for the acquisitions of the "Windsor Beauties," and all the various ways in which their contemporary viewers understood the paintings individually and collectively, may always elude us. Examining the precedents for such a group and making comparisons with other contemporary sets does enable us, however, to understand some of the ways in which series such as these conveyed meaning in the years just after they were assembled. These paintings, when hung together, not only imparted information about the specific individuals and their relationships to the portraits' owners, but also reflected and contributed to the generalized ideals of beauty pervading artistic and court culture at the time of the paintings' creation. In addition, the groups of paintings by Lely and his studio assembled during the Restoration period in England reflected the prevailing preoccupation of court society with notoriety, scandal, fashionable beauty, and

political connections. Over time, as these meanings, specific to the individuals involved and the society in which they lived, were lost to viewers, stories—or myths—about the sitters have enveloped them, creating a new layer of generalized anecdote, which itself further enhances the qualities of the groups as "series" rather than individual paintings.

As we have seen with the Northumberland "Beauties" or "Countesses" and with the "Maids of Honour" mentioned by Pepys, this process of substituting the recognition of individuals with a single, overarching (and often misleading) category could be rapid, even almost immediate. The urge toward grouping, labeling, and classifying was strong in late-seventeenth-century England, an era in which great collections of natural specimens were being formed and the Royal Society was founded. Pepys himself, like others around him, was later to take the advice of John Evelyn, and other writers, in forming his own collection of prints (including a huge number of portraits), which he pasted into albums, where they were ordered and classified in a complex series of categories.[72] Changes in Lely's own style during the later part of Charles II's reign also contributed to diminishing the individuality of his paintings; the originality and complexity found in so many of his early portraits gave way to compositions in which, both in style and in subject, the general triumphed over the specific, the ideal over the individual, and meaningful symbolism became mere fashionable accessory.[73]

The categorizing and generalizing that took place in relation to Lely's "Windsor Beauties" strongly influenced the genesis—and subsequent appreciation—of a further group, painted in the last years of the century (figs. 36 and 37). This series comprised eight portraits of court women painted by Godfrey Kneller, who was paid £400 for them in 1691. Contemporary anecdotal evidence links the payment to the queen, Mary II (who was Anne Hyde's daughter), rather than the king, William III, but this evidence is much more substantive than that for the link between the "Windsor Beauties" and Anne Hyde.[74] It seems likely that Mary commissioned the paintings in emulation of what her mother was believed to have done twenty-five years before. The single payment does seem to confirm that these portraits, unlike the earlier group, were the result of one coherently conceived commission. In addition, the narrower size of two of the portraits (see fig. 37) suggests that Kneller was directed to paint them to hang in specific locations in the Water Gallery at Hampton Court, where they were displayed until William began stripping his late wife's rooms of their decor in order to furnish his own newly created suites in 1699; at that time, they were moved to the "Eating Room below Stairs"—where it was said that William would retire from the hunt immediately into a "debauch" (and where they hang today).[75] In terms of costume, setting, and attributes, the portraits exhibit a degree of visual disparity, but this seems likely to have been

36. Godfrey Kneller, *Frances Whitmore, Lady Middleton*, oil on canvas (1690–91), 92 x 56¼ in. (233.7 x 142.9 cm). The Royal Collection, Her Majesty Queen Elizabeth II.

influenced by the "Windsor Beauties." Conversely, the circumstances of the commission of this set have become a rather distorting glass through which the "Windsor Beauties" have been viewed, reinforcing the assumption that the latter group was also commissioned as a set, by a female patron. Like many sequels, Kneller's "Hampton Court Beauties" have come, by association, to suggest a shared series of values and intentions in their predecessors that were not originally there.

In common with their predecessors, however, the "Hampton Court Beauties" provide no obvious single coherent theme in terms of their subject matter, to satisfy the viewer's need to label. Contemporary visitors to Hampton Court came up with a variety of categories when trying to decipher a coherent program. Daniel

37. Godfrey Kneller, *Diana de Vere (later Duchess of St. Albans)*, oil on canvas (1691),
92 x 45¼ in. (233.6 x 115 cm). The Royal Collection, Her Majesty Queen Elizabeth II.

Defoe identified the women as "the principal ladies attending upon her majesty, or who were frequently in her retinue; and this was the more beautiful sight, because the originals were all in being, and often to be compar'd with their pictures."[76] A variant description was given by the young traveler and diarist Celia Fiennes, who recorded that she had seen the pictures of "Ladyes of the Bed Chamber in Queen Maryes time."[77] Lady Anne Capel, Countess of Carlisle, sister-in-law of Mary Bentinck, Countess of Essex, one of the women in the set, was more closely associated with the sitters than Defoe or Fiennes, and her evidence is, therefore, perhaps more reliable. She recalled that the set was intended to represent the most beautiful women at court, but she also recorded the very real problem that

such a theme, openly expressed as the basis for a commission, could cause a patron. To create a gallery of "beauties" was not only a supremely subjective exercise, but also a politically and personally hazardous one for those hoping to succeed at court. (It is important to remember that Bussy created his gallery far from Paris during his exile.) In the world of Restoration politics, populated with astute courtiers and ever-shifting allegiances, who would have run such a risk? As the Countess of Carlisle observed, Mary's gallery of beauties "contributed much to make her [the queen] unpopular," for, as Katharine Sedley, Countess of Dorchester, is said to have explained to the queen, "Madam, if the King were to ask for the portraits of all the wits in his court, would not the rest think he called them fools?"[78]

Much of the material in this essay was first presented by Julia Marciari Alexander in "Self-Fashioning and Portraits of Women at the Restoration Court: The Case of Peter Lely and Barbara Villiers, Countess of Castlemaine, 1660–68" (PhD diss., Yale Univ., 1999) and subsequently in a paper entitled "Beauties Series in Restoration England," given by Catharine MacLeod at a National Trust / National Portrait Gallery symposium, *Sitters in Portraits: Inscriptions, Identifications and Sets*, held at the National Portrait Gallery on 16 Nov. 2001.

1. Oliver Millar, *The Tudor, Stuart and Early Georgian Pictures in the Collection of Her Majesty the Queen*, 2 vols. (London: Phaidon Press, 1963), 1:125.

2. This was apparently first claimed by Anthony Hamilton in about 1714; see note 16 below. For a discussion of the Duchess of York's possible patronage of the group, see pages 101–2 and note 39 below.

3. "Professional beauties" is a term used by Ernest Law; see Law, *The Royal Gallery of Hampton Court, Illustrated: Being an Historical Catalogue of the Pictures in the Queen's Collection at That Palace with Descriptive, Biographical and Critical Notes, Revised Enlarged and Illustrated with a Hundred Plates* (London: G. Bell and Sons, 1898), 70. "Kept-mistresses" is the critic William Hazlitt's term, which he used to describe the "Windsor Beauties" when he published a series of essays anonymously in 1824 as "Sketches of the Principal Picture-Galleries in England . . ."; the citation here is from *The Complete Works of William Hazlitt*, ed. P. P. Howe, after the edition of A. R. Waller and Arnold Glover, 21 vols. (New York: AMS Press, 1930–34), 10:38. For a synopsis and examination of the critical reception to the group, see Julia Marciari Alexander, "Beauties, Bawds and Bravura: The Critical History of Restoration Portraits of Women," in *Painted Ladies: Women at the Court of Charles II*, ed. Catharine MacLeod and Julia Marciari Alexander, exh. cat. (London: National Portrait Gallery, London, in association with the Yale Center for British Art, 2001), 62–71.

4. *The Diary of Samuel Pepys*, ed. R. C. Latham and W. Matthews, 11 vols. (London: Harper Collins, 1995), 9:284. This comment has had much impact on the way in which these paintings—and Lely's art generally—have been regarded, and, it has become a cliché of Lely criticism that his portraits are "good, but not like," although this is not an accurate understanding of his Lely's style; see Catharine MacLeod, "'Good, But Not Like': Peter Lely, Portrait Practice and the Creation of a Court Look," in MacLeod and Marciari Alexander, *Painted Ladies*, 50–61.

5. The following list is in the order of what we have judged to be the chronological sequence of the pictures; we are giving the full titles of each sitter, although some did not have these titles at the time their portrait was painted.

6. Bodleian Library, Oxford Univ., MS 891, fol. 7v; Millar, *Tudor, Stuart and Early Georgian Pictures*, 1:37, and for Millar's discussion of the pictures, 1:125–26.

7. Michael Wenzel, "Heldinnengalerie—Schönheitsgalerie: Studien zu Genese und Funktion Weiblicher

Bildnisgalerien, 1470–1715" (PhD diss., Heidelberg Univ., 2001), 280–90, and Wenzel, "The *Windsor Beauties* by Sir Peter Lely and the Collection of Paintings at St James's Palace, 1674," *Journal of the History of Collections* 14, no. 2 (2002): 205–13. Wenzel points out that Sir Oliver Millar first identified this room as being in St. James's Palace in Millar, *The Queen's Pictures* (London: Her Majesty's Stationery Office, 1977), 70.

8. Millar, *Tudor, Stuart and Early Georgian Pictures*, 1:124; for the Schiavone pictures, see John Shearman, *The Early Italian Pictures in the Collection of Her Majesty the Queen* (Cambridge: Cambridge Univ. Press, 1983), 228–31.

9. British Library, London (hereafter BL), Harleian MS 1890, "Inventory of His Majesty's Goods 1688," fol. 83; George Vertue's copy of this inventory (BL, Add. MS 15752) was published as *A Catalogue of the Collection of Pictures etc. Belonging to King James the Second* (London: Printed for W. Bathoe, 1758), hereafter known as Bathoe; the paintings are nos. 1111–1120 in Bathoe, 93.

10. Millar, *Tudor, Stuart and Early Georgian Pictures*, 1:124.

11. Much of this research was conducted by the authors in preparation for Marciari Alexander, "Self-Fashioning," and MacLeod and Marciari Alexander, *Painted Ladies*. Securely identified portraits of some of the women in this group can be found in *Painted Ladies*; material about other sitters remains unpublished.

12. See Millar, *Tudor, Stuart and Early Georgian Pictures*, 1:125–26; Marciari Alexander, "Self-Fashioning," 34–37; and MacLeod and Marciari Alexander, *Painted Ladies*, esp. 92–96, cats. 15, 17.

13. The complicated history of the identifications of two of these portraits, Frances Brooke and Mary Bagot, is explored in Marciari Alexander, "Self-Fashioning," 34–40, and Alastair Laing has also reconsidered the identities of the portraits called Margaret Brooke and Mary Bagot in relation to traditional identifications of copies of these portraits at Chirk Castle (in unpublished correspondence with Catharine MacLeod).

14. We know that the Frances Hyde painting had left the group by 1688, and none of the ten paintings in the group today can represent the duchesse d'Orléans, the only other possible sitter, whose iconography is well established. See MacLeod and Marciari Alexander, *Painted Ladies*, 78–81, cats. 4, 5.

15. See Sonya Wynne, "The Mistresses of Charles II and Restoration Court Politics, 1660–1685" (PhD diss., Univ. of Cambridge, 1997), 263, and Marciari Alexander, "Self-Fashioning," 41–42.

16. See critical commentary by Cyril Hughes Hartmann, ed., in *Memoirs of the Comte de Gramont*, by Anthony Hamilton, trans. Peter Quennell (New York: George Routledge and Sons Ltd., 1930), 329–69; for a summarized list, see Marciari Alexander, "Self-Fashioning," 42 nn. 50, 51.

17. Anthony Hamilton, *Mémoires de la Vie du Comte de Grammont: Contenant Particuliérement l'Histoire Amoureuse de la Cour d'Angleterre, sous le Regne de Charles II* (Cologne: P. Marteau, 1713); the first English translation was published in 1714. References in the current text are to the translation by Peter Quennell; see note 16 above.

18. Hamilton, *Memoirs*, 190.

19. The more prominent accounts of "beauties" at the English court include Hamilton's *Memoirs*, the lists compiled by Lorenzo Magalotti in his account of Archduke Cosimo (later Grand Duke Cosimo III) de' Medici's visit to England in 1668–69, and Samuel Pepys's *Diary*. For a detailed discussion of the differences among these accounts, see Marciari Alexander, "Self-Fashioning," chap. 1, esp. 44–45 nn. 55, 56. For a complete transcription of Magalotti's lists, see *Lorenzo Magalotti, Relazioni d'Inghilterra 1668 e 1688*, ed. Anna Maria Crinò (Florence: L. S. Olschki, 1972), 160–62, and Crinò, "Gli Wits e le Più Belle Donne nella Londra della Restaurazione Secondo Lorenzo Magalotti," in *Fatti e Figure del Seicento Anglo-Toscano* (Florence: L. S. Olschki, 1957), 127–49.

20. Hamilton, *Memoirs*, 223.

21. For Frances Jennings, see Hamilton, *Memoirs*, 223–24; for Anna Maria Brudenell and Elizabeth Butler, see MacLeod and Marciari Alexander, *Painted Ladies*, 110–11 and 76–78, cats. 29 and 3, respectively.

22. For series of portraits of kings and queens, see Robin Gibson, "The National Portrait Gallery's Set of Kings and Queens at Montacute House," *National Trust Year Book* (1975): 81–87, and Susan Foister, "Edward Alleyn's Collection of Paintings," in *Edward Alleyn: Elizabethan Actor, Jacobean Gentleman*, ed. Aileen Reid and Robert Maniura, exh. cat. (London: Dulwich Picture Gallery, 1994), esp. 39–52.

23. For further, fuller surveys of the phenomenon of the beauties gallery, see Lada Nikolenko, "The Beauties Galleries," *Gazette des Beaux-Arts*, ser. 6:67 (Jan. 1966): 19–24; Stephanie Tasch, "Studien zum Weiblichen

Rollenporträt in England von Anthonis van Dyck bis Joshua Reynolds" (PhD diss., Ruhr-Universität, Bochum, 1999), esp. 37–43; and Wenzel, "Heldinnengalerie."

24. Lorne Campbell, *Renaissance Portraits: European Portrait Painting in the 14th, 15th and 16th Centuries* (New Haven and London: Yale Univ. Press, 1990), 218, 272 n. 131. It is unclear whether these portraits were hung together.

25. On the collection of Ferdinand von Tirol, see F. Kenner, "Die Porträtsammlung des Erzherzogs Ferdinand von Tirol," *Jahrbuch der Kunsthistorischen Sammlungen des Allerhöchsten Kaiserhauses* 14 (1893): 35–186; 15 (1894): 147–259; 17 (1896): 101–274; 18 (1897): 135–261; 19 (1898): 6–146.

26. Campbell, *Renaissance Portraits*, 220, 272 n. 131; Nikolenko, "Beauties Galleries," 19–24.

27. For a discussion of the Versailles beauties gallery, and the sources for it, see Marciari-Alexander, "Self-Fashioning," 53–54, esp. nn. 72–75.

28. The comte de Bussy's *Histoire Amoureuse des Gaules* was circulated in manuscript form from 1662 and first published in Paris in 1665. Publication of the *Histoire* led to Bussy's imprisonment in the Bastille for a time, and then to exile at his château in Burgundy. See Marciari Alexander, "Self-Fashioning," 55 n. 77.

29. In his own description of his decorative program, "under each [portrait of the kings], a banner indicates all that need be known about the subject's actions" (authors' translation), quoted in *Le Château de Bussy-Rabutin*, by Maurice Dumoulin (Paris: Gallimard, 1933), 21–22.

30. "A large private apartment follows, where one finds only members of my family, and this suite terminates in a large salon, where one finds the most beautiful women of the court, who have given me their portraits. The whole program forms four highly decorated rooms that comprise an abbreviated history of the past and present, which is all I wish my children to understand on this subject" (authors' translation), quoted in Dumoulin, *Château de Bussy-Rabutin,* 21–22.

31. These were famously composed and written in collaboration with the writer and historian Jean Regnault de Segrais and were possibly meant to complement a gallery of painted portraits she compiled (about which nothing further is currently known) at the Château de Saint-Fargeau; see Marciari Alexander, "Self-Fashioning," 52.

32. See the discussion of the relationships among literary, drawn, and painted portraits in Marciari Alexander, "Self-Fashioning," 51–53, and, for a slightly differing view as to the effects of the portrait in the *recueil*, see Susan Shifrin, "'A Copy of My Countenance': Biography, Iconography, and Likeness in the Portraits of the Duchess Mazarin and Her Circle" (PhD diss., Bryn Mawr College, 1998), 226.

33. Bussy's inscription reads, "La plus belle femme de son temps, moins fameuse par sa beauté que par l'usage qu'elle en f"t"; for further discussion of Bussy's rhetorical program, see Edouard Pommier, *Théories du Portrait de la Renaissance aux Lumières* (Paris: Gallimard, 1998), 204.

34. On this series and all subsequent ones by Ferdinand Voet, see Francesco Petrucci, *Ferdinand Voet (1639–1689), Detto Ferdinando de' Ritratti* (Rome: Ugo Bozzi, 2005), chap. 5 (105–35), esp. 108, 109.

35. Francesco Petrucci, "Monsù Ferdinando Ritrattista: Note su Jacob Ferdinand Voet (1639–1700?)," *Storia dell'Arte* 84 (1995): 284; Petrucci, *Ferdinand Voet*, 113–14.

36. See the essay by Susan Shifrin in this volume.

37. Petrucci, *Ferdinand Voet*, 125.

38. Petrucci, *Ferdinand Voet*, 125; see also the essay by Susan Shifrin in this volume.

39. Hamilton, *Memoirs*, 190. Generally, Hamilton's statement has been accepted without question. Oliver Millar echoes it in Millar, *Tudor, Stuart and Early Georgian Pictures* (1:121, 124), but he suggests that the duke was the patron, in Millar, *Sir Peter Lely, 1618–80*, exh. cat. (London: National Portrait Gallery, London, 1978), 15. The patronage of the group is also discussed in Marciari Alexander, "Self-Fashioning," 32–33; Shifrin, "'A Copy of My Countenance,'" chap. 5; and Wenzel, "Heldinnengalerie," 280–90.

40. Wenzel, "*Windsor Beauties*," 205–13; see also Millar, *Tudor, Stuart and Early Georgian Pictures*, 1:123–24, nos. 252, 254.

41. Shearman, *Early Italian Pictures*, 228–31.

42. Diana Dethloff, "Van Dyck's Legacy: Lely, the Duchess and the Restoration Court," unpublished paper given at a conference on Sir Anthony Van Dyck at the National Portrait Gallery, London, in 1999. The authors are most grateful to Dethloff for giving us permission to cite this paper.

43. See E. Hendriks and K. Groen, "Lely's Studio Practice," *Hamilton Kerr Institute Bulletin* 2, ed. A. Massing (1994): 21–37.

44. See Millar *Tudor, Stuart and Early Georgian Pictures*, 1:124–25, and Marciari Alexander, "Self-Fashioning," 26–27; for the relationship between Saint Catherine imagery and bridal portraits, see Diana Dethloff, "Portraiture and Concepts of Beauty in Restoration Painting," in MacLeod and Marciari Alexander, *Painted Ladies*, 24–26, and the same volume, 92.

45. Millar, *Tudor, Stuart and Early Georgian Pictures*, 1:124–26.

46. Kenneth J. Garlick, "A Catalogue of Pictures at Althorp," *Walpole Society* 45, 1974–76 (1976): 1–128 (esp. 51), nos. 399, 400.

47. Pepys, *Diary*, 7:102.

48. For the most in-depth analysis of Lely's studio practice, see M. Kirby Talley, *Portrait Painting in England: Studies in the Technical Literature before 1700* (London: Paul Mellon Centre for Studies in British Art, 1981), and his earlier article, "Extracts from the Executor's Account-Book of Sir Peter Lely, 1679–91: An Account of Sir Peter Lely's Studio," *Burlington Magazine* 120 (1978): 745–50; see also MacLeod, "'Good, But Not Like,'" 50–61.

49. For a critical history of the Lely "look," see MacLeod, "'Good, But Not Like,'" 50–61, and Marciari Alexander, "Beauties, Bawds, and Bravura," 62–71.

50. The importance of Lely's studio stock can be inferred from—among other evidence—the huge number of portraits by the artist and his assistants left in his studio at his death, including multiple portraits of some of the more prominent court figures, including Barbara Villiers, Duchess of Cleveland, and Anne Hyde, Duchess of York. See "Editorial: Sir Peter Lely's Collection," *Burlington Magazine* 83 (1943): 185–88.

51. See MacLeod and Marciari Alexander, *Painted Ladies*, 98–99, cats. 19, 20.

52. Hamilton, *Memoirs*, 102.

53. Entry for 13 July 1660, Pepys, *Diary*, 1:199: "the King and Dukes [of York and Gloucester] there with Madam Palmer, a pretty woman that they have a fancy to to make her husband a cuckold."

54. Hamilton, *Memoirs*, 190.

55. Later in life (1676–80), Jane Needham was certainly the mistress of Laurence Hyde, first Earl of Rochester, the Duchess of York's brother, but since the duchess died in 1671, this fact does not have any bearing on her inclusion in the series; see Sonya Wynne, "Jane Myddelton (née Needham; bap. 1646, d. between 1692 and 1703)," in *Oxford Dictionary of National Biography*, ed. H. C. G. Matthew, Brian Harrison, and Lawrence Goldman (Oxford: Oxford Univ. Press, 2004–), http://www.oxforddnb.com/view/article/19684 (accessed Sept. 2007).

56. Entry for 10 June 1666, Pepys, *Diary*, 7:158.

57. W. A. Speck, "Spencer, Robert, second earl of Sunderland (1641–1702)," in Matthew, Harrison, and Goldman, *Oxford Dictionary of National Biography*, http://www.oxforddnb.com/view/article/26135 (accessed Sept. 2007).

58. See Garlick, "Catalogue of Pictures at Althorp," 51, nos. 399, 400, for the Earl and Countess of Sunderland, and MacLeod and Marciari Alexander, *Painted Ladies*, 103, for Jane Needham, Mrs. Myddelton.

59. See Garlick, "Catalogue of Pictures at Althorp," 49–55, and MacLeod and Marciari Alexander, *Painted Ladies*, 102–3, 126–27, 138–39, 158–59, cats. 22, 39, 46, 61.

60. "Una colletione miracolosa per adornare una stanza, con ricche cornici indurate"; Archivio di Stato di Firenze, Mediceo, 4240, c.6, cited in "Sir Peter Lely and the Grand Duke of Tuscany," by Anna Maria Crinò and Oliver Millar, *Burlington Magazine* 100 (1958): 127 and n. 10.

61. Much of the information given here on this is published and discussed in Crinò and Millar, "Sir Peter Lely and the Grand Duke," 124–31.

62. For these additional purchases of female and male portraits, see Crinò and Millar, "Sir Peter Lely and the Grand Duke," 124–31.

63. Anna Maria Crinò, "The Relations between Samuel Cooper and the Court of Cosimo III," *Burlington Magazine* 99 (1957): 16–21.

64. Edward Wright, *Some Observations Made in Travelling Through France, Italy, &c., in the Years MDCCXX, MDCCXXI, MDCCXXII* (London: Printed for A. Miller, 1764), 429, cited in Crinò and Millar, "Sir Peter Lely and the Grand Duke," 129 and n. 38.

65. Gilbert Burnet, *Bishop Burnet's History of His Own Time*, 2 vols. (London: Printed for T. Ward, 1724–34), 1:472; entry for 21–22 Oct. 1666, Pepys, *Diary*, 7:337.

66. For George Vertue's transcription of Charles Beale's notebook of 1666–67, see George Vertue, "Note Books," in *Walpole Society*, 6 vols. (London, 1930–47), 4:173.

67. The de Saumarez pictures were sold at Sotheby's, London, 5 April 1967; the sale catalogue illustrates some of the portraits under discussion. See also R. B. Beckett, "Baptist May's Collection," *The Connoisseur* 126 (1950): 32–38.

68. This is a topic worthy of further study, as it could shed light on just how pervasive the practice of collecting and displaying portraits of women, of both good repute and bad, was in late-seventeenth-century England. The popularization of collecting "beauties series," however, is beyond the scope of this essay.

69. Marciari Alexander, "Self-Fashioning," 57 n. 80; for the portrait of the Countess of Sunderland, see Susan J. Barnes, Nora De Poorter, Oliver Millar, and Horst Vey, *Van Dyck: A Complete Catalogue of the Paintings* (New Haven and London: Yale Univ. Press for The Paul Mellon Centre for Studies in British Art, 2004), 605, where other uses by Lely of this pose are noted.

70. Christopher Rowell, "'Reigning Toasts': Portraits of Beauties by Van Dyck and Dahl at Petworth," *Apollo* 157 (2003): 39–47, esp. 40–42.

71. Rowell, "'Reigning Toasts,'" 42; Peter van der Ploeg and Carola Vermeeren, eds., *Princely Patrons: The Collection of Frederick Henry of Orange and Amalia of Solms in The Hague*, exh. cat. (The Hague: Mauritshuis, 1997–98), 164–69.

72. For Evelyn's advice, see John Evelyn, *Numismata, a Discourse of Medals, Antient and Modern* (London: Benjamin Tooke, 1697), 266; for Pepys's collection of prints, see Robert Latham, ed., *Catalogue of the Pepys Library at Magdalene College, Cambridge*, 7 vols. (Cambridge and Woodbridge, UK: D. S. Brewer, 1978–94).

73. For this trend in artistic style and practice, see MacLeod, "'Good, But Not Like,'" 56–57, and MacLeod and Marciari Alexander, *Painted Ladies*, 152.

74. The information on the "Hampton Court Beauties" that follows is from Millar, *Tudor, Stuart and Early Georgian Pictures*, 1:146–48.

75. For the history of the rooms at Hampton Court and the sequence of decoration, see Simon Thurley, *Hampton Court: A Social and Architectural History* (New Haven and London: Yale Univ. Press for The Paul Mellon Centre for Studies in British Art, 2003), chap. 10, esp. 172, 194.

76. Cited in Millar, *Tudor, Stuart and Early Georgian Pictures*, 1:146–47; for a critical, modern (though abridged) edition of Defoe, see Daniel Defoe, *A Tour Through the Whole Island of Great Britain*, ed. P. N. Furbank and W. R. Owens, with picture research by A. J. Coulson (New Haven and London: Yale Univ. Press, 1991), 71.

77. Cited in Millar, *Tudor, Stuart and Early Georgian Pictures*, 1:146–47; for a modern annotated edition of the diary and journeys of Celia Fiennes, see *The Illustrated Journeys of Celia Fiennes, 1685–c. 1712*, ed. Christopher Morris (London: Macdonald & Co., 1982), 241.

78. Horace Walpole, *Anecdotes of Painting; With Some Account of the Principal Artists, with Additions by the Rev. James Dallaway, and Vertue's Catalogue of Engravers Who Have Been Born or Resided in England*, ed. R. N. Wornum, 3 vols. (London: Chatto and Windus, 1876), 2:206–7 n. 2.

Sites of Instruction: Andrew Marvell and the Tropes of Restoration Portraiture

Steven N. Zwicker

I WANT TO BEGIN THESE COMMENTS on Andrew Marvell and the figurative arts with a little puzzle buried in the midst of a brilliant but quite unpleasant portrait that the poet hangs near the opening of his great verse satire *The Last Instructions to a Painter* (1667). Some eighty lines into his denunciation of sexual corruption, military incompetence, and political folly—after the savage cartooning of Henry Jermyn, first Earl of St. Albans, and Anne Hyde, Duchess of York—Marvell turns to another court figure, Barbara Villiers, Countess of Castlemaine (later Duchess of Cleveland). She was at the center of sexual politics in the early 1660s, a figure of estimable political and erotic powers. Not coincidentally—and perhaps in direct proportion to her influence—she was also the object of venomous satire, none of it, I think, more wounding than that of Andrew Marvell. We might rather associate Marvell with pastoral subtleties than poisonous slander, but he was well practiced in that art, and though the Restoration boasts unusual satiric riches—the verse of John Dryden, the Earl of Rochester, John Oldham, and Aphra Behn, to name the most obvious—in acts of literary assault Marvell could certainly hold his own. In complexity of address, perhaps he outshines them all. The satiric and complimentary work of *The Last Instructions* will remind us of the rhetorical brilliance of Marvell's pastoralism, but fully to appreciate the poem's subtleties we will have to work a bit harder at unlocking its figurative puzzles, and these begin with Barbara Villiers:

> Paint Castlemaine in colours that will hold
> (Her, not her picture, for she now grows old):
> She through her lackey's drawers, as he ran,
> Discerned love's cause, and a new flame began.
> Her wonted joys thenceforth and court she shuns,
> And still within her mind the footman runs:
> His brazen calves, his brawny thighs—the face
> She slights—his feet shaped for a smoother race.

Poring within her glass she readjusts
Her looks, and oft-tried beauty now distrusts,
Fears lest he scorn a woman once assayed,
And now first wished she e'er had been a maid.
Great Love, how dost thou triumph and how reign,
That to a groom couldst humble her disdain!
Stripped to her skin, see how she stooping stands,
Nor scorns to rub him down with those fair hands,
And washing (lest the scent her crime disclose)
His sweaty hooves, tickles him 'twixt the toes.[1]

For compression, for humiliating detail, for unnerving juxtapositions, this image of aging beauty and sexual voracity is unmatched. What Marvell does so incomparably is to join together, in one glance, an unsettling sexual explicitness that hints at unnatural postures and practices with a subtle address to the psychology of aging beauty. Perhaps this is something of a Marvellian specialty, this conjoining of misogyny and empathy; here the figure is at once touching and repugnant, poignant and embarrassing. The portrait is moving and shocking, nowhere more so than in the paradoxes of erotic compulsion that the poet explores at its close: "Great Love, how dost thou triumph and how reign, / That to a groom couldst humble her disdain! / Stripped to her skin, see how she stooping stands."

And now Marvell's most puzzling stroke: "And washing (lest the scent her crime disclose) / His sweaty hooves, tickles him 'twixt the toes." Marvell's nice punning conjoins rank with rankness; indeed, the wordplay on running and races, and on hooves, feet, and footman, is spun like a bright comic thread through the fabric of this entire scene, which reads perhaps like a little essay on foot fetishism. Nor was Marvell alone in noting this compulsion. In an anonymous lampoon on Castlemaine, "She swives, like a stoate, / Goes to 't hand and foote, / Levell-Coyle with a prince, and a player."[2] As in *The Last Instructions*, the satirist twins compulsive sexual appetite with indiscriminate social leveling.[3] But at some point in his own rendering, Marvell seems to draw a veil over exactly how these lovers have been entertaining each other; his scene conveys a certain sweaty energy, but nothing of the reproductive and redemptive force of sexual fecundity.[4] And that, of course, is the burden of Marvell's address to the sexual toils of the Restoration court throughout *The Last Instructions*, in which we read of beauty misused, bodies deformed, sexuality misspent—all the carnality we might want to imagine—but nothing of the fertility and reciprocity that ought, from the polemical perspective of this Country politician, to issue from such congress. This is the high-minded theme of the envoi that closes the poem with its decorative emblems of fecundity

and prosperity: Ceres, Bacchus, and Flora bound together in a celebration of the proper intimacy of king and country; and this, through inversion, is the argument of the satiric portraiture that opens the poem with its cold and disheartening images of murder, witchcraft, and abortion.

What has yet to be explained, however, is the closing moment of the scene: Castlemaine washing, what shall we say, the "hooves" of her lover. We hear of other body parts in this blazon—of "brawny thighs," of "brazen calves," and of what Marvell calls, with mock delicacy, "love's cause"—but why should we hear of this particular humbling? Posing the question this way suggests one answer, for what we ought to hear in these lines is an echo of Scripture, Marvell playing out a brief parody or adaptation of the verses from Luke (7:37–38) where the woman of sin washes Christ's feet. The principals in Marvell's scene are blissfully unaware of the parody, but we can hardly be innocent of the juxtaposition. Now, perhaps, the line "Great Love, how dost thou triumph, and how reign" takes on a deeper resonance, for scriptural parody turns the force of divine love back on these lovers as a mocking and high-minded correction, though we hardly need scriptural citation to get that point, to understand that *caritas* and gratitude are nowhere to be discovered in this court. Marvell's final couplet may provide a humiliating turn, but perhaps the scripturalism seems adventitious, under-motivated, a piece of gratuitous high-handedness in the midst of rather low sexual slander. It does not, after all, take Scripture to underscore the argument of sexual waste and humiliation, and if we are looking for satiric coherence or for the hinge on which the scene turns, the scriptural allusion might seem a distraction; it collects on the punning "footman" of the scene, but he in fact seems an invention of the poet, as the annals of Castlemaine's sexual triumphs include no such liaison, and the satiric energies of the citation seem oddly misspent on the nameless lackey.[5]

But perhaps we ought to ask not only, what does this passage encourage us to hear, but also, what does it urge us to see? And answering that question allows the scene to pivot in a superb new direction, slightly away from high-minded moralism toward aesthetics in general, more specifically toward court portraiture, and even more specifically toward what was, by the mid-1660s, one of Castlemaine's most prominent iconographic programs: the royal mistress as Mary Magdalene (figs. 38–40).[6] For if we superimpose on Marvell's scene the image of Castlemaine as the Magdalene, she emerges as a kind of grotesque variation on the sometimes melancholy figure portrayed, most notably by Peter Lely, in the early 1660s—when, indeed, she reigned supreme. And now the puzzle begins fully to unfold. The details that animate Marvell's portrait allow the circulation of gossip and the high-minded moralism of scriptural citation; however, they also allow him to conjure up and to reconfigure Lely's Magdalene portrait of Castlemaine, and in so doing

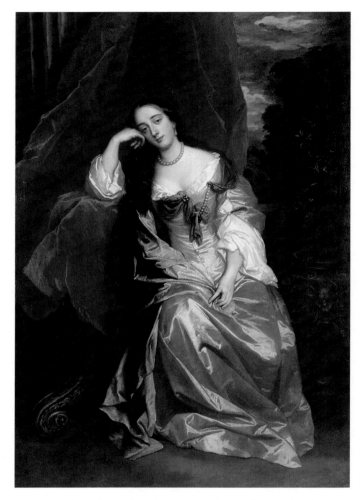

38. Peter Lely, *Barbara Villiers, Countess of Castlemaine (later Duchess of Cleveland)*, oil on canvas (ca. 1662), 74 x 50½ in. (188 x 128.2 cm). Private collection.

to engage the program of court portraiture and more broadly the discursive field of aesthetics—that is, they allow Marvell to pose questions about the meaning and uses of beauty and about the relations among art, politics, and morality.

In Lely's Magdalene portrait, Castlemaine appears—head resting at a tilt on her right hand, hair flowing loosely—as the penitent woman of sin.[7] There is no doubting either the scandalous wit or the audacity of posing Castlemaine as the Magdalene; the posture and iconography capture the complex sexual allure of the figure, but what the symbolic portraiture also capitalizes on, outrageously, is

39. William Faithorne after Peter Lely, *Barbara Villiers, Countess of Castlemaine*, line engraving (1666), 14 x 10⅞ in. (35.4 x 27.6 cm). The British Museum, Department of Prints and Drawings.

40. J. Enghels after Peter Lely, *Barbara Villiers, Countess of Castlemaine, as the Magdalene*, etching (1667), 11 x 8 in. (28 x 20.2 cm). The British Museum, Department of Prints and Drawings.

the notion that the history of this whore and her royal lord might properly call to mind the story of Mary Magdalene and her Lord and Redeemer. Perhaps in court portraiture it was a thing just imaginable, this positioning of one famous whore within the signs and sites of another; there is, after all, a venerable tradition in Renaissance religious painting of posing contemporaries as minor figures within such scenes as the Annunciation, the Passion, or the Crucifixion, a kind of easy historicizing in which individuals, perhaps a patron and his family, are allowed to occupy the sites of religious history within the redemptive present tense of religious experience. In the mid-1660s Jacob Huysmans depicted the young Duke of Monmouth as Saint John the Baptist;[8] a few years earlier Barbara Villiers had emerged within the frame of sacred history, though I suspect that posing her as Mary Magdalene drew less on the eternal verities of redemption than on the scandalous wit of situating the king's whore, and hence by implication the king himself, within the precincts of Christ's redemptive love. For surely that is the meaning of the Magdalene story, that Christ's love knew no conventional boundaries of class, circumstance, or personal history, that redemption is a miracle available to all, even to the woman of sin who redeems her past through "great love." The language and detail of the Magdalene story are pointedly evoked in Marvell's parody, whose aim is at once to bring to mind the scriptural scene and Lely's portraits of Castlemaine. Lely renders her languorous beauty as the woman of sin, a melancholic with dark tresses flowing freely across her shoulder. Her consequent reputation as the Magdalene—prostitute, penitent, and convert—and Castlemaine's conversion to Roman Catholicism in 1663 were well and widely known after Lely painted the Magdalene portrait. But it is not solely Lely's Castlemaine on whom Marvell trained his sights in this scene; it is as well a tradition of court portraiture and an aesthetic that glorified in this kind of representation: "Paint Castlemaine in colours that will hold." Marvell engages the scandal of sexual immorality at the court of Charles II; the blasphemy of its representation in the icons and images of sanctity; and the beauty, grandeur, and visual authority of its art.

The group of paintings by Peter Lely of court beauties (later known as the "Windsor Beauties"; see figs. 19–28)[9] and the corresponding set of "Flagmen" were probably displayed by James, Duke of York, and his wife, Anne Hyde, to celebrate aristocratic beauty and martial honor, and they form a visual counterpart to the project of heroic drama that John Dryden and Roger Boyle, first Earl of Orrery, were—at exactly the same moment—inventing for the newly reopened stage: theatrical entertainment under the patronage, and for the eyes, of the very figures portrayed in Lely's paintings. The king himself had commanded Orrery to fashion this new drama for the Restoration stage, and the Countess of Castlemaine early encouraged Dryden's work for this theater. Nor is it difficult to understand

why the heroic drama and Dryden, as its chief agent, became bywords for eleva-
tion and flattering excess. Listen as Dryden addresses the Duke of York in the ded-
ication to one of the most extravagant of the heroic dramas, the two-part, ten-act
Conquest of Granada:

> Since . . . the World is govern'd by precept and Example; and both these can
> onely have influence from those persons who are above us, that kind of Poesy
> which excites to vertue the greatest men, is of the greatest use to humane
> kind. 'Tis from this consideration, that I have presum'd to dedicate to your
> Royal Highness these faint representations of your own worth and valour in
> Heroique Poetry: or, to speak more properly, not to dedicate, but to restore
> to you those Ideas, which, in the more perfect part of my characters, I have
> taken from you. . . . And certainly, if ever Nation were oblig'd either by the
> conduct, the personal valour, or the good fortune of a Leader, the English
> are acknowledging, in all of them, to your Royal Highness. Your whole life
> has been a continu'd series of heroique Actions.[10]

Marvell was not alone in understanding the dangerous allure of absolutism
and grandeur. His patron, George Villiers, second Duke of Buckingham, mocked
the ideological absolutism and stylistic elevation of Dryden's epic theater in a skit
called *The Rehearsal*, and Marvell's republican colleague John Milton twinned and
attacked politics and aesthetics in his preface to *Paradise Lost*, denouncing, at
almost exactly the moment when Marvell was writing *The Last Instructions*, the
vulgarity of Restoration heroics and the "modern bondage of rhyming."[11] Marvell
may be issuing "instructions" in his poem, but his aim is not so much to educate
as to humiliate the carnal and the visual, to expose sexual as well as aesthetic vio-
lation. He mocks a particularly outrageous piece of royal iconography but also an
entire culture, aesthetic and political, by taking—with utmost seriousness, along
with a brilliant and grim wit—the iconography of court portraiture and forcing it
to a logical conclusion, demonstrating with great exactness the meaning of the
images and style Lely had so richly and surely adapted. In *The Last Instructions*
Marvell engages, with a kind of low and dirty realism, the entire suite of court por-
traits, counterpointing the idealizations of the "Windsor Beauties" and "Flagmen"
with his own arresting set of portraits that mock and devalue the decorative
mythologies of royalism and strip bare Lely's elegant figuration. When Samuel
Pepys visited St. James's Palace, he remarked, "This day I did first see the Duke of
York's room of pictures of some Maids of Honour, done by Lilly; good, but not
like."[12] There is no question that Pepys would have recognized the sharp likeness
Marvell had drawn.

Nor, of course, does Marvell's answer to Lely's Castlemaine stand alone; with equal point and brilliance he portrays the Duke and Duchess of York, the Earl of St. Albans, and Edward Hyde, first Earl of Clarendon. In Lely's portraits, and in the long tradition of courtly portraiture, such aristocrats are imagined in elegant postures, bearing emblems of office and authority, and sumptuously covered; their bodies are masked and softened, sheltered by velvet drapery, and heightened by the sheen of silks and satins, as well as by techniques of portraiture that Lely and others inherited from the master of the English court portrait, Sir Anthony Van Dyck. Marvell would burn off this paint, counter the heightened images, expose these figures in their barrenness and deformity. It may be his particular or peculiar obsession to uncover the most private of parts—the Duchess of York's "rump" (line 63), St. Albans's "Instrument of Peace" (line 42), Clarendon's "hem'royd veine" (line 497)—but within these lurid renderings Marvell aims at something more than prurient detail: the poet would answer, point by point, limb by limb, the painted images of aristocrats and courtiers that decorated the closets and galleries of the great. Beyond that, what is striking about the portraits that open *The Last Instructions* is their brutality, their intensity, and above all their ugliness: "Paint him with drayman's shoulders, butcher's mien / Member'd like mules, with elephantine chine" (lines 33–34); "Paint her with oyster lip and breath of fame, / Wide mouth that 'sparagus may well proclaim; / With Chanc'llor's belly and so large a rump, / There (not behind the coach) her pages jump" (lines 61–64). The rawness of Marvell's language, the stiffness of syntax, the dissonance of rhythms and bluntness of rhymes are themselves the instruments and engines of his argument. How else and how more forcefully could he counter the refinement and elevation of court portraiture? This is a level of aesthetic brutality far beyond the traditional roughness of satire, and it is meant to convey, in the most palpable terms, the poet's revulsion at the world around him. Marvell wrote of the painter of antiquity who, despairing over the problem of representation, threw his brush at the canvas: "His desperate pencil at the work did dart: / His anger reached that rage which passed his art" (lines 23–24). So Marvell would argue of his own righteous political and aesthetic despair.

But the program of brutality and exposure provides only half of the painterly story, for in *The Last Instructions to a Painter* not everything is ugliness itself. Against his mocking and degraded version of the "Windsor Beauties" and the "Flagmen," Marvell counterpointed images of valor, innocence, and refinement, of visual mystery and allure. These portraits are surely heightened by their position in the midst of visual and moral squalor, but they have as intricate an aesthetic point and procedure and as powerful a polemical meaning as his satiric portraiture. Within this gallery Marvell poses Michael de Ruyter, the Dutch admiral who had destroyed

the English fleet in the Medway; Frances Teresa Stuart, who had appeared at the English court under the provocative and desiring eye of Charles II; and, perhaps most curiously, Archibald Douglas, neither courtier nor English aristocrat, but a member of a Scottish military family. At line 649 Marvell begins lovingly to conjure up the image of "brave Douglas"

> on whose lovely chin
> The early Down but newly did begin,
> And modest Beauty yet his Sex did veile,
> While envious Virgins hope he is a Male.
> His yellow Locks curle back themselves to seek,
> Nor other Courtship knew but to his Cheek.
> Oft as he in chill Eske or Seine by night
> Harden'd and cool'd his limms, so soft, so white,
> Among the reeds, to be espy'd by him
> The Nymphs would rustle, he would forward swim.
> They sigh'd and said, "Fond Boy, why so untame,
> That fly'st Loves fires, reserv'd for other Flame?"
> .
> His shape exact, which the bright Flames infold,
> Like the Sun's Statue stands of burnisht Gold.
> Round the transparent Fire about him glows,
> As the clear Ambar on the Bee does close;
> And as on Angell's heads their Gloryes shine,
> His burning Locks adorn his face devine.
>
> (lines 649–84)

At the time of his death Douglas was the thirty-four-year-old commander of a company of the Royal Scots, a husband, and father of two. Defending to the death HMS *Royal Oak*, Douglas had indeed displayed the valor Marvell attributes to him, and his sacrifice stood him in shining contrast to the English sailors who fled the Dutch assault on the Royal Navy, a "race of Drunkards, Pimps, and Fools" (line 12); Marvell's Scottish hero, like his Dutch admiral, points up a tale of national shame. Such a program does not surprise at this juncture, midway through the poem—but what might well surprise is Douglas's image as so lithe and delicate a youth that the envious virgins can only "hope he is a Male" (line 652). In the satiric portraits Marvell makes a point of disclosing not simply sexual misdemeanor but sexuality itself—the carnal in all its sweaty and salty particularity. The poet veils Douglas's sexuality, sketching an androgynous youth and erasing marriage,

masculinity, and fatherhood—a surprising move, for Douglas might well have been offered as the model not only of martial virtue but of patriarchy, purity, and fecundity. We cannot be certain of the full register of sexual feeling within the portrait, but in the poem at large sexuality seems everywhere tainted by a kind of national spoilage. Denying Douglas's sexuality, Marvell suggests the reproductive hopelessness of England humbled by the Dutch and humiliated by a court that was a stew of sexual violence and misdemeanor. And the erasure of Douglas's sexuality might also just hint at an inevitable corruption of rule by lineal descent, underscoring the virtue of forms of governance that avoided such taint and corruption—and none would have been more obvious than the republic. In the envoi Marvell softens the indictment, pausing for a moment over his vision of a properly constituted state that conjoins propriety, balance, and harmony with abundance and ease; however, only in such a fantasy does Marvell allow England's fertility. In the body of the poem, sexuality is violence and vice; the androgynous figure of Douglas functions as a cynosure of innocence, integrity, and virtue. The very principle of regeneration must be denied by the corruption so thoroughly plotted elsewhere in the text.

In the world of this poem, beauty can be sheltered, reproduced, and rendered immortal only through art—hence the translation of Douglas from military hero to hapless angel: the golden locks; the soft, white limbs; the figure transmuted by sacrificial flames. Verse immortalizes the innocence and beauty of this object of desire, made to do so much work in this text of rich visual imagery. For the rendering of androgynous beauty carries not only the weight of homoerotic feeling but also an argument about national honor, personal virtue, sexual innocence, and, perhaps most complex of all, Marvell's own poetics of liminality and eternity. In his version of the "Flagmen" and "Windsor Beauties" Marvell shows us the ravages of time: images of aging, spoilage, and decay; in the portrait of Douglas he freezes time, enclosing, in the lapidary perfection of his verse, a moment of physical innocence and moral perfection. In the broad moral and political economy of *The Last Instructions*, Douglas's virginity is used not to deny chaste marriage but to underscore the outrageous sexual appetites, deformities, and decay of the poem's opening portraits, and more importantly to anticipate the closing portrait of the king dreaming in his bedchamber—surely the poem's most serious and most daring act of portraiture, and quite properly the culminating argument of *The Last Instructions*, one final and brilliant assault on the moral and visual culture of the Stuart court:

> Paint last the king and a dead shade of Night
> Only dispers'd by a weak Taper's light,

And those bright gleams that dart along and glare
From his clear Eyes (yet those too dark with Care).
There, as in the calm horror all alone
He wakes and muses of th' uneasy Throne,
Raise up a sudden shape with Virgin's Face
(Though ill agree her posture, hour, or place)
Naked as born, and her round Arms behind
With her own Tresses interwove and twin'd;
Her Mouth lockt up, a blind before her Eyes;
Yet from beneath the Veile her blushes rise,
And silent Tears her secret anguish speak;
Her Heart throbs and with very shame would break.
The object strange in him no terror mov'd;
He wonder'd first, then pity'd, then he loved,
And with kind hand does the coy Vision presse,
Whose beauty greater seem'd by her distresse,
But soon shrunk back, chill'd with her touch so cold,
And th' airy Picture vanish't from his hold.
In his deep thoughts the wonder did increase;
And he divin'd, 'twas *England* or the *Peace*.

<div align="center">(lines 885–906)</div>

The king's attempt to rape the bound virgin is an image prepared by the opening portraits in the poem and by the elegy for Archibald Douglas; Douglas is both analogue for the virgin England and a reminder of the civic uses of passion. In death he is the "glad lover" (line 677); for him passion is explicitly civic duty, and love is the embrace of honor, the defense of king and country. The slumbering monarch reaches for the captive virgin; excited by her distress, he would satisfy his appetites on the hapless figure. Luxury and sensuality at the center of this court are, for Marvell, fundamentally political in character: pleasure rather than honor or abundance is the aim of this monarch; private passion rather than public trust is the principle of this court. Though not in detail quite as vile as the images of the scratching courtiers, the implications of the king's undifferentiated appetites are more damaging. What the scene urges is a recognition that England herself is matter simply to excite and relieve the king's desires. Perhaps because the indictment is read so directly against the king, Marvell casts the portraiture as a dream vision, a device that allows him to soften visual detail in the scene. But it also permits him to historicize the scene in a particularly interesting way, to anchor the portraiture in an episode of the king's erotic history that works with a wonderful economy

against the scene's elevation. The combination of allegory, historical narrative, and visual iconography conjoins, as does the poem throughout, politics and whoring; the covering of the narrative by allegory concentrates the indictment and sharpens the explicitness of the case, for the image of the bound virgin is at once Britannia, an allegorical representation of Britain, and a portrait of Frances Stuart, who had first appeared at the court of Charles II in 1662.

Painted by Lely as Diana (fig. 41), as well as by Huysmans, Henri Gascar, and Samuel Cooper, Stuart was widely admired for her beauty—and by no one more than by the king. Her sexual history was the focus of interest and gossip throughout the early 1660s, particularly in 1667, when first, in February, she sat at the king's direction for the figure of Britannia that appeared on Jan Roettier's *Peace of Breda* medal (fig. 42), and then, at the end of March, she secretly eloped from Whitehall to marry Charles Stuart, third Duke of Richmond and sixth Duke of Lennox. In so eluding the king's sexual demands and preserving her virginity—a story that Marvell subtly retells in this twinned portraiture—Stuart was rumored to have been assisted by Lord Chancellor Clarendon, who, the king believed and others suggested, had arranged the secret marriage to frustrate the king's passions and correct his morals. Marvell's brief scene also records, in addition to the official iconography, several details of Charles's pursuit of Stuart: her resistance, her virtue, her fondness for games, including, suggestively, blindman's buff—a detail that renders both poignant and ridiculous the blindfolded figure in the portrait—and, of course, her escape from the king's hold and his surprise and frustration over her disappearance into the night. The most telling juncture of detail is provided by the puns of the portrait's final line, where the language tangles together coins, whores, medals, and politics: "England" and the "Peace" of line 904 refer to Stuart's portrait as Britannia on the farthing and on the *Peace of Breda* medal; those meanings are folded together with the more colloquial meanings of piece as "whore" and piece as "money," the latter meaning already conjured with reference to Stuart earlier in the poem when Marvell alludes to her appearance on the farthing (lines 761–62). The puns underscore, as does the whole scene, the compounding of lust with policy, and so they serve as structural and argumentative cruxes linking the king's dream to the dismissal of Clarendon that takes place in the next scene of the poem.[13]

Given the superb busyness of the scene, part of what surprises is how exact and how detailed is Marvell's engagement with visual forms: not only painting, but coinage and medallic portraiture as well. The visual detail here—like the rhetorical questions that drive the opening of the poem—demonstrates the depth of Marvell's interest in representation, in its familiar Renaissance guise as colloquy or competition between poetry and painting over expressive primacy, but also as

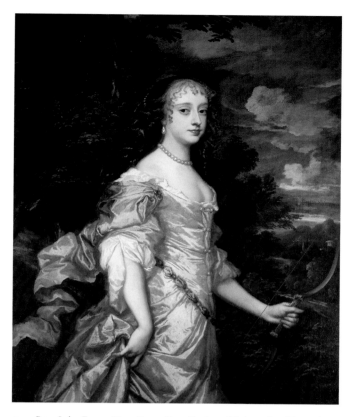

41. Peter Lely, *Frances Teresa Stuart (later Duchess of Richmond and Lennox),*
oil on canvas (ca. 1662), 49½ x 40⅜ in. (125.8 x 102.7 cm). The Royal Collection,
Her Majesty Queen Elizabeth II.

a broader engagement with the problems, the politics, and the morality of expressiveness itself—that is, with aesthetics. The painterly idioms not just of this scene but of the poem as a whole make it abundantly clear that Marvell considered aesthetics a primary discursive field, a metaphoric anchor, a way of thinking that takes the technical and expressive idioms of the visual arts as a vocabulary for politics and morality. He aimed not simply to reconfigure court portraiture, but to demonstrate what it means to take the representation of the body seriously as a moral and political problem and to invest morality and politics with the expressive force of art.

Rosalie Colie long ago remarked on Marvell's unusual alertness "to visual convention and technique," and in the rich mazes of Marvell's *Upon Appleton House* she discovered a canvas filled with images and conceits, optical tricks of enlargement and reduction that deploy the visual as a way of rendering palpable the

42. Jan Roettier, *The Peace of Breda*, gold medal (1667), diameter 2¼ in. (5.6 cm). The British Museum, Department of Coins and Medals.

disproportions and instability of revolutionary England, what Colie called the "topsy-turveydom," the "randomness and unpredictability of brute experience."[14] Had Colie gone beyond the 1650s in her appreciation of the argumentative and expressive field of Marvell's visual poetics, she would have not only confirmed her discoveries about the importance of the painterly to the pastoral, but also found in the Restoration satires remarkable evidence of Marvell's fascination with the visual (and, we should add, with voyeurism): not just the technical idioms of painting, drawing, minting, and medallic portraiture—limning and sketching; cartoons and quick effigies; images, martial standards, and trophies; dead shades, dark shadows, and cerulean blues—but also a rapt attention to physiognomy and physical detail, to the work of eye and hand in rendering the meaning of that dizzying corruption and ineffable beauty that lay like an open field before him in the series of poems called *Instructions to a Painter*. When Marvell first read Edmund Waller's "Instructions to a Painter"—a poem designed to celebrate, with decorative abandon, the Duke of York's naval victory over the Dutch off the English coast in June 1665—the opportunities for engagement with Waller's field of visual imagery and argument must have danced before his eyes. For he saw, with a savagery and profundity that developed gradually over the course of his three Advice-to-a-Painter poems, the opportunity that Waller's "Instructions to a Painter" presented to address not merely the politics and painterly idioms of the Stuart court but the whole problem of seeing and feeling that had long been lurking at the edges (and sometimes at the center) of his poetry.

It would not have been difficult to understand the summer and early fall of 1667, the time when Marvell wrote this poem, as an apocalyptic moment in England's political history: the Great Fire of London had burned a quarter of the city the year before, the plague decimated its population, and the Anglo-Dutch trading wars had ended with the devastation of the English navy. In "Eyes and Tears" Marvell had written, "How wisely Nature did decree, / With the same Eyes to weep and see!" (lines 1–2). He came fully to understand and deploy that wisdom in *The Last Instructions*, especially toward the close of the poem, in the twinned portrait of Charles II and Frances Stuart: "Her Mouth lockt up, a blind before her Eyes; / Yet from beneath the Veile her blushes rise, / And silent Tears her secret anguish speak" (lines 895–97). The bound virgin can neither see nor say, though she weeps for what she feels. Seeing, feeling, and speaking are the aim of this poem that would make the reader feelingly see the world of Restoration court corruption, of parliamentary politics, and of imperiled beauty and innocence. In the traditional competition of poet and painter, the poet asserts the power of the word over the image. Andrew Marvell puts that competition aside to compound the verbal and the visual, not only to have us read the words on the page but also to see and feel, through his astonishing and unsparing visual details, what it meant to paint the body politic as the Four Horsemen of the Apocalypse were in the midst of their descent.

1. *The Last Instructions to a Painter*, lines 79–96, in *Andrew Marvell: The Complete Poems*, ed. George de Forest Lord (London: Dent, 1984), 155; all further quotations from and citations to Marvell's works are from this edition and will be given parenthetically in the text.

2. Bodleian Library, Oxford Univ., MS Don. b. 8, quoted in *The Penguin Book of Restoration Verse*, ed. Harold Love, rev. ed. (Harmondsworth, UK: Penguin Books, 1997), 80.

3. This, of course, is Rochester's theme in "A Ramble in St. James's Park."

4. In this regard we should note that Marvell wholly elides Castlemaine's sexual plenty: the five illegitimate children whom Charles II fathered on her.

5. Lord comments, "Although Lady Castlemaine's many love affairs seem to be minutely and extensively recorded, this seems to be the only account of her alliance with the lackey"; 155, note to lines 79–104.

6. I am indebted throughout this discussion to the account that Julia Marciari Alexander gives of the Castlemaine portraits in her PhD dissertation, "Self-Fashioning and Portraits of Women at the Restoration Court: The Case of Peter Lely and Barbara Villiers, Countess of Castlemaine, 1660–68" (Yale Univ., 1999), and in her commentary and annotations in *Painted Ladies: Women at the Court of Charles II*, ed. Catharine MacLeod and Julia Marciari Alexander, exh. cat. (London: National Portrait Gallery, London, in association with the Yale Center for British Art, 2001).

7. For variations among the painted and print versions of this work, see cats. 33–36 in MacLeod and Marciari Alexander, *Painted Ladies*, 118–24.

8. Jacob Huysmans, *James (Crofts) Scott, Duke of Monmouth and first Duke of Buccleuch*, oil on canvas (ca. 1665), Buccleuch estates, Selkirk, Scotland.

9. See the images and discussion in MacLeod and Marciari Alexander, *Painted Ladies*, 64–70; see also the essay by Catharine MacLeod and Julia Marciari Alexander in this volume.

10. See *The Works of John Dryden*, ed. E. N. Hooker and H. T. Swedenberg, Jr., et al., 20 vols. (Berkeley and Los Angeles: Univ. of California Press, 1956–2000), 11:3.

11. Milton, "The Verse," in *John Milton*, ed. Stephen Orgel and Jonathan Goldberg (Oxford and New York: Oxford Univ. Press, 1991), 355.

12. Entry for 21 Aug. 1668, in *The Diary of Samuel Pepys*, ed. R. C. Latham and W. Matthews, 11 vols. (London: HarperCollins, 1995), 9:284.

13. I first discussed the presence of Frances Stuart in Marvell's poem in "Virgins and Whores: The Politics of Sexual Misconduct in the 1660s," in *The Political Identity of Andrew Marvell*, ed. Conal Condren and A. D. Cousins (Aldershot, UK: Scolar Press, 1990), 85–110.

14. See Rosalie L. Colie, *"My Ecchoing Song": Andrew Marvell's Poetry of Criticism* (Princeton: Princeton Univ. Press, 1970), 181–238.

"Subdued by a Famous Roman Dame": Picturing Foreignness, Notoriety, and Prerogative in the Portraits of Hortense Mancini, Duchess Mazarin

Susan Shifrin

O N 2 JULY 1699 Hortense Mancini, Duchess Mazarin, died at her home on the outskirts of London, in the village of Chelsea.[1] John Evelyn soberly noted the event in his diary:

> Now also died, the famous Dutchesse of Mazarine, in her time the richest Lady in Europ, Niepce to the greate Cardinal Mazarine, & married to the Richest subject in Europ, as is said: she was born at Rome, Educated in France, an extraordinary Beauty & Witt, but dissolute, & impatient of Matrimonial restraint, so as to be abandoned by her husband, came into England for shelter, liv'd on a pension given her here, & is reported to have hastned her death, by intemperan[t]ly drinking strong spirits &c: She has written her owne Story & Adventures.[2]

Evelyn had described in the same diary, nearly a quarter century earlier, one of his first encounters with Mme Mazarin, at a dinner given by the Lord Chamberlain, "where also supped," as Evelyn characterized her, "the famous beauty & errant Lady, the *Dutchesse of Mazarine* (all the world knows her storie)."[3] Evelyn's diary entries, bracketing the arrival in England and the exit from her earthly existence of a woman much mythologized by her own and subsequent times, provide the textual point of departure for this case study of the representation and reception of notoriety at the seventeenth-century courts of England, France, and Italy.

This essay focuses on the visual and textual extrapolation of the "notorious identity" of a certain type of fallen *femme de qualité*, a signifier commonly used during the seventeenth century and appropriated by the Duchess Mazarin to characterize those among whom she ranked herself.[4] It will examine, then, the ramifications of notoriousness for a woman perceived as having transgressed the bounds conventionally prescribed for her by a measure of quality predicated upon gender, class, wealth, and reputation, or some combination thereof, and—in the case of the Duchess Mazarin—further tarnished with the stain of foreignness.

Linda Charnes has posited a notion of "fame beyond the merely exemplary," as she terms it, which functions usefully in the context of the early-modern period and provides a subtext here for my own references to the notion of notoriety. She proposes that "if we regard fame as the 'normal' counterpart to notoriety (insofar as it attaches to the persons it represents), 'notorious identity' can be considered a peculiarity of fame which . . . detach[es] itself from, and thereby render[s] immaterial, irrelevant, or redundant, the persons or figures it 'originally' designates."[5] Charnes's "notorious identity" envisions the supplanting of a person as the object of consideration by an accretion of legendary inscriptions of that person. She studies the case of Cleopatra, among others: the figure of Cleopatra as re-created and created anew by Shakespeare and as confronted by the legendary narratives that inscribe her as a notorious, quasi-historical figure outside of Shakespeare's play but very much within the collective, cultural imagination of his audiences. I will return to the case of Cleopatra myself later in this essay. For now, I wish to propose the usefulness of thinking of and picturing the Duchess Mazarin—as I shall suggest her contemporaries did—as a "notorious identity" in the sense that Charnes has articulated: as a figure displaced by the stories told about her, which came to stand in her stead.

The Puritan commentator Richard Brathwaite, whose often-cited conduct manuals for the "English Gentleman" and the "English Gentlewoman" had achieved multiple printings by the mid-seventeenth century, drummed into his readers the elements that in his view constituted the gentlewomanly claim to quality. He exhorted his readers to imagine those elements as

> emblemes of yourselves (Noble Ladies) who so highly tender your honour, as Estimation gaines you more then what your bloods gave you. . . . These [ever-living vertues, which shall eternize you] are of power to make such as long since dyed, and whose unequall'd beauty is for many ages since to ashes turned, reteine a flourishing fame in the gratefull memory of the living.[6]

Likewise, he cautioned them to

> take heed, then, lest publike rumour brand you. Scandall is more apt to disperse what is ill; then Opinion is to reteine what is good. When the world is once possest of your shame; many deserving actions of piety can hardly wipe off that staine.[7]

The author and proto-feminist Mary Astell was moved by the Duchess Mazarin's widely publicized marital infidelities and resulting defeats in France's

highest courts of legal appeal to reflect in print upon marriage itself as a vexed institution. Writing in 1700, a year after Mazarin's death, Astell cast her as the unfortunate squanderer of the "Name and Treasure" of her distinguished forebear Cardinal Mazarin:

> The Dutchess of Mazarine's Name has spread perhaps as far as her Uncle's, and one can't help wishing that so much Wit and Beauty, so much Politeness and Address, had been accompany'd and supported by more valuable and lasting Qualities; one cannot but desire that her Advocate instead of recriminating had clear'd the imputations laid on her, and that she herself, who says enough in her Memoirs, to shew she was unfortunate, had said more to prove her self discreet.[8]

Mazarin indeed acknowledged in her memoirs that her name and her story had been made vulnerable to a public celebrity unbecoming to a woman of her position. She defended her own rupture of discretion by entreating the readers of her memoirs not to discount the

> natural repugnance I feel at having to explain matters that concern my private affairs: but it is even more natural to defend oneself against untruths. . . . I know that the honor of a woman consists in never being talked about . . . ; but one can not always choose to lead the kind of life one would want to lead, and it is those things that are most related to one's conduct which prove most fatal.[9]

Yet in an age in which, as Peter Stallybrass has expressed it, the "normative 'Woman'" was signified "within the discursive practices of the ruling elite [by] . . . the enclosed body, the closed mouth, the locked house,"[10] by the very act of putting her name to a version of her story that sought to convey by public means a truth counter to that published by her estranged husband, Mazarin had engaged in conduct that would fuel the "publike rumor."[11]

Evelyn's rueful epitaph for the duchess catalogues the markers of her story that functioned as her attributes and signifiers, the cornerstones of her legend on which the numerous written portraits of her were founded. Born in Rome, summoned to Paris and educated and married at the French court by her uncle Cardinal Mazarin, and finally seeking refuge at the English court from her unhappy marriage, the Duchess Mazarin was three times a foreigner. Even as a child at the French court, she had been essentialized by commentators as an exotic or outsider: as "un jeune Astre oriental" by Jean Loret, chronicler of the court of Louis XIV during the decades of the 1650s and 1660s; as "l'aimable Transalpine" and "[une] jeune

beauté du Tibre" by an admiring Paul Scarron, who earlier in his career had casti-
gated both Cardinal Mazarin and his nieces as unwelcome foreign interlopers at
the French court.[12] Foregrounding her notoriety both as an exotic foreigner and as
a bewitcher of men, Henri de Massue, marquis de Ruvigny, French ambassador to
the Court of St. James's, hailed Mazarin's long-anticipated arrival in England in
1675 as harking back to that of the Saracen sorceress Armida taking by storm the
camp of Godefroy; he added that she was spoken of everywhere, with admiration
by men and with jealousy and anxiety by women.[13] She was conceived by many of
her contemporaries, men and women alike, as "extravagant" (or vagrant),[14] an
exotic fugitive who had "departed France and gone running around the world, car-
rying her shame and that of her husband to all of the climes of Europe."[15] Stories
of the intemperance of her habits and the dissoluteness of her lifestyle of gaming,
gallantry, and self-indulgence both preceded and dogged her.[16]

Yet these accounts of the Duchess Mazarin's transgressions were nearly always
mediated by paeans to her fabled beauty, which both commodified her physical
beauty as her most reliable and profitable form of currency and figured it as presid-
ing over and partaking of her notorious identity. A bilingual *Coffee-house Conver-
sation* burlesque marked her arrival in England in December 1675 with warnings of
the political upheaval it was likely to cause, emphasizing the already heightened
level of exasperation with Charles II's perceived subordination to his mistresses and
yet crediting Mazarin's renowned and unparalleled (and notably Roman) beauty
with the potential for effecting likewise unparalleled diplomatic disarray.

1st Coffist. Indeed the arrival and reception of this dutchesse Mazarin at
Court, does afford notable matter for politick reflexions, even
out of a Coffee-house.

3rd Coffist. Though I have been silent hitherto, I am lesse a stranger to this
matter then the rest of you appear to bee. I have heard it variously
discoursed of already. Some say that the Nation, already too sensi-
ble of the Amorous excesses of their Prince, may be more enflamed,
by such an accession of great expense that way, as this appears likely
to prove. Besides, her great beauty, quality and adroictnesse, Of
w^ch there is so great a Character in print, seem to furnish occasion
for apprehending a greater power in her over the king, if once he
come to love her, than any other of his Mistresses have had.

4th Coffist. They are fools, in my opinion, who fear that. For since our good
king, with all his good parts, has a weak side towards women, . . .

I think it much more honourable for great Brittain to have its Monarch subdued by a famous Roman dame, than by an Obscure damsel of little Britain Or by a frisking comedian.[17] . . . And who will blame his Ma^{tie} to take his pennyworth, if hee can, out of so fine a creature, and a dutchesse already to his hand. No small convenience.

2^{nd} Mons^{r}. Je prens ma part a vos plaisanteries, mais Je n'entre point dans vos politiques, Et me contenteray de vous dire, que la Duchesse Mazarin est en verité si charmante, que si vostre Roy la baise seulement une fois, Je tiens la de Portsmouth pour foutüe.[18]

Likened in this same *Coffee-house Conversation* (as well as in other contemporary commentaries) to a "new Queen of the Amazons . . . come from beyond the mountains" (again reiterating that notion of the "transalpine"), Mazarin was also portrayed in both paint and verse as a latter-day Cleopatra, subjugator of two Roman rulers, and as the goddess Diana, consummate huntress and destroyer of the voyeur Actaeon.

The quintessential figure of the transplanted female transgressor, Cleopatra—a Macedonian interloper to the Egyptians, an Egyptian infiltrator to the Romans—was at once valued for her exotic beauty and despised as the feminine, foreign emasculator of masculine Rome. The historical paradigm of Cleopatra as seducer and destroyer, established by Augustan poets and sustained by Dante, Boccaccio, and Spenser, rendered hapless the warrior Mark Antony, who, made effeminate and incapable by the "lustful and avaricious" Cleopatra, was led to neglect

the whole world's rule for Cleopatra's sight,
Such wondrous power hath women's fair aspect
To captive men, and make them all the world reject.[19]

Shakespeare's Cleopatra subjugated Antony, "put my tires and mantles on him, whilst / I wore his sword Philippan."[20] Later seventeenth-century adaptations of the story of Antony and Cleopatra, such as Charles Sedley's *Antony and Cleopatra: A Tragedy* (first performed at the Duke's Theatre in February 1677) and John Dryden's *All For Love; or, The World Well Lost . . .* (performed ten months later at the Theatre Royal, Drury Lane, by the King's Company), appropriated those aspects of the narrative that both construed Cleopatra as a transgressor of gender boundaries, ranging into the territories given exclusively to male prerogative, and constituted the men she had subjugated as emasculated—"unmanned"—by her transgressions.

During much of his reign Charles II was perceived by many at court as having fallen victim to the Cleopatras of his own time. Samuel Pepys recorded in his *Diary* the influential roles played by the mistresses of both the king and his brother, James, Duke of York, in directing the politics of the court and of the country. Pepys bewailed "the horrid effeminacy of the King, . . . [who] hath taken ten times more care and pains making friends between [his mistresses] when they have fallen out, than ever he did to save his kingdom. . . . [He] . . . adheres to no man, but this day delivers himself up to this and the next to that, to the ruin of himself and business. . . . [He] is at the command of any woman like a slave."[21] Meanwhile, at the theater, the court looked on as the tragic unraveling of a once-sovereign Roman ruler's empire was played out onstage through the illicit relations of two notorious identities, one a feminized warrior, the other his concubine consort who, as Ventidius, Antony's general, laments in act 1 of *All for Love*, had "deck'd his ruin with her love, / . . . left him / The blank of what he was; / . . . quite unman'd him. . . ."[22] Contextualized by an audience mindful of the emasculation of their own Antony, portraits personifying the "famous beauty & errant Lady, the *Dutchesse of Mazarine*" as Cleopatra played on the sitter's well-known story as a conqueror of the hearts and minds of powerful men from Charles Emmanuel II, Duke of Savoy, to the French ambassadors to the Prince of Monaco to Charles II himself.

The Althorp portrait of Mazarin as "Cleopatra with the pearl" (fig. 43),[23] painted, in all likelihood, in Italy during the early 1670s and recently reattributed to the Flemish portrait painter Ferdinand Voet, served as an iconographic precedent for several other paintings of her that appear to have found their way into English collections during her lifetime or shortly thereafter.[24] These portraits pictured their sitter in a significant, determinant moment from the familiar narrative related by Pliny in which Cleopatra, in order to fulfill a boast made to Antony that she would hold a banquet costing in excess of 10 million sesterces, dissolved her pearl earring in vinegar and drank it. As representations of this narrative moment, the portraits of Mazarin emblematized an act of scandalous extravagance self-consciously generated by the whim of a powerful woman. They could be viewed as signifying Cleopatra/Mazarin's conquest of her own male consort(s) by a notorious act of bravura and extravagance (indeed, her consort here is strikingly absent from the tableau of the canvas).

Letters of the French ambassadors, among others at the Restoration court, confirm that Mazarin was viewed in the political arena much as her portraits "in the character of Cleopatra" would have suggested: as a procurer of patriarchal disarray, her very body the site of political upheaval.[25] In April 1676 the marquis de Ruvigny cautioned his successor as the French ambassador extraordinary to England:

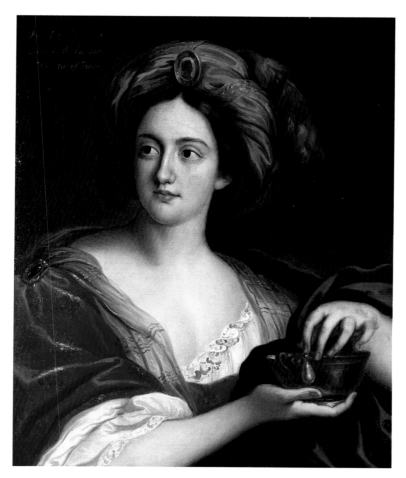

43. Ferdinand Voet (previously attributed to Godfrey Kneller), *Hortense Mancini, Duchess Mazarin, in the character of Cleopatra*, oil on canvas (ca. 1670), 28 x 22½ in. (71.1 x 57.1 cm). The Collection at Althorp.

The arrival of the Duchess Mazarin provoked a great stir and provided a new focus of attention at [the English] court. The king of England appeared moved by her beauty, and although their liaison has been conducted until now with a degree of secrecy, it appears that this nascent passion will take precedence in the heart of this prince. His Majesty [the French king] will have all the more interest in [observing] . . . what the intentions of this duchess are with regard to him.[26]

A letter from Ruvigny's successor, Honoré de Courtin, written to Louis XIV two months later, noted that the damage to French interests wrought by the anti-French sentiments of Charles's highest ministers would be dangerously compounded by a failure on the part of the French themselves to appease his new mistress:

> We have discussed with [the king of England] . . . the Cabals that have been organized to join forces with Madame de Mazarin. He firmly assured us that he will not allow them to win him over: but she is beautiful, he speaks with her more readily than with anyone else when he chances to meet her. All those about him speak of nothing but her merits. It will be very difficult for him to resist the temptation for long, and [meanwhile], it will be a dangerous thing to have to combat both the [king's] minister and his mistress at the same time.[27]

Finally, in a letter of August 1676, Courtin sent a similar warning to the French secretary of foreign affairs:

> You know better than I that the whole of the English nation is full of animosity against France, that the Lord Treasurer, he who of all the ministers is the most ascendant in the esteem of the king of England, affects the same sentiments. . . . It only remains for us to have turned against us the person who occupies the greater part of the heart of this prince. . . . [It] is most perilous to allow to fall into a condition of want a lady who has as great resources at her disposal as Madame Mazarin may have here.[28]

An anonymously authored broadsheet, *The Dutchess of Mazarines Farewel to England*, printed in 1680 (five years after the Duchess Mazarin had first arrived in England, nearly four years after Mazarin had abrogated her alliance with the king through a misalliance with the Prince of Monaco, and three years after Sedley's and Dryden's plays had first been performed), further elaborated the lastingly apposite analogy between Mme Mazarin and Cleopatra.[29] Inscribing her perpetual condition of exile in the opening lines of the duchess's imagined farewell—"Does Fate decree I must renew my dance, / And wheel about from England now to France?"—the broadsheet reaffirms the parallels between Mazarin and her notorious prototype.[30] In verse that calls to mind images of Cleopatra's royally appointed barge, on which she and Antony first met and where they were to attempt to eclipse their political losses in brilliant shows of sumptuous diversion, the departing duchess is imagined bidding farewell to the river that has carried her in triumph to her adopted court:

44. Ferdinand Voet (previously attributed to Pierre
Mignard), here identified as *Hortense Mancini as Cleopatra*
(previously called *Marie Mancini as Cleopatra*), oil on canvas
(1668–72), 29½ x 24⅜ in. (75 x 62 cm). Staatliche Museen
zu Berlin, Germany.

Farewel, thou underlying Silver Thames;
Oft have I sported with thy gliding streams,
And oft my self committed to thy Charge,
Triumphasing sate in my delightful Barge;
And oft to Whitehal with like pleasure came,
As Egypts Queen, when she on Cydnus swam.[31]

The language of this passage further heightens the parallels it describes between
"Egypts Queen" and the peripatetic Duchess Mazarin by indirectly quoting from
adaptations of the story of Antony and Cleopatra widely familiar to seventeenth-
century audiences, such as Shakespeare's, in which Enobarbus recalls, "When she
first met Mark Antony, she / pursed up his heart, upon the river of Cydnus. / . . .
The barge she sat in, like a burnished throne."[32]

Several other painted portraits associated with the Duchess Mazarin portray
their sitters in the guise of Cleopatra with the pearl. One, in the collection of the
Staatliche Museen zu Berlin (National Museums in Berlin) (fig. 44), attributed by

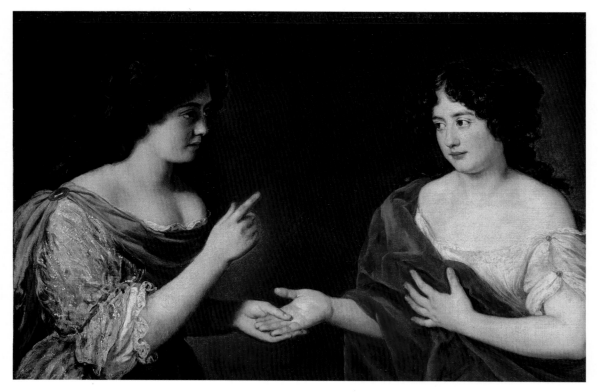

45. Ferdinand Voet (previously attributed to Pierre Mignard), *Hortense Mancini and Her Sister, Marie*, oil on canvas (ca. 1670), 31⅜ x 47 in. (79.7 x 119.3 cm). The Royal Collection, Her Majesty Queen Elizabeth II.

convention to Pierre Mignard but now (like many others) thought to have been painted by Voet, appears directly related to a double portrait of Hortense and Marie Mancini in the Royal Collection (fig. 45). Although the latter bears in French the inscription "Hortense Mancini, niece of Cardinal Mazarin, predicts to her sister Marie, secretly fallen in love with the young Louis XIV, that she will marry a young and gallant king," it was Marie, not Hortense, who, like their father, was notorious in her lifetime for having steeped herself in astrology and fortune-telling.[33] In keeping with Marie's and Hortense's widely circulated reputations, it is more likely that the portrait depicts Marie telling Hortense's fortune, offering to the painting's viewers Marie's left hand grasping her sister's open palm and her right index finger raised rhetorically as gestural attributes of a reputation for fortune-telling, known well to them. In addition, the iconography of the right-hand portrait—the sitter's particular form of undress, with one breast bared by a lace-trimmed white chemise, the sleeve of which is caught up with lozenge-shaped

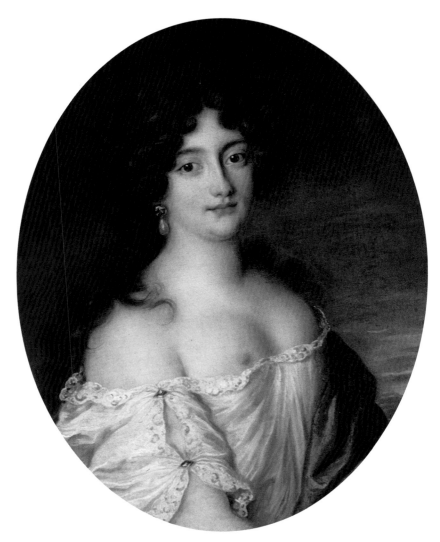

46. Ferdinand Voet (previously attributed to Pierre Mignard),
Hortense Mancini, Duchess Mazarin, oil on canvas (ca. 1670), 29⅛ x
23¼ in. (74 x 59 cm). Earl of Sandwich 1943 Settlement.

jewels—recurs in several other images associated more securely with Hortense
than with Marie (fig. 46).[34]

 Such portraits of the Duchess Mazarin with one breast bared suggest the identity
of their sitter not only through recourse to her own self-referential iconography,
but by reference to iconographic traditions of European portraiture as a whole. The
legacy of French royal mistress iconography—most prominently represented by
the sixteenth-century Fontainebleau School of painters—and of sixteenth-century

47. Otto van Veen, "Lookes are loves arrows," woodcut, from *Amorum Emblemata, Figuris Æneis Incisa . . . (Emblems of Love with Verses in English and Italian)* (Antwerp, 1608), 151. British Library.

Italian works construed by convention to be representations of Roman and Venetian courtesans provides an iconographic lineage for portraits of Mazarin. They can be understood to function in this sense as citations of her reputation as a notorious mistress at the French, Italian, and English courts. Rendering the sitter in these revealing portraits as a latter-day Venus engaged her viewers as reenactors of and accomplices to her notoriety. An emblem from Otto van Veen's popular early-seventeenth-century *Amorum Emblemata* (fig. 47) bears witness to the power wielded by the gaze of a pictured Venus over her viewer. The *subscriptio* to the emblem reads, in its seventeenth-century English translation,

Lookes are loves arrowes.

My loves lookes unto mee, the force of love empartes,

Each glance an arrow is, which from her eyes proceed,

Now Cupid rest thy self, to shoot tho[u] [hast] no need,

For her lookes wound my harte as well as do thy dartes.[35]

Conventions such as highlighting the power of the female gaze to "wound [the] harte"—the glance of the beloved as an amorous, a martial, and a mortal weapon—derive from Petrarchan precedents for many of the encomiastic verses devoted to the Duchess Mazarin. Verses that catalogue in written portraits of Mazarin the "triumph[s] of her conqu'ring eyes," attesting to their "sovereign sway" and certifying that "when she looks stedfastly upon any one . . . , they think she pierces their very Souls,"[36] have their visual counterparts in painted portraits such as the iconic image of her with one breast bared: portraits that simultaneously solicit the onlooker to seek access to the female subject while rendering inevitable the voyeur's resulting "wounded harte." Contemporary treatises and conduct manuals directed stern and prolific reproofs at those women who, in "laying out [their] naked Breasts," offered "a temptation to sinne, both in the Actor, and the vaine Spectator."[37] A late-seventeenth-century treatise on the theory and practice of painting concurred, instructing painters of women that "Wantoness should be Express'd with Wanton Looks, [with] the most Allective Parts Naked, as [the] Breasts."[38] These images offered Mme Mazarin to onlookers in a reinscription of her role as a mistress-for-consumption, implying (if not delivering) the consummation of possession.[39]

The commerce of the gaze as played out in the presentation and reception of the portrait image—the portrait image as a token of exchange within the arenas of personal and political commerce, a marker of physical access to the sitter through possession of his or her image—is at the heart of a series of news reports and accounts relating to the iconography of the Duchess Mazarin.

In May 1670 a letter was sent to Whitehall (presumably by one of the king's compilers of newsletters abroad) reporting the following news of Jocelyn Percy, eleventh Earl of Northumberland, abroad in Rome, who had sought redress for a rival nobleman's misappropriation of a portrait of the Duchess Mazarin apparently intended for Northumberland by the sitter:

> The Earle of Northumberland who is worthyley aclaimed for his gracious deportment in all places . . . the like also at Rome where he has gained much especially in the judgement of the French, who challenge to themselves a kind of mastershipe in the punctilios of Honor. [It so] occasions this the

Dutchesse of Mazarina, a person of great note there, had given him the favor of her picture which Dom Domingo Gusman Brother to the Duke of Modina de los Torres, by some means got of the Painter. That Lord [Northumberland] being satsifyed it was not by default of the painter sent a challenge to [Dom Domingo Gusman] by the Duke of Rohan. Dom Domingo though something unwilling he coldly (for so the relation sayes) complyed so farr as to come into that field him selfe, with one of his servants only, but not in a fighting posture. When he alighted from his Horse he Embraced the Earle and thought to have drolled it off, but when my Ld appeared in very good earnest Dom Domingo . . . took the Earle of Northumberland and the Duke of Rohan into his coach and carryed them to the Spanish Ambassadors House where the picture was restored and they made friends after which Dom Domingo to give him further satisfaction went with him to the Dutchesse of Mazarine's.[40]

The portrait of the Duchess Mazarin, commissioned by her and designated by her to convey her "favor" to its recipient, embodies her in this narrative in the arenas of commerce, diplomacy, and passion. As vital a stimulus to codes of conduct as the woman it represents, the portrait image here provides the instrument by means of which the privilege of possession is dispensed, disputed, and secured.

In another such account Jacques de Belbeuf, the only son of a counselor to the Parliament of Normandy, having arrived in Rome in December 1669 and found refuge there at the Palazzo Colonna,[41] dispatched a letter in May 1671 to his mother at home in which he alerted her that he was forwarding to Paris for safekeeping a package containing a small portrait of the Duchess Mazarin given to him by the sitter herself. Apparently taking for granted that his mother would wish to view the portrait and show it to others, and describing it as an original and of the finest execution that might elicit in those who beheld it the desire to have it copied, Belbeuf admonished his mother to guard the integrity—the purity, we might say—of the portrait: not to allow it out of her sight or to let it fall into the hands of anyone who might copy it. That, he declared, would cause him great displeasure.[42] One of a number of young men whose attentions Mazarin apparently encouraged while in Rome, Belbeuf seems to have construed the originality and what he assumed to be the singularity of the portrait as emblematic of the singularity of his union with Mazarin, of whom he, enraptured, had written to his mother previously. He had had his own portrait affixed to Mazarin's, swearing to keep them thus paired forever. To prohibit the production of copies of her portrait was to close off the possibility that others might have access to, and knowledge of, her through her image. And yet both access and knowledge they appeared to have, as the Earl of Northumberland's and other such stories attest.

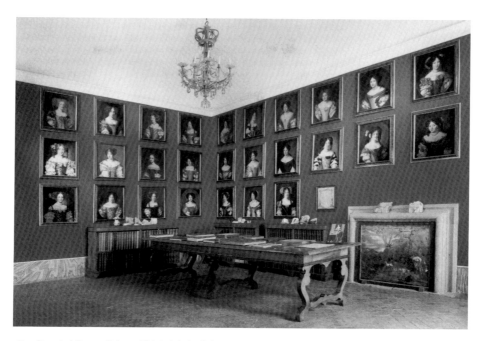

48. Beauties' Room, Palazzo Chigi, Ariccia, Italy.

The proliferation of images of the Mancini sisters in portrait series and their derivative copies further broadened this access—and, along with it, the notoriety of the sisters. In all probability it was through Marie Mancini's alliance with Cardinal Flavio Chigi, one of Rome's most influential patrons of art, that both her husband, Lorenzo Onofrio Colonna, Constable Colonna, and the Duchess Mazarin became familiar with the work of the Flemish painter Voet, the author of the most influential of these series during his tenure in Rome from the mid-1660s until 1679. During the same period of time that witnessed prolific commissions and production of "beauties series" in England, the parochial courts of Italy also seem to have been swept by a passion for this portrait genre. Francesco Petrucci has documented the popularity of the *gallerie delle belle* during the latter half of the seventeenth century in the houses of such distinguished families as the Chigi and Colonna, as well as the influence of their "beauties galleries" on the commissions made by other prominent patrons such as the Duke of Savoy.[43] The Mancini sisters and their cousins seem to have become household names through their representation in most of these series and the copies that proliferated.[44] Petrucci has argued convincingly that Chigi's commission of thirty-seven portraits by Voet, begun in 1672 and completed in 1678 (fig. 48),

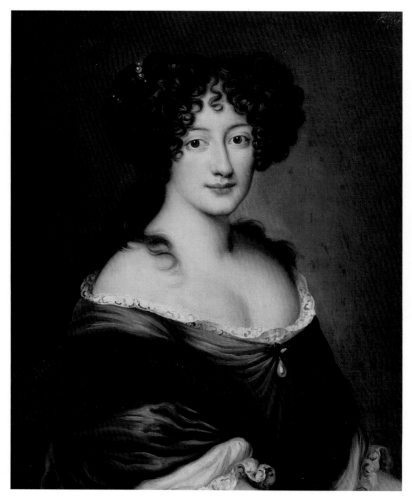

49. After Ferdinand Voet, *Hortense Mancini, Duchess Mazarin* (previously called *A Mancini Sister*), oil on canvas (early 1670s), 29⅜ x 24½ in. (74.5 x 62.3 cm). Cartwright Collection, Iford Manor.

represents the earliest of the seventeenth-century Italian commissions for beauties galleries, and indeed, that in all likelihood it provided the iconography for the series commissioned in turn by Colonna in 1673.[45] Portraits of Hortense and Marie are thought to have been included in both the Chigi and Colonna series, and perhaps in the one commissioned by the Duke of Savoy in 1673; while the Chigi portrait of Hortense was stolen a number of years ago, a related painting, apparently also by Voet or a contemporary copyist and known to have

belonged for generations to the Chigi family, is currently in a private collection in England (fig. 49).[46]

What I have called the commerce of the gaze—that ocular exchange between the sitter and spectator that both invites access and asserts the prerogative of prohibition against it in the portraits of the Duchess Mazarin discussed so far—leads finally to one more portrait image. Sometime between 1676, when the sitter took up residence in England, and 1688, when the painter departed England for France with the exiled court of James II—Mazarin commissioned the Italian artist Benedetto Gennari to paint her in the guise of the goddess Diana (fig. 50). Gennari described the painting in his register of works:

> A fairly large painted portrait of the Duchess Mazarin surrounded by four Moors, one of whom is playing a horn; another, smaller one sits astride a large dog, another holds the leash of a second dog in his hands, and the largest, with a bowl in his hands, takes a little water from the fountain to give to the dogs to drink; the Duchess sits with a dart in her hand and is dressed like a Diana. Which painting was made for the same [Duchess].[47]

While more than fifty painted portraits have been associated in one way or another with Mazarin's likeness, and while textual references to portraits painted of her at her own behest are many, the Gennari "Diana" remains the only portrait to date whose commission appears securely attributed to the Duchess Mazarin herself. Through a brief survey of the mythologies and iconographies of the goddess Diana in currency during the period culminating in the second half of the seventeenth century, and an analysis of the intersections of these with the rhetorical devices and portrait iconographies used to figure Mazarin's body and story, I will conclude this exploration of the imagery of foreignness, notoriety, and prerogative in the portraits of the Duchess Mazarin by addressing the implications of viewing and displaying oneself as a Diana at the post-Restoration English court.

The mythologies surrounding women at the courts of seventeenth-century England, France, and Italy frequently harnessed the iconographic force of earlier mythologized figures. The mythology of the Roman goddess Diana was thus familiar to seventeenth-century audiences through the works of French and English sonneteers who eulogized their subjects as latter-day Dianas, as well as the myriad narrative tapestries (fig. 51), mythological paintings, and portraits "en Diane" recorded in seventeenth-century inventories that all testify to the popularity and currency of imagery associated with the goddess. Roman mythology characterized Diana as a lunar deity, sister to the sun god Apollo; as a champion of the hunt; and as the virginal, fierce protector of women both chaste and in childbirth.

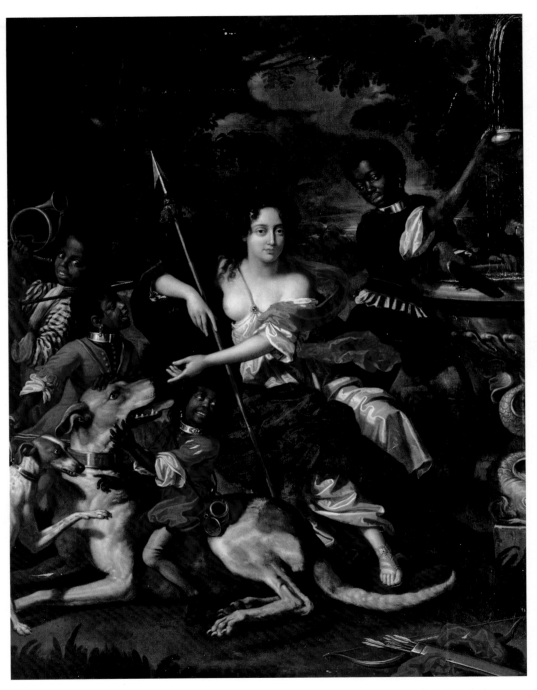

50. Benedetto Gennari, *Duchess Mazarin as a Diana*, oil on canvas (ca. 1684), 90 x 70⅛ in. (228.5 x 178 cm).
Private collection.

51. Brussels tapestry, *Diana and Actaeon* (second half of the seventeenth century), 124⅜ x 196⅞ in. (316 x 500 cm). Christie's, New York (2 June 1993, lot 80).

She figured in multiple narratives that were told in their most influential form by Ovid and retold by authors who appropriated Ovid's narratives through the Renaissance into the sixteenth and seventeenth centuries. Ovid's *Metamorphoses* locates Diana within two divergent narrative conventions, one of which, encompassing the two tales of Actaeon and Callisto, characterizes her as an effacer of the male gaze and as the safeguard of woman's chastity. The other Ovidian narrative casts her as a lovelorn counterpart to the Adonis-enthralled Venus, describing Diana as Endymion's seducer rather than as his challenger.

Many post-Renaissance narratives and representations of the encounter between Diana and Actaeon dramatize, above all, the act of voyeurism embodied in Actaeon's gaze. Ovid's account gives initial precedence to the nymphs' view of Actaeon, only subsequently making reference to Actaeon's act of looking. Thus Ovid emphasized two acts of looking on which he insisted throughout his account. Indeed, I would propose that the "implicit equation between the two figures . . . [the] mirroring

relationship between the mortal and the goddess" that Leonard Barkan takes from this Ovidian narrative[48] is rhetorically affirmed by the mirror-image viewpoints in which Ovid bracketed their encounter: first, "The Nymphs, all naked, when a man they view'd . . . ," and then

> [Diana] . . . though inviron'd by her Virgin trayne,
> Shee side-long turnes, looks back. . . .
> These words shee addes, which future Fate presage:
> Now, tell how thou hast seene me disarray'd.[49]

And this mirroring of goddess and mortal, viewed and viewer, becomes a particularly compelling force in the context of a portrait sitter caparisoned as a Diana and her audience cast by implication as a type of Actaeon.

Boccaccio delineated a Diana who followed in the traces of Ovid's: the vengeful destroyer of Actaeon, linked with the moon, "[who] appears to us to throw [her] rays as though they were arrows."[50] This construction of Diana as a figure properly enthroned in the night skies reemerged in sixteenth- and seventeenth-century poetry that made use of astral and luminary imagery to pay homage to women figured as Dianas. Jean Ogier de Gombaud, for example, writing in the first half of the seventeenth century, made the association between the goddess and illumination explicit:

> When I see her shine under a funereal veil
> Like another Diana in the middle of the Night,
> What is my fate? To what am I reduced?
> I remain confused, speechless and motionless.[51]

References to the flame of Diana's chastity, and to the luminary illustriousness of the women imagined to follow from or supersede her legacy, permeate such poems with metaphors and similes of luminosity. For example, Loret's epithet for the young Hortense Mancini cited earlier—as "un jeune Astre oriental"—not only figures her desirable exoticism, but subscribes as well to the language of astral luminosity that was proper to the iconography of Diana.

In addition to elaborating this astral imagery of Diana, Gombaud's quatrain reiterates the experience of Actaeon before Diana, his vision of the goddess rendering him, like the proverbial deer, immobilized and inarticulate. This experience translated into a poetic convention that celebrated woman's beauty by characterizing it as leaving the poet inarticulate and incapable of apt description: by implication, rendering the poet an Actaeon whose gaze on a transfixing Diana deprived

him of his art. In a letter to the fable writer and poet Jean de La Fontaine in 1687, Charles de Marguetel de Saint Denis, Seigneur de Saint-Evremond, Mazarin's most faithful champion at the English court during the nearly twenty-five years she spent there, likewise characterized his own art and that of his fellow poet as incapacitated by the act of looking upon the brilliance of the Duchess Mazarin's beauty: "Try, Monsieur, great poet that you are, to conceive a beautiful ideal, and despite your mind's every effort, you will be ashamed of what you have conceived when you see a person as wondrous [as the Duchess Mazarin]."[52] I would suggest that the act of viewing a portrait of the Duchess Mazarin figured as Diana shared some of the implications of the act of viewing the lady herself as construed in the preceding textual excerpts.

Scholars have analyzed at length the self-conscious appropriation of the Diana myths for political purposes during the sixteenth and early seventeenth centuries. Both Diane de Poitiers, mistress of Henri II of France, and Elizabeth I of England, for instance, fashioned themselves (and were fashioned) in the image of the virgin-hunter goddess. Françoise Bardon has described the art devoted to Diane de Poitiers as "an official art, a court art," fashioned by the subject herself to accrue to her own persona the virtuous attributes of the goddess whose name she shared.[53] The significance for its author, enactors, and audience of Ben Jonson's masque *Cynthia's Revels* (1600), which reinscribed the myth of Diana and Actaeon in the context of court spectacle and whose express purpose Barkan identifies as that of commenting on contemporary court politics, suggests a paradigm for readings of reinscriptions of that myth onstage, in text, and in images later in the seventeenth century. Appropriations of this and the other Diana myths continued to function (whether by design or by reception alone) as conduits for political commentary, providing a framework within which characterizations of contemporary court figures were delineated by transcribing mythical or figurative characters onto the familiar characters of the court.

John Crowne's masque *Calisto; Or, The Chaste Nimph*, commissioned by Charles II in 1674–75 and performed in the early months of 1675, provides a case in point. Ovid's tale of the nymph Callisto was driven in part by the same elements that had driven the Actaeon narrative, its premise and outcome depending primarily from male penetration—here in the form of Jupiter—into Diana's circle of chaste nymphs. Two future queens of England were cast in central roles, as were several more or less notorious ladies of the court. Andrew Walkling notes that "*Calisto* was regarded as an important event, and . . . the public memory of the production did not fade when the audience left the theatre."[54] Walkling has surmised that the commission for Crowne's masque grew out of Charles's attempt to "remake himself in the image of his 'absolutist' cousin Louis XIV . . . manifested

(among other ways) in a new fascination at court with French opera and *ballet de cour.*"[55] It would appear likely, however, that the political agenda that initiated the lavish production suffered certain compromises in the subtexts summoned forth by the vagaries of its performance and reception. Ostensibly celebrating chastity, the masque's prominent cast included players somewhat less renowned for their chastity than the young Princess Mary, who played the title role. Jupiter, for instance, was played by a cross-dressed Lady Henrietta Wentworth, the avowed mistress of James Scott, Duke of Monmouth, illegitimate son of Charles II. The self-righteous Juno was played by Anne Fitzroy, Countess of Sussex, who was acknowledged as the king's illegitimate daughter and was herself the subject of much notoriety. Crowne's appropriation of the Diana and Callisto myth for the English court and its audiences, saturated as they were with the myths of their own "notorious identities," evidently added layers of signification to the classical myth, rendering it the channel for both official and unofficial, sanctioned and illicit, contemporary politics.[56]

Thus I would argue that Gennari's portrayal of the Duchess Mazarin "dressed like a Diana" represents not a monolithic reinscription of a singular Diana myth, but rather a multivalent amalgamation of references to multiple mythologies. Contemporary viewers of the portrait, I believe, would have juxtaposed its reappropriations of classical mythology with the influences of seventeenth-century court politics, familiar modes of looking at women in general, and the particular ways in which the Duchess Mazarin, her body, and her stories were regarded and mythologized during the period in which the portrait was commissioned and completed.

The painting manifests its referentiality to classical mythology and narratives both formally and thematically. The attributes of Ovid's Diana demarcate the space of the canvas. Her spear forms the apex of the triangular composition of the duchess/goddess's figure and her entourage. Her bow and quiver of arrows lie—relinquished—on the ground, pointedly foregrounded by the artist, as though following the narrative sequence of Ovid's verse: "her Bowe, her Jav'ling, and her Quiver; / Doth to a Nymph, one of her Squires, deliver." "Her light impoverisht Robes," as described by Ovid,[57] are painted to emulate the looseness of classical garb in keeping with conventions established by such portrait painters as Peter Lely, and her feet are depicted sandaled in buskins.[58] Like the verses of a poet's blazon that deconstruct, visualize, and savor each member of (his) subject's body in order to celebrate the beauty of the whole, the careful and explicit detailing of each of these classicized attributes further substantiates the referentiality of the image to its classical sources.

Inclining her left hand toward the muzzle of the hound nearest to her, the sitter is herself implicated in gesturing toward the classical and Renaissance narrative subtexts of her portrait, beyond the markers of a Diana located physically in the

classical world. The dogs signify Diana herself as hunter, Actaeon as hunter, and the demise of Actaeon-as-hunted: "The well-mouth'd hounds pursue the princely prey. / Where oft he wont to follow, now he flyes."[59] They are shown here in apparent obeisance to Diana, as figured by their subordinate placement below her in the triangular composition of the image and by the restraints implicitly exercised upon them by collar and leash. I would suggest that they are represented to the viewer as having served Diana's means, in the aftermath of the notably absent Actaeon's transformation. The presence of the fountain pictured toward the right margin of the canvas further emphasizes the multiple and simultaneous narrative references of the image. George Sandys's version of Ovid's Diana, naked to Actaeon's gaze, "wish't her bow; / Yet, what she had she in his face did throwe, / With vengefull Waters sprinkled"[60]—thus transforming him into a stag and procuring his destruction in the jaws of his own dogs. The presence of a source of water in this painting simultaneously reminds the viewer of this episode and, somewhat ironically, appears to serve the purpose of a token of approbation to the pictured dogs for a job well done. As Gennari himself describes the scene in his own register of paintings cited earlier, "The largest [Moor], with a bowl in his hands, takes a little water from the fountain to give to the dogs to drink."

I have proposed that this portrait operates by means of a variety of references to the narrative of the classical Diana and Actaeon myth. I would argue further that it refers obliquely, at the same time, to those Diana myths outside the realm of the Actaeon tale, by means of its appropriation and reconfiguring of that classical tale and its traditional imagery. Gennari deviates most obviously from conventional representations of Diana's encounter with Actaeon in his substitution of black servants for the white nymphs in Diana's entourage (fig. 52). Gennari's description in his register of works makes very clear the centrality of these figures to the overall composition, constituting the "four Moors" as the agents of all action within the confines of the canvas. The Duchess Mazarin was widely associated with a particular "Moor," a page named Mustapha who was said to have accompanied her in her flight across Europe, and who remained with her throughout her exile in England. In Saint-Evremond's letters to Mazarin he referred to Mustapha's valued status as her ally in adversity. A newsletter written in June 1699 to England's ambassador in France, relating the details of Mazarin's death, noted: "The duchess of Mazzarin died yesterday morning, without any manner of concern for what was past or what was to come. . . . It was believed she had nothing to leave besides her monkies, parrots, and Mustapha, a Mahometan boy."[61]

Gennari's inclusion of the black pages in his portrait of Mazarin as Diana may therefore embody the collaboration between the artist and his sitter who had commissioned the work herself, as well as the grounding of portrait imagery "en Diane"

in the "living" and specific example of its sitter.[62] In what can perhaps be read as a further inclination toward the dominion of his sitter over the image, Gennari depicts the pages wearing silver collars around their necks. Kim Hall, who includes in the book *Things of Darkness* another portrait thought to depict the Duchess Mazarin with a black page, has noted that gold or silver collars bearing the family seal or the name of those to whom they were indentured were frequently riveted on the necks of young black male servants. Thus the pages pictured by Gennari in the service of the Duchess Mazarin/Diana can be read as attesting not only to a particular and well-known attribute of her own story, but to her status as property owner as well.[63]

The supplanting of the white, female nymphs of Diana with black, male servants is notable for the reading of the painting on several counts. The very whiteness of Diana's nymphs, according to Boccaccio's construction of her myths, affiliates them visually and symbolically with the moon; white, he writes, is counted "among those colors appropriate to the moon." He conceives the nymphs to embody the moist humors of the moon "[who] curbs and restrains by her frigidness carnal concupiscences."[64] The conventional account of Diana's encounter with Actaeon configures the nymphs in a protective cluster around the naked goddess, handmaidens in her championing of chastity and followers in her crusade to confound the male gaze.

The insertion of four male, black bodies into the painting—foreign to the narrative of the myth by their gender, by the color of their skin, and by their costume—calls for consideration of the particular relevance of "foreignness" to interpretation of the image. To begin with, the space in which the viewer finds Diana is no longer iconically inviolate from male penetration. Hall has pointed out that the rhetoric of blackness in early-modern England conceived of such figures as the four pages as enhancing by contrast the whiteness of the skin with which theirs was juxtaposed; they served, in these terms, as anti-attributes accentuating the purity (and thus the desirability) of the portrait's primary subject. Yet by the re-gendering of the Diana myth effected through their presence within the tableau, another kind of referentiality is suggested. Mazarin figured as Diana here becomes a reminder of, and link with, the figure of Venus in such paintings as Peter Paul Rubens's *Venus Before the Mirror* (ca. 1616), in which a voluptuous woman, naked to the eyes of the viewer, is attended by a black page in an implicit enactment of procurement and carnal love.[65] Thus, while the allegory of Diana could impute to the subject of a written or painted portrait "en Diane" the virtues associated with the righteous adversary of Actaeon, the appropriation of Diana's persona, with references adapted to the particularities of the sitter's own story, could overlay those associations with additional and sometimes conflicting layers of

52. Jan van Neck, *The Bath of Diana*, oil on copper (seventeenth century), 13 x 17 in. (33 x 43.2 cm).
Private collection.

signification. As Hall has commented and as I have touched on here (and discussed
elsewhere at greater length), in relation to the Duchess Mazarin herself and to
those in whose guise she was figured, "female transgression is located in the space
of the foreign or strange."[66] The Duchess Mazarin, as we have seen, was figured
frequently in English and French accounts as foreign and "other"—as "Egypt's
queen,"[67] as a "Roman beauty, no way like our Baby Visaged, and Puppet-like
Faces of France," and attired in "those Dresses which would make other Women
look like Witches, [but which] wonderfully become her."[68] Her story—one of irre-
sistible allure and irrefutable transgressions—both invited closer scrutiny and yet
also warned of its consequences.

The preponderance of representations of Diana during the sixteenth and early
seventeenth centuries pictured her in her guise as goddess of the hunt or in the
midst or aftermath of her encounter with Actaeon, as in Titian's now iconic por-
trayal of the punishment of Actaeon. The predominance of such representations
over those of Diana and Endymion, for instance, continued throughout the sev-
enteenth century. This emblematization of Diana as, above all, a challenger to the

hegemony of male viewers (and, implicitly, as a disrupter of male penetration of the female world)[69] underscores the construction of her during the same period as affined with the figure of the Amazon. A contemporary treatise on the history of the Amazons offered an account of the mythical warrior women as devotees of the cult of Diana, whom they viewed as a model and protectress, according to the treatise's author.[70]

Like classical images of the Amazons and their contemporary reproductions (fig. 53), seventeenth-century images of Diana and portraits of women "en Diane" often pictured them with one breast bared. I have written elsewhere about a range of contemporary commentaries that, like the *Coffee-house Conversation* burlesque discussed earlier, envisioned the Duchess Mazarin as a latter-day Amazon whose "great beauty, quality and adroictnesse . . . seem to furnish occasion for apprehending a greater power in her over the king . . . than any other of his Mistresses have had."[71] Saint-Evremond, himself employing the figure of the Amazon, restated more particularly the threat inherent in the Duchess Mazarin's arrival in England. He made explicit that the threat—that is, Mazarin's capacity to conquer—existed in the act of beholding her: "Along with the likeness of Helen, Madame Mazarin had the air and équipage of a queen of the Amazons; she appeared equally equipped to charm and to fight." And in the same passage, he added that "a beauty so extraordinary is of more value than all valor, and . . . more conquests can be made by [Mazarin's] eyes than by the arms of the city's great men."[72] Mazarin, previously pictured in both painted and written portraits as a castrating Cleopatra to Charles II's hapless Mark Antony, is figured here by Saint-Evremond and by the language of popular commentary as, in effect, a transfixing Diana, to gaze on whom is to suffer the fate of an Actaeon or the disempowerment of a king. In having herself literally and figuratively "pictured" as Diana, then, Mazarin courted perceptions of herself as both chaste (that is to say, virginal) and chaser, all-powerful in her ability simultaneously to compel and defeat the attentions of her male audience and thereby—in the age of a court often lamented for its susceptibility to the whims of royal mistresses—to manipulate and dominate an implicitly male court politics.

The compositional format of Gennari's portrait of Mazarin as Diana and his own written description of the painting highlight the hounds that emblematized both Diana's persona as goddess of the chase and Actaeon-turned-stag's evisceration in the jaws of his own hunting dogs, an act set in motion by Diana. The figure of Actaeon himself can be read as conspicuous by its absence from the tableau. Yet a lineage of sixteenth- and seventeenth-century images depicting Diana surprised at her bath by Actaeon or revealing the resulting punishment of Actaeon informs images such as Gennari's, which depict a Diana attended but lacking an audience within the confines of the canvas. The viewer of Gennari's portrait is implicated

Part.II.p.1.

Ch.Mathey Sculp.

53. Charles Mathey, "Figure of Amazon," engraving, from [Claude-Marie Guyon], *Histoire des Amazones Anciennes et Modernes . . . ,* part 2 (Amsterdam: Zacharie Chatelain, 1748), 1. Houghton Library, Harvard College Library.

in filling the role of the effaced voyeur in compliance with the edicts of the myth. Mazarin/Diana looks out full front at the viewer who regards her. In a reenactment of the mirror-imaging of voyeur and viewed that Barkan finds in Ovid, which by implication renders both Diana and Actaeon subject to the authority of each other's gaze, Mazarin/Diana appears to assert forcefully the authority of her own gaze as not only subject to, but subduing and compelling, that of her viewer. If male, her viewer is reminded of his susceptibility to the attractions and punishment suffered by Actaeon; if female, she is called upon to recognize that the Duchess Mazarin, wielding the dart of the Roman goddess Diana, wields her other weapons and prerogatives as well.

1. There is some discrepancy in the record regarding the precise date of the Duchess Mazarin's death. Two newsletters sent from Whitehall to Ambassador Sir Joseph Williamson on 23 June 1699 note that the Duchess Mazarin died the morning of the previous day. *La Gazette de France*, 11 July 1699, in an entry from London dated 2 July, reports, "The Duchess of Mazarin died today at 8 a.m., in the village of Chelsey near this city" (234). The July 1699 issue of *Le Mercure Galant* likewise notes, "We have heard that the Duchess Mazarin, who had resided for some time in England, died on the second of this month in the village of Chelzer [*sic*], near London" (224). The discrepancy between the English and French sources reflects the approximately ten-day discrepancy between so-called Old Style and New Style dating. The entry from John Evelyn's *Diary* cited below, however, is possibly erroneously published as dating to 15 June 1699.

2. *The Diary of John Evelyn*, ed. E. S. de Beer, 6 vols. (Oxford: Clarendon Press, 1955), 5:330–31.

3. Evelyn, *Diary*, 4:97–98.

4. The phrase *femme de qualité* is found in frequent use (among other places) in gazettes and newsletters published throughout the European continent and read equally widely during this period, such as *La Gazette d'Amsterdam* and *Le Mercure Galant*.

5. Linda Charnes, *Notorious Identity: Materializing the Subject in Shakespeare* (Cambridge, Mass., and London: Harvard Univ. Press, 1993), 3.

6. Richard Brathwaite, *The English Gentlewoman* (London: Printed by John Dawson, 1641), 329.

7. Brathwaite, *English Gentlewoman*, 340.

8. Mary Astell, *Some Reflections upon Marriage, Occasion'd by the Duke and Dutchess of Mazarine's Case, Which Is Also Considered* (London: Printed for John Nutt, 1700), 3.

9. *Mémoires d'Hortense et de Marie Mancini*, ed. R. Gérard Doscot (Paris: Mercure de France, 1987; orig. pub. 1675), 31–32, my translation from the French: "vous n'ignorez pas non plus la repugnance naturelle que j'ai à m'expliquer sur les choses qui me regardent: mais il est encore plus naturel de se defender contre la médisance. . . . Je sais que la gloire d'une femme consiste à ne faire point parler d'elle . . . ; mais on ne choisit pas toujours le genre de vie qu'on voudrait mener, et il y a de la fatalité dans les choses memes qui semblent dépendre le plus de la conduite." As Patricia Cholakian has described it, in her *Women and the Politics of Self-Representation in Seventeenth-Century France* (Newark: Univ. of Delaware Press, 2000), 85–100, 182–84, this *"incipit"* to the *Mémoires* appeals directly to the dedicatee, Charles Emmanuel II, Duke of Savoy, who had granted protection at Chambéry to the Duchess Mazarin during the three years from 1672 to 1675, when his death (and, presumably, his widow's preference) precipitated her removal to England. Still, through the conceit of her appeal to an intimate who is assumed to know well Mazarin's preference for self-effacement, the rhetoric of the *Mémoires* in effect establishes and then confirms a self-evident truth for its readers at large—that the Duchess Mazarin is appropriately reluctant to publicize her own affairs, but simultaneously compelled to do so by circumstances and the need to reassure those who have supported her that their devotion was not misplaced.

10. Peter Stallybrass, "Patriarchal Territories: The Body Enclosed," in *Rewriting the Renaissance: The Discourses of Sexual Difference in Early Modern Europe*, ed. Margaret W. Ferguson, Maureen Quilligan, and Nancy J. Vickers (Chicago and London: Univ. of Chicago Press, 1986), 123–42.

11. The issue of authorship is a particularly fraught and complex question for the seventeenth-century memoirs of so-called notorious women whose stories were widely circulated. As has been the case with the memoirs of the Duchess Mazarin, libraries, archives, and historians have, as a matter of convention, represented these works as "shadow-authored" by male writers. And, indeed, there was a risk for a woman of being perceived as breaching decorum by the very act of publishing her story for public consumption, as Mazarin's own apologia suggests. César Vichard, the Abbé de Saint-Réal, a companion and devotee of the Duchess Mazarin during her years of exile from France, has conventionally been considered the "coauthor" of Mazarin's memoirs. Yet Saint-Réal claimed to be neither the author nor the editor of her memoirs, and the fact that they were published with his collected works into the nineteenth century may well have had to do more with the stories that circulated rumoring a possible romantic attachment between him and the Duchess Mazarin than with the pen behind the memoirs. Fortunately, recent scholarship has reinvigorated

the debate over this very significant question of female authorship and agency. See, in particular, Elizabeth Goldsmith, *Publishing Women's Life Stories in France, 1647–1720: From Voice to Print* (Aldershot, UK, and Burlington, Vt.: Ashgate Publishing, 2001).

12. Excerpt from Book 9, Letter 6, dated 9 Feb. 1658 (line 86), in *La Muze Historique ou Recueil des Lettres en vers Contenant les Nouvelles du Temps Ecrites a Son Altesse Mademoizelle de Longueville, depuis Duchesse de Nemours (1650–1665),* by Jean Loret, 2nd ed. (Paris: P. Jannet, Libraire, 1857); the poet and dramatist Scarron is cited in *Les Mazarinettes ou les Sept Nièces de Mazarin,* by Jacques Hillairet (Paris: Les Editions de Minuit, 1976), 95.

13. "Elle est entrée dans la Cour d'Angleterre comme Armide entra dans le camp de Godeffroi; on parle d'elle par tout, les hommes avec admiration, les femmes avec jalousie et inquietude." Archives des Affaires Etrangères, Paris: Correspondence Diplomatique, Angleterre, vol. 117, fol. 160, cited in *Saint-Evremond: Lettres,* ed. René Ternois, 2 vols. (Paris: Librairie Marcel Didier, 1967–68), 1:324–25.

14. In its seventeenth-century usage, "extravagant" had connotations of vagrancy.

15. *Plaidoyez Touchant la Demande Faite par Monsieur le Duc de Mazarin pour Obliger Madame la Duchesse de Mazarin Son Epouse de Revenir avec Luy, après une Longue Absence, & de Quitter l'Angleterre où Elle Est Presentement. Avec l'Arrest Intervenue le 29. Decembre 1689, sur Ces Plaidoyez* (Toulouse, 1690?), 15, my translation from the French: "Elle est sortie de France, elle est allée courir le monde, & promener sa honte & celle de son mary dans tous les Climats de l'Europe."

16. Marie Sidonie de Lenoncourt, marquise de Courcelles, an early collaborator of Mazarin's in much-reported rebellious pranks supposedly carried out by the two inside a convent in which both were cloistered for a time by their husbands, later added her own fuel to this discursive fire, reflecting—not altogether charitably— that "what is most strange is that this woman triumphs over all her disgraces by an excess of folly which has no parallel and that after receiving [these setbacks] she thinks only of enjoying herself. When passing through here [in her flight from Savoy to England] she was on horseback, befeathered and bewigged, escorted by twenty men. She talked of nothing but violins and of hunting parties and everything else that gives pleasure." *Mémoires et Correspondance de la Marques de Courcelles: Publiés d'après les Manuscrits* (Paris: Chez P. Jannet, Libraire, 1855), 107, my translation from the French: "mais ce qu'il y a de rare, c'est que cette femme triomphe de toutes ses disgrâces par un excès de folie qui n'eut jamais d'exemple, et qu'après avoir eu ce dégoût elle ne pense qu'à se réjouir. En passant ici, elle était à cheval, en plumes et en perruque, avec vingt hommes à sa suite, ne parlant que de violons et de parties de chasse, enfin de tout ce qui donne du plaisir." (It is worth noting here as a bibliographic matter that a number of sources originally printed in the seventeenth century are available to us today in published form largely through later eighteenth- and nineteenth-century editions, as is the case in this 1855 edition of the memoirs of the marquise de Courcelles.)

17. This last referred both to Charles's mistress reigning at the time of Mazarin's arrival, Louise de Kéroualle, whom he had first encountered in France in 1671, in the retinue of his sister, and to whom he granted the title of Duchess of Portsmouth in 1673, and to the actress Nell Gwyn, also favored with Charles's attentions during the 1670s.

18. Public Record Office (hereafter PRO), Kew, SP 29/376, fol. 198 [138]. "I will take part in your banter, but will not enter a whit into your politics. And I shall content myself with telling you, that the Duchess of Mazarin is in reality so charming, that, if your king kisses her but once, I hold her of Portsmouth as done for" (my translation). The handwritten document opens with the following scenario, setting the stage for the recorded conversation: "Some dayes before the poor Coffee-houses fell under persecution two french Gentlemen had the Curiositie to see what passed at a chief one of them, whereof they had heard much talk; And accordingly they went to Garraway, near the Exchange, where some Company at a little by-Table perceiving them to be Strangers, and they themselves having been travellers, Invited them to their Societie. Being sate down with them, the Conversation began as followeth."

19. Edmund Spenser, *The Faerie Queene,* bk. 5, canto 8, st. 2, cited in *Cleopatra: Histories, Dreams and Distortions,* by Lucy Hughes-Hallett (London: Bloomsbury, 1990).

20. William Shakespeare, *The Tragedy of Antony and Cleopatra,* ed. Barbara Everett, Signet Classic Shakespeare Series (London and New York: Penguin Books, 1988), act 2, scene 5, lines 21–23.

21. Entries dated 24 June and 27 July 1667 in *The Diary of Samuel Pepys*, ed. R. C. Latham and W. Matthews, 11 vols. (London: HarperCollins, 1995), 5:288, 356.

22. John Dryden, *All for Love; or, The World Well Lost, A Tragedy . . . Written in Imitation of Shakespeare's Stile*, in *The Works of John Dryden*, ed. Maximillian E. Novak and George R. Guffey, vol. 13 (Berkeley: Univ. of California Press, 1984), act 1, scene 1, lines 170–80.

23. The portrait is described as "in the character of Cleopatra" in an eighteenth-century inventory, British Museum MSS: Althorp Papers L15, *Catalogue of the Pictures at Althorpe and Wimbledon belonging to the late Hon^{ble} M^r Spencer*, 1746.

24. See Susan Shifrin, "'A Copy of My Countenance': Biography, Iconography, and Likeness in the Portraits of the Duchess Mazarin and Her Circle" (PhD diss., Bryn Mawr College, 1998), 99–101, 271–76, for a discussion of this and related portraits, as well as of the artist's work. See also Francesco Petrucci, "Monsù Ferdinando Ritrattista: Note su Jacob Ferdinand Voet (1639–1700?)," *Storia dell'Arte* 84 (1995): 283–306; Petrucci, "Gaulli, Maratta e Voet: Nuove Attribuzioni," *Fima Antiquari Arte Viva* 9 (1996): 54–64; and Petrucci, *Ferdinand Voet (1639–1689), Detto Ferdinando de' Ritratti* (Rome: Ugo Bozzi, 2005).

25. For more on this subject, see Susan Shifrin, "'At the End of the Walk by Madam Mazarines Lodgings': Si(gh)ting the Transgressive Woman in Accounts of the Restoration Court," in *Women as Sites of Culture: Women's Roles in Cultural Formation from the Renaissance to the Twentieth Century* (Aldershot, UK, and Burlington, Vt.: Ashgate Publishing, 2002), 195–203.

26. Baschet Transcripts, PRO, 31/3/132, fol. 138, my translation from the French: "L'Arrivée de la Duchesse Mazarin causa une grande et nouvelle attention en ceste Cour. Le Roy d'Angleterre a paru touché de sa beauté, et bien que ceste affaire se conduise jusques à ceste heure avec assez de secret, il y a apparence que ceste passion naissante prendra la première place dans le coeur de ce Prince. Sa Majesté aura d'aultant plus d'intérest que le Sieur Courtin observra quelles seront les intentions de ceste Duchesse à son esgard."

27. PRO, 31/3/132, fol. 178–80, my translation from the French: "Nous sommes mesme entrez avec luy sur les Cabales qu'on fait pour l'engager avec Madame de Mazarin. Il nous a fort asseurez qu'il ne se laisseroit pas gâgner: mais ell est belle, il luy parle plus volontiers qu'à personne quand il la rencontre en son chemin: Tous ce qui est auprez de luy ne s'entretient que de son mérite: Il sera fort difficile qu'il se défende longtemps contre la tentation, et pour lors ce seroit une chose dangereuse d'avoir à combattre le Ministre et la Maistresse tout à la fois."

28. PRO, 31/3/133, fol. 256, my translation from the French: "Vous sçavez mieux que moy que toute la nation Angloise est pleine d'animosité contre la France, que le Grand Trésorier, celuy de tous les Ministres, qui a le plus d'ascendant sur l'esprit du Roy d'Angleterre, affecte de paroistre dans les mesmes sentimens. . . . Il ne reste plus qu'à avoir icy contre nous la personne qui aura le plus de part dans le coeur de ce Prince. . . . il est très périlleux de laisser tomber sans la nécessité une Dame qui a d'aussi grandes ressources que Madame Mazarin en peut avoir icy." Thomas Osborne, first Earl of Danby (later Duke of Leeds), was Lord Treasurer at the time that Courtin wrote his letter.

29. Although the author of this broadsheet remains unnamed, Langly Curtis, the bookseller for whom it was printed, was fairly well known for his animosity toward the court. See Henry R. Plomer's entry on Langly Curtis in *A Dictionary of the Printers and Booksellers Who Were at Work in England, Scotland and Ireland from 1668 to 1725*, ed. Henry R. Plomer, Harry Gidney Aldis, and Arundell James Kennedy Esdaile (Oxford: Oxford Univ. Press, 1922).

30. *The Dutchess of Mazarines Farewel to England* (London: Printed for Langley Curtis, 1680), 1.

31. *Dutchess of Mazarines Farewel*, 2.

32. *Antony and Cleopatra* (Everett), act 2, scene 2, lines 192–97.

33. See, as just one reflection of this reputation, verses attributed to Marianne Mancini, the youngest sister of Marie and Hortense Mancini, cited in *Marie Mancini: La Première Passion de Louis XIV*, by Claude Dulong (Paris: Librairie Académique Perrin, 1993), 54–55: "My sister Hortense thinks of nothing / But to amuse herself full well, / She loves with all her heart, / So send her a handsome serving-man. / My sister Marie / Does her one better, / She reads astrology / Plutarch, Seneca, and philosophy."

34. Jacques Wilhelm, in "Some Unpublished Portraits by Jacob-Ferdinand Voet, or From His Atelier," *The*

Connoisseur (Aug. 1966): 251–56, also suggests that the Berlin portrait (and by extension, the figure with bared breast in the double portrait) is more securely associated with Hortense Mancini than with her sister Marie. Francesco Petrucci has also concluded that the conventional identification of these two related images requires reconsideration, and that they are more likely to depict Hortense than any of her sisters. See Petrucci, "Gaulli, Maratta e Voet," 63, and Petrucci, *Ferdinand Voet*, 190–91, cats. 124.a, 126.b.

35.　Otto van Veen, "Lookes are loves arrowes," woodcut, in *Amorum Emblemata . . .* (Antwerp, 1608).

36.　Edmund Waller's encomium to the Duchess Mazarin includes the verse "When through the world fair Mazarin had run / Bright as her fellow-traveller, the sun, / Hither at length the Roman eagle flies, / As the last triumph of her conqu'ring eyes," cited in *The Mazarine Legacy: The Life of Hortense Mancini, Duchess Mazarin*, by Toivo David Rosvall (New York: Viking Press, 1969), 162–63. Rosvall also cites Jean de La Fontaine's verse solicited by Mazarin's champion and fellow expatriate in England, the poet and philosopher Charles de Marguetel de Saint Denis, Seigneur de Saint-Evremond: "Wherever the busy sun enlightens day, / Hortensia's eyes have sovereign sway" (200–201). The unidentified author of the *Letter Containing a True Character of Her Person and Conversation* writes, "[Her eyes] are so lively, and so quick, that when she looks stedfastly upon any one, which she rarely does, they think she pierces their very Souls." Published in *The Memoires of the Dutchess Mazarine. Written in French by Her Own Hand and Done into English by P. Porter Esq. Together with the Reasons of Her Coming into England. Likewise a Letter . . .*, trans. P. Porter, 2nd ed. (London: Printed for William Cademan, 1676), 116–17.

37.　Thomas Hall, *The Loathsomenesse of Long Haire. . . . With an Appendix against Painting, Spots, Naked Breasts, etc.* (London, 1654), 107.

38.　Marshall Smith, *The Art of Painting According to the Theory and Practise of the Best Italian, French, and Germane Masters . . .*, 2nd ed. (London: Printed by M. B. for the author, and . . . sold by R. Bently, 1693), 44.

39.　It is possible that the Sandwich portrait of Mazarin (see fig. 46) may have passed from the sitter herself to Ralph Montagu, ambassador to France, one of her most devoted allies and admirers at the English court, and ultimately one of the two executors of her estate. Credited by many with having been instrumental in bringing the Duchess Mazarin to England in the first place, Montagu was reported to have been forbidden by the king to associate with her even after the king himself was no longer involved with her. "Mr. Montagu goes no more to Madam Mazarin's, the town says he is forbid: whether his love or his politics were too pressing I know not," recorded the Countess of Sunderland in March 1680. Anne Digby, Countess of Sunderland, to Henry Sidney, 22 March 1680, cited in *The Duchess Hortense: Cardinal Mazarin's Wanton Niece*, by Bryan Bevan (London: Rubicon Press, 1987), 88. The possession of this portrait image may have provided a means of fulfilling a desire for the original—either in his banishment from her or following her death—otherwise unattainable by Montagu.

40.　PRO, SP 29/275, fol. 74. Lucien Perey indicates that an alternate version of this story was published in a letter printed in the *Gazette d'Amsterdam* in April 1670: "Don Domenico Gusman and Don Augustin Chigi, having quarreled over a small portrait of Madame Mazarin that one of them had received, were on the verge of settling their differences at sword-point, but the Constable Colonna reconciled them." Lucien Perey [Clara Adéle Luce Herpin], *Une Princesse Romaine au XVIIe Siécle: Marie Mancini Colonna* (Paris: Ancienne Maison Michel Lévy Frères, 1896), 94.

41.　The Palazzo Colonna in Rome was the primary residence of the Duchess Mazarin's sister Marie and her husband, Lorenzo Onofrio Colonna, Constable Colonna, and the site of a number of Mazarin's own self-exiles from her husband in France.

42.　Jacques de Belbeuf to his mother, La Haye, 21 May 1671, transcription in Perey, *Une Princesse Romaine*, 94.

43.　See Petrucci, "Monsù Ferdinando Ritrattista," and Petrucci, *Ferdinand Voet*, 210–61.

44.　Likewise, there appears to be little question regarding the consistently notorious nature of Voet's clientele during his time in Rome. Didier Bodart, in his entry on Voet in the first volume of his *Les Peintres des Pays-Bas Méridionaux et de la Principauté de Liège à Rome au XVIIème Siècle*, Etudes d'Histoire de l'Art (Brussels and Rome: L'Institut Historique Belge de Rome, 1970), cites contemporary documents that acclaim Voet as a "painter [celebrated] . . . for his sublime style of portraiture and in particular for flattering his women sitters not only in their beauty but in their curiously exotic costumed poses." The same sources also

record that "he was expelled from Rome by the government on the grounds that his brush was an instrument of licentiousness and his home a continuous resort of ladies and their escorts buying portraits" (Archivio di Stato di Firenze, Avvisi di Roma, 29 Jan. 1678, in Alesssandro Ademollo, *I Teatri di Roma nel Secolo XVII* [Rome, 1888], 152, cited in Bodart, *Les Peintres*, 194 n. 2). Indeed, Petrucci suggests that Voet's expulsion from Rome in 1678 on the grounds of libertine conduct may well have been directly related to the popular perception of his most popular portrait subjects.

45. Petrucci, the curator of the Chigi collection at Ariccia, describes the Chigi series as "the first and original, progenitor of all the others" in "Monsù Ferdinando Ritrattista," 289. See also his assertion several pages earlier: "The initial series was commissioned by Chigi and not Colonna, as has repeatedly, arbitrarily been claimed" (283). Petrucci proposes for the first time in the scholarly literature surrounding these series that even the earlier, 1672 series commissioned by Chigi is likely to have been based largely on existing portraits, sketches, or designs, copied and assembled as a series for the first time, rather than painted from the life for the purposes of the "beauties gallery." For a discussion of "beauties series" in the 1660s and 1670s, see the essay by Catharine MacLeod and Julia Marciari Alexander in this volume.

46. While in many respects I am in full agreement with the judgments of Francesco Petrucci regarding the iconography of the Duchess Mazarin and Voet's role in promulgating that iconography, in this particular instance we part ways. While Petrucci designates this particular portrait subject as Lucrezia Colonna, sister of Lorenzo Onofrio Colonna and sister-in-law of Maria and Hortense Mancini (see Petrucci, *Ferdinand Voet*, 238, cat. 188.d), my own assessment of the portrait is that it depicts instead Hortense Mancini, Duchess Mazarin, as does Petrucci's cat. 188.c. I make this judgment in part on the basis of the striking iconographic similarities between these two portraits and Petrucci's fig. 18, a painting in the collection of the Palazzo Colonna tentatively identified as a representation of Marie Mancini as Armida but which, for several reasons, may more likely depict her sister Hortense in the same guise. Additionally, Petrucci himself acknowledges that the inscriptions verso on cats. 188.c and d on which he relies for identification of the sitter are not necessarily contemporary with the paintings themselves (written communication to author, 10 Sept. 2007).

47. Prisco Bagni, *Benedetto Gennari e la Bottega del Guercino* (Bologna: Nuova Alfa Editoriale, 1986), no. 91, my translation from the Italian: "Un quadro assai grande ritratto della duchessa Mazarini atorniata da quattro mori uno dei quali sta sonando un corno, l'altro piú piccolo sta a cavallo di un gran cane e l'altro tiene nella mani il lasso di un altro et il maggiore con una scodella all mano prende da una fontana un poco d'acqua per darlo a bere a detti cani stando la Duchessa a sedere con un dardo alla mano vestita come una Diana. Questo quadro fu fatto per lei medesima." The register records as well that Gennari subsequently copied from the full-sized portrait of Mazarin a smaller one (see Bagni, *Benedetto Gennari*, no. 98).

48. See Leonard Barkan, "Diana and Actaeon: The Myth as Synthesis," *English Literary Renaissance* 10 (1980): 317–59. Barkan posits that this identification of goddess and mortal derives on its most basic level from the fact that, in the terms of the narrative, both Actaeon and Diana are hunters and both have taken refuge from the heat of the sun in the same wood.

49. *Ovid's Metamorphosis Englished, Mythologized, and Represented in Figures by George Sandys*, ed. Karl K. Hulley and Stanley T. Vandersall, with a foreword by Douglas Bush (Lincoln: Univ. of Nebraska Press, 1970), bk. 3, lines 178–91. This is the modern critical edition of *Ovid's Metamorphosis English'd by G[eorge] S[andys]* (London: Printed by William Stansby, 1626), the first English translation of the *Metamorphoses*.

50. Boccaccio, *Genealogie Deorum Gentilium Libri*, ed. Vincenzo Romano, 2 vols. (Bari: G. Laterza, 1951), 2:801, excerpted in Françoise Bardon, *Diane de Poitiers et le Mythe de Diane* (Paris: Presses Universitaires de France, 1963), 5, my translation from the French: "afin que pour ce c'est entendu la Lune, laquelle jette ses rais qui sont entendus en lieu des fleches."

51. Jean Ogier de Gombaud, *Les Poésies de Gombaud* (Paris, 1646), 53, cited in "Le Portrait en Diane et la Préciosité," by Françoise Bardon, *Rivista di Cultura Classica e Medioevale* 12 (1970), my translation from the French: "Quand je la vois briller sous un voile funeste / Comme une autre Diane au milieu de la Nuit, / Quelle est mon aventure, à quoi suis-je réduit? / Je demeure confus, sans parole et sans geste."

52. "Lettre à Monsieur de La Fontaine, [Nov. 1687,]" in Ternois, *Saint-Evremond: Lettres*, 2:109–10, my translation from the French: "Travaillez, Monsieur, tout grand Poëte que vous estes, à vous former une belle idée,

et malgré l'effort de vostre esprit, vous serez honteux de ce que vous aurez imaginé, quand vous verrez une personne si admirable." For a detailed discussion of the relationship between the Duchess Mazarin and Saint-Evremond, see Denys Potts, "The Duchess Mazarin and Saint-Evremond: The Final Journey," in *"The Wandering Life I Led": Essays on Hortense Mancini, Duchess Mazarin, and Early Modern Women's Border-Crossings*, ed. Susan Shifrin (Newcastle upon Tyne: Cambridge Scholars Publishing, forthcoming, 2008).

53. Bardon, *Diane de Poitiers*, 50, my translation from the French: "L'art consacré à Diane de Poitiers fut un art officiel, un art de cour."

54. Andrew R. Walkling, "Masque and Politics at the Restoration Court: John Crowne's Calisto," *Early Music* 24, no. 1 (Feb. 1996): 31.

55. Walkling, "Masque and Politics," 51.

56. James A. Winn has commented on the ironies inherent in the casting of *Calisto* in *"When Beauty Fires the Blood": Love and the Arts in the Age of Dryden* (Ann Arbor: Univ. of Michigan Press, 1992), 237.

57. Hulley and Vandersall, *Ovid's Metamorphosis Englished*, bk. 3, lines 165–67.

58. See Diana de Marly, "The Establishment of Roman Dress in Seventeenth-Century Portraiture," *Burlington Magazine* 117 (1975): 443–51.

59. Hulley and Vandersall, *Ovid's Metamorphosis Englished*, bk. 3, lines 227–28.

60. Hulley and Vandersall, *Ovid's Metamorphosis Englished*, bk. 3, lines 187–89.

61. PRO, SP 32/15, fols. 359–60.

62. I am indebted for this notion of a "living" imagery to Bardon's conceptualization of the transition in the iconography of Diane de Poitiers to a "living allegory," animated by its application to the specifics of contemporary history and quotidian existence. It is said by Bardon to have combined "the prestige of mythology and the mystery of legend" to Diane's greater glory, and to have given a particular face to what had been routinely relegated to a recondite classical allegory uninflected by attachment to a specific human subject during the Italian Renaissance. See Bardon, *Diane de Poitiers*.

63. See Kim F. Hall, *Things of Darkness: Economies of Race and Gender in Early Modern England* (Ithaca, N.Y., and London: Cornell Univ. Press, 1995), 245. Hall also remarks on several other portraits of this period of women represented with black servants; she cites one in particular that has been identified as a depiction of Barbara Villiers, Countess of Castlemaine. The portrait tentatively identified by Hall as that of the Duchess Mazarin has conventionally been called "Duchess of Portsmouth." While it is not my brief here to confirm or question Hall's suggested reidentification, I would certainly concur that, as she notes, the features of the sitter portrayed by Willem Wissing subscribe less to the established iconography of Louise de Kéroualle, Duchess of Portsmouth, and more to that of the Duchess Mazarin (see, for instance, the ca. 1693 portrait of the Duchess Mazarin at the Graves Art Gallery, Sheffield, attributed to Godfrey Kneller, in Shifrin, "'A Copy of My Countenance,'" 301, pl. XXXI). Additionally, the reidentification may be further bolstered by the appearance here of the semi-ubiquitous parrot included as an attribute in several written and painted portraits of the Duchess Mazarin, such as the Gennari "Diana" and a hybrid genre/portrait painting attributed to Francesco Maltese, to be discussed at length along with the Gennari portrait in a forthcoming essay coauthored with Andrew Walkling in Shifrin, *"The Wandering Life I Led."*

64. These words from Boccaccio's *Genealogia* are cited in Bardon, *Diane de Poitiers*, 5, my translation from the French: "les physiciens attribuent la couleur blance entre les couleurs de la Lune"; "laquelle refrène et resserre par la froideur les concupiscences charnelles."

65. This construction of an inherent carnality in the relationship between black and white adheres to the prevailing characterizations of blackness in early-modern European courts. For a more detailed discussion of the contemporary figurations of the Duchess Mazarin's presumed transgressions in terms of the metaphor of "blackness," see Shifrin, "'A Copy of My Countenance,'" 204–7.

66. Hall, *Things of Darkness*, 76; see also Shifrin, "'A Copy of My Countenance,'" 72–222.

67. For further discussion of Cleopatra, "foreignness," and "blackness," see Hall, *Things of Darkness*, 182–87.

68. *Letter Containing a True Character*, 116, 119–20.

69. As we have seen in the foregoing passage, however, the disruption of male penetration was by no means complete or without ambivalence in even the most conventional retelling of the story: even faced with the

dire consequences suffered by Actaeon, the lure to look at a painted Diana proved irresistible as a matter of course, just as the original Actaeon had been powerless to avert his gaze.

70. [Claude-Marie Guyon], *Histoire des Amazones Anciennes et Modernes* . . . , 2 vols. (Amsterdam: Zacharie Chatelain, 1748).

71. PRO, SP 29/376, fol. 198 [138].

72. From "Oraison Funèbre de Madame Mazarin" [1684], in Saint-Evremond, *Oeuvres Choisies de Saint-Evremond* . . . , ed. A.-Ch. Gidel (Paris: Garnier Frères, Libraires-Editeurs, 1866), 394–95, my translation from the French: "Jamais Hélène ne parut si belle qu'était Hortense. . . . Avec le visage d'Hélène, madame Mazarin avait l'air, l'équipage d'une reine des Amazones: elle paraissait également propre à charmer et à combattre," and ". . . une beauté si extraordinaire est préférable à toute valeur, et . . . il y a plus de conquêtes à faire par ses yeux, que par les armes de ses grands hommes."

The Female Politician in the Late Stuart Age

Rachel Weil

O N 27 NOVEMBER 1688 Elizabeth Hastings, Countess of Huntingdon, having come home to her old neighborhood after "a visit to my cousen," wrote to her "brother" with news:

> Your young freand that was in love so much the last summer and your witty profane freand has plaid a very wise part and though younger may giv you all an excample in these love matters; and if you will not follow itt you must be enfallibly ruened; we women understanding these afairs, you may take our advise, and if you will not you shall loose your mestris. The fat gentlewoman's freand will I am confident be a freand to you; if you wount accept itt hee will make love for himself You will wonder that I talke of these threvolos [frivolous] afairs in these serios times, for averybody puts on a grave fase and here is a bondans [abundance] of news, but I allwais resolv to write none.[1]

The next week she was still obsessed with romantic matters: "My cousen is a very prudent person, and I would bee with her as soon as I might if I could hope to due my brother any servic in his amour, but whilst he gose on in the way he is in tis not possible."[2] On 7 December she was more urgent, telling her "brother" that "his letle nephew has . . . a great senc of the advantage that this match will be."[3]

These letters at first glance seem to prove that women cared more about love and marriage than about politics. Elizabeth Hastings pointedly ignored news about the invasion of William of Orange, which was occurring at the time she wrote. But on closer inspection the letters turn out to be all about William of Orange. Thanks to the editors of the Historical Manuscripts Commission volume of the Hastings manuscripts, who crack the code for us, we know that the recipient of the letter was in fact not Elizabeth's brother but her husband, Theophilus, seventh Earl of Huntingdon; that "my cousen" was Princess Anne, in whose entourage Elizabeth served; and that the "young freand" and "witty profane freand" were a Captain Tidcombe and Ensign Bonfoy, respectively, who had joined the Prince of Orange.[4]

The courtship that Elizabeth was so desperate to urge was Theophilus's political courtship of William. She was, quite sensibly, telling her husband (who had been up to this point one of James II's most dedicated henchmen) to join the winning side, and to make use of all available intercessors such as the "prudent" Princess Anne to obtain William's friendship. Showing a properly feminine indifference to politics, Elizabeth Hastings was giving very smart political advice.

Claims that women care, or should care, nothing for politics seem in the late Stuart period to have been made with a wink, a nudge, and fingers crossed behind the back. The Countess of Huntingdon's disingenuous disavowal of interest in serious political matters was echoed in the closing of the 1697 pamphlet *Letter to a Gentlewoman Concerning Government*, in which female readers were admonished that "silence becomes your sex . . . especially in a matter so far above your reach." The author advised that with respect to politics, "the most commendable quality in a woman is believing and speaking as your fathers, husbands, brothers and kinsmen do, or, however, keeping your opinion and judgment to your selves."[5] The very fact that the pamphlet was addressed to a female audience, however, suggested that its author was concerned about what women thought.

Our understanding of the scope of women's involvement in early modern political life has expanded dramatically over the last two decades. It is no longer possible to believe that seventeenth- and eighteenth-century women were confined to the home and excluded from the political sphere. Pioneering biographical studies by Frances Harris on Sarah Churchill, Duchess of Marlborough, Amanda Foreman on Georgiana Cavendish, Duchess of Devonshire, and Lois G. Schwoerer on Lady Rachel Russell, among others, have documented the commitments and actions of individual women.[6] An important collection edited by Amanda Vickery, *Women, Privilege and Power: British Politics, 1750 to the Present*, stresses how utterly normal it was for elite women to engage in activities that must in some sense, and sometimes an obvious sense, be called political. Thus, Elaine Chalus contends in her study of women's patronage requests to Thomas Pelham-Holles, first Duke of Newcastle, in the 1750s that women's involvement in patronage networks was "eminently suitable to women" of the political elite.[7] Judith Lewis makes the simple but stunning point that when the Duchess of Devonshire canvassed for Charles James Fox in the Westminster election of 1784—an act made famous by vicious visual and verbal satires about it—she was in fact one of six or seven women to do so.[8] Another recent collection, edited by James Daybell, *Women and Politics in Early Modern England, 1450–1700*, likewise emphasizes the political roles of women prior to the eighteenth century.[9]

This new literature on women and politics is wonderful for many reasons. The writers I've mentioned show a healthy skepticism with respect to the difference

between precept and practice, which the example of the Countess of Huntingdon bears out. These studies also emphasize the agency of women, always a welcome thing. Moreover, they show an appreciation for the very blurriness or malleability of the lines between public and private, personal and political. In this sense the new work on women and politics feeds and draws from the budding field of "court history," which places an emphasis on informal means of exercising power.[10] Studies of women in politics have thus contributed to a rethinking not only of the role of women but of the nature of politics, and of what counts as politics.

Nonetheless, there are aspects of this new historiographical trend that raise questions. First, it is oddly Namierite in its approach to politics. That is, scholars have been most successful in uncovering the power of women when they treat politics in terms of personal relationships, as a matter of making connections and building patronage networks.[11] In this sense, the new scholarship on women and politics runs counter to more recent work in the fields of political history and political culture. For the late Stuart period, for example, such historians as Tim Harris and Mark Knights have stressed the importance of ideology, propaganda, images, party conflict, and politics "out of doors."[12] Moreover, the large claims that have been made for the political influence of court women like Louise de Kéroualle, Duchess of Portsmouth, can ironically come to replicate (albeit with inverted values) allegations made by angry contemporaries about female rule behind the throne.[13] By discovering and celebrating women's exercise of power, we also may lose a sense of its limits. There is certainly no doubt that the mistresses of Charles II were successful as patronage brokers, obtained favor for friends, and were present in spaces where political negotiations or conversations took place.[14] Some claims made by historians about the extent of these women's power, however, can go too far.

The Duchess of Portsmouth, for example, has been credited with controlling access to Charles II.[15] But although Portsmouth's apartments were indeed a place where politicians met the king informally, they were hardly the only route of access. Indeed, George Savile, Marquess of Halifax, who was by no means a fan of Portsmouth, consoled himself with the thought that the king "had one quality that would preserve him from being very long in ill hands, which was he would hear all persons, and admit of informations by the back door, when those that seemed favourites little dreamt of it."[16] There is some evidence, moreover, that access to the mistresses' apartments was indirectly controlled by Charles. When George Digby, second Earl of Bristol, offended the king over the impeachment of Edward Hyde, first Earl of Clarendon, and other matters, he tried to remain in Charles's presence by dining at the apartments of Barbara Villiers, Countess of Castlemaine (later Duchess of Cleveland). Charles announced that either he or Bristol would have to discontinue such visits, and so Castlemaine temporarily forbade Bristol to attend.[17]

The friendship of mistresses and successful male politicians is also frequently cited as evidence of the former's power.[18] However, although one might be tempted to think that Portsmouth's friendships with the earls of Arlington, Danby, and Sunderland advanced these men in the king's favor, it is just as possible—if not more so—that she attached herself to them precisely because they were influential. Indeed, the fact that mistresses tended to attach themselves to politicians on the rise might be indicative of their own lack of power as independent players. The role of any favorite was to please the king, which meant confirming him in courses he was already taking rather than disputing his decisions. A favorite whose political views differed sharply from the king's would lose favor. For this reason, the idea that Charles's mistresses were powerful because of their influence over the king should be taken with several spoonfuls of salt. As Sonya Wynne sums it up, "It cannot be claimed that any of the mistresses convinced Charles to do something he did not wish to do (indeed, they had some spectacular failures) and there is not enough evidence to tell us whether they influenced him on matters where he did not already have a strong opinion.[19]

How, then, do we navigate a course between the Scylla of trivializing women's role in politics and the Charybdis of wishfully attributing power to them that they did not have? In the rest of this essay, I will sketch out an approach that acknowledges the ways women might have had power but also stresses the limits on, and sometimes the illusory nature of, that power. This will focus on two of the female royal favorites of the late Stuart period: the Duchess of Portsmouth in the reign of Charles II and the Duchess of Marlborough in the reign of Queen Anne.

The first case study in this essay owes a tremendous debt to the excellent research of Sonya Wynne. My approach differs from hers, however, in emphasis. Wynne privileges "secrecy" as the key to women's participation. It was precisely because women were thought to be innocent and uninvolved in the realm of politics, she argues, that they could carry out unique and important functions. A case in point is Henrietta Anne, duchesse d'Orléans, who was instrumental in concluding the secret Treaty of Dover in 1670 under the guise of a social visit to her brother Charles II.[20] Likewise, the French ambassador was able to meet Charles secretly in the apartments of the Duchess of Portsmouth. In a similar vein, Wynne points out that women often received gifts that in reality were intended for the men with whom they were associated, in contexts where an open gift to the man in question would have led to negative publicity. Louis XIV's gifts to Portsmouth and Castlemaine, for example, were understood by Charles II as gifts to himself. Madame Colbert de Croissy (wife of the French ambassador) gave a present to Lady Arlington after the completion of the Treaty of Dover, even when Henry Bennet, first Earl of Arlington, had refused such a gift. "The point," Wynne concludes, "was

that women were not officially involved in politics at this level, and therefore they could show the gifts around the court, to be admired by all, with impunity, whereas a man could have been open to charges of bribery, even treason."[21] It is, then, women's association with the nonpolitical that was politically enabling: "Seventeenth-century belief in female inferiority meant that women's presence in high politics was duly overlooked. The consequent theoretical non-participation of women combined with an involvement in practice, which enabled the mistresses to play a significant part in the conduct of court politics."[22]

Although women may have been able to carry out "undercover" political activities, it strikes me as more important that women were entirely visible in the political arena. The king's relations with his mistresses were highly public. We may be most familiar with their negative role of scapegoat. Charles's mistresses were depicted in satire—mostly unpublished satire—as sources of festering, putrid corruption, responsible for all the bad policies (popery, tyranny, the Anglo-French alliance) pursued by the otherwise pure and virtuous king.[23] Yet that does not exhaust the images or the role of those images. Charles's very public sexuality also conveyed positive messages about kingship. It displayed his virility, his likeness to the biblical David, and his distance from pleasure-shunning Puritans. The circulation of images of Charles's mistresses in poses that invited the viewer to be seduced created a bond between Charles and his subjects as desirers of the same woman.

Where my approach differs from Wynne's, then, is in its attention to the public representation and symbolic role of mistresses. I am interested in how the reality of women's involvement in politics was affected by the ways in which that involvement was represented. This approach hinges on the symbolic, discursive, and public rather than the personal or private: I will look not at what mistresses did that was not seen and cannot be known (that is, their undocumented influence), but at what contemporaries did see, and what they thought they were learning, when they watched mistresses at court.

Mistresses were part of the *semantics* of politics. They were an element of the symbolic language of male politicians in their relations with one another. Male politicians put their associations with court women to use: to be seen as being associated with the currently most powerful royal mistress would boost one's credibility in the eyes of other male courtiers, regardless of whether it actually gave one leverage over the king. When Charles II publicly bedded Louise de Kérouaille at Lord Arlington's house at Euston, it no doubt enhanced Arlington's standing as a person thought to be trusted by the king.[24] Likewise, Robert Spencer, second Earl of Sunderland, was not simply making a statement about the mistress's power, but about his own as well, when he instructed Henry Sidney to tell William of Orange

how instrumental she hath been in changing the council, and in several other things. In short, I am to tell him that she is the one Lord Sunderland does make use of, and that he must do so too if he intends to do any good with the king. She hath more power over him than can be imagined.[25]

Mistresses were also part of the political language employed by the king. Relations with mistresses were not put by contemporaries into the category of "private," but rather understood (rightly or wrongly) to have precise political meanings. The rises and falls of women in Charles's favor were watched closely not merely out of prurient interest but as portents of shifts in the king's policies or choice of ministers. When Samuel Pepys reported that Edward Montagu, first Earl of Sandwich; Sir Henry Bennet (later first Earl of Arlington); and George Villiers, second Duke of Buckingham, were a "committee . . . for the getting Mrs. Stuart for the King,"[26] or when Grace, Lady Chaworth passed on to Lord Roos "the various reports of Lady Portsmouth, some saying she is going out, others that she is still highly in favour,"[27] they were not merely gossiping about sex, but recording news of political import. It is significant in this respect that the most important mistresses had known connections to politicians and factions. That is, it was public knowledge that the Countess of Castlemaine loathed the Earl of Clarendon and that Hortense Mancini, Duchess Mazarin, was connected to the Duke and Duchess of York. Even the politically "innocent" Nell Gwyn was known to dislike Thomas Osborne, first Earl of Danby. And of course, after 1682, any visitor to the Duchess of Portsmouth's apartments would have been reminded of her French identity and friendship with Louis XIV, as the apartments were furnished, according to John Evelyn, with a "new fabrique of *French Tapissry* . . . some pieces had *Versailles*, St. *Germans* & other Palaces of the French King with Huntings, figures, & landscips, Exotique fowle & all to the life rarely don."[28]

It is precisely because of these associations of mistresses and political figures that Charles could use his mistresses to communicate intentions or preferences; he could send signals about matters of state through his handling of matters in the bedchamber. Clarendon's decline in the king's favor was played out on the terrain of relations between their respective female companions: when Charles learned that Clarendon's wife had not visited the Countess of Castlemaine, the king reprimanded the chief minister for his wife's lack of courtesy.[29] Similarly, Lord Danby's political vulnerability would have been evident in court circles, and perhaps to a wider public, from the fact that Lady Danby had been caricatured in a private performance at the house of Nell Gwyn, a performance that the king had witnessed and enjoyed, and about which he declared that "he would not deny himself an hour's divertissement for the sake of any man."[30] A similar use of humiliation of

and by a woman to indicate the standing of a man occurred in 1669 when the Countess of Castlemaine, after an elaborate exchange of insults with Elizabeth Harvey, engaged the actress Katherine Corey to ridicule Lady Harvey on stage. As the latter was an ally of Buckingham and Arlington, Charles's refusal to honor Buckingham's request that Mrs. Corey be disciplined could be taken as a slap at Buckingham *through* Lady Harvey.[31]

I would further argue that in the reign of Charles II, mistresses had an especially significant place as the carriers of political messages not because they were coded as belonging to the apolitical or private sphere, but because they occupied an ambiguous space between the public and private. Their status as women did not render their politically relevant actions invisible, but rather made the political meaning of these actions both visible and "plausibly deniable" at once. Here, the political style of Charles II was crucial to the dynamic. The king was the master of the mixed signal. Having seen his father lose his head as well as his throne by a stubborn adherence to principles, Charles II adopted a strategy of being all things to all people, holding out hope to all parties at all times. Charles's real intentions—whether he intended to prorogue or dissolve the Parliament, uphold the Church or the dissenters, convert to Catholicism or not, make war on the French or the Dutch, banish the Protestant Duke of Monmouth or the Catholic Duke of York—were perpetually obscure to contemporaries, and indeed to later historians. As John Spurr has aptly noted, "an air of secrecy, deception and equivocation pervaded all manner of activities" in the period.[32] The important point, then, is not simply that Charles used his very public interactions with mistresses to communicate political intentions and preferences, but rather that he used them to communicate intentions and preferences that he might later wish to deny. After all, a night of revelry with a lady is not the same thing as a royal proclamation; it might have a political meaning, but it might also be written off as merely a matter of private pleasure. Precisely because such events could be construed as merely private, they offered plausible deniability.

Two aspects of the Duchess of Portsmouth's career as a royal mistress help illustrate the way that Charles's relations with mistresses worked as a means of political communication, providing the king with opportunities to make gestures to indicate he might favor a policy that he nonetheless did not openly embrace and might later disavow. First, Portsmouth was a visible symbol of France and French interests. When war loomed between England and France in 1678, John Reresby recalled, he himself "thought it impossible by what I heard, and seeing the king, duke [of York] and French ambassador so often very merry and intimate at the Duchess of Portsmouth's lodgings, laughing at those that believed it in earnest."[33]

The warm reception that Portsmouth received when she visited France from March to June 1682 was a conspicuous token of the friendship between Charles and Louis XIV: Charles asked Louis to support her interests, Louis obliged and further showered her with gifts, and Charles showed her great affection on her return.[34] This exchange of friendly gestures nicely served the English king's diplomatic agenda. It came at a time when Charles, seeking to avoid being pressured by the Spanish and Dutch into a defensive war against the French king, was presenting himself to them as a mediator who could restrain Louis's ambitions. The mutual caressing of Portsmouth by Charles and Louis encouraged the Dutch and Spanish (and perhaps the English public) to think that Charles had some sway over Louis, as well as warned them that they should not expect Charles to break with Louis even if the latter should prove aggressive. It stopped short, however, of being an open declaration of an Anglo-French alliance, which would have constituted a slap in the face to the other European powers whose trust Charles was trying to gain, and might have provoked a hostile reaction at home. Portsmouth's visit thus sent a usefully equivocal message to foreign and domestic audiences, demonstrating Charles II's closeness to the French king without committing him to actions that would destroy his credibility as a mediator or stir up immediate domestic outrage.[35]

An even more intriguing episode in Portsmouth's political career is her abandonment of the Duke of York and apparent support for the Exclusion Bill in 1680 and early 1681. Portsmouth's behavior was surprising to contemporaries. She had been savagely attacked by the Whigs and, given her reputation as the proponent of tyranny and Catholicism, was not a likely person to support the exclusion of Charles's Catholic brother from succession to the throne. Newsletters of the time reveal that her stance was public knowledge: as Christopher Philipson wrote to Daniel Fleming, "The d[uchess] of P[ortsmouth] is turned to the Pro[testant] religion and, as 'tis said, one of Shaftesbury's convert, and very kind to the d[uke] of M[onmouth]."[36] Not surprisingly, her behavior was read as an indication of the king's secret preferences. French diplomatic dispatches decoded Portsmouth's break with York as a sure indication that Charles himself must have abandoned his brother, for "it is not thought that someone who has the intimate confidence of the king of Great Britain would act lightly and on such an important occasion, and Mme. Portsmouth would be closely allied to the duke of York if she believed that he will be supported [by the king]."[37] Of course, in the end Charles II did not support the Exclusion Bill. But, as Wynne persuasively argues, Portsmouth may well have been acting with the king's knowledge and approval. Charles did in fact persist in secret negotiations with Exclusionists even after publicly rejecting the legislation, even if only (though it is hard to tell) for the sake of stringing them

along. In that context, Portsmouth's behavior was a signal (useful at the time, albeit ultimately misleading) that the king might just change his mind.[38] It was—or was taken to be—a signal of Charles's intentions, but it was a plausibly deniable one.

Women were good vehicles for the sending of ambiguous political messages precisely because one's politically significant interactions with them occurred on the boundary of public and private; that is, those dealings could be labeled public and significant, or private and irrelevant, depending on one's needs at the time. This observation can lead to the depressing conclusion that court mistresses were more pawns than agents; king and courtiers had reasons to make mistresses seem to wield power, but ultimately in ways that enhanced their own. We can also suggest, however, that even the illusion of power constituted a form of power in early-modern court society. There is a relationship between the presence of images of women as powerful and the power that they actually have, but it is not a straight-forward descriptive relationship. In Portsmouth's situation, being used as a symbol actually gave her some power. We might be skeptical of claims that Portsmouth really influenced the king, or that he needed her as a conduit to Louis XIV, or that she controlled access to him; such claims make Charles seem a prisoner and a fool. But the relevant point is that people thought she had such powers. That belief in itself gave her leverage—if not with Charles, then with those politicians who sought access to the king. In fact, Portsmouth was courted and bribed by numerous political actors.[39] Not surprisingly, royal mistresses strove not merely to retain the king's affection, but to be *seen* to have the king's affection.[40] The perception that mistresses had power took on a life of its own and translated into a form of power.

If the perceived power of mistresses gave them some form of power, however, it also set limits on what they could do. I would hypothesize that for this reason the female politician's lot was always somewhat different from the male politician's, though further comparative work would be needed to make good on that claim. For now, we can look at one figure who presents some intriguing parallels to the Duchess of Portsmouth, but who, unlike Portsmouth, left a record of her own frustrations in controlling her own image. That figure is Sarah, Duchess of Marlborough.

Sarah Jennings was in her youth the best friend of Princess Anne, who became queen in 1702. In 1688 Sarah married John Churchill, eventually first Duke of Marlborough, the greatest general of the age. From Anne's accession in 1702 until about 1707, her friendship with Sarah underpinned or at least coincided with her trust in Marlborough and his close associate, Sidney Godolphin, the Lord Treasurer: the Marlborough-Godolphin ministry and the friendship between Queen Anne and Sarah were mutually reinforcing if not causally connected. But about 1707, and culminating in 1711, two things went wrong. First, the friendship of Anne and Sarah cooled down; the queen instead developed a close friendship

with Abigail Masham, a lady of her bedchamber who was a cousin and ally of Robert Harley, the Tory politician who challenged Marlborough and Godolphin. Second, Anne was disenchanted with Marlborough and Godolphin and began to listen to Tories instead. This led to the dismissals first of Godolphin from the treasury, then of Sarah from the bedchamber, and finally of Marlborough from his command. What the relationship was between those two processes, the personal breach and the political transition, was much debated by contemporaries, and indeed by historians.[41]

Some of the interesting parallels between the Duchess of Marlborough and the Duchess of Portsmouth have to do with the monarchs with whom they associated. While Queen Anne differed from her uncle Charles in many respects, their styles of political communication were oddly similar. Contemporaries found Anne, like Charles, almost impossible to read or predict. Hating to be the prisoner of one party, she played Whigs and Tories off against one another, moving between them in a way that left observers puzzled as to her intentions and apt to imagine that she was in thrall to favorites. And like Charles, Anne used her relations with favorites to send political signals that contained a degree of plausible deniability.[42]

As with Portsmouth, Sarah's capacity to dictate to the monarch was much exaggerated, but the belief that she held sway with the queen had enormous consequences. Marlborough and Godolphin needed to demonstrate to their Whig allies at home and their Dutch allies abroad that they had credit with the queen. Sarah's continued presence at court and the shows of royal favor to her were, they thought, a sign of this credit. Accordingly, Sarah's standing in the queen's affection was eagerly watched by observers of all political stripes as evidence of the standing and future longevity of the Marlborough-Godolphin ministry. Like Portsmouth, she was a sign by which the queen's political intentions were thought to be communicated.[43]

There were also some important points of difference between the two duchesses. A major one is that Sarah self-consciously defined herself against the court favorites of corrupt reigns, which of course included those of Charles II. She held herself to be the unique exception to the general rule that courtiers were obsequious parasites who flattered princes in order to advance their own interests; instead, she was virtuous, and had the public good at heart. As she put it in her memoirs:

> Young as I was, when I first became this high favourite I laid it down for a maxim that flattery was a falsehood to my trust . . . that I did not deserve so much favour, if I could not venture the loss of it by speaking the truth, and by preferring the real interest of my mistress before the pleasing her fancy, or the sacrificing to her passion.[44]

Sarah claimed, as did male politicians of the day, that she possessed the quality of political virtue, the capacity to prefer public to private interest. As her friend Arthur Mainwaring put it, she was a "courtier in the interest of the country," "the only favourite a sovereign was better for."[45]

So confident was Sarah in her sense of exceptionalism that when she perceived the queen had a new and Tory best friend, Sarah slipped into a familiar language of blaming favorites for everything, with no sense that the accusations could ricochet back at her. In fact, she likened Anne and Masham to Charles II and the Duchess of Portsmouth, making the comparison firmer by hinting at a sexual relationship between the two. It is a sign of the difference in tone between the two courts that Sarah's accusations of sexual impropriety were euphemistic and veiled: in letters to Anne and to her friends, she called Anne's relationship with Abigail Masham "a very strange passion," an "extravagant passion," "an inclination that is shameful and must be concealed or denied."[46] Had it been Charles II's reign, she would have named body parts and their diseases. But the logic was identical to attacks on the Duchess of Portsmouth; like them, Sarah's point was to show that the queen's personal affection for Abigail was a matter of national rather than personal concern. By rejecting the forthright Sarah in favor of the servile Masham, Anne had shown herself addicted to flattery, and a prince who loved flattery was a tyrant. By giving way to an absurd and unjustifiable passion, Anne showed herself to be abandoned to lust, again the mark of a tyrant (like Charles II). And by breaking a youthful oath never to let herself be parted from Sarah, Anne demonstrated impiety, a sure sign that she was a tyrant. It was therefore no wonder, Sarah thought, that Anne's turn toward Masham went hand in hand with a turn toward the Tories. In Sarah's view, tyrants liked Tories; evil favorites encouraged tyranny and therefore Toryism; Masham, being a bad and flattering favorite rather than a good and honest one, could make Anne turn Tory; Tories had promised to protect Abigail from angry Whig critics and thus had won Anne's trust. The logics Sarah employed were multiple and confusing, but their import was the same: Anne's love of Abigail and rejection of Sarah constituted not a personal misfortune for Sarah but a crisis for the nation, the sign and cause of political undoing.[47]

In making this case, however, Sarah failed dismally. The queen made, in public, the powerful argument that she had a right to love whom she pleased, and on that ground she successfully fended off an effort (instigated by the Duke of Marlborough) to force her to dismiss Masham from her bedchamber. It was also on that ground that the queen justified firing Sarah from her office as Groom of the Stole. In all this we can see Masham and Sarah both being used by the monarch, as Portsmouth had been before them, as political signs. By defending Masham and firing Sarah (especially over the protests of Sarah's husband), Anne was sending a

fairly clear political signal but presenting it as merely a personal and private matter. The queen was thus able to float a trial balloon, to test the reactions to and consequences of the course she was later to take (that is, changing her ministry), before actually committing to that course.

Anne was extremely successful in having her break with Sarah defined as a personal rather than political matter. For different reasons, Whigs and Tories alike found it convenient to accept publicly the truth of that claim. The Tories, in supporting Anne's right to love whom she pleased, were supporting the presence of a Tory in the bedchamber. The Whigs, when they saw that they could not prevent Anne from getting rid of Sarah, downplayed the significance of her dismissal as anything but a personal matter. Thus, only Sarah was left saying out loud that the choice of Abigail as a favorite portended alterations in the state. She was right: the Duke of Marlborough was dismissed a year later, and the Tory Robert Harley became prime minister.[48]

Sarah Churchill left a much more complete record of her reactions to her political fate than did the Duchess of Portsmouth. It is clear in her writings that the key issues for her hinged upon the definition of events as "public" or "private." What was so isolating and humiliating for Sarah was not that she failed as a favorite to retain Anne's affections (she managed to see this as a sign of her virtuous inability to flatter the queen), but that she could not get anyone to believe she was a politically redemptive favorite different from other favorites who were politically corrupting. She was pegged by others, political friends as well as enemies, merely as a woman scorned. Ironically, her publicly demonstrated feelings of righteous anger at Anne's change of heart and bedchamber were then given a symbolic meaning by Tory propagandists, as illustrations of the self-dramatizing, self-aggrandizing, and selfish tendencies of the former Whig ministry. Her claims to disinterested political virtue were almost universally dismissed.[49] But even the highly political use of Sarah to discredit the Whigs in general relied on maintaining the fiction that Sarah's troubles with Anne were merely personal.

It is by no means clear that other female court favorites wished, as Sarah did, to be perceived as advisers, politicians, or counselors whose relations with monarchs were indistinguishable from those of men. Indeed, as Wynne's work suggests, many of them might have found the notion that their relationship with a monarch was "merely personal" to be highly convenient. The important point here, however, is that while any female favorite's relationship with a monarch was always *both* personal and political, the labeling of that relationship as personal or political was not under the control of the woman in question. Although women had opportunities for political action in the seventeenth and eighteenth centuries, they were not necessarily able to define the terms of their own participation and the public perception of it. Sarah Churchill is a poignant case in point. She wanted to be seen

as a virtuous politician, a selfless defender of the public good, a statesperson rather than a favorite. Instead, what influence she had came along with being read as a sign of her husband's credit. She lost control of the meanings given to her rise and fall in Anne's affections; those meanings were given according to other people's political needs. If we celebrate the political influence and informal powers that women had in the old regime, we would do well also to remember the constraints on those powers.

This essay has suggested, at a methodological level, that questions about representation be put center stage in considering questions of women's political power. There was a dynamic and interdependent relationship between the way court women were seen and the power that they had. This is not to deny women's potential for agency. Indeed, women could be active partners in the creation of images of themselves. Moreover, as I have indicated, the very existence of beliefs that women were powerful actually gave them some power. Rather than put images of women in one box and their actual "power" in a separate box, we should look at how a woman's role as symbol gave her opportunities for agency—actual power— but also constrained those opportunities and created vulnerabilities. The complex interplay between female political symbolism and female political agency can be untangled only by the joint efforts of art historians, literary scholars, and political historians working together. We have yet to explore this rich territory fully.

1. [Elizabeth Hastings to Theophilus Hastings], 27 Nov. 1688, in *Report on the Manuscripts of the Late Reginald Rawdon Hastings*, ed. Historical Manuscripts Commission, vol. 2 (London: His Majesty's Stationery Office, 1930), 197.

2. [Elizabeth Hastings to Theophilus Hastings], 6 Dec. 1688, *Report on the Manuscripts*, 2:203–4.

3. [Elizabeth Hastings to Theophilus Hastings], 7 Dec. 1688, *Report on the Manuscripts*, 2:204.

4. The identification is made in *Report on the Manuscripts*, 197.

5. *Letter to a Gentlewoman Concerning Government* (London: E. Whitelocke, 1697), 27.

6. Frances Harris, *A Passion for Government: The Life of Sarah, Duchess of Marlborough* (Oxford: Clarendon Press; New York: Oxford Univ. Press, 1991); Amanda Foreman, *Georgiana, Duchess of Devonshire* (New York: Random House, 2000); Lois G. Schwoerer, *Lady Rachel Russell: "One of the Best of Women"* (Baltimore: Johns Hopkins Univ. Press, 1988).

7. Elaine Chalus, "'To Serve My Friends': Women and Political Patronage in Eighteenth-Century England," in *Women, Privilege and Power: British Politics, 1750 to the Present*, ed. Amanda Vickery (Stanford, Calif.: Stanford Univ. Press, 2001).

8. Judith S. Lewis, "1784 and All That: Aristocratic Women and Electoral Politics," in Vickery, *Women, Privilege and Power*.

9. James Daybell, ed., *Women and Politics in Early Modern England, 1450–1700* (Aldershot, UK: Ashgate, 2004).

10. The best-known work in this field is, of course, David Starkey, ed., *The English Court: From the Wars of the Roses to the Civil War* (London and New York: Longman, 1987).

11. Sir Lewis Namier's *The Structure of Politics at the Accession of George III* (published in 1929) emphasized the primacy of patronage and personal connection as the drivers of politics. For a seminal critique of Namier, see John Brewer, *Party Ideology and Popular Politics at the Accession of George III* (Cambridge: Cambridge Univ. Press, 1976).

12. Tim Harris, *London Crowds in the Reign of Charles II: Propaganda and Politics from the Restoration until the Exclusion Crisis* (Cambridge: Cambridge Univ. Press, 1987); Mark Knights, *Politics and Opinion in Crisis, 1678–81* (Cambridge: Cambridge Univ. Press, 1994); Knights, *Representation and Misrepresentation in Later Stuart Britain: Partisanship and Political Culture* (Oxford: Oxford Univ. Press, 2005).

13. For an example of a study that uses quasi-pornographic satire as evidence of female political power, see Nancy Klein Maguire, "The Duchess of Portsmouth: English Royal Consort and French Politician, 1670–85," in *The Stuart Court and Europe: Essays in Politics and Political Culture*, ed. R. Malcolm Smuts (Cambridge: Cambridge Univ. Press, 1996).

14. Maguire, "Duchess of Portsmouth"; Sonya Wynne, "The Mistresses of Charles II and Restoration Court Politics, 1660–1685" (PhD diss., Univ. of Cambridge, 1997); Wynne, "The Mistresses of Charles II and Restoration Court Politics," in *The Stuart Courts*, ed. Eveline Cruickshanks (Stroud, UK: Sutton, 2000).

15. Maguire, "Duchess of Portsmouth," 258–60.

16. *Memoirs of Sir John Reresby: The Complete Text and a Selection from His Letters*, ed. Andrew Browning (Glasgow: Jackson & Co., 1936), 299.

17. Wynne, "Mistresses" (1997), 105; Wynne's source is Public Record Office (hereafter PRO), 31/3/112, 28 June–5 July 1663, and PRO, 31/3/112, 25 June 1663.

18. Maguire, "Duchess of Portsmouth."

19. Wynne, "Mistresses," in *Stuart Courts*, 185.

20. Wynne, "Mistresses," in *Stuart Courts*, 172.

21. Wynne, "Mistresses," in *Stuart Courts*, 184.

22. Wynne, "Mistresses," in *Stuart Courts*, 186.

23. On this literature, see Rachel Weil, "Sometimes a Scepter Is Only a Scepter: Pornography and Politics in Restoration England," in *The Invention of Pornography: Obscenity and the Origins of Modernity, 1500–1800*, ed. Lynn Avery Hunt (New York: Zone Books, 1993), and works cited therein.

24. The incident was reported in *The Diary of John Evelyn*, ed. E. S. de Beer, 6 vols. (Oxford: Clarendon Press, 1955), 3:589–90.

25. Entry for 26 June 1679, in *Diary of the Times of Charles the Second by the Honourable Henry Sidney (Afterwards Earl of Romney)*, ed. Robert Willis Blencowe, 2 vols. (London: Henry Colburn, 1843), 1:15; see also Wynne, "Mistresses" (1997), 127.

26. Entry for 6 Nov. 1663, in *The Diary of Samuel Pepys*, ed. R. C. Latham and W. Matthews, 11 vols. (London: HarperCollins, 1995), 4:366, quoted in Wynne, "Mistresses" (1997), 97.

27. Grace, Lady Chaworth to Lord Roos [John Manners, first Duke of Rutland], 19 April 1676, in *Manuscripts of His Grace the Duke of Rutland*, ed. Historical Manuscripts Commission, vol. 2, 12th Report, appendix pt. 5 (London: Her Majesty's Stationery Office, 1889), 28, quoted in Wynne, "Mistresses" (1997), 47–48.

28. Evelyn, *Diary*, 4:343.

29. Edward Hyde, Earl of Clarendon, *The Life of Edward, Earl of Clarendon* (Oxford: Clarendon, 1761), 3:683; see also Wynne, "Mistresses" (1997), 108–9.

30. [Richard Butler,] first Earl of Arran to [James Butler, first Duke of] Ormond, 9 Feb. 1678, in *Calendar of the Manuscripts of the Marquess of Ormonde*, ed. Historical Manuscripts Commission, n.s., 4 (London: His Majesty's Stationery Office, 1906), 106; see also Wynne, "Mistresses" (1997), 123.

31. Wynne, "Mistresses," in *Stuart Courts*, 180–81.

32. John Spurr, *England in the 1670s: "This Masquerading Age"* (Oxford and Malden, Mass.: Blackwell Publishers, 2000), 2.

33. Entry for 30 June 1678, in Browning, *Memoirs of Sir John Reresby*, 149.

34. The tour of France is discussed in Wynne, "Mistresses" (1997), 199; see also Sonya Wynne, "Louise Renée Penancoët de Kéroualle (1649–1734)," in *Oxford Dictionary of National Biography*, ed. H. C. G. Matthew, Brian

Harrison, and Lawrence Goldman (Oxford: Oxford Univ. Press, 2004–), http://www.oxforddnb.com/view/article/15460 (accessed June 2007).

35. See John Miller, *Charles II* (London: Weidenfeld and Nicolson, 1991), 360–65.

36. C. Philipson to Sir Daniel Fleming, 6 Nov. 1680, in *Manuscripts of S. H. Le Fleming*, ed. Historical Manuscripts Commission, vol. 2, 12th Report, appendix pt. 7 (London: Her Majesty's Stationery Office, 1890), 173–74; see also Wynne, "Mistresses" (1997), 138.

37. PRO, 31/3/146, 9 Sept. 1680, quoted and translated in Wynne, "Mistresses" (1997), 135 n. 168.

38. Wynne, "Mistresses" (1997), 144–47.

39. See Maguire, "Duchess of Portsmouth," for evidence on this point.

40. Wynne, "Mistresses," in *Stuart Courts*, 173–74.

41. Rachel Weil, *Political Passions: Gender, the Family and Political Argument in England, 1680–1714* (Manchester: Manchester Univ. Press, 1999), 215–23.

42. The best biography of Queen Anne remains Edward Gregg, *Queen Anne* (London: Ark, 1984).

43. Weil, *Political Passions*, 189–95.

44. Sarah Churchill, Duchess of Marlborough, *An Account of the Conduct of the Dowager Duchess of Marlborough* (London: George Hawkins, 1742), 11–12.

45. Arthur Mainwaring to Sarah Churchill, 6 April 1708, British Library, London (hereafter BL), Add. MS 61459, fol. 16; draft of letter, 13 March 1708, BL, Add. MS 61417, fols. 123–29.

46. Sarah Churchill to Queen Anne, 29 Oct. 1709, BL Add. MS 61418, fols. 36–43; Arthur Mainwaring to Sarah Churchill, April 1708, in *Private Correspondence of Sarah, Duchess of Marlborough*, by Sarah Churchill, Duchess of Marlborough, 2 vols. (London: Henry Colburn, 1838), 1:129, discussed in Weil, *Political Passions*, 210.

47. Weil, *Political Passions*, 212–14.

48. Weil, *Political Passions*, 215–23.

49. Weil, *Political Passions*, 215–2.

The Apotheosis of Absolutism and the Interrupted Masque: Theater, Music, and Monarchy in Restoration England

Andrew R. Walkling

IN ACT 4, SCENE 1, of William Shakespeare's *The Tempest*, the magician Prospero, rightful Duke of Milan, employs his powers to summon up a wedding masque in celebration of the anticipated nuptials of his daughter Miranda with Ferdinand, heir to the Kingdom of Naples. Seeking simultaneously to entertain the pair and to grant his blessing on their union, Prospero commands the "airy spirit" Ariel and his companions to "Bestow upon the eyes of this young couple / Some vanity of mine art,"[1] an allegorical tableau in which the goddesses Iris, Ceres, and Juno meet "Here on this grass plot / . . . / A contract of true love to celebrate, / And some donation freely to estate / On the blest lovers" (4.1.73, 84–86). This masque takes up the dual themes of mutual joy and prosperity that, Prospero has indicated, await those who honor the solemnity of marriage vows and value the proper ceremonies attached thereto. But it is more than a mere didactic exercise, a dry attempt by Prospero to "enact / My present fancies" (4.1.121–22). The performance, a product and reflection of Prospero's quasi-divine authority as both sovereign and magus, made possible through the labors of his subject spirits, serves to provoke wonder and admiration by marshaling spectacle, lofty utterance, music, and bodily movement and presenting them before a spellbound audience.

In crafting this embedded piece Shakespeare drew upon the model of real-life courtly spectacles of his day, elaborate multimedia theatrical works presented by and for an elite social-political group centered around King James I, in which the monarch's fantasies of quasi-divine power are played out in Neoplatonic terms whereby the higher "truth" of royal omnipotence supersedes and shuts out the dull veracity of physical existence, as represented by fallible flesh, wood and cloth, and unrealizable ideals. In keeping with these "court masques," the wedding masque conjured up by Prospero requires a special kind of suspension of disbelief, one in which the viewer entirely rejects the everyday world, accepting in its place a new and alternative reality defined purely in terms of its own creator's art. Like his real-world royal counterpart, Duke Prospero is figured as simultaneously inventor, designer, and prime moving force of a vision that requires—uncharacteristically

for a seventeenth-century audience—rapt attention: as he urges the young lovers when the masque begins, "No tongue! All eyes! Be silent" (4.1.59).

Juno and Ceres having offered their respective benedictions, the masque progresses to a celebration, for which Iris summons troupes of naiads and "sunburnt sicklemen" to dance their measures on the enchanted ground. Yet as the first dance nears its conclusion, Prospero *"starts suddenly, and speaks"*:

> I had forgot that foul conspiracy
> Of the beast Caliban and his confederates
> Against my life. The minute of their plot
> Is almost come. [*To the Spirits.*] Well done! Avoid; no more!
> (4.1.139–42)

In this sudden moment of recognition the old reality intrudes, the spell is broken, and *"to a strange, hollow, and confused noise, [the masquers] heavily vanish"* (4.1.138). Confronted with a genuine danger to his authority, the magician/duke sheds the fragile accoutrements of the masque, reminding his charges in a well-known passage:

> These our actors,
> As I foretold you, were all spirits and
> Are melted into air, into thin air;
> And, like the baseless fabric of this vision,
> The cloud-capped towers, the gorgeous palaces,
> The solemn temples, the great globe itself,
> Yea, all which it inherit, shall dissolve,
> And, like this insubstantial pageant faded,
> Leave not a rack behind. (4.1.148–56)

Shakespeare's *coup de théâtre* drives home a crucial point about the masque: not merely that masque is ephemeral, but that its status as an expression of royal power must be understood in terms of the converse, the absence of masque as a sign of the fragility of power. In 1609 the poet Ben Jonson had explored this same theme, opening his *Masque of Queens* with what he then called "a foil or false masque" of "hags or witches . . . the opposites to good Fame."[2] Jonson's innovation, later to be codified as antimasque, presupposed a unidirectional process in which the forces of chaos yield to those of order: the threat of the witches to "blast the light; / Mix hell with heaven, and make Nature fight / Within herself" (134–36) comes to nothing when *"on the sudden was heard a sound of loud music . . . with which not only the hags themselves but the hell into which they ran quite vanished,*

and the whole face of the scene altered, scarce suffering the memory of such a thing"
(334–37). Later on, when the royal and noble masquers appear, they are accompanied by *"the hags bound before them"* (474–75). Writing two years later in *The Tempest*, however, Shakespeare reverses Jonson's dynamic, allowing Prospero's masque to be interrupted by the specter of disorder as precipitately as Jonson's anarchic witches had been dismissed by the impending arrival of the masquers. In allowing for the possibility that the masque holds no special claim to any kind of unidirectional process leading to a predetermined end point (what philosophers would describe as *telos*), the phenomenon I shall call "interrupted masque" opens new interpretive possibilities and reflects a more multifarious conception of the role of allegorical theater in seventeenth-century English political discourse.

If, as Stephen Orgel has observed, "the masque presents the triumph of an aristocratic community; at its center is a belief in the hierarchy and a faith in the power of idealization,"[3] the very notion of presenting a masque as interrupted raises fundamental questions about the premises underlying early-modern royal authority, a royal authority of which spectacle and assertions of divine approbation constituted elemental supports. The interrupted masque suggests that, in the face of some real-world peril, the foundations of idealization are susceptible to collapse, leaving not merely the temporal power structure, but the essential ideological framework of monarchy, in doubt.

Such considerations appeared particularly trenchant within the fraught political culture of Restoration England, where the desire to come to grips with the execution of a king and two decades of constitutional experimentation produced a collective fascination with the dynamics and structures of politics and power. In the realm of cultural production, the revitalization of the heroic form in drama and poetry, the resurgence of state spectacle, and the emerging visual rhetoric of the high Baroque all contributed to an increased attentiveness to the political potential of court-sponsored artistic endeavors. Explorations of kingship and its sacral qualities can be found in profusion in the Restoration, particularly on the theatrical stage; this trend necessarily brings with it a renewed utility for the masque as a signifier of that kingship and a means of considering its attributes and processes. When we encounter an *interrupted* masque in the Restoration, then, we have an opportunity to examine the vulnerabilities and contingencies of kingship through the lens of this society for whom the shape of royal authority was becoming an increasingly divisive issue.

The aim of the present essay is to examine three instances of interrupted masque from the 1670s, 1680s, and early 1690s and to assess the significance of each, both within its theatrical context and with respect to contemporary political considerations. Each of these three masques presents a different view of the

vulnerability of kingship and its associated spectacular manifestations, yet each explores issues that were germane to the concerns of the Restoration and immediate post-Restoration polity. Moreover, all three of the masques under discussion rely heavily on the expressive and structural power of music, both as a sign of elevated discourse and as an indicator of temporality, meaning, and difference.

My purpose in undertaking this exploration is not so much to find definitive "proof" of how contemporaries understood the dynamics of interrupted masque—for that matter, there is precious little surviving commentary on the structural and philosophical aspects of any type of masque from early-modern witnesses. Rather I wish to show how our modern, theoretically developed understanding of the masque as a vital political form can be applied to the particular generic strategies of the interrupted masque. The ultimate aim is to encourage a more sophisticated view of the masque's relationship to seventeenth-century absolutist ideas and, in the process, to demonstrate the importance of dramatic structure, theatricality, and the deployment of music to the masque's expressions of sovereignty, both present and absent.

It is worth noting that, in order to function properly, the interrupted masque must, like the antimasque, exist as part of a larger environment in which the forces that bring about the change from one state of being to the next are articulated and played out. There is a crucial difference, however, between antimasque and interrupted masque. Ben Jonson's antimasque/masque model allows for the maintenance of a hermetically sealed fiction, where the intrusion of the world outside comes only in the form of time's inexorable progress, expressed through the (still mythologically figured) arrival of morning to arrest the revels of the night. The interrupted masque, on the other hand, presupposes the potency of human action in the "real" world and its power to disrupt, if not entirely overthrow, the "insubstantial pageant" and its ideological trajectory. This distinction is important because it touches upon the oft-cited criticism of the early Stuart court masque that the form's inherent disconnection from reality ultimately fosters a dangerously insecure fantasy world in which the monarch dupes himself into believing his own exalted, artificial rhetoric. The solution to such a quandary would seem to lie in the configuration of the interrupted masque, where dreams of power must always be considered against the encroachments of reality. Indeed, if we want to identify a meta-interrupted masque, we might locate it in the collapse of Charles I's "personal rule"—and its associated annual masquing celebrations—at the beginning of the 1640s.

Having said this, it is nonetheless instructive to turn our attention to the Restoration, for it is in this period, with its interruption by the political and constitutional tidal wave of 1688–89, that we encounter a unique opportunity to

examine a fundamental realignment in the masque's function: not so much its effacement as a vehicle for the manifestation of kingship as its redirection into new modes of signification, as will be illustrated in my exploration of *King Arthur*, the last of the three works to be discussed here. Indeed, the three interrupted masques that form the subject of this essay, and the larger musical/dramatic works that contain them, each represent a different phase in the evolution of monarchical theory and practice during and immediately after the Restoration:[4] Settle and Locke's *The Empress of Morocco* falls within the period of Charles II's earliest experiments with ideologically grounded, French-inspired absolutism (1673–78); Tate and Purcell's *Dido and Aeneas* derives from the era of English monarchical absolutism established under Charles II in the early 1680s and maintained throughout much of James II's brief reign; and Dryden and Purcell's *King Arthur* represents the new state of affairs prevailing in the aftermath of the Revolution of 1688–89. As we shall see, these differences of context are reflected in the narrative and structural features of the works, as well as in the functioning of the interrupted masque that each contains.

1. *THE EMPRESS OF MOROCCO* (1673)

Described by Curtis Price as the Restoration play that presents "the most skillful use of a masque to advance a plot,"[5] Elkanah Settle's rhymed heroic tragedy *The Empress of Morocco* is noteworthy for a variety of reasons.[6] When it first appeared in public at the recently constructed Dorset Garden Theatre in July 1673, it had already been performed at court by a cast of noble amateurs on at least two occasions, most likely earlier the same year.[7] The author, an ambitious young poet who enjoyed the support of John Wilmot, second Earl of Rochester, and his circle, made the most of his court connections, including a 1672 appointment as a Sewer in Ordinary to the King, trumpeting his status as "Servant to his Majesty" on the title page of the printed playbooks of *The Empress of Morocco* and several subsequent publications.[8] The *Empress of Morocco* playbook constituted an important event in another way as well: bound into the text were six engravings, including a frontispiece by William Sherwin showing the Thames-bank facade of the Dorset Garden Theatre and five images by William Dolle in which representations of important scenes from the play were each inserted into a mortised "frame" purporting to depict the theater's grand proscenium arch and elaborate architectural detailing (fig. 54). In addition, the music for Settle's play was written by Matthew Locke, the leading composer of the day, who was shortly to assume a pivotal role in the development of English opera. Taken together, all of the aforementioned

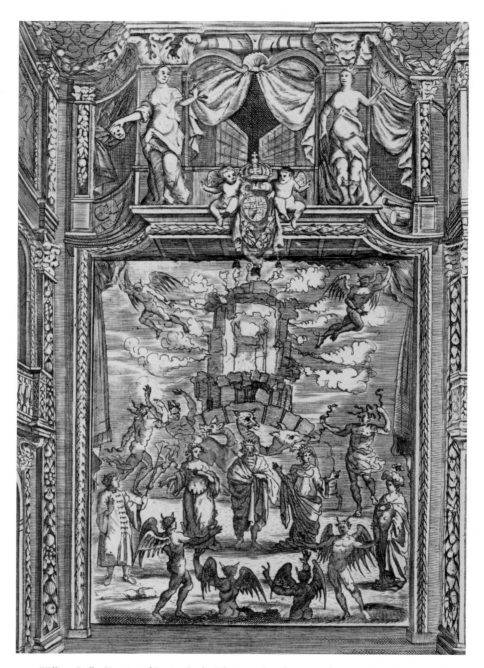

54. William Dolle, "Interior of Dorset Garden Theatre and performance of Masque of Orpheus," mortised engraved print, plate 8¼ x 5¾ in. (21 x 14.5 cm), from Elkanah Settle, *The Empress of Morocco A Tragedy. With Sculptures. As It Is Acted at the Duke's Theatre* (London: Printed for William Cademan, 1673), opp. 46. Beinecke Rare Book and Manuscript Library, Yale University.

elements proved too inviting a target for Settle's literary rivals. John Dryden, Thomas Shadwell, and John Crowne, each of whom had his own stake in the emerging field of courtly spectacular entertainments, collaborated on a pamphlet lambasting Settle's efforts—to which the young poet, in turn, replied with a detailed rebuttal far more voluminous, in its ninety-seven densely packed pages, than the play itself.[9]

The unusual circumstances of *The Empress of Morocco*—as courtly event, as public theatrical event, and as print phenomenon—underscore the perceived importance of the work at a time of both increasingly elaborate musical/theatrical productions and growing public concern about the role and power of the English monarchy. The early months of 1673 had seen a contentious parliamentary session in which Charles II and his ministers found themselves on the defensive over a range of issues, including religion, the royal prerogative, and an unpopular war with the Dutch. In particular, fears about the growing influence of Roman Catholicism at court prompted the passage of the first Test Act, a law prohibiting "Papists" from holding any public office or court appointment. In its wake, a number of Catholics were forced to withdraw from royal service, including not only lower-level musicians and dancers but even James, Duke of York, Charles II's brother and heir presumptive. The duke's failure to receive Anglican communion at Easter services in late March and his subsequent resignation of the office of Lord High Admiral on 17 June awakened a national debate about the limits of royal authority and the nature of kingship and legitimacy that would plague English politics for the next two decades and beyond.

This volatile atmosphere serves as a background to the troubled state of Morocco in Settle's play.[10] *The Empress of Morocco* is a catalogue of usurpation, treachery, murder, and lust, expressed in bombastic rhymed heroic couplets spiced with stark Hobbesian rhetoric, in which the eponymous Empress Laula crosses and double-crosses her way into the seats of power. From the opening of the first scene to the gruesome finale, four separate individuals sit on the Moroccan throne: the old emperor, poisoned at the behest of Laula, his wife; their son Muly Labas; Crimalhaz, the empress's scheming "Gallant"; and the royal prince and military leader Muly Hamet, beloved by Laula's daughter Mariamne. As the tortuous plot winds forward, the empress (played on the public stage by the actress Mary Betterton) emerges as Morocco's histrionic-in-chief, weeping, cooing, gloating, and raging in turn as occasion requires, always in the service of her evil intent. When, in act 5, Emperor Crimalhaz reveals his affection for the young Morena, daughter of the neighboring king Taffalet and now widow of Muly Labas, the jilted Laula stabs Morena while feigning to seek her pardon. She then attacks Crimalhaz but, foiled, dispatches herself instead, proclaiming:

In all my Race, I nothing find that's ill;
But that I've Barren been; and wanted still
More Monarchs to dethrone, more Sons to Kill. (61)

Laula's most stunning theatrical gesture comes in act 4, when she orchestrates the masque in which her son, Muly Labas, is to be murdered. Crimalhaz, recently entrusted with command of the Moroccan army, has decamped with the troops and the royal treasury to the slopes of Mount Atlas. Laula, counterfeiting support for Muly Labas, advises the young emperor to seek a parley with the rebel. Under pressure from Taffalet's invading army, Muly Labas agrees, reasoning,

Staying, I tamely Perish; if I go,
I face my Ruine, and I Charge my Foe.
It will more like an act of Courage look,
To be by Ruine met, than over-took.
But at my sight perhaps he in my brow
May something read which his High thoughts may bow.
Kings that want Armes, do not want Majesty.
Heav'n is still Heav'n, though't lays its Thunder by. (36)

Laula, however, has other ideas. With her son safely in Crimalhaz's camp, she approaches his wife Morena with soothing words, assuring her of the rebel commander's good intentions: "He has not from the paths of Honour mov'd. / And to appear extravagantly great, / He makes a splendid Mask his this nights Treat" (41). Urged by Laula to "lay by Majesty for Masquerade" and take part in the performance, Morena, who has "been an Actor in such Comick Sport, / When in my Father *Taffaletta's* Court" (41), readily consents.

Having gained the acquiescence of her intended victims, Laula returns to Muly Labas, warning her son that Crimalhaz intends to poison him, and that he and Morena must escape from the camp and return to the safety of town. Their only hope is to slip away in disguise, and the evening's planned entertainment provides an ideal opportunity:

To you this Night he does a Mask present,
A smiling Prologue to his black intent.
And the intrigue of this Dramatique sport,
Is *Orpheus* his descent to *Plutoes* Court.
To fetch *Euridice* from th' infernal shade;

. .

And that your flight may be more safe and free,
Your Self, and your fair Queen shall Masquers be:
You shall act *Orpheus*, she *Euridice*.
When by the Masks design by Hell's Command,
Euridice is given to *Orpheus* Hand,
You the last entry shall his Shape assume,
And in dumb show enter in *Orpheus* Roome.
Her then you shall lead out, and in that Shape
Pass through the Guards, and to the Town Escape. (43)

In keeping with masque convention, the young Queen/Empress Morena has been assigned the silent role of Euridice. The major singing part given to Orpheus, however, would be inappropriate for Emperor Muly Labas—to say nothing of the non-singing actor (Henry Harris in the Dorset Garden production) who played the role. Settle neatly dispenses with this problem, having Laula arrange for her son to enter—without speaking—in a duplicate Orpheus costume once the singing is finished.

As Muly Labas prepares for his theatrical debut, Laula confronts his wife with a different story: Crimalhaz intends to ravish Morena and will come to her during the masque under the guise of Orpheus in order to "rudely snatch you from the place, / And basely force You to his foul Embrace" (44). Simultaneously Muly Labas will be assassinated, "Whil'st with the noyse of Drums, and Trumpets sound, / Your Out-cryes, and his Dying Groans are drown'd." Morena's only hope is to stab the masked Orpheus to the heart as he attempts to seize her. Horrified at this revelation, the young queen readily accepts the proffered dagger. The tragic sequence of events now fully set in motion, Laula and Crimalhaz settle down in their grand tent to enjoy the show.

Settle and Locke's Masque of Orpheus presents a fairly straightforward, if somewhat abridged, retelling of the classic tale. The scene opens on "*a Hell, in which* Pluto, Proserpine, *and other Women-Spirits appeared seated, attended by Furies*" (46; see fig. 54). Orpheus enters, singing of the horrors of the underworld and the palliative effects of his music. Affronted by the mortal's temerity, Pluto commands his minions to torture Orpheus to death; however, Proserpine intervenes, imploring her husband, "*Let not such noble worth your Victim fall: / Be kind both to a Lover and a Stranger*" (47). Encouraged by the goddess, Orpheus explains his mission, whereupon Proserpine exhorts the reluctant Pluto to permit Euridice's return to the land of the living, reasoning "*That when on Earth they come; / To th'wondring World he in soft Aires may tell, / Mercy as well as Justice Rules in Hell*" (48). Yielding to his wife's argument, Pluto relents, commanding Proserpine to

> *Conduct Her in, but in such State,*
> *As fits the Court of Fate;*
> *And to his Hand the fairest Guest restore,*
> *That Ever Landed on the Stygian Shore.* (48)

When Proserpine exits "*and Reenters with the young Queen Drest for* Euridice" (48), Orpheus sings a ravishing duple-time air, echoed in $\frac{3}{4}$ time by a chorus, extolling the power of a love that can overturn the laws of "*Heaven Earth and Hell,*" and the capacity of beauty to tame the gods.

Up to this point the Masque of Orpheus has faithfully reproduced the conventional features of an actual English court masque. As codified in the early years of the seventeenth century, the masque form—in particular the "main masque" that followed the defeat of the antimasque and its disorderly figures—incorporated a number of recurring narrative and structural elements that helped to define the genre and give it its unique profile. Of particular relevance here is the opening section of the main masque, in which allegorical figures reveal in conversation the circumstances surrounding the imminent appearance of the masque's central character—circumstances that, however minimally, constitute the heart of the masque's dramatic "plot." The basic outlines of the story are strikingly similar from masque to masque: a conflict or dilemma is established, involving the search for a lost or troubled innocent whose security is threatened by some dire situation; the conflict is resolved, permitting the appearance of the innocent, played by a royal performer who emerges on stage suitably dressed and attended; having been revealed, the royal performer remains silent but visually prominent while awed onlookers sing choral encomia to mark the event.

Given the congruence established thus far, any knowledgeable audience (whether "Moroccan" or English) observing the Masque of Orpheus would expect this moment of "discovery" to be followed by the next conventional phase of the court masque: a preordained sequence of alternating songs and dances, culminating in general social dancing among masquers and audience. The performance would then conclude with a valedictory song urging the departure of the masquers and articulating a novel and more satisfactory resolution to the received myth—in this instance, we might imagine, Orpheus would be allowed to return with his bride to Earth (rather than relinquishing her as in the original story), thereby fulfilling the masque form's customary teleological promise of an enduring happy ending.

Of course, this is not to be, and the reversal of the Masque of Orpheus's expected progression from bad to good is first signaled when Euridice's appearance is followed not by a courtly dance, but by "*a Dance . . . perform'd . . . by several infernal Spirits, who ascend from under the Stage*" (49).[11] Although the stage directions are

silent on this count, we may presume that during the dance the acting/singing Orpheus quietly exits and is replaced by Muly Labas in identical costume. This would also accord with established masque convention, allowing a high-born Orpheus to take over from a socially inferior professional actor and join the royal Euridice in the courtly dance extravaganza to follow.[12] Morena/Euridice is expecting just such a substitution: not only is she familiar with the masque form, as she has already acknowledged, but she has received the empress's warning—pointedly echoing Laula's earlier advice to Muly Labas, quoted above—that it is Crimalhaz who "with the Masker subt'ly has engaged, / His shape in the last entry to assume, / And seize you in the suppos'd *Orpheus* room" (44). Laula has craftily admonished Morena to beware the moment "When the bold Ravisher seizes You" (45), and to take immediate action, but without clearly articulating that moment's precise timing. Knowledgeable in the ways of masque, Morena might reasonably assume that the "noyse of Drums, and Trumpets" intended to drown out both her screams and her husband's "Dying Groans" will occur at the end of the performance, as the royal party processes out of the acting space; indeed, the young queen could justifiably suppose that such a stealthy and well-coordinated attack is to be carefully choreographed so as not to alarm the other spectators and will thus most likely be integrated organically into the masque's natural conclusion.

Given these considerations, it is no wonder that the already agitated Morena reacts in haste when the unexpected progress of events takes her by surprise. Advised by his mother to "lead [Morena] out" from the masque and make an escape while still in disguise, Muly Labas, who has just come onstage, jumps the gun and interrupts the progress of the masque. As the dance of infernal spirits ends, he "*Offers to snatch the Young Queen from the Company*" (49). In response, Morena "*instantly draws her Dagger, and stabs him*," crying "Take that[,] Ravisher." The suddenness of the event brings the performance to a screeching halt. Muly Labas unmasks, gasping, "By my *Morenas* hand!" and his wife, realizing her terrible error, falls into a faint. Seizing advantage of the confusion, Crimalhaz summons his physicians and guards, proclaiming, "The Emperour Stab'd, the Queen his Murderer!" (49). Mortally wounded, Muly Labas offers a final speech, wondering at the supposed treachery of his beloved yet declaring his undying passion for her, even as he expires.

The interruption of the Masque of Orpheus plays out its consequences on a variety of levels. Practically speaking, the plot has succeeded: the young emperor has been murdered, leaving Laula's hands clean and her lover Crimalhaz free to ascend the throne—thus the masque is, as has already been observed, integral to the design of Settle's tragedy. But the masque also carries and deploys meanings inherent to its own generic makeup, and to its constructed status as an alternative, enhanced manifestation of reality. As emperor-masquer, Muly Labas shares with

his beloved the crucial responsibility for the masque's successful outcome, not simply as a pragmatic means of escape from the clutches of Crimalhaz, but as a vehicle for the articulation of royal authority—"in my brow / . . . something . . . which his High thoughts may bow." This latter effect, as he has already observed ("Kings that want Armes, do not want Majesty"), is an essential weapon in the battle against the would-be usurper, an especial power granted only to those divinely ordained to rule. Yet, whether through ignorance or imprudence, Muly Labas abdicates that power by disregarding the logic of masque and the form's capacity to modify the established mythic outcome. Pressed by fears and doubts, he commits the archetypal Orphic error of allowing impulse to prevail over deliberation, thereby condemning himself to reenact the fable in its original shape and forfeiting the chance, offered him through the masque's transformative power, to return unmolested with his bride to the safety of the world above.

If the masque's counterpoising of Hell and Earth is meant to adumbrate a dichotomy between rebel camp and royal city, then the interruption of the masque, with its parallel consequences for the fates of Orpheus/Euridice and Muly Labas/ Morena, brings the congruence between the two planes of signification into sharp focus. Neglecting his duty to supply the guiding force behind the masque, Muly Labas allows the antimasque to triumph and causes the world of masque to overwhelm the world of reality, impelling its negative force outward with catastrophic effects. The constitutive status of masque is thereby demonstrated: like the venerable formula of king-in-Parliament, the fount of law and secular authority, king-in-masque functioned, for the seventeenth century, as the originary source of ideology and supernatural power. But Muly Labas, having only recently succeeded his tyrannical father, is incapable of wielding this kind of power—particularly since, unlike his foreign-born wife, he appears not to be familiar with masque convention. Instead, he abandons the form and it abandons him; as his corpse is borne off the stage, a weeping Morena observes, "Heav'ns since from You the power of Monarchs springs, / Sure you were bound t'have had more care of Kings" (51).[13]

On yet another level, Muly Labas's failure to make good the masque's potential conveys a pointed message that would have resonated with the court audience before which *The Empress of Morocco* was first performed. Theatricality and illusion are an essential component of royal authority and fundamental to its God-given mission of imposing order and harmony upon human society. But when these potent forces are misunderstood, mishandled, imperfectly employed, or ignored they can just as easily bring about destructive consequences, turning order to chaos. Kings, therefore, must be schooled in the arts of illusion so that illusion does not end up controlling them. According to the dominant ideology of the period, a masque is far more than Prospero's "insubstantial pageant": it presents

and enacts the Platonic *idea* of kingly authority, and when it is interrupted and its natural outcome forestalled, the (lesser) "reality" of kingship is destabilized, opening the door to regicide, usurpation, and tyranny. Muly Labas's fate and that of Morocco illustrate these consequences in the play, but in 1673, whether the threat was configured as creeping popery or radical republicanism, Charles II's and England's circumstances were seen by many as tending in a similar direction. Read into this larger and more pressing context, the interrupted masque of *The Empress of Morocco* is no mere gesture of theatrical bravado; it is an admonition to Charles both to harness this potent ideological force and to do so wisely and with a full understanding of its associated possibilities and dangers.[14] Embedded as it is within what would prove to be the opening salvo in a barrage of courtly spectacular entertainments produced throughout much of the 1670s, the Masque of Orpheus boldly offers its royal auditor, in terms pitched directly to his distinctive status, both an object lesson and an opportunity.

2. *DIDO AND AENEAS* (?1687)

If *The Empress of Morocco* can be understood to function in a highly public context, with its poetic grandiloquence, its multiple performances at court and at Dorset Garden, its elaborate printed edition, and the vituperative literary controversy it engendered, Nahum Tate and Henry Purcell's *Dido and Aeneas* presents us with a nearly opposite scenario. This small-scale yet unassumingly powerful work has come down to us through scattered and incomplete sources, surviving only in a fragmentary state. Its text, created with through-composed musical setting in mind, is necessarily abbreviated and elliptical in shape, tone, and character; despite modern attempts to classify it as an "opera," in its form, structure, and language it most closely resembles a freestanding courtly masque. Its performance circumstances and reception history are shrouded in obscurity: although there is now general agreement that the work began life at the Restoration court, this theory is founded not on any hard evidence but on informed supposition, while the exact date of the work's hypothetical premiere remains a matter of dispute.[15]

Paradoxically, *Dido and Aeneas* is considerably more familiar to present-day readers and audiences than *The Empress of Morocco*, in part on account of the curiously modern appeal of its tragic sensibility, in part due to Purcell's extraordinary musical setting, and in part precisely because its fragmentary nature has allowed—even encouraged—latter-day directors, performers, and editors to reshape it to fit their needs and expectations. What *Dido and Aeneas* shares with its more bombastic cousin, aside from a court provenance and an interest in the complexities of

human folly, is an awareness of the value of masque for exploring modalities of kingship and royal authority through the exploitation of the form's iconic qualities and established generic expectations. In both cases, a masque is interpolated into its parent work at a critical turning point in the drama. Whereas Elkanah Settle deploys his interrupted masque and its dramatic subject matter to initiate a moment of theatricalized climax, however, Nahum Tate chooses, by contrast, to position the interrupted masque of *Dido and Aeneas* as part of a larger structural framework and to configure it as a static, almost nondramatic moment whose negligible contribution to the progress of the story belies its importance for the larger work on other levels.

The dramatic inconspicuousness of the interrupted masque in *Dido and Aeneas* may explain in part why its very existence has gone largely unnoticed, despite the intense critical scrutiny to which Tate and Purcell's work has been subjected over the last half century or so. As I will be arguing in greater detail elsewhere,[16] when *Dido and Aeneas* is carefully examined in the light of several critical characteristics—its incomplete state and the quirks and vagaries of its sources; the establishment of structural and generic expectations deriving from court masque; the importance of dance to the overall tone and pacing of the work; and, not least, an acknowledgment of the tendency of modern editors and scholars to jump to conclusions when assessing the work's qualities and elements—it becomes possible to imagine more effectively how this theatrical piece might have looked in its original form. Such an exercise becomes particularly useful in puzzling out the dramatic and textual cruxes found in one scene in particular, the "Grove Scene" (act 2, scene 2), where the logical progress of the plot is seemingly brought to a halt in order to present a diorama of courtly leisure in which oddly decontextualized invocations, unlikely assertions of fact, inexplicable non sequiturs, and bizarre behavior predominate. Once the drama's action resumes, the scene appears to regain its sense of equilibrium and the story again moves forward in largely predictable ways, but the perplexingly kaleidoscopic sequence of elements in the scene's first half persists in the viewer's recollection as a baffling prelude to the important events that follow. In order to understand how this scene works, and what problems it presents, it is first necessary to survey the plot of *Dido and Aeneas* in its entirety.

Drawn from the fourth book of Virgil's *Aeneid*, the plot of Tate's adaptation would have been well known to contemporary audiences, even despite certain changes of emphasis and causality introduced by the Restoration librettist. After an allegorical prologue featuring the gods Phoebus and Venus, the personification of Spring, and a bevy of lesser aquatic and pastoral figures—the music for which unfortunately no longer survives—act 1 presents the Carthaginian Queen Dido in her palace, surrounded by her court. Consumed with melancholy she reluctantly

admits her passion for the newly arrived Trojan hero, Aeneas. Aware of Fate's mandate that Aeneas establish himself in Italy and found the city of Rome, Dido resists her desires, even after their object declares the sentiment mutual, announcing,

> *Æneas* has no Fate but you.
> Let *Dido* Smile, and I'le defie
> The Feeble stroke of Destiny.[17]

Dido eventually relents, and the court rejoices at the impending royal union, reflexively urging itself forward to a celebration:

> To the Hills and the Vales, to the Rocks and the Mountains[,]
> To the Musical Groves, and the cool Shady Fountains.
> Let the Triumphs of Love and of Beauty be Shown,
> Go Revel ye *Cupids*, the day is your own. (5)

The mood shifts dramatically, however, for act 2, scene 1, in which a malicious sorceress and her coven of witches plot Dido's demise. They, too, are aware of Aeneas's divinely ordained mission, and they plan to send an evil spirit, disguised as Mercury, to him, commanding the Trojan to abandon his dalliance and depart immediately for "th' *Hesperian* Shore" (6). Discerning the sounds of the royal chase in the distance, the cackling hags prepare to disrupt the court's activities further with a thunderstorm that will "Mar their Hunting Sport, / And drive 'em back to Court" (6).

The witches having withdrawn into their "deep-Vaulted Cell," the aforementioned Grove Scene begins. The court appears no longer to be actively engaged in the hunt; instead, Dido's attendants reflect on the theme of hunting from a posture of repose. Belinda extols the idyllic setting of "these Lo[n]esome Vailes,"[18] invoking Diana, the goddess of the hunt. After a dance to a solo guitar, the music for which is not extant, the otherwise unnamed "Second Woman" takes up the Diana theme and relates the tale of Actaeon, the young hunter who happens upon the goddess at her bath and is transformed, for punishment, into a stag. In a curious twist the singer relocates the classic tale to the precise spot on which the court is standing, declaring, "Here *Acteon* met his Fate," that is, both his metamorphosis and his untimely end after being chased down and eviscerated by his own hunting dogs. This is followed by another dance "*to Entertain Æ*neas," after which the hero interposes himself, incongruously announcing his success in having beheaded a giant boar "[W]ith Tushes far exceeding, / Th[o]se did *Venus*['] Huntsm[a]n Tear."[19] Why the Trojan is suddenly, after all the dancing and storytelling, brandishing a

huge bloody head, and how Venus's lover Adonis fits into the picture, is never made clear, for Dido abruptly steps in, observing the onset of the promised storm. As the court scrambles for shelter, Aeneas is accosted by the false Mercury and ordered to depart. Caught between honor and love but aware of his heroic responsibilities, Aeneas reluctantly accepts the call to duty and leaves to begin his preparations while the witches return to celebrate their victory.

The third act of *Dido and Aeneas* presents, in two scenes, the denouement of the action set up in act 1 and act 2, scene 1, and brought to a head in the just-completed act 2, scene 2. In the first scene, a group of sailors prepares to embark, and the witches again rejoice at Dido's downfall while plotting further mayhem. The second scene returns us to the palace, where the queen grieves over her lover's betrayal, angrily rejects his halfhearted attempts to make amends, and stoically accepts the inevitability of her death. As she expires, the court performs a solemn lament, and cupids conclude the work with a mournful dance.

Dramatically speaking, the story of *Dido and Aeneas* is relatively straightforward, lacking the labyrinthine twists and turns of *The Empress of Morocco*. Instead the work trades in the kinds of generic and structural intricacy commonly associated with the court masque in its early-seventeenth-century classic form. Thus, the heart of its meaning lies, and must be sought, first and foremost in the internal arrangement of the work and the interrelationships of its structural components. This examination is particularly useful when confronting the perplexing features of the opening portion of the Grove Scene, the one point in Tate and Purcell's opus that does not fit its otherwise persistent rhythms of forward dramatic movement. In several respects, the Grove Scene can be understood to constitute the center point of *Dido and Aeneas*. It is the third of the work's five palindromic scenes (Palace–Cave [/ witches]–Grove–Ships [/ witches]–Palace); it falls midway between the four neoclassical components of tragedy (the concurrent *protasis*/*epitasis* clusters of 1.1 and 2.1, encompassing the introductory and developmental parts of the drama, as against the *catastasis*, the turning of the plot toward its tragic end, of the latter part of 2.2 and the *catastrophe*, the outcome of the tragedy, of 3.1 and 3.2); and it contains the second of Henry Purcell's three masterful ground-bass arias, the first and third of which constitute the principal articulations of Dido's despair and thereby frame both the development of her character and the work as a whole. Thus, this scene's centrality would appear to point to some greater significance lying beneath the seemingly random components that make up its first section.

The resolution to the puzzle of the Grove Scene, however, is not to be arrived at merely through a close inspection of the two most important surviving sources: a printed libretto from the masque's 1689 performance (as "An Opera") at a boarding school for young ladies in Chelsea,[20] and a manuscript score compiled by an

unknown copyist with an antiquarian bent sometime about 1775.[21] Rather, it requires comparing the two sources with an eye to the limitations of each, resisting the urge to apply the simplest solution when the sources diverge. For example, the boarding-school libretto (which, of course, has musical cues but no actual music) follows the solo aria "Oft she Visits this Loved Mountain" with the indication "*A Dance to Entertain Æneas, by* Dido Vemon" (fig. 55), while the eighteenth-century "Tenbury" score, which does not signal any dance at this juncture, provides an elaborate musical ritornello proceeding directly out of the sung portion of the same aria; yet we should not necessarily assume that the dance called for in the libretto would have been performed to the ritornello presented in the score. In fact, ensemble dances (the mysterious "Dido Vemon" is usually emended to read "Dido's Women") were rarely performed to instrumental ritornelli in works of this nature. Moreover, the Tenbury score is fraught with lacunae of various kinds, and it could well be missing an independent dance movement at this point; indeed, careful consideration suggests that as many as four such dances from diverse parts of *Dido and Aeneas* may have been eliminated from earlier, now-lost scores on which Tenbury is stemmatically based.[22]

If we refuse to settle for the most obvious response to these differing sources, and instead employ a methodology that takes cognizance of the complexities of musical and textual transmission and the need to consider performance expectations as a significant factor, then the opening portion of the Grove Scene undergoes an extraordinary transformation, metamorphosing from a series of disconnected and nonsensical statements about landscape, mythology, and ritualized carnage into a full-blown, methodically paced and articulated theatrical masque. This courtly entertainment, developed around the legend of Actaeon and Diana and performed by Dido's ladies, with the queen's new lover Aeneas in the eponymous role of the young huntsman, presents an elaborate sequence of musical numbers: an overture-like ritornello (as provided in the Tenbury score); a scene-setting prologue—"Thanks to these Lo[n]esome Vailes"—sung by Belinda and repeated by the full chorus; a solo dance to a ground-bass movement played on guitar (indicated as a stage direction in the 1689 libretto); an ominous summary of the action, sung to another ground bass by the Second Woman and followed with a lush string ritornello; a dance for Aeneas/Actaeon, performed by the ladies onstage (as discussed above); and an opening recitative for Aeneas in his Actaeon role, flourishing an artificial bleeding boar's head and boasting of his prowess in a recent hunt. Where this interpolated masque would have gone next is left uncertain when reality bursts in as Dido, the performance's royal auditor, notes the rapidly brewing downpour, causing the suddenly de-theatricalized masquers to scurry away to the safety of the nearby city. The Masque of Actaeon is over practically before it

has begun, and only Aeneas, now no longer a courtly performer but rather his unadorned, vulnerable self, lingers to receive the shattering—if utterly fraudulent—news of the gods' displeasure.

Understanding the events of the Grove Scene in this way allows us to connect its seemingly disparate components into a coherent whole, and to superimpose an interpretive framework that illuminates our understanding of all of *Dido and Aeneas*, highlighting both the broad thematic intentions and the troubling internal dynamics of this extraordinary musical and dramatic excursion. Tailor-made as it is for a bloody and unsettling ending, an interpolated courtly masque on the subject of Actaeon would seem an odd choice, particularly in view of the first act's concluding injunction: "Let the Triumphs of Love and of Beauty be Shown" (5). Yet by the mid-1680s, when *Dido and Aeneas* is now believed to have been written, the English court had itself developed a taste for masques that culminated not in teleological resumptions of divine and earthly harmony, but instead in moments of sublime tragedy.

The paradigmatic example of this is the diminutive masque *Venus and Adonis*, performed for Charles II sometime about 1682. In keeping with long-standing convention, this through-sung work, the music for which was supplied by the court composer John Blow, featured two performers with royal credentials: the king's former mistress Mary "Moll" Davis and their natural daughter Lady Mary Tudor. Although Venus, Davis's character, does not relinquish her life at the end of the work, her lover Adonis dies beautifully in the aftermath of a fatal encounter with a wild boar, and Venus's dolorous response adds to the scene's intense pathos. Having the royal masquer Aeneas assume the part of a similarly doomed individual, then, is not as far outside the realm of possibility as we might imagine. More importantly, the Actaeon role would allow Aeneas suitable opportunities to express and conduct himself in a heroic manner—note that at no point in the fateful encounter with Diana can Actaeon's behavior be construed as unheroic per se; in the *Metamorphoses*, Ovid pointedly concludes his tale by recording the diversity of opinion regarding the justice of the goddess's actions.[23] Prior to the masque's untimely interruption, we—and, significantly, Dido—are treated to a superlative example of heroic display as Actaeon/Aeneas inaugurates the mimetic portion of the performance with his well-known gesture of phallic bravado. The "Monsters Head," oozing its disgorged fluids down the shaft of Actaeon's "bending Spear," brilliantly encapsulates the dual masculinized roles of hunter and lover germane to the persona the Trojan masquer wishes to adopt, and through which the masque's text strives to compliment its exalted participant. For the Restoration audience attending *Dido and Aeneas*, moreover, the invocation of the lover/hunter Adonis and, by implication, the earlier court production that many of them might

Sorc. But e're we, we this perform,
 We'l Conjure for a Storm.
 To Mar their Hunting Sport,
 And drive 'em back to Court.

Cho. In our deep-Vaulted Cell the Charm wee'l prepare,
 Too dreadful a Practice for this open Air.

Eccho Dance.

Inchanteresses and Fairees.

Enter Æneas, Dido and Belinda, and their Train.

Scene the Grove.

Bel. Thanks to these Lovesome Vailes,
Cho. These desert Hills and Dales.
 So fair the Game, so rich the Sport,
 Diana's self might to these Woods Resort.

Gitter Ground a Dance.

2d. Wom. Oft she Visits this Loved Mountain,
 Oft she bathes her in this Fountain.
 Here *Acteon* met his Fate,
 Pursued by his own Hounds,
 And after Mortal Wounds.
 Discovered, discovered too late.

A Dance to Entertain Æneas, by Dido Vemon.

Æneas, Behold upon my bending Spear,
 A Monsters Head stands bleeding,
 VVith Tushes far exceeding,
 These did *Venus* Huntsmen Tear.

Dido. The Skies are Clouded, heark how Thunder
 Rends the Mountain Oaks asunder.
 Hast, hast, to Town this open Field,
 No Shelter from the Storm can yield. [*Exit.*

 { *The Spirit of the Sorceress descends*
 { *to Æneas in likness of* Mercury.

Spir. Stay Prince and hear great *Joves* Command,
 He Summons thee this Night away.

Æn. To Night.

Spir. To Night thou must forsake this Land,
 The Angry God will brook no longer stay,
 Joves Commands thee waft no more,
 In Loves delights those precious Hours,
 Allowed by the Almighty Powers.
 To gain th' *Hesperian* Shore,
 And Ruined *Troy* restore.

Æn. *Joves* Commands shall be Obey'd,
 To Night our Anchors shall be weighed,

 But

55. Printed text from program libretto, showing the opening of act 2, scene 2 ("*Scene the Grove*") of *Dido and Aeneas*, from Nahum Tate, *An Opera Perform'd at Mr. Josias Priest's Boarding-School at Chelsey. By Young Gentlewomen* ([London], [1689]), 6. Royal College of Music, London.

have attended further strengthens the association between tragic musical masque (Adonis) and tragic musical masque-within-a-masque (Actaeon)—itself part of another such masque, whose own tragic machinery is, at this very instant, about to be set in motion.

But the assertions of Aeneas's manhood articulated through his assumption of the Actaeon character are rhetorically constructed: a theatricalized substitute, as it were, for Aeneas's—or rather, Tate and Purcell's Aeneas's—oft-remarked weakness of character. Masques are fictions of state, in which the diametrically opposed spheres of contrivance and hyper-reality converge on a common plane in order to establish a world both fantastic and utterly believable, where day-to-day certainties are transcended, reconfigured, and reflected back in the service of a greater truth. The Grove Scene of *Dido and Aeneas* creates precisely such a dynamic. As a newly united royal couple, Dido and Aeneas might be expected to present a model of conjugal harmony; however, the text gives them no opportunity to do so. Prior to her angry outburst—"Thus on the fatal Banks of *Nile*, / Weeps the deceitful Crocodile" (8)—in the work's final scene, Dido speaks only one line to Aeneas, "Fate forbids what you [pur]sue" (4), in act 1.[24] Between his extended response to that initial challenge and his sheepish entry in act 3, scene 2, Aeneas, too, never directly addresses his lover. In the intervening scenes, apart from one speech each character delivers when the other is absent, their only other utterances—each a brief recitative passage: "Behold upon my bending Spear . . ."; "The Skies are Clouded . . ."—occur in direct succession at the moment the Actaeon masque is interrupted. Thus, their relationship, particularly in the Grove Scene, must perforce be represented visually (as modern directors of *Dido and Aeneas* are well aware[25]) and figuratively: only in the constructed realm of the masque, where one partner assumes a borrowed mantle of heroism and the other becomes the omnipotent observer and external focal point of the performance, can the two royal personages truly experience the bond that defines them as a couple.[26]

The interruption of the masque overthrows this dynamic, dispelling the sole medium in which Aeneas and Dido can genuinely come together in some sort of personal union. With the masque gone, Aeneas's assumed masculinity and heroism, which had been propounded only as a reflection of the fictional, theatricalized character of Actaeon, are also dissolved, and the witches, whose opportune thunderstorm has effected the reversal, immediately strike. Confronted with a dubious apparition of Mercury, Aeneas's resistance and the resolve shown in his earlier declarations of fidelity to Dido crumble unheroically into the emasculated bluster of his pronouncement, "*Joves* Commands shall be Obey'd, / To Night our Anchors shall be weighed" (6). When he finally approaches the queen in act 3, scene 2, the situation deteriorates further: Aeneas is pathetically indecisive in the

face of Dido's fury, and the encounter rapidly devolves from an accelerating sticho-mythic exchange into a disordered shouting match. What both this scene and act 1 make clear is that Dido and Aeneas are at their best when interacting through and within formal courtly structures; when they attempt to engage as individuals, the results are at best unpromising.

If Aeneas appears to lose his heroic attributes beyond the artificial confines of the masque, Dido manages to preserve her integrity as a character precisely by remaining outside that context. In keeping with her conventional role as the Actaeon masque's originary motivating force and raison d'être, Dido constitutes the central reference point of the masque's dynamic. Aeneas's heroic posturing is put on for her benefit, and it may in part be understood as a response to her con-tinued ambivalence over the wisdom of their course of action. Moreover, it is she who observes the coming storm and steps in to halt the performance. Dido is, of course, only the proximate cause of the masque's interruption, but she also pro-vides the impetus for the witches' actions throughout *Dido and Aeneas*. Thus, in contrast to Aeneas's internalized and largely procedural association with the masque, which depends upon the realignment of his personal attributes as he moves from within to without, Dido relates to the masque as emblem. The Masque of Actaeon, like actual court masques throughout the seventeenth cen-tury, is an emanation of her mind and will as sovereign, as the central axis of her hierarchical world. When the witches' malevolence destroys the masque, that world, too, begins to unravel, and Dido's own destruction is not far behind.

For Dido the message of an Actaeon masque must also derive from its emblematic qualities. Where Aeneas glibly assumes the heroic traits of a dashing young huntsman, Dido can see the moral beneath the fable: in pursuit of manly glory, Actaeon stumbles unawares into the sexualized realm of an imperious queen, triggering an elemental shift in condition and status that culminates in his grisly demise. As in *The Empress of Morocco*, with its parallel between Orpheus/Euridice and Muly Labas/Morena, the broadly ominous tone of this story is complemented by the expectation—again derived from masque convention—of some specific applicability. Is Actaeon meant to represent Aeneas, in over his head since arriving in Carthage? His glorious later history, the province of Virgil, does not inform Tate's more localized retelling, in which Aeneas's divine summons is a mean-spirited trick and the hero's subsequent fate is left open to conjecture after the witches resolve to "storme [him] on the Ocean" (7). Or is there perhaps a thematic lesson to be taken from this complex of signification, something that not only the stage-bound Dido, but also Nahum Tate's royal and aristocratic audience, could find relevant? In appropriating the Actaeon story for his libretto, Tate might well have consulted the glosses accompanying George Sandys's 1632 translation of the

Metamorphoses, in which several possible interpretations of this classic myth of transformation and evisceration are advanced. Among other prospective readings, Sandys suggests that

> *Actaeon*, neglecting the pursuite of virtue and heroicall actions, puts off the minde of a man, and degenerates into a beast; while hee dayly frequents the wild woods to contend with such enimies.[27]

Could Tate have selected the legend of Actaeon for its ability to convey just such a message? And if so, how is the message to be received? For Dido, Aeneas's neglect "of virtue and heroicall actions" is double-edged: on the one hand, the Trojan could embody these qualities by honoring his vows to her; on the other, the most "heroicall" choice would have been never to offer such vows in the first place. In the event, Aeneas is capable of neither course of action, and it is his feeble vacillation during their final encounter that most infuriates the jilted queen.

Given its structural prominence, its centrality to the plot, and its ominous tone and implications, the Masque of Actaeon functions as a multilayered site of meaning within *Dido and Aeneas*. If, as I have proposed elsewhere, Tate intended that his text operate on a variety of levels, including that of political allegory, Sandys's reading quoted above could also apply to the disastrous conduct of James II that, I suggest, informs the allegorical import of the work.[28] Tate's putative representation of James in the character of Aeneas underscores the hapless qualities of the deluded English monarch, widely perceived as a subverter of the English constitution and a tool of his wicked Roman Catholic advisers, and thus unable to assume the heroic stature appropriate to an "absolute" monarch and sponsor of court masques. The lesson for Aeneas in the Masque of Actaeon can thereby be extrapolated into the lesson imparted to James by *Dido and Aeneas*, and specifically by the embedded masque at its heart. To quote Sandys's preferred reading of the episode, the devouring of Actaeon

> bee meant by his maintaining of ravenous and riotous sycophants: who have often exhausted the Exchequors of opulent Princes, and reduced them to extreame necessity. Bountie therefore is to be limited according to the ability of the giver, and merit of the receaver: else it not onely ruinates it selfe, but looseth the name of a vertue, & converts into folly. (152)

"Bountie," in this case, can be construed as James's unabashed favoritism toward his popish advisers, a flaw that, like the corresponding susceptibility of Aeneas to the chicanery of the witches, sets in motion the destruction of the noble heroine—

whether the English nation, teetering on the brink of constitutional crisis in 1687–88, or her allegorized alter ego, the tragically fated Queen Dido.

The Masque of Actaeon, then, lies at the core of a complex web of signification in which both the theatricalized tale and its apparent application to political events are deftly interwoven, allowing the interrupted Actaeon story to direct both the characters' subsequent actions and the interpretations that Tate may have wished the encompassing masque of Dido and Aeneas to engender. But another of Sandys's analyses of Actaeon may also have caught the poet's eye as he sought to shape a court entertainment that trod the precarious line between cautious advice and perilous disloyalty:

> But this fable was invented to shew us how dangerous a curiosity it is to search into the secrets of Princes, or by chance to discover their nakednesse: who thereby incurring their hatred, ever after live the life of a Hart, full of feare and suspicion: not seldome accused by their servants, to gratulate the Prince, unto their utter destruction. For when the displeasure of a Prince is apparent, there commonly are no fewer Traitors then servants, who inflict on their masters the fate of *Actaeon*. . . . Guard we therefore our eyes; nor desire to see, or knowe more then concerns us: or at least dissemble the discovery. (151)

Read in this light, the Masque of Actaeon could also subtly convey the anxieties of the author as he presented his royal patron with a carefully constructed fable whose underlying message, once fully understood, was bound to be unwelcome.

Tate's imaginative foray into dissimulation in *Dido and Aeneas* offers an elaborate tapestry of interconnected formal, dramatic, and evocative elements in which mutually contingent meanings interact and overlap to create a work for which the music of Henry Purcell is only the crowning touch. At the heart of this creation lies the interrupted Masque of Actaeon, whose effects radiate outward through the work and its characters as its truncated performance generates a mounting sense of dread, of the inevitability of tragic consequences, that primes the surrounding action for the imminent collapse of Dido's secure, courtly world—and, perhaps, of other such worlds beyond its fictional confines.

3. *KING ARTHUR* (1691)

The changing status of court masque in the aftermath of the Revolution of 1688–89—a period in which, as J. M. Armistead has observed, "the courtly masque ceases to be the appropriate form for celebrating the national identity"[29]—can be

seen in the functioning of the third interrupted masque to be examined here. John Dryden's "*Dramatick* Opera" *King Arthur* straddles the temporal and psychological gap created by the Revolution: originally conceived as a celebration of Charles II's reign, it was abandoned by the poet in 1684 in favor of the through-sung and blatantly allegorical *Albion and Albanius*, then revived in an altered form as the United Company's spectacular production for 1691, with music provided by Henry Purcell. *King Arthur* represents a coming-of-age for that peculiarly English form of musical drama often labeled "semi-opera," a genre pioneered two decades earlier with Thomas Shadwell's "operatic" rendition of *The Tempest* (1674, based on an earlier adaptation by Dryden and Sir William Davenant) and his *Psyche* of the following year, and revived in the post-Revolution period with the musical adaptation of John Fletcher's *The Prophetess*, performed in 1690. The less-derogatory designation "dramatick opera," which Dryden himself coined for the published edition of *King Arthur*, adequately characterizes the form but not the content of this complex interweaving of spoken play with sung masque episodes in which, as Joanne Altieri puts it, "the dramatic, as we conceive it, is sacrificed to the emblematic, the psychologically forceful to the allegorically meaningful."[30] The 1690s saw a growing interest in the spectacular possibilities of musical drama in England, as Curtis Price and others have shown,[31] and *King Arthur* might initially be viewed as an extreme case of the frivolous and irrelevant deployment of music within an otherwise self-sustaining play. Yet as in so many of these works, based as they are on the model of court masque, the apparently haphazard insertion of mostly static musical items into the ongoing dramatic fabric of *King Arthur* conceals larger structural patterns, in which issues of royal authority are treated on a conceptual level that surpasses the orderly localism of the spoken dialogue.

Drawing upon a wide body of mytho-historical source material that ranges well beyond traditional notions of the "matter of Britain,"[32] Dryden's operatic essay on the legendary national leader invokes patriotic sensibilities through its counterpoising of Briton and Saxon for dominance over the island of Great Britain, and of Arthur and his Saxon rival Oswald for the hand of Emmeline, the blind daughter of Conon, Duke of Cornwall. Emmeline's lack of physical vision is compensated for by her heightened ability to perceive and understand—James Winn has dubbed her "a kind of poet"[33]—and her capacities are enhanced in act 3 when her sight is restored, thanks to a vial of "Soveraign Drops"[34] supplied by Merlin and administered, in Arthur's presence, by the airy spirit Philidel. Arthur, by contrast, must undergo a succession of trials and setbacks, which culminate when he braves the temptations offered by an enchanted wood in act 4 and engages Oswald in hand-to-hand combat early in act 5. Halfway through the final act the plot is resolved, and Arthur and the other protagonists are witnesses to a grand

masque, summoned up by Merlin "to treat thy Sight and Soul" (5.2.80) with a vision of Britain's glorious future state.

In Dryden's hands the plot of *King Arthur* develops by means of a series of oppositional pairings and dynamics played out on such diverse levels as character, scenography, and episodic structure, where formalized statements of nationalistic pride shape and punctuate a process of becoming for an emergent British identity. At the center of this binary framework is Emmeline, growing in her capacity to distinguish good from evil and to discern right love, who serves, alongside her allegorical alter ego of British nationhood, as the prime force behind the opera's dramatic impetus. Competing for her affection are the rival kings, Arthur and Oswald, both equally honorable and equally courageous, representing the two nations who ultimately, Merlin tells us in act 5, "shall be once one People; / One Common Tongue, one Common Faith shall bind / Our Jarring Bands, in a perpetual Peace" (5.2.87–89). Each king is supported by his respective magician, in Arthur's case Merlin, and in Oswald's the vile and lascivious Osmond, who subsequently imprisons his master in order to seek Emmeline's love for himself. The magicians are, in turn, assisted by spirits: the airy Philidel for Merlin and the earthy Grimbald for Osmond. Despite their future unity, made possible perhaps by the equivalent heroism of the two leaders, the Britons and Saxons as groups are unambiguously situated within another binary structure, a hierarchy of good and evil: the pagan Saxons vainly offer human and animal sacrifices to their Teutonic gods, and both Osmond and Grimbald rely on subterfuge, misrepresentation, and threats of force to achieve their ends, while Merlin patiently awaits the natural outcome of events, serving as "an earthly catalyst for God's will,"[35] and Philidel periodically intervenes to counter Grimbald's diabolical actions.

A dissection of the plot of *King Arthur* in terms of the physical/visual elements of each act and scene helps to clarify some of the larger structural features of the opera, in particular the fact that both the drama and its scenography fall neatly into a bipartite arrangement centered on act 3, scene 2, Emmeline's visual awakening. As table 1 illustrates, the action throughout acts 1 and 2, as well as the first scene of act 3, is situated at the multiple sites of physical warfare, represented by the preparations for combat, by the battle itself—"supposed to be given behind the Scenes" (start of act 1, scene 3)—and by its aftermath, in which the defeated Oswald kidnaps Emmeline while the victors lie "debauch'd: / All Drunk or Whoring" (2.3.3).[36]

The first of these three locations among which the action cycles is the British camp, a nondescript space that could be played solely on the theater's forestage, either in the presence of an existing scene, left visible in the receding scenic space behind the proscenium arch, or even (though this would be unlikely, given Restoration stage conventions) in front of a painted curtain; when the setting returns in

TABLE 1: Scenic and Musical Elements in *King Arthur*

Act/Sc.	Description		Scene type	Music
1.1	British camp		forestage	—
1.2	Saxon camp	(*"a place of Heathen worship,"* 1.2.0)	scenic stage[a]	A
1.3	Battlefield		?scenic stage[b]	B
2.1	Battlefield	(Philidel: "this bloody Field," 2.1.1)	scenic stage[c]	CD
2.2	British camp	(*"Pavilion Scene,"* 2.2.0[d])	forestage	X
3.1	British camp		forestage	—
3.2	Wood →	(*"a Deep Wood,"* 3.2.0)	scenic stage[e]	pE
	"Yzeland"	(*"a Prospect of Winter in Frozen Countries,"* 3.2.276+)	scenic stage[f]	F . . .
	"Yzeland" with discovery	(*"the Scene opens, and discovers a Prospect of Ice and Snow to the end of the Stage,"* 3.2.305+)	vista stage	. . . F
	?Wood returns[g]		?	—
4.1	Wood	(*"Scene of the Wood continues,"* 4.1.28+[h])	scenic stage[i]	GH
5.1	Wood →	(Conon: "The forcing of that Castle," '5.2.3'[j])	scenic stage	—
	Seascape	(*"the British Ocean,"* '5.2.89'+)	scenic stage[k]	Y_1
	Seascape with discovery	(*"The Scene opens, and discovers a calm Sea, to the end of the House,"* '5.2.89'+)	vista stage[l]	Y_2–Y_6
	Seascape with double discovery	(*"The Scene opens above, and discovers the Order of the Garter,"* '5.2.196'+)	vista/upper stage	Y_7

KEY TO MUSICAL COMPONENTS

(N.B. Spelling and capitalization modernized; does not include extant trumpet fanfares or incidental music.)

Symbol	Incipit *(italics indicate lack of surviving musical setting)*	Category	Theme
A	Woden, first to thee	Incantation	Saxons (*bad*)
B	Come if you dare	Celebration	Britons (*good*)
C	Hither this way // Come . . . follow me	(diegetic)	Britons led to safety
D	Let not a moon-born elf	(diegetic)	Britons led astray
X	How blest are shepherds	Pastoral interlude	Britishness
p	*We must work, we must haste*; *Thus, thus I infuse*	(brief songs for Philidel, associated with E)	
E	*Oh sight, the mother of desires*	Apparition—Masque	Briton (*good*)
F	What ho, thou genius of the clime	Apparition—Masque	Saxon (*bad*)
G	*O pass not on* / Two daughters of this aged stream	Apparition—Temptation	Briton led astray
H	How happy the lover	Apparition—Incitement	Briton led astray
Y	Concluding grand masque	Apparition—Masque	Britishness
	1 Ye blust'ring brethren		
	2 Round thy coasts		
	3 For folded flocks		
	4 Your hay it is mow'd		
	5 Fairest isle		
	6 You say, 'tis love		
	7 St. George, the patron of our isle		

act 2, scene 2, Dryden's text labels it "*Pavilion Scene.*" None of the three British camp scenes (1.1, 2.2, and 3.1) requires any special scenic or machine effects—even the musical diversion presented there in the second act ("*How blest are Shepherds*") is explicitly unmagical, consisting of "a Crew of *Kentish* Lads and Lasses" who entertain Emmeline "With Songs and Dances" (2.2.33–35). Thus, this setting would not require the Dorset Garden Theatre's elaborate scenic stage, and the forestage configuration would have the added benefit of establishing a degree of intimacy, and hence sympathy, between the audience and Arthur and his followers.

By contrast, the Saxon camp shown in act 1, scene 2, is a site of at least moderate visual display, as the opening stage direction indicates:

> The Scene represents a place of Heathen worship; The three Saxon Gods, Woden, Thor, and Freya placed on Pedestals. An Altar.

The forestage would also be employed here (note the stage direction "Grimbald *goes to the Door, and Re-enters with 6* Saxons" at 1.2.48+), and the mere presence of the statues and altar would distinguish this one-off scene, obviating the need for a dedicated set of wings, borders, and shutters; nevertheless, the setting would differ from that of the British camp in requiring some element of scenic depth.[37]

The third scenic locale required in the first half of *King Arthur* is that of the battlefield itself, which plays host to the British victory song "Come if you dare" at the end of act 1 and remains as the opening scene of act 2, in which Philidel and

Notes to Table 1

a. 1.2.0: ". . .[T]hree Saxon *Gods . . . placed on Pedestals. An Altar.*" Trapdoor at 1.2.15+.

b. 1.3.0: "A Battle supposed to be given behind the Scenes . . . After which, the *Britons . . .* sing this Song . . ."

c. 2.1.6+: "*Merlin, with Spirits, descends to* Philidel, *on a Chariot drawn by Dragons*"; 2.1.54+: "*Exit* Merlin *on his Chariot.*" Trapdoor at 2.1.108+.

d. 2.2.65–66: Oswald: "we are faln / Among their foremost Tents." Subsequent editorial scene change after 2.2.91 (and return to earlier scene after '2.3.3') is unnecessary.

e. 3.2.74+: "*Enter* Emmeline *and* Matilda, *at the far end of the Wood*"; 3.2.78+: "Emmeline *and* Matilda *come forward to the Front.*"

f. 3.2.276+: "*Cupid Descends.*" Trapdoor at 3.2.280+.

g. 3.2.329+: "*the Singers and Dancers depart.*"

h. Editorial scene change after 4.1.28 is unnecessary.

i. '4.2.82'+ and '4.2.92'+: "Arthur *strikes at the Tree . . . Blood spouts out of it,*" etc. Trapdoors at '4.2.27'+, ?'4.2.78'+, '4.2.136'+, '4.2.144'+.

j. Editorial scene change after 5.1.11 unnecessarily presupposes a different setting for Osmond's soliloquy, 5.1.1–11.

k. '5.2.89'+: "*Æolus in a Cloud above: Four Winds hanging*"; '5.2.104'+: "*Æolus ascends, and the four Winds fly off.*"

l. ?Trapdoor at '5.2.104'+ ("*An Island arises*").

Grimbald vie for the trust of Arthur and his bewildered followers as they "*wander at a distance in the Scenes*" (2.1.54+). Prior to their appearance, Merlin has descended and reascended "*on a Chariot drawn by Dragons*" (2.1.6+), providing the audience with a foretaste of spectacular effects to come. Both of these elements clearly mark "this bloody Field" (2.1.1) as a location demanding not only the scenic space itself, with its attendant flying machinery, but substantial scenic depth as well. In light of the overlapping qualities of these three scenes, whatever (probably stock) "outdoor" wings and shutters constituted the battlefield scene could also have stood in as a background for the two opposing camps, with the requisite scene-change signals already discussed. Moreover, the unified appearance of the first half of *King Arthur* and its associated action would have conveyed to its audience a sense of thematic continuity and compartmentalization, which would compare with the similar thematic and scenic grouping of the opera's latter half.

The end of act 3, scene 1, marks the transition to the second part of Dryden's plot. With Emmeline in the hands of his rival, Arthur sets out, under Merlin's guidance, to find his beloved and deliver the potion that will restore her sight. As the hero leaves his camp, the scene changes to "*a Deep Wood*," whose perspective landscape underpins the visual texture of the opera from this point forward. Any subsequent scene "changes" are in fact magical apparitions conjured up by and for characters actually situated in this (conveniently) enchanted forest. The opera, consequently, shifts from the realistic, warlike, and communal realm of the first half to a supernatural, subtly treacherous world in which Arthur must be tested on a personal, psychological level before being able to emerge victorious at the work's conclusion. Act 3, scene 2, is thus a pivotal scene in the development of *King Arthur*'s plot and characters, and it is here that Emmeline both regains her sight and is treated to two very different masque-like presentations, each of which touches on the related subjects of vision and love.

The first masque comes on the heels of the miraculous cure and Emmeline's charmingly naive exploration of her newfound faculty during which, while gazing into a mirror, she first glimpses Arthur's face as he looks over her shoulder. Once the initial astonishment has worn off, Philidel momentarily assumes the functions of a combined Prospero/Ariel, conjuring up a vision of "Airy Forms" (3.2.174) in order

> to Congratulate
> Your new-born Eyes; and tell you what you gain
> By sight restor'd, and viewing him you love. (3.2.171–73)

Sung by a man and a woman with accompanying chorus,[38] this musical episode, "*Oh Sight, the Mother of Desires*," treats the causal connection between seeing and

love: the terms "see," "look," "view," and "discover" all appear at least once in the brief text, which comments in the third person on the circumstances of Emmeline and Arthur without addressing either lover directly. In its structure, this "Masque of Sight" consists of three poetic stanzas, each with an independent rhyme and metrical scheme. The first two stanzas present binary A/B configurations in which the text of A invokes the pleasures associated with seeing, while that of B seeks to trump *"such cheap Delights"* (3.2.186) through an appeal to the special joy of witnessing one's beloved; the chorus, in each instance, reiterates part B. A third, shorter stanza follows, summarizing the foregoing B motif by locating that which *"Charms both Nymph and Lover"* in the ability *"To Sigh, to Look, to Languish, / On each others Eyes"* (3.2.196, 199–200), a sentiment then repeated in its entirety by the "Chor. of all Men & Wom[en]." In its rhetoric, the masque looks forward to the blissful union of Arthur and his lady, who has now experienced her—literally—eye-opening transformation. But despite Emmeline's passage to wholeness, the drama itself is only half-finished, and deferral is the order of the day. Arthur must still undergo his own trial; in the meantime, having penetrated deep inside enemy territory thanks to Merlin's and Philidel's efforts, he can only temporarily enjoy the bliss promised in the masque. As the chorus concludes its recapitulation of *"To Sigh, to Look, to Languish . . . ,"* Philidel interrupts the performance, commanding, "Break off your Musick; for our Foes are near" (3.2.202), whereupon the *"Spirits vanish."* Caught up momentarily in the false *telos* of ecstatic union with Emmeline, Arthur must now retreat from the wood, leaving the object of his desire to the competing ministrations of his new and dangerous rival, the magician Osmond.

Osmond's reply to the understated and abbreviated Masque of Sight represents, again—and, again, literally—a polar opposite. Thwarted in his clumsy attempts to woo Emmeline, he reverts to battering her with overstated metaphor. Horrified by his "odious Image" (3.2.229) and his treachery against Oswald, Emmeline exclaims, "I Freeze, as if his impious Art had fix'd / My Feet to Earth" (3.2.265–66). Osmond's literalist response is to offer a grand vision of Cupid's "force in Countries cak'd with Ice" (3.2.268), where the figurative "Warmth" of love incongruously becomes the literal heat that "supplies the distant Sun" (3.2.276). Scenically and musically designed to evoke wonder, both in Emmeline and in the Dorset Garden audience, the famous "Frost Scene" or, more appropriately, "Masque of Ice," nevertheless emblematizes Osmond's impotence, both as lover and as semiologist: he has misinterpreted Emmeline's aversion as arising from frigidity on her part, rather than recognizing the cause in his own grotesque unsuitability, and the masque telegraphs the flaws at its very heart. Cupid's breezy dismissal of the shivering *"Genius of the Clime"* (3.2.277) as a *"Doting Fool"* (3.2.288) more accurately characterizes *"the Whining Pretender"* (3.2.322) Osmond himself than it does

someone resistant to Love's dictates, while the cogency of the masque's glorious (and frequently recapitulated) final chorus is undercut by its poetically lame and logically unsound couplet, *"In spight of Cold Weather, / He brought us together"* (3.2.315–16). Sight, as the earlier masque has demonstrated, can engender love, but ice, manifestly, cannot. When the elaborate presentation falls flat, Osmond resorts to brute force, and Emmeline is saved only by another interruption, that of Grimbald crying out for release from the enchantment with which Philidel had ensnared him, and struck him "Dumb for one half Hour" (3.2.60), early on in the scene. It is perhaps noteworthy that Dryden allows the Masque of Ice to run its course, thereby highlighting the decisive quality of Osmond's failure as against Arthur's progress toward success within the setting of the far more diminutive, and truncated, Masque of Sight.

The noble Oswald's replacement by his "griezly" (3.2.239) subordinate as a contender for Emmeline's affection is important to the plot, because it counteracts the parallel nobility of Briton and Saxon, enabling Dryden to produce the more focused set of contrasts encapsulated within this scene, the effective center point of the opera. Alongside the disparity established between the scene's two masques, and the associated classification of Arthur and Osmond as, respectively, good and bad lovers, the scene presents other rhetorical and performative correspondences. Cupid as an improbable sun-substitute echoes (and falls short of) Emmeline's "discovery" of the real solar orb in the dialogue that leads from her unblinding to the first masque performance. In the same way, Osmond's glittering vision of ice cannot effect the true mimesis achieved by the small mirror in which Emmeline sees first her own, and then Arthur's, visage. The rival lovers are even balanced as characters on a graphic level when Dryden literally substitutes them on the forestage, Arthur (and Merlin) exiting *"at one Door"* as Osmond enters *"at the other"* (3.2.221+).

The strategic juxtaposition of the two masques in act 3, scene 2, has gone unremarked largely because whereas Purcell's celebrated "Frost Scene" is common currency in the realm of 1690s English opera (it was frequently revived on its own throughout the eighteenth century and beyond), no music survives for *"Oh Sight, the Mother of Desires."* But as *Dido and Aeneas* reminds us, the modern absence of a musical setting does not necessarily indicate that no such setting ever existed; Curtis Price has nicely summarized the problematic state of the *King Arthur* sources,[39] sources that, taken together, exclude or obfuscate a number of important musical passages—almost all of them from the latter, magical half of the opera. There are many possible explanations for these lacunae: for example, that the texts in question were withdrawn from Purcell's compositional assignment at an early stage and never set;[40] that Purcell set the texts, but they were cut from the performance to

save time and the music disappeared as a result; or that Purcell's settings were heard by the 1691 audience and were lost at some later date as a consequence of the transmission process.[41] In considering these we must not lose sight of the fact that Dryden chose to include them, presented as sung passages, in his printed playbook. Particularly in the case of *"Oh Sight . . ."*—which, along with its two brief preliminary songs for Philidel, is the only complete episode not accounted for in the surviving sources—Dryden's commission is telling. The dual Masques of Sight and Ice in act 3 are part of a larger pattern, outlined in table 1, in which each of the first four acts of *King Arthur* affords its own contrasting pair of musical episodes. In act 1, it is the Saxon incantation scene (A) and the British victory song (B), two separate items placed, respectively, before and after the crucial battle. Act 2 presents the competing importunities of Philidel and Grimbald in the tmetically configured *"Hither this way, this way bend"* / *"Let not a Moon-born Elf mislead ye"* / *"Come follow, follow, follow me"* (C-D-C); here, the musically differentiated components are woven together to form a unitary episode, punctuated by snatches of interstitial dialogue.[42] Fittingly, this most diegetic of *King Arthur*'s musical sections features sung performances by two of the principal speaking characters.[43]

With act 3 and its pair of masques (EF) having illustrated the process of Emmeline's enlightenment, act 4 plays out Arthur's moral and spiritual trial in a sequence of visions intended to divert him from the path of righteousness. The first two of these, offered up in quick succession, are also musical: a pair of sirens tempts him to lustful dalliance in *"O pass not on, but stay"* (G),[44] and a troop of nymphs and sylvans performs the grand passacaglia *"How happy the Lover"* (H), a seemingly innocuous invitation to seize the pleasure of the moment, which Arthur nonetheless rejects as "Fantastick Fairy Joys" (4.2.75) incommensurate with his noble passion for Emmeline. Like the corresponding element of act 2, in which is explored an identical motif of Britons being enticed away from their heroic destiny, the linked episodes in act 4 are at least somewhat diegetic and present an appearance of scenographic unity as the naked sirens remain onstage, visible at least *"to the Waste"* (4.2.27+) in their trapdoor, throughout the subsequent musical section.[45] Besides mirroring structural and other elements of the musical portion of act 2, the act 4 visions echo the two apparition-masques from act 3: in each case, the first of the pair invokes the sensuous pleasures of physical intimacy while the second seeks to incite its auditor to a more general submission to love's power—although in each case the seemingly inoffensive presentation masks a more sinister intent.[46]

If acts 1–4 of *King Arthur* establish a pattern of binary musical episodes whose interconnections across the larger work intensify as the opera progresses, act 5 presents the fulfillment of the opera's grand, two-part sequence, as well as its

advancing thematic trajectory. With the outcomes of physical, psychological, and amorous contestation achieved, Merlin offers his highly wrought vision of future national unity and pride (Y), featuring successive representations of British naval supremacy, maritime and pastoral economic prosperity, rural boisterousness, nobility of passion, romantic fidelity, and chivalric glory. But the concluding masque's elaborate articulation of harmonious Britishness has already been anticipated in the last musical episode of the opera's public, unmagical first half, the pastoral interlude "*How blest are Shepherds, how happy their Lasses*" (X). This notable exception to the pattern of geminated musical segments in the first four acts plays its own important structural role within the opera. First, the dramatically verisimilar and scenically unremarkable episode encapsulates the visual and performative texture of *King Arthur*'s first part, while at the same time rounding out a thematic cluster, enumerated in table 1, in which individual static portrayals of bad Saxons and good Britons (AB) are succeeded by interlinked diegetic efforts to lead Britons out of or into dire predicaments (CD), which in turn give way to a summary depiction of British identity (X). Second, the pattern is repeated in part 2, this time, appropriately enough, through a series of supernatural apparitions (EF/GH/Y) that contrast with the realistic figures populating the part 1 episodes. In keeping with this correspondence, the idyllic "X" episode offers a foretaste of the fifth-act "Y" masque's depiction of national unity: the "*Bright Nymphs of* Britain*, with Graces attended*" (2.2.46) are, we should note, "*Kentish* Lads and Lasses" (2.2.33), subjects of the Saxon Oswald, not the British Arthur. Third, the impromptu song-and-dance entertainment provides an important link between the opera's first and second halves: as a divertive presentation for the blind Emmeline, who "tho' I cannot see the Songs, I love 'em; / And Love, they tell me, is a Dance of Hearts" (2.2.37–38), it anticipates the crucial act 3 love masques (EF) offered for Emmeline once her sight has been restored. Finally, the injunction to the shepherdesses to "*Let not your Days without Pleasure expire*," and their no-nonsense rejoinder demanding suitable nuptial agreements, points toward the deceptive *carpe diem* invitations (GH) to Arthur in act 4 and beyond them to the penultimate number of the act 5 masque (Y_6), with its expression of propriety and balance in male-female relations: "*Youth for Loving was design'd. / I'll be constant, you be kind*" (5.2.192–93).

Within this ever-tightening network of references, act 3, scene 2, stands not merely as a turning point in the opera's plot structure, but as an embodiment of the overall message *King Arthur* seeks to convey. That message, like those of so many earlier operatic works, concerns the nature of kingship and kingly authority. But whereas *King Arthur*'s precursors emphasized the mystical and divine qualities of royal power, Dryden's post-Revolutionary opera shows us a human king

who must undergo a process of learning in order to emerge as the "Valiant" (5.2.197) and "Great" (5.2.226) leader from whose reign will spring momentous historical currents. The process entails passing through consecutive stages of success tempered with adversity, each of which further tests Arthur's capacity for wisdom and understanding. Driven forward by his love for Emmeline while simultaneously held in check by Merlin's admonition to "Hold, Sir, and wait Heav'ns time" (3.1.25), Arthur comes to accept the inevitability of deferral and to embrace a principle of moderation, as against the heat of overweening passion. His third-act visit to Emmeline "to snatch a short liv'd Bliss; / To feed my Famish'd Love upon your Eyes, / One Moment, and depart" (3.2.158–60) includes the similarly "short liv'd" Masque of Sight in which that ocular feeding is symbolically played out. In its "Break[ing] off" upon Osmond's approach, the unfinished performance echoes the opera's larger sequence of postponements in which the British military victory of act 1 must be followed by the abortive pursuit of the Saxon forces and the abduction of Emmeline in act 2, by Osmond's rise to power in act 3, by the snares of the enchanted forest in act 4, and by the single combat with Oswald at the beginning of act 5 before the hero's triumph is finally assured. Arthur's successful negotiation of these trials depends upon his, and Emmeline's, ability to eschew the immoderate warmth so graphically displayed by Osmond in the pivotal scene under investigation here. Musing that "If I was fir'd before, when she was Blind, / Her Eyes dart Lightning now, she must be mine" (3.2.233–34), the magician (who has already "breath'd Brimstone" [3.2.168] on his captive) seeks in his Masque of Ice to obtain the instantaneous melting of Emmeline's resistance. Emmeline, by contrast, understands the value of moderation: upon first seeing the sun, she sagely observes, "How well art thou, from Mortals so remote, / To shine, and not to burn, by near approach!" (3.2.101–2). Significantly, Arthur too has begun to understand this principle: as he flees Osmond's arrival, he reminds Emmeline that

> True Love is never happy but by halves;
> An *April* Sun-shine, that by fits appears,
> It smiles by Moments, but it mourns by Years. (3.2.219–21)

In their statements and deeds the three central figures of act 3, scene 2—a scene essentially devoid of traditional dramatic action—encapsulate the themes and ideas underlying the opera as a whole, and this dynamic of correspondence is cemented in the emblematic Masques of Sight and Ice. The former, in particular, underscores the significant departure from prior articulations of monarchy that *King Arthur* represents. The interruption of the Masque of Sight, though seemingly

occurring in an atmosphere of danger to Arthur and his ideals, in fact expresses the open-endedness of Arthur's learning curve and his potential for increasing success as his attainment of wisdom progresses. On the other hand, despite his having provoked the interruption, Osmond's advantage is fleeting; he comes unopposed, makes his utmost effort, and fails, leaving Arthur to assume, at the opera's conclusion, unchallenged supremacy in both power and love. Thus, unlike the interrupted masques in *The Empress of Morocco* and *Dido and Aeneas*, that in *King Arthur* constitutes an appropriate turn of events, a strategic retreat in the face of illegitimate force that allows for the strengthening of right authority as it readies itself, through a process of personal growth and the acquisition of vision, for its eventual triumph.

It is perhaps ironic that, in the wake of James II's own interrupted experiment in monarchical absolutism, his staunch supporter John Dryden would turn his energies to the promotion of a new, non-courtly form of musical/theatrical entertainment. On the surface, the former poet laureate might seem to have little to gain from such a move, even if it did provide a forum for the expression of his aspirations within the political realm. In Dryden's view, the Saxon invaders—a category encompassing both the noble Oswald and the unscrupulous Osmond—would probably most closely correspond to the foreign "usurper" William III, while Arthur, wellspring of the true British monarchy, would serve to represent King James. In early June 1691, when *King Arthur* probably reached the stage,[47] the decisive naval battle of La Hogue was still nearly a year in the future, and true believers might readily subscribe to the view that James, having suffered a temporary military setback in Ireland, was biding his time in preparation for a triumphant return to power at the head of a French armada. Yet for all his partisanship, Dryden was wise enough to understand that the terms of the debate had already changed. If James were to have any hope of regaining his throne, he must first embark upon the same journey to greater self-knowledge traversed in the opera by Arthur, a journey undertaken in order finally to recover that stolen moment of unconsummated bliss in the arms of his beloved, as enacted in the Masque of Sight and as figured in James's curtailed embrace of his subjects prior to December 1688. At the same time, Dryden's dispensation of this message is of necessity couched in a new rhetorical and generic context, one that acknowledges the realities of the post-Revolutionary moment. Sacred kingship is no longer a sufficient justification for the wielding of authority, and James's return, if it is to be accomplished, must take place with full cognizance of this altered circumstance, a position reinforced through *King Arthur*'s novel approach to monarchy and its expression through theatrical forms.

While seldom given much consideration on account of its lack of musical setting, the interrupted Masque of Sight needs to be understood as crucial to the

rhetorical program of Dryden's opera on both a thematic and a metatheatrical level. In *King Arthur* as in *Dido and Aeneas*, an underlying unity of structure allows the work as a whole to operate not merely as drama but, to use Joanne Altieri's term, as hieroglyphic. The opera's carefully ordered musical episodes are thus part of a methodically conceived and executed edifice of signification in which, as was the case with the court masque, broad considerations of form, genre, and intertextuality go hand in hand with textual and dramatic elements to establish the overarching meaning of the work. In *The Empress of Morocco* and *Dido and Aeneas*, the appearance of an interpolated masque within the fabric of the drama signals a consideration of the nature of royal authority, while the masque's interruption by dramatic forces outside its own purview shows that authority under assault and scrutinizes the foundations on which it is constructed. In *King Arthur*, royal authority is again emblematized in the Masque of Sight, but this time, in the wake of the Williamite shift in the nature of monarchy, its foundations have changed, and both the masque and its role as symbol must change as well. With the all-perceiving eye of the sacred royal auditor no longer a factor, the Masque of Sight, acting both per se and as a synecdoche for the opera as a whole, must work out its implications through a new dynamic of seeing and being seen in which vision, both literal and figurative, becomes itself the object of theatrical analysis.

What characterizes all three of the interrupted masques here is not just their deployment of meaning on a variety of levels, but their transitoriness as well. Like Prospero's wedding masque, the Masque of Orpheus, the Masque of Actaeon, and the Masque of Sight are all performed not in grand banqueting houses at royal courts, but out-of-doors, in temporary settings: a military encampment, a "grove," an enchanted wood.[48] In one respect, the situating of these masques in such unlikely places highlights their fleeting nature, their susceptibility to dislocation, both within the drama itself and as super-dramatic metaphors for the inherent fragility of monarchical absolutism. But it also carries to a logical extreme the paradox at the heart of all court masque: that these intricate expressions of the highest ideals of Renaissance and Baroque kingship are by their very nature evanescent. Contemporary audiences knew this well whenever they joined in the post-performance stage strike, tearing down the meticulously constructed machines and scenic effects on which the masque depended for its awe-inspiring visual power. And modern scholars are similarly aware of the phenomenon as they attempt to piece together the scattered and fragmentary remains of these magnificent and celebrated theatrical events.

One particular casualty of the unruly state of masque source material is music, and we should note that the three Restoration interrupted masques under discussion here are, again, no exception to the general rule. Each appears in a work, and

was set by a composer, regarded as influential in the development of English opera during the last quarter of the seventeenth century, yet each suffers, in its own way, from incompleteness, misunderstanding, or worse. Matthew Locke's Masque of Orpheus survives nearly whole, but it has yet to be made available in a modern recording; Henry Purcell's Grove Scene and its Masque of Actaeon, I have argued, has come down to us only in a mutilated, condensed form; any music Purcell may have written for the Masque of Sight in *King Arthur* is missing entirely, and it will probably never be recovered. The absence, to one degree or another, of the musical elements of these interrupted masques is itself a part of the interpretive nexus that informs our inquiry. As with the masques for which they were created, it is necessary to keep alert for the moment at which they break off and, more importantly, to wonder why.[49]

1. *The Tempest*, ed. David Bevington et al. (New York: Bantam Books, 1988), 62 (4.1.40–41). Subsequent references to this work are given parenthetically in the text, citing act, scene, and line number.

2. *Ben Jonson: The Complete Masques*, ed. Stephen Orgel (New Haven and London: Yale Univ. Press, 1969), 122–23 (lines 12, 15–16). Subsequent references to this work are given parenthetically in the text, citing line number.

3. Stephen Orgel, ed., *The Illusion of Power: Political Theater in the English Renaissance* (Berkeley: Univ. of California Press, 1975), 40.

4. For a discussion of Restoration absolutism and its periodization, see Andrew R. Walkling, "Court, Culture, and Politics in Restoration England: Charles II, James II, and the Performance of Baroque Monarchy" (PhD diss., Cornell Univ., 1997), 1:106ff., 177ff.

5. Curtis A. Price, *Music in the Restoration Theatre: With a Catalogue of Instrumental Music in the Plays, 1665–1713* (Ann Arbor, Mich.: UMI Research Press, 1979), 30.

6. Elkanah Settle, *The Empress of Morocco A Tragedy. With Sculptures. As It Is Acted at the Duke's Theatre* (London: Printed for William Cademan, 1673); reprinted in *The Empress of Morocco and Its Critics: Settle, Dryden, Shadwell, Crowne, Duffet*, comp. and introduction by Maximillian E. Novak, Augustan Reprint Society, Special Publications 3 (Los Angeles: William Andrews Clark Memorial Library, 1968).

7. *The Empress of Morocco*, sig. A2v (dedication to Henry Howard, later sixth Duke of Norfolk): "For besides it's noble Birth, you gave it a noble Education, when you bred it up amongst Princes, presenting it in a *Court-Theatre*, and by persons of such Birth and Honour, that they borrow'd no Greatness from the Characters they acted" (italics reversed). Two different prologues for the court performances were spoken by Lady Elizabeth Howard, a daughter of the dedicatee.

8. *The Empress of Morocco*, sig. A1r. Subsequent references to this work are given parenthetically in the text, citing page number. For a discussion of the court production of the work and of Settle's position at Whitehall, see Eleanore Boswell, *The Restoration Court Stage (1660–1702) with a Particular Account of the Production of Calisto* (Cambridge, Mass.: Harvard Univ. Press, 1932), 131–34. Settle's appointment, listed in a "rough establishment" book of 1671 (National Archives, London, LC 3/27, 94), is not mentioned in *Officials of the Royal Household, 1660–1837, Part 1: Department of the Lord Chamberlain and Associated Offices*, comp. Sir John Christopher Sainty and Robert O. Bucholz (London: Univ. of London, Institute of Historical Research, 1997), 27.

9. *Notes and Observations on The Empress of Morocco* (London: [Printed for Richard Bentley], 1674) and Elkanah Settle, *Notes and Observations on The Empress of Morocco Revised* (London: Printed for William Cademan, 1674), both reprinted in Novak, *Empress of Morocco and Its Critics.*

10. According to Settle, the inspiration for his story came from the embassy of his dedicatee, Henry Howard, to Morocco in 1669–70 (dedication to *The Empress of Morocco*, sig. A2v); however, he also appears to have relied on Lancelot Addison's *West Barbary; or, A Short Narrative of the Revolutions of the Kingdoms of Fez and Morocco* (Oxford: Printed for John Wilmot, 1671), 17–21.

11. Locke's score, which survives in Christ Church, Oxford, Mus. MS 692, ends with the preceding chorus, providing no music for this dance.

12. Instances in which aristocratic masquers may have "stepped in" to preexisting parts introduced by professionals during the antimasque can be found in Thomas Campion's *The Lord Hay's Masque* (1607) and the recently discovered *Essex House Masque* discussed in Timothy Raylor, *The Essex House Masque of 1621: Viscount Doncaster and the Jacobean Masque* (Pittsburgh: Duquesne Univ. Press, 2000).

13. Laula, we should note, had prepared a less subtle Plan B in case the staged murder were to fall short: "Had not Her hand struck home to back her Crime, / The Surgeons I had brib'd to poyson him" (52).

14. Viewed in this light, *The Empress of Morocco* offers a useful perspective on the early stages of Elkanah Settle's notoriously fluid literary and political career. Although his stint as a virulent Whig polemicist and coordinator of pope-burning processions did not commence until the beginning of the 1680s, even the relatively youthful Settle of 1673, perhaps inspired by his association with the Earl of Rochester, appears to have felt comfortable engaging in the kind of "corrective" political discourse that distinguishes many of the court-sponsored dramatic works of the mid-1670s. For more on Settle during this period, see Jeannie Dalporto, "The Succession Crisis and Elkanah Settle's *The Conquest of China by the Tartars*," *The Eighteenth Century* 45 (2004): 131–46.

15. See Bruce Wood and Andrew Pinnock, "'Unscarr'd by Turning Times'?: The Dating of Purcell's *Dido and Aeneas*," *Early Music* 20 (1992): 372–90; Andrew R. Walkling, "'The Dating of Purcell's *Dido and Aeneas*'?: A Reply to Bruce Wood and Andrew Pinnock," *Early Music* 22 (1994): 469–81; Walkling, "Political Allegory in Purcell's 'Dido and Aeneas,'" *Music and Letters* 76 (1995): 540–71; and other articles and letters cited in the last of these, 540–41, nn. 2, 3.

16. Andrew R. Walkling, "The Masque of Actaeon and the Antimasque of Mercury: Dramatic Structure and Tragic Exposition in *Dido and Aeneas*," forthcoming.

17. Nahum Tate, *An Opera Perform'd at Mr. Josias Priest's Boarding-School at Chelsey. By Young Gentlewomen* ([?London], [1689]), 4. The unique copy of this source, commonly known as the Priest libretto, is in the Royal College of Music, London (shelfmark D144); a facsimile can be found in *Dido and Aeneas*, ed. Margaret Laurie, vol. 3 of *The Works of Henry Purcell* (Sevenoaks, UK: Novello [Purcell Society], 1979), xiii–xx. As there is as yet no good critical edition of the text of *Dido and Aeneas*, all quotations here are taken directly from this source, with necessary emendations marked in square brackets. Subsequent references to this eight-page booklet are given parenthetically in the text when necessary for purposes of clarity, citing page number.

18. The Priest libretto (see fig. 55) prints "Lovesome," which is generally regarded as a typographical error—one of many in this poorly composed source.

19. The Priest libretto gives "VVith" for "With," "These" for "Those," and "huntsmen" for "huntsman."

20. Tate, *An Opera Perform'd at Mr. Josias Priest's Boarding-School.*

21. Bodleian Library, Oxford Univ., MS Tenbury 1266 (5), entitled "The Loves of Aeneas and Dido." The manuscript was previously in the library of St. Michael's College, Tenbury Wells; the date of ca. 1775 is proposed in Ellen T. Harris, *Henry Purcell's "Dido and Aeneas"* (Oxford: Clarendon Press, 1987), 45.

22. See Walkling, "Masque of Actaeon."

23. "'Twas censur'd variously: for, many thought / The punishment farre greater then the fau't. / Others so sowre a chastitie commend, / As worthy her: and both, their parts defend." This version of *Metamorphoses* 3.253–55 is from the translation by George Sandys: *Ovid's Metamorphosis English'd by G[eorge] S[andys]*,

1st complete ed. (London: Printed by William Stansby, 1626); the modern, critical edition used here is *Ovid's Metamorphosis Englished, Mythologized, and Represented in Figures by George Sandys*, ed. Karl K. Hulley and Stanley T. Vandersall, with a foreword by Douglas Bush (Lincoln: Univ. of Nebraska Press, 1970), 133.

24. The Priest libretto gives "Ensue" for "pursue."

25. It should be noted, however, that few directors have availed themselves of the opportunity to represent graphically Dido's acquiescence to Aeneas's overtures by reinserting the missing guitar chaconne, a formal dance in which the couple's courtship would almost certainly have been played out, near the end of act 1.

26. This, of course, differs significantly from Virgil's original narrative, which emphasizes Aeneas and Dido's sexual consummation in the cave where they have sought shelter from an unexpected (but in this case presumably natural) cloudburst.

27. George Sandys, *Ovid's Metamorphosis Englished, Mythologized, and Represented in Figures* (Oxford: Printed by [J]ohn Lichfield, 1632), quoted in Hulley and Vandersall, Ovid's *Metamorphosis*, 151–52. Subsequent references to this work are given parenthetically in the text, citing page number.

28. Walkling, "Political Allegory."

29. J. M. Armistead, "Dryden's *King Arthur* and the Literary Tradition: A Way of Seeing," *Studies in Philology* 85 (1988): 53–72.

30. Joanne Altieri, "Baroque Hieroglyphics: Dryden's *King Arthur*," *Philological Quarterly* 61 (1982): 431–51, esp. 437.

31. See Price, *Music in the Restoration Theatre*; by 1700, Price argues, "the abuse of music in Restoration drama" (93) had become a matter of concern sufficient to provoke acrimonious debates between the theatrical establishment and would-be reformers.

32. See Armistead, "Dryden's *King Arthur*," esp. 54–58, 63–66, for an exploration of early-modern treatments of the Arthurian legend upon which Dryden may have relied.

33. James Anderson Winn, *"When Beauty Fires the Blood": Love and the Arts in the Age of Dryden* (Ann Arbor: Univ. of Michigan Press, 1992), 277.

34. *The Works of John Dryden*, ed. E. N. Hooker and H. T. Swedenberg, Jr., et al., 20 vols. (Berkeley and Los Angeles: Univ. of California Press, 1956–2000), 16:38 (3.2.68). Subsequent references to this work are given parenthetically in the text, citing act, scene, and line number. The edition of *King Arthur* (ed. Vinton A. Dearing, 1996) is on 1–69, with supplementary materials at 281–343, 441–56, and 475–513.

35. Armistead, "Dryden's *King Arthur*," 65.

36. As the notes to table 1 indicate, the *Works* edition of *King Arthur* unnecessarily adds several scene changes in acts 2, 4, and 5, apparently on the assumption that a momentarily empty stage must signal a scene division—even though such a distinction falls far short of any conventional notion of "French scene." While I utilize the scene/line numbers from this edition throughout, the scene distinctions enumerated in table 1 are based on the presumed need for an actual change of scenery on the stage, or at least some movement between discrete zones of the stage intended to indicate a noncontinuous shift in location. In the table, what I consider to be "faulty" references are given within single quotation marks.

37. Table 1 also notes the presence of stage directions requiring trapdoors, although these could as easily have been located in the forestage as in the scenic space behind the proscenium arch. For the placement of trapdoors just behind the proscenium arch in *The Empress of Morocco*, see fig. 54.

38. We might consider how these nondescript characters could be identified with the "personal genii" posited by Altieri (434–35) as Dryden's Christianizing answer to the Classical motifs and divine figures of earlier operas.

39. Curtis Alexander Price, *Henry Purcell and the London Stage* (Cambridge: Cambridge Univ. Press, 1984), 297–98.

40. See, for example, Andrew Pinnock, "*King Arthur* Expos'd: A Lesson in Anatomy," in *Purcell Studies*, ed. Curtis Price (Cambridge: Cambridge Univ. Press, 1995), 243–56.

41. Although it would be pure speculation, might we imagine the master composer building some musical incompleteness into his Masque of Sight, thereby rendering it unperformable outside its dramatic context and, consequently, of no interest to later copyists?

42. I use "tmetically" here as the adverbial form of *tmesis*, the cutting or separation of a compound formation by the intervention of a separate, generally unitary, item; such terminology is normally employed in a linguistic

context, but it is here used to characterize the insertion of Grimbald's strophic A-major *"Let not a Moon-born Elf"* into the middle of the more complex D-minor/D-major *"Hither this way . . . Come follow"* structure associated principally with Philidel and her attendent spirits. For a detailed reading of this episode, see Rodney Farnsworth, "'Hither, This Way': A Rhetorical-Musical Analysis of a Scene from Purcell's *King Arthur*," *The Musical Quarterly* 74 (1990): 83–97.

43. Charlotte Butler, who performed the combined spoken/sung role of Philidel, also doubled as the singing Cupid in the "Frost Scene"/Masque of Ice. Grimbald, who laments, "I had a Voice in Heav'n, ere Sulph'rous Steams / Had damp'd it to a hoarseness" (2.1.84–85), was in fact played by the experienced Purcellian bass John Bowman. As Butler and Bowman often worked together, Olive Baldwin and Thelma Wilson reasonably wonder whether Bowman might have sung the part of the "Cold Genius" in the "Frost Scene" as well; see "Purcell's Stage Singers," in *Performing the Music of Henry Purcell*, ed. Michael Burden (Oxford: Oxford Univ. Press, 1996), 105–29, esp. 110.

44. Music survives only for the second part of this episode, the languishing duet *"Two Daughters of this Aged Stream are we."*

45. The stage direction after 4.2.78 states, *"Here the Dancers, Singers and Syrens vanish."* Given their continued presence, might we entertain the possibility that the two treble sirens joined with one of the nymphs to sing the voluptuous trio *"In vain are our Graces"* in the latter episode? Reintroducing the alluring sirens here would make sense in terms of the text's shift from the anaphoric to the hortatory between the first and second stanzas. Ignoring the evidence of the stage direction, Andrew Pinnock (*"King Arthur* Expos'd," 255–56) offers the *absence* of these two singers from the passacaglia as an explanation for the confused state of the musical sources at the point where the trio occurs.

46. Andrew Pinnock, moreover, has beautifully demonstrated the textual congruences between the Masque of Sight and *"How happy the Lover"* (*"King Arthur* Expos'd," 254–55), albeit with the contrary aim of suggesting that the latter text "began life as a metrically more regular re-write of 'O sight', suitable . . . for a strophic setting and probably meant to replace 'O sight' in Act 3."

47. See Judith Milhous and Robert D. Hume, "Dating Play Premières from Publication Data, 1660–1700," *Harvard Library Bulletin* 22 (1974): 374–405, esp. 398.

48. The circumstances of the Masque of Orpheus are clarified by Settle in his *Notes and Observations on the Empress of Morocco Revised*, 66, responding to criticism of his stage direction at the outset of the masque: "I know 'tis nonsense to say *women Spirits*, and I know dear heart, as thou doest, *that Spirits have no Sexes*. But this being in the direction is spoken in reference to the *Actors* that were *women* not the *Characters* they presented. For if the description only related to the *persons* or *business* in the *Play*, then it should not have been the [Scene open'd] but [*the Tent open'd*] *is presented*, &c. nor should it have been [the Stage is fill'd on both sides with *Crimalhaz*, &c.] for this Mask is suppos'd perform'd in a *Pavilion*, in a Camp. But all *marginal descriptions* or *entryes* in Plays refer indifferently to the *real place* or *Persons*, as to the *represented Characters*."

49. I owe many thanks to James Winn for his generosity in offering a number of penetrating insights and helpful suggestions. This essay originated as a public lecture-recital given at the Yale Center for British Art in 2002, in conjunction with the *Painted Ladies* exhibition. I am grateful to the Center, and particularly to Julia Marciari Alexander, for sponsoring that talk and for supporting the musical performance that accompanied it.

Celebrity Erotics: Pepys, Performance, and Painted Ladies

Joseph Roach

> Of all the religious and artistic treasures which a visitor may see at Westminster Abbey, the collection of eighteen funeral effigies in the Museum is perhaps the most intriguing. Carved in wood or in wax, these full-sized representations of kings, queens and distinguished public figures, many of them in their own clothes and with their own accoutrements, constitute a gallery of astonishingly life-like portraits stretching over more than four centuries of British history.
>
> —HRH the Prince of Wales

CAN ONLY THE DEAD astonish us by seeming "life-like"? Perhaps even the living can induce this uncanny effect from time to time. Of the eighteen royal funeral effigies in the Norman undercroft at Westminster Abbey, the one to which the Prince of Wales's description most appositely refers belongs to his predecessor and namesake Charles II. The last of its kind, it was constructed at the time of his death in February of 1685. Yet King Charles's lifelike (and at an imposing six feet two inches, fully life-size) effigy played no part in his funeral obsequies, the austerity of which departed from traditional royal mortuary practice—which required the display of a wooden or wax effigy of the monarch along with the corpse—perhaps because rumors of the king's deathbed conversion to Catholicism inhibited the mourners. Whatever economies or sectarian scruple curtailed the ritual, however, none stinted the materials and craftsmanship lavished on the object itself, which crowned a collection of venerable forebears, going back to the stiff wooden mannequin carved for the burial of Edward III in 1377. To represent Charles as close to life as possible, expert artisans molded the pale skin of his hands and face in wax, probably working from a life mask made in anticipation of the occasion. They fashioned the large, brown eyes from glass and the pencil-thin mustache and eyelashes from human hair. They fabricated a skeleton from wood and iron wire, fleshing it out with straw sewn into a canvas skin. Then they dressed the body in the king's own clothes, from foundation garments to Garter robes—

silk drawers, breeches, stockings, shirt, embroidered doublet, hood, surcoat, scarlet mantle, cravat—topped off with accessories: high-heeled shoes, wig, sword, jewelry, and plumed hat (fig. 56). He stands on view today as he has since then, opened out in fourth position, turned ever so slightly contrapposto to make an interesting line of the body; chin up, head back, as if preparing without any special urgency to step forward and to speak, languidly animated by the bubble of impudence—"astonishingly life-like" indeed.[1]

Some objects do seem to want to speak for themselves. The English royal effigies, even those constructed with far less verisimilitude than Charles II's, belong to this class of lively artifacts, which trouble the finality they serve to commemorate. Along similarly paradoxical lines, the word "effigy" itself, which in ordinary usage refers to one version or another of a straw man, shares a meaning with a number of cognates that describe various kinds of vital activity: "effectiveness," "efficiency," "efficacy," "effervescence," and "effeminacy"—all ring changes on the theme of movement outward from an animating source. "Effigy" can also be used as a verb, meaning to evoke an absence, to body something forth, especially something from the distant past.[2] In that sense, it is very close to the meaning that many users intend when they say the word "performance," which, among other capacities, communicates personas as well as practices over time and space.

What follows is a meditation on the last of the English royal effigies as a historical prefiguration of modern celebrity and the special performances by which it is most efficaciously established and maintained. As a sacred relic, a medieval holdover that symbolized the immortal "body politic" of the superannuated, double-bodied monarch, the effigy performed a function that continues to occupy the vast technical capacities of various media today: it attempted to preserve and publicize the image of an individual in the absence of his or her person. Such a process defines celebrity. Seventeenth-century usage of the word "celebrity" captures its historical relationship to performance—a solemn funeral could be performed with "great celebrity," for instance, or a ritual could be denominated as "the first Celebrity of Divine Service with organ and Choristers."[3] At the same time, the royal effigy gave a performance that could best be described by the present meaning of the word "celebrity"—an idolized person or the exalted state of being one, a kind of apotheosis marked by a persona that circulates even when the person does not.

The funeral effigy did its work in part by materializing in death a well-known likeness, symbolizing, at a moment of high ritual expectancy, the general image that all the subjects of a monarchy might reasonably be expected to hold in their minds' eyes. The use of royal effigies died out with Stuarts. Wax figures eventually commemorated William and Mary, and Queen Anne, the last of her dynasty, but their construction followed the deaths of the honorees by decades. Other notables in the

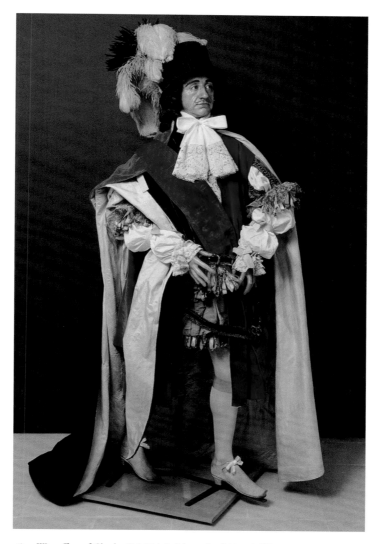

56. Wax effigy of Charles II (1685), height 74 in. (188 cm). Westminster Abbey Museum.

eighteenth century commissioned their own effigies, but the last public figure to be honored in this way was Vice Admiral Horatio Nelson, first Viscount Nelson, in 1806. At the moment of the funeral effigy's disappearance from history, however, derivative specters multiplied in public memory and imagination, anticipating the burgeoning phenomenon described by the word "image" today: the mediatized conception of a person or institution (as in "corporate image"), not reducible to any one

of the many icons that publicize it, but rather disseminated pervasively as a ghostly semblance, specific yet intangible, seen by no two people in exactly the same way, yet intelligible to nearly everyone. This essay examines the development of that kind of mental image, one that oscillates back and forth at the speed of gossip between public and private fantasies, lending itself more readily to description than to illustration.

Once, when objects such as coins and popular religious icons alone mediated between relative obscurity and visibility, circulation of personal imagery was restricted to an elite of emperors and saints. In seventeenth-century England, however, as elsewhere in early-modern Europe, the production and distribution of personal images underwent an expansion, minor in comparison to what was to come, yet significant as a harbinger of long-term trends in the history and culture of celebrity. By the terms of this expansion, ordinary mortals could reach for the publicity once reserved for sovereigns or divines. Even as the use of funeral effigies dwindled, successor forms of image making grew in popularity: full-size portraits, miniatures, engravings, busts, and statuary, including many of the monuments that have clogged the aisles of Westminster Abbey and other English places of worship. In Book 3 of *The Stones of Venice*, John Ruskin traced the path of this "semi-animate type" from Italy to England. He notes how the corpse-like, piously recumbent effigies on medieval tombs first "raised themselves up on their elbows, and began to look round them." What they saw must have pleased them, for Ruskin continues:

> The statue, however, did not long remain in this partially recumbent attitude. Even the expression of peace became painful to the frivolous and thoughtless Italians, and they required the portraiture to be rendered in a manner that should induce no memory of death. The statue rose up, and presented itself in front of the tomb, like an actor upon a stage, surrounded not merely, or not at all, by the Virtues, but by allegorical figures of Fame and Victory, by genii and muses, by personifications of humbled kingdoms and adoring nations, and by every circumstance of pomp, and symbol of adulation, that flattery could suggest, or insolence could claim.[4]

Many of these new effigies emerged from representations of aristocratic celebrities and the growing ranks of their social emulators, but they no longer required the death and beatification of their subjects to provide occasion for their production. Most tangibly, they came from images of the kind produced in the studios of portraitists, led from the mid-seventeenth century by Peter Lely; more intangibly but no less consequentially, they were circulated as performed "images" in the modern sense, materially assisted by the availability of relatively inexpensive prints, generalized by the appropriable "looks" they promulgated to an increasingly

fashion-conscious consumer society, and augmented by both theatrical performances and the gossip-inducing displays of conspicuous consumption that resembled them—socially staged promenades "in their own clothes and with their own accoutrements." Yet along with such premeditated appearances came a concomitant desire to appear spontaneous. This required readiness on the part of the performers to adopt an air of "life-like" informality, which actors call public intimacy and portraitists, dishabille. The kind of life that it is most like—more or less glamorous icons humanized by provocative glimpses of their vulnerabilities—is erotic life.

That at least was one of the compelling messages communicated by the exhibition titled *Painted Ladies: Women at the Court of Charles II*, which ran at the National Portrait Gallery, London, in late 2001 and at the Yale Center for British Art in early 2002. It recovered the best physical evidence of a significant moment in the history of image making, poised on the cusp of sacred and secular celebrity. The exhibition featured some of Lely's famous "Windsor Beauties," a group of portraits painted in the early to mid-1660s, and other securely identifiable images of women who were known to have been at the court of Charles II. Significantly, the curators included in the exhibition prints as well as paintings. As the didactic panels and catalogue copy of *Painted Ladies* demonstrated by frequent citation, the most extraordinarily revealing view of this moment in the history of image making was recorded by Samuel Pepys, Admiralty clerk and famously candid diarist. At the twilight of sacral monarchy and in the moral shadow of its most concupiscent court, what Pepys witnessed was the appropriation of the religious aura of celebrity by an erotic one. His *Diary* shows why such transformative image making required performance: never entirely separable as objects of desire, sacred and sexual celebrities mingled willy-nilly in the secular portraiture, public behavior, and actor-centered dramatic characterization of the English Restoration. Charles II, "the Merry Monarch," God's anointed vicar on earth and titular head of the theater in the bargain, created an image of sexual celebrity that fascinated and troubled his subjects. Nowhere was he more disturbingly yet tellingly effigied than by his obscene proxy, Bollixinion, in the demented mock-heroic play *Sodom; or, the Quintessence of Debauchery* (1674),[5] but an equally critical portrait emerges from the far less scurrilous expressions of apprehension and disgust recorded by Pepys and his fellow diarist John Evelyn. Pepys thought that the king "hath taken ten times more care and pains" to reconcile his feuding mistresses "then ever he did to save his kingdom."[6] Evelyn confided an epitaph to his diary at the time of the king's death that illuminates the airy insouciance of the king's effigy: "An excellent prince doubtlesse had he ben lesse addicted to Women, which made him uneasy & allways in Want to supply their unmeasurable profusion."[7] Yet in the manipulative negligence of his royal image, which became inseparable from those of the women whose profusion Evelyn could

not measure, Charles beguiled Pepys, warming his subject with images of public intimacy and exciting him to remarkable feats of vicarious emulation.

Public intimacy is the sexy version of the worthy but stolid bourgeois public sphere described by Jürgen Habermas. It consists of libidinous mental imagery socially expanded beyond the formal institutions of state or Church and broadcast through the collective media of mimetic desire such as the arts (especially theater), advertising, and pornography. Mimetic desire summons together a community of daydreamers, motivating them with the chimera of something that they think they want because others they see seem to want it too, or, more urgently, seem to have it exclusively to themselves. Like the theater, mimetic desire generates a parade of substitutes, surrogates, stand-ins, body doubles, and knockoffs, especially when the sexual icon assumes the trappings of the sacred one—a process that is the generative pattern for early-modern celebrity erotics.

The massed hanging of Restoration portraiture in *Painted Ladies* restaged the impious relationship of public intimacy and mimetic desire in room after room, paramour after paramour. There the beholder learned, for instance, that Barbara Villiers, Countess of Castlemaine (later Duchess of Cleveland), longtime mistress of King Charles II, posed along with their bastard son as Madonna and Child (see fig. 2). A version of this blasphemously flattering portrait by Lely later turned up in the chapel of a French convent, where it hung unsuspected above the altar until the nuns finally learned of its objectionable provenance and sent it back. The penitent Mary Magdalene offered a more plausible model for "role portraits" of Castlemaine and one of two other royal mistresses, actresses Eleanor "Nell" Gwyn or Mary "Moll" Davis. Which player sat for the Magdalene is not certain—a confusion exacerbated by the tendency of later authorities to identify almost any unknown female sitter in Restoration portraits as "Nell Gwyn." With the advent of Catherine of Braganza as queen, portrait images of fashionable women as the martyred Saint Catherine, including several of the inexhaustible Castlemaine, accumulated.[8] Their power to titillate derived in no small measure from the notorious proximity of the sitters to the king's person, and his royal playhouse publicized the trend: speaking the epilogue to John Dryden's *Tyrannick Love* (1669), Nell Gwyn was made to rhyme "St. Cathar'n," in whose tragic story she had just played a role, with "Slater'n," the popularly known role that she was then playing in the royal service.[9] Frances Teresa Stuart (later Duchess of Richmond and Lennox), "La Belle Stuart," the most famously pulchritudinous of all the "Windsor Beauties," seems to have successfully resisted the advances of the besotted king. Intriguingly, she appears in Lely's celebrated Windsor portrait with a bow in hand, evoking the chaste pagan deity Diana (fig. 57). In the same vein, she graces a role portrait by another artist as a spear-toting Minerva, and her image was cast in a

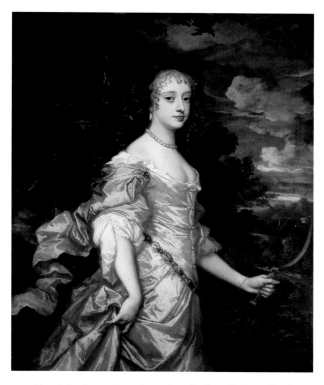

57. Peter Lely, *Frances Teresa Stuart (later Duchess of Richmond and Lennox)*, oil on canvas (ca. 1662), 49½ x 40⅜ in. (125.8 x 102.7 cm). The Royal Collection, Her Majesty Queen Elizabeth II.

bronze medal as the similarly armed Britannia (see fig. 42). But she does not appear as a Christian icon, vulnerable in her negligence. Frances Stuart, who will return shortly below in connection with Pepys's active fantasy life, was the exception that proves the rule of sacred and profane love at the court of Charles II.[10]

Socially emulating the glamorous women of the court (and the actresses who were their working-class surrogates or stunt doubles), privileged individuals of lesser rank could aspire to their own performances of mimetic identification and desire—the trickle-down effect of erotic celebrity. As it does with almost every important trend of the period 1660–69, Pepys's *Diary* records the secularization of the sacred effigy in the fashionable female portrait firsthand. After having long admired the Jacob Huysmans portrait of Queen Catherine as Saint Catherine, Pepys is at last able to note his satisfaction at the sight of his wife, Elizabeth, posing bare-shouldered in John Hayls's studio for her role portrait as the Sacred Bride of Christ (fig. 58). Sitting for such a portrait was a performance in itself. It required

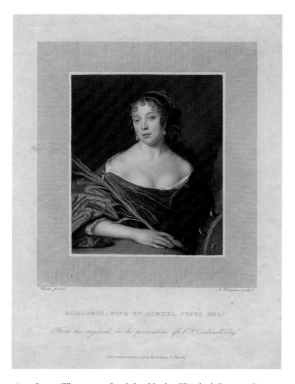

58. James Thomson after John Hayls, *Elizabeth Pepys as Saint Catherine*, stipple engraving (published 1825), paper size 10⅞ x 8⅜ in. (27.7 x 21.3 cm). National Portrait Gallery, London.

mimetically mastering an iconography that had been recycled through the queen and the other painted ladies of the Carolean court: "Here Mr. Hales begun my wife in the posture we saw one of my Lady Peters, like a St. Katherine. . . . It did me good to see it, and pleases me mightily—and I believe it will be a noble picture."[11] When Pepys says that his wife's portrait will be "like a St. Katherine," which is like Lady Peters, which is like the queen, he effigies her as the latest candidate to claim possession of a venerable role, newly reanimating it by a certain eroticized "look." That look is very distinctive. The heavily lidded, "sleepy" eyes, the oval face framed by corkscrew curls, the rouged lips parted slightly, the flushed cheeks, and the emphatic décolleté that characterize the celebrated "Windsor Beauties" also mark the sitters for the religious role portraits, including the virtuous and long-suffering Elizabeth Pepys. She embodies Saint Catherine in the negligent act of losing track of her satin gown at the extremity of her shoulders, even as she artfully displays her pearl-drop earrings and tiara in languorous equipoise. At Elizabeth's side the

menacing rim of the spiked wheel on which Saint Catherine was cruelly martyred appears iconically and suggestively. Among other things it insinuates the sitter's readiness to endure pain, which her guilty husband confessed to having inflicted on her more often than his devoted Christian's conscience could easily bear.[12]

The casual construction of such an effigy in the daily life of his marriage illuminates two other scenes from Pepys's *Diary* that shock the reader with their matter-of-fact infusion of the sacred with the sexual. The first consists of the several occasions when he confesses his habit of masturbating in church. The second is when he recounts with self-satisfied jollity how he violated the corpse of Catherine of Valois, Henry V's queen, which was then on display by special arrangement in Westminster Abbey. Both narratives bear on the historical transmission of the effigy from the medieval to the modern practice of erotic celebrity.

Judging from the doubly coded language of the diary entries recording his intimate practices, masturbating during religious services made Pepys feel more guilty but also more excited. His diary descriptions of his onanism, like those of his adulteries, employ not only shorthand but also a polyglot lexicon combining French and Spanish. Pepys's keyword is "mi cosa" ("my thing"). Thus, the entry for 11 November 1666 reads: "Here at church (God forgive me), my mind did courir upon Betty Michell, so that I do hazer con mi cosa in la eglisa même."[13] Betty Michell was the teenage daughter of one of Pepys's friends and later the wife of another. On Christmas Eve, 24 December 1667, he pleasured himself during High Mass in the Queen's Chapel, Whitehall. Although he would not wish to be thought a Papist, the elaborated liturgy and the presence of her most Catholic majesty with her attendants seem to have inspired him to virtuosic efforts: "The Queen was there and some ladies. . . . But here I did make myself to do la cosa by mere imagination, mirando a jolie mosa and with my eyes open, which I never did before—and God forgive me for it, it being in the chapel."[14] On 3 May of the next year, he tried it with eyes wide shut, so to speak: "After dinner to church again where I did please myself con mes ojos shut in futar in conceit the hook-nosed young lady, a merchant's daughter, in the upper pew in the church under the pulpit."[15] Like the artisans who crafted the royal effigies, Pepys had techniques to make his dreams astonishingly lifelike. The obligatory element, in expectation and execution, was the mental image of a woman, sometimes one who was physically present (as with the queen in her chapel and the merchant's hook-nosed daughter), but also one who was absent (as with Betty Michell in the first church episode). That the real power resided in the summoned mental image—hence in memory, in performance, in effigy—is suggested by the fact that Pepys closed his eyes to fantasize about the merchant's daughter, even though she was then present to his sight in her pew beneath the pulpit. To complete his performance, he turned her into what he called a "conceit."

Pepys's diurnal encounters in and around London and Westminster provided him with a panoply of potential "conceits" for later use. Their staging can be highly theatrical, replete with dramatic conflict, sets, costumes, and props. Celebrity intensifies their effects, but it also reveals the inner process of making the images whereby celebrity is constructed. On 13 July 1663, for instance, Pepys sees the king, the queen, and Lady Castlemaine taking the air. The king is paying attention to his wife. Castlemaine is in a royal pout. Pepys is captivated not only by the glamour of the queen, but also by the flirtatious play of the court ladies, especially Frances Stuart, who stages an impromptu fashion show, featuring feathered hats. He records:

> All the ladies walked, talking and fidling with their hats and feathers, and changing and trying one another's, but on another's head, and laughing. But it was the finest sight to me, considering their great beautys and dress, that ever I did see in all my life. But above all, Mrs. Steward in this dresse, with her hat cocked and a red plume, with her sweet eye, little Roman nose, and excellent *Taille*, is now the greatest beauty I ever saw I think in my life.[16]

The vaudeville of the hat exchange suggests the fungibility of the painted ladies in the erotic economy of the court, but Pepys puts to work the remembered image of "Mrs. Steward," then the chief yet ever elusive object of the king's sexual designs, and secondarily that of the queen herself to effect the private climax of his mimetic desire, celebrity fantasy, and subsequent auto-performance: "to bed—before I sleep, fancying myself to sport with Mrs. Steward with great pleasure." Then, two nights later: "to bed, sporting in my fancy with the Queen."[17]

Pepys's nocturnal juxtaposition of the images of Queen Catherine and Frances Stuart gives the reader a glimpse into a private nodal point in the larger network of erotic celebrity. In this network the bearers of a certain look and a certain reputation could substitute for one another in the minds of fantasists with even greater celerity than they did in the king's bed. Quite apart from the testimony of Pepys, the strength of that network appears to be confirmed by the physical evidence of the effigies in Westminster Abbey. The wax figure of Charles II is not paired with one in the same style that depicts Catherine of Braganza, his queen, but rather one of Frances Stuart, Duchess of Richmond and Lennox, his unrequited love (fig. 59). In a codicil to her will, dated shortly before her death in 1702, she provided for an "Effigie as well done in wax as can be," dressed in the gown she had recently worn at the coronation of Queen Anne. Even then, forty years and a bout with smallpox later, the *Daily Courant* remembered her as "that celebrated Beauty," and skilled artisans fixed her comely image for posterity wearing

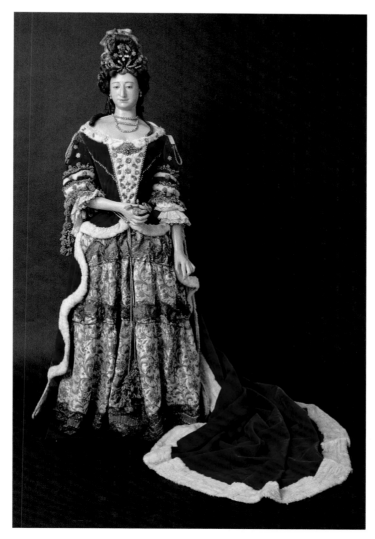

59. Wax effigy of Frances Teresa Stuart, Duchess of Richmond and Lennox (1702),
height 68 in. (172.7 cm). Westminster Abbey Museum.

her own clothes and accessories, including her stuffed parrot, a West African gray,
the oldest-known object of its kind, which became a tourist attraction in its own
right later in the eighteenth century.[18] By then the painted ladies had long been
collectibles, with a number of sets, called "beauties series," turned out by Lely
and his staff of copyists, featuring not only celebrated women but also notorious
ones, those whose liaisons with Charles II had marked them in public memory and

imagination. Pepys narrates the spectacle of their circulation and implicates himself in it by his ornate fantasies. By 1663, when he swooned at her in her "*Taille*," La Belle Stuart had at least momentarily supplanted Castlemaine as the primary object of the king's extramarital attentions; however, Castlemaine quickly returned to the king's favor and perforce to pride of place among Pepys's repertoire of mental images and those of the portraitists. Just as Elizabeth Pepys excited her husband by emulating Lady Peters emulating the Queen as Saint Catherine, Castlemaine's return reactivated another erotic trio, wherein, as if at the Judgment of Paris, Pepys could imaginatively stand in for the king.

The theater offered both the metaphor and the materials for such dream-state expressions of mimetic desire, and Shakespeare, more than any other playwright, insinuated his imagery into Pepys's consciousness of his own sensations. He did so, for instance, in a key passage in which the diarist's imagination fixes again on Lady Castlemaine, who came to him in a mid-August night's wet dream in the plague year of 1665. Hamlet's "To be or not to be" soliloquy, which Pepys had already heard the great actor Thomas Betterton deliver a number of times, frames the recovery of his erotic dream as a waking fantasy:

> Up by 4 a-clock, and walked to Greenwich, where called at Captain Cockes and to his chamber, he being in bed—where something put my last night's dream into my head, which I think is the best that ever was dreamed—which was, that I had my Lady Castlemayne in my armes and was admitted to use all the dalliance I desired with her, and then dreamed that this could not be awake but that it was only a dream. But that since it was a dream and that I took so much real pleasure in it, what a happy thing it would be, if when we are in our graves (as Shakespeare resembles it), we could dream, and dream but such dreams as this—that then we should not need to be so fearful of death as we are in this plague-time.[19]

In a way that recalls the controlling metaphor of Pedro Calderón de la Barca's *La Vida Es Sueño* (*Life Is a Dream*)—that even dreams themselves are dreams, nesting dolls of consciousness—Pepys enjoys even his own experiences vicariously. Castlemaine, standing in for an actress, exists for him as a voyeuristic image to be acquired, savored, and re-fleshed at intervals, most often at the theater, where he noted her presence in the company of the king, and at court, where a glimpse of her lacy hem sent him into an ecstasy. A celebrity before the age of mass culture, Castlemaine's image circulated in the absence of her person. Pepys vowed to obtain a copy of her most famous portrait by Lely, and he did so as soon as it was engraved in 1666 (see fig. 39). In fact, he bought three prints, one to be

varnished and framed for display, two to be set aside for private use.[20] He longed not only to possess her image, but also to take his idea of her with him to the grave. This is the modern effigy, a mesmerizing image of unobtainable yet wholly portable celebrity.

On the afternoon of Shrove Tuesday, 23 February 1669, Pepys encountered another kind of effigy, a very old-fashioned one. His performance at this macabre event encapsulates the moment of historic rupture in the splitting away of early-modern image making from the medieval.[21] He records in his *Diary* entry for that day, his birthday, how he came to be touring Westminster Abbey with members of his family. He and Mrs. Pepys were entertaining out-of-town cousins, to whom the shows of London beckoned on the last day before Lent. Having been disappointed by the postponement of the opening of Thomas Shadwell's *Royal Shepherdess* at the Duke's Playhouse, the party settled on an alternative entertainment. Coming upon a secular relic and minor tourist attraction in the Confessor's Chapel, the partially mummified remains of Catherine of Valois, he picked up and fondled the torso and kissed on the lips the body of the woman whose life inspired Shakespeare to write the character of "Queen of all, Katherine" in *Henry V*:

> Therefore I now took them to Westminster Abbey and there did show them all the tombs very finely, having one with us alone (there being other company this day to see the tombs, it being Shrove Tuesday); and here did we see, by perticular favour, the body of Queen Katherine of Valois, and had her upper part of her body in my hands. And I did kiss her mouth, reflecting upon it that I did kiss a Queen, and that this was my birthday, 36 year old, that I did first kiss a Queen.[22]

Cutting up for his tour group, which included his teenage nieces as well as his wife, and performing a makeshift love scene as if he were an actor on a stage or a carnival masquerader (it was, after all, Fat Tuesday), Pepys found quite a leading lady, celebrated in her own time and thereafter. As the daughter of Charles VI of France, Catherine had served as a bargaining chip in the dynastic showdown wherein Henry V of England insisted on a suitable trophy in marriage as part of the price of peace after Agincourt. As Shakespeare has the warlike Harry say, wooing the demure princess with broken French but unremitting purpose:

> You have witchcraft in your lips, Kate; there is more eloquence in the sugar touch of them than in the tongues of the French council; and they should sooner persuade Harry of England than a general petition of monarchs. (act 5, scene 2, lines 288–93)

Persuaded he was, and their son became Henry VI. Widowed early, Catherine married Owen Tudor. Their grandson became Henry VII. She died in 1437 at the age of thirty-six, precisely the age of Samuel Pepys on the day of his assignation with her remains 232 years later, on a holiday from his job at the Admiralty, where he helped to build up the professional bureaucracy of the modern nation-state in the unsettled and unsettling twilight of sacral monarchy.

The turbulence of the intervening history—from medieval to early modern— is uncannily enacted by the restless perambulations of Queen Catherine's corpse. When her sepulchre in the Lady Chapel was disturbed by renovations ordered by Henry VII, her body was placed in a coffin at the east end of the Confessor's Chapel at the side of the tomb of Henry V. There she rested (but not undisturbed) on view by "especial favour" until at least the mid-eighteenth century, her most recent reburial dating from 1878.[23] By the time Pepys handled the fragile segments of this ghastly heirloom, the torso had become detached from the pelvis and legs. Pepys, whose stolen backstage kisses from pretty actresses made his diary so quotable to theater historians,[24] dreamed of planting them on most of the player-queens. He, vicariously playing King Henry or Owen Tudor's part, intimately but publicly osculated with the ghostly celebrity, recruiting little Babs, Betty, and Elizabeth Pepys as his captive audience, cast as "Ladies of the Court" over which the spectral queen presides; she, the aging diva (remarkable for her years, having passed through so many hands), shows that two and half centuries later there's still witchcraft in her lips.

Shakespeare's *Henry V* was not the stage version of the betrothal of Catherine of France performed during Pepys's lifetime, but the diarist's delight that he "did kiss a Queen" resonates equally in the one that he did see enacted, *Henry the Fifth* (1664), the version in rhymed couplets by Roger Boyle, first Earl of Orrery. In it Mary Betterton ("Ianthe") played Katherine, for whose hand King Henry V, played by Henry Harris, and Owen Tudor, played by the great Betterton, are rivals. Pepys records his enthusiasm for the play and the production, with but one significant reservation:

> And to the new play at the Dukes house, of *Henery the 5th*—a most noble play, writ by my Lord Orery; wherein Baterton, Harris, and Ianthes parts are most incomparably wrote and done, and the whole play the most full of heighth and raptures of wit and sense that ever I heard; having but one incongruity or what did not please me in it—that is, that King Harry promises to plead for Tudor to their mistress, Princess Katherine of France, more then when it comes to it he seems to do; and Tudor refused by her with some kind of indignity, not with the difficulty and honour that it ought to have been done in to him.[25]

Here Pepys sides with the self-fashioning new man in his wooing of Katherine in competition with King Henry. The intense appeal of this particular action to the diarist's fantasy life, demonstrated by his rave review, dominates his understanding of the characters. That he could not be satisfied with the king's efforts on behalf of Owen Tudor only goes to show the depth of his identification. What King Henry actually says seems pretty generous to the impartial listener:

> Madam, I have injurious been to him
> As far as ignorance could make a crime:
> I did employ him in my suit to you
> But I declare (which some amends may be)
> That he, at least, in all things equals me
> Unless in title, but it's greater far
> A crown to merit than a crown to wear.
> Can title in that balance e'er prevail
> Where love is merit and you hold the scale?
> (*Henry the Fifth*, act 5, scene 4, lines 1–10)

Music to the ears of mimetic desire this speech ought to have been, particularly in view of the subsequent history of Owen and Catherine, but the theater, while it appeals to private fancies, remains in the control of those accountable to the public at large. Not that the producers stinted on staging the parallels between the Lancastrian monarch and the Stuart. First, they cast the sympathetic Betterton as Owen Tudor, the dynastic founder. Second, they somehow persuaded King Charles II, the Duke of York, and Aubrey de Vere, twentieth Earl of Oxford, to lend their coronation robes to the theater for this production, clothing the stage effigies in a remarkably authentic, if anachronistic, way. The old prompter John Downes records that while Harris as Henry V wore the Duke of York's suit and William Smith as Burgundy wore Oxford's, Charles's own robes were assigned to Betterton, an unrealistic but powerful anticipation of the eventual ascent of the Tudor (and perforce the Stuart) line.[26]

Enter the actress. In his naming of the cast of Orrery's *Henry the Fifth*, Pepys rigorously genders the erotics of celebrity: the men, Betterton and Harris, appear under their own names, while he identifies the woman by and with her role. "Ianthe," the familiar name for Mary Betterton, one of the very first women to have acted on the English stage, comes from the name of a leading character in Sir William Davenant's *The Siege of Rhodes* (1661), with whom she was thereafter identified.[27] Recruited principally from the lower classes to stand in for the *beau monde* on the stage, the first actresses replaced the boy actors who had taken all the female parts

before the theaters were closed in 1642, and they generally excelled them in their ability to cast a spell of public intimacy over the audience. Among the painted ladies, the actresses Moll Davis, Nell Gwyn, and Margaret "Peg" Hughes all had very public affairs with prominent men. Moll Davis joined the Duke's Company in 1662 and the ranks of the king's mistresses five years later. The lovely Lely portrait of her playing the guitar seems to be telling this story. Downes reports that her poignant singing of the ballad "My Lodging It Is on the Cold Ground" in Davenant's *The Rivals* greatly moved the king: "She perform'd that so Charmingly, that not long after, it Rais'd her from her Bed on the Cold Ground, to a Bed Royal."[28] Nell was kept first by the actor Charles Hart, then briefly by Charles, Lord Buckhurst, and thereafter by the king, to whom she saucily referred as "Charles III." Peg Hughes was the mistress of the king's cousin, Prince Rupert. Prologues and epilogues, Pepys's *Diary*, and scandal sheets reveal a great deal of contemporary interest in the intimate details of these affairs, especially when they complicated Charles's liaisons with his aristocratic mistresses and led to open rows, as they did even in so public a place as the auditorium of the playhouse itself.

Theater historians have rehashed these anecdotes with relish, but they have not fully acknowledged the role of such offstage performances as theatrical labor, providing commercial versions of the "life-like" illusions that upper-class women negotiated privately. Producing public intimacy is, like all sex work, hard work. Actresses could expect to be groped and partially disrobed as part of the stage business, and they were routinely visited backstage by gentlemen, Pepys among them, who were permitted to watch them change. Here the desire for public intimacy, unsatiated by the stage itself, invaded the privacy of the dressing room, recalling how many of the Restoration portraits present the upper-class sitter in a negligent state of dress. The concept of the celebrity effigy might help to account for the uncanny sameness of the portraits in the *Painted Ladies* exhibition, actresses and aristocrats alike, so many of which (though not all) seem to have the same features, the same skin, and certainly the same bedroom eyes—the face of public intimacy. Contemporaries found this look (and it is "a look," in the fashion-model sense) epitomized in Nellie's countenance during scenes of amorous encounter—lips parted and the languishing eyes half asleep. When both theater and art historians note that unidentified female portraits of the period are more often than not claimed as representing "Nell Gwyn," they wonder that only one woman's physiognomy survived the Glorious Revolution intact, but sexual celebrity endures by turning an image into an idea. Like the mortal husk of Queen Catherine, Nell Gwyn's image keeps turning up hundreds of years later, in perennial biographies and reruns of *Forever Amber*, but behind that transhistorical celebrity is the ghostly effigy of an erotically compelling type.

60. Funeral effigy of Catherine de Valois (1437), height 63 in. (160 cm). Westminster Abbey Museum.

In this expansion of celebrity erotics, effigies continued to exert their considerable charm, as they still do today in the guise of tradition-bearing (and tradition-inventing) monarchs of many titles: beauty queens, queens of the silver screen, queens for a day, drag queens, welfare queens, and, most poignantly of late, queens of hearts. As is the case of the painted ladies, the image today often consists of the name, the face, and the scandal. But the true modern effigy is larger than that. Of the supposed Benjaminian "aura" surrounding the inescapably pervasive images of Princess Diana, Adrian Kear has written: "The 'auratic' quality of these portraits was accentuated by the media's ceaseless circulation of them at the time of her death as 'effigies' directly designed to stand in for the dead Diana."[29] Such effigies have burned themselves into the mind's eye of a global public. As HRH the Prince of Wales aptly said of Charles II and the other wax figures in Westminster Abbey, her image, which is the idea of her, continues to appear to the hallucinating public as "astonishingly life-like," at least as much if not more than his own.

In drawing attention to this quality, the Prince of Wales probably did not mean to refer to the more ancient but less prepossessingly lifelike effigies in the Abbey Museum, the medieval figures carved from single blocks of wood and painted in polychrome, which has flaked and faded through the centuries. Among them is the funeral effigy of Catherine of Valois, carved from one piece of oak for her funeral in February of 1437 (fig. 60). She has remained on display in Westminster

Abbey ever since, eerily doubling the corpse with which Samuel Pepys staged his assignation. Her right arm and left hand are missing. Her face is plainly carved, probably from her death mask, with compressed features and drooping eyelids; yet for all that, across the vicissitudes of time, "the dead face has beauty as well as pathos."[30] Her image painted on wood is no doubt as close as a vision can come to realizing her presence. Imagination can do more. Onstage in effigy, Katherine becomes the ventriloquized object of mimetic desire, re-fleshed at intervals by actresses from Mary Betterton to Emma Thompson, as in life her body, like Diana's, became the reusable vehicle of dynastic succession. It is Shakespeare's Henry V, not Orrery's, who captures in one summary speech the sense of the royal effigy's power to communicate itself vicariously to contemporaries and to generations yet unborn. Like Pepys, he seals the one-way bargain with a stolen kiss:

> O Kate, nice customs cur'sy to great kings. Dear Kate, you and I cannot be confin'd within the weak list of a country's fashion. We are the makers of manners, Kate; and the liberty that follows our places stops the mouths of all find-faults, as I will do yours, for upholding the nice fashion of your country and denying me a kiss; therefore patiently and yielding. [*Kisses her*]
> (act 5, scene 2, lines 281–86)

King Henry might just as well have been speaking of the power of modern celebrities, which skilled artisans now model out of electrons as they once made effigies of wood and wax. Like the figures of Westminster Abbey, from medieval to early modern, his words are relics of an idea whose time has come.

A version of this essay was previously published in *The Yale Journal of Criticism* 16, no. 1 (2003): 211–30.

1. Anthony Harvey and Richard Mortimer, *The Funeral Effigies of Westminster Abbey* (Woodbridge, UK: Boydell Press, 1994), 79–94.

2. J. A. Simpson and E. S. C. Weiner, eds., *The Oxford English Dictionary*, 2nd ed. (Oxford: Clarendon Press, 1989).

3. Simpson and Weiner, *Oxford English Dictionary*.

4. *The Complete Works of John Ruskin*, ed. E. T. Cook and Alexander Wedderburn, 39 vols. (London: George Allen, 1903–12), 11:110–11.

5. Harold Weber, "Carolinean Sexuality and the Restoration Stage: Reconstructing the Royal Phallus in *Sodom*," in *Cultural Readings of Restoration and Eighteenth-Century English Theater*, ed. J. Douglas Canfield and Deborah Payne Fisk (Athens, Ga.: Univ. of Georgia Press, 1995), 67–88. See also James Grantham Turner, "Pepys and the Private Parts of Monarchy," in *Culture and Society in the Stuart Restoration: Literature, Drama, History*, ed. Gerald M. MacLean (Cambridge and New York: Cambridge Univ. Press, 1995), 95–110.

6. Entry for 24 June 1667, in *The Diary of Samuel Pepys*, ed. R. C. Latham and W. Matthews, 11 vols. (London: HarperCollins, 1995), 8:288.

7. *The Diary of John Evelyn*, ed. E. S. de Beer, 6 vols. (Oxford: Clarendon Press, 1955), 4:410.

8. Catharine MacLeod and Julia Marciari Alexander, eds., *Painted Ladies: Women at the Court of Charles II*, exh. cat. (London: National Portrait Gallery, London, in association with the Yale Center for British Art, 2001), 124–25, 123, 129, 157.

9. Philip H. Highfill, Jr., Kalman A. Burnim, and Edward A. Langhans, eds., *A Biographical Dictionary of Actors, Actresses, Musicians, Dancers, Managers, and Other Stage Personnel in London, 1600–1800*, 16 vols. (Carbondale: Southern Illinois Univ. Press, 1973–93), s.v. "Eleanor Gwyn."

10. MacLeod and Marciari Alexander, *Painted Ladies*, 171.

11. Entry for 15 Feb. 1666, Pepys, *Diary*, 7:44.

12. For the most recent account, see Claire Tomalin, *Samuel Pepys: The Unequalled Self* (New York: Alfred A. Knopf, 2002), 191–210.

13. Pepys, *Diary*, 7:365.

14. Pepys, *Diary*, 8:588.

15. Pepys, *Diary*, 9:184.

16. Pepys, *Diary*, 4:230.

17. Entries for 13 July 1663, 15 July 1663, Pepys, *Diary*, 4:230, 232.

18. Quoted in Harvey and Mortimer, *Funeral Effigies*, 95, 97.

19. Entry for 15 Aug. 1665, Pepys, *Diary*, 6:191.

20. Entries for 7 Nov. 1666, 1 Dec. 1666, 21 Dec. 1666, 8 May 1667, Pepys, *Diary*, 7:359, 393, 417, 8:206.

21. For a treatment of this episode in different context, see my "History, Memory, Necrophilia," in *The Ends of Performance*, ed. Peggy Phelan and Jill Lane (New York: New York Univ. Press, 1998), 23–30.

22. Entry for 23 Feb. 1669, Pepys, *Diary*, 9:456–57.

23. Pepys, *Diary*, 9:457 n. 1.

24. Entry for 23 Jan. 1667, Pepys, *Diary*, 8:27–28.

25. Entry for 13 Aug. 1664, Pepys, *Diary*, 5:240–41.

26. John Downes, *Roscius Anglicanus; or, An Historical Review of the Stage*, ed. Judith Milhous and Robert D. Hume (1706; London: Society for Theatre Research, 1987), 52, 61.

27. John Harold Wilson, *All the King's Ladies: Actresses of the Restoration* (Chicago: Univ. of Chicago Press, 1958), 117.

28. Downes, *Roscius Anglicanus*, 55.

29. Adrian Kear, "Diana Between Two Deaths: Spectral Ethics and the Time of Mourning," in *Mourning Diana: Nation, Culture and the Performance of Grief*, ed. Adrian Kear and Deborah Lynn Steinberg (London: Routledge, 1999), 170.

30. Harvey and Mortimer, *Funeral Effigies*, 41.

Notes on Contributors

Tim Harris is the Munro-Goodwin-Wilkinson Professor of European History at Brown University. He is the author of *London Crowds in the Reign of Charles II* (1987), *Politics under the Later Stuarts* (1993), *Restoration: Charles II and His Kingdoms, 1660–1685* (2005), and *Revolution: The Great Crisis of the British Monarchy, 1685–1720* (2006). He is currently working on a study entitled *The Stuart Kings and the Age of Revolutions* for Oxford University Press and researching a book on prejudice in early-modern England.

Catharine MacLeod is Curator of Seventeenth-Century Portraits at the National Portrait Gallery, London. She co-curated the exhibition *Painted Ladies: Women at the Court of Charles II* with Julia Marciari Alexander and also coedited and cowrote the corresponding catalogue. She has published on sixteenth- and seventeenth-century British portraiture and portrait miniatures.

Julia Marciari Alexander is Associate Director for Exhibitions and Publications at the Yale Center for British Art, New Haven. She co-curated the exhibition *Painted Ladies: Women at the Court of Charles II* with Catharine MacLeod, and they coedited and coauthored the exhibition catalogue. Editor of *Howard Hodgkin: Paintings, 1992–2007* (2007), she has curated a number of exhibitions for the Center and other institutions, published widely in her field, and taught courses in the History of Art Department at Yale University.

Sheila O'Connell is Curator of British Prints before 1880 at the British Museum. She is the author of *The Popular Print in England: 1550–1850* (1999) and *London 1753* (2003), and she edited *Britain Meets the World: 1714–1830* (2007).

Joseph Roach is the Charles C. and Dorathea S. Dilley Professor of Theater at Yale University, where he directs the World Performance Project. He is the author of *The Player's Passion: Studies in the Science of Acting* (1985), *Cities of the Dead: Circum-Atlantic Performance* (1996), and *It* (2007).

Kevin Sharpe is Leverhulme Research Professor and Director of the Centre for Renaissance and Early Modern Studies at Queen Mary, University of London. He is the author of, among other books, *The Personal Rule of Charles I* (1992),

Reading Revolutions (2000), and *Remapping Early Modern England* (2000), and, with Steven Zwicker, the editor of *Politics of Discourse* (1987), *Refiguring Revolutions* (1998), and *Reading, Society and Politics* (2003).

Susan Shifrin is Assistant Professor of Art History and Associate Director for Education at the Philip and Muriel Berman Museum of Art at Ursinus College in Collegeville, Pennsylvania. She is contributing editor of *Women as Sites of Culture . . .* (2002), *Re-framing Representations of Women: Figuring, Fashioning, Portraiting and Telling in the "Picturing Women" Project* (forthcoming, 2008), and *"The Wandering Life I Led": Essays on Hortense Mancini, Duchess Mazarin and Early Modern Women's Border-Crossings* (forthcoming).

Andrew R. Walkling is Dean's Assistant Professor of Early Modern Studies at the State University of New York, Binghamton, where he teaches in the departments of Art History, English, Theater, Music, and History and is Director of the Binghamton Baroque Ensemble. He is the author of a number of articles on court theater, music, and politics in the reigns of Charles II and James II and is currently working on a book entitled *Masque and Opera in Restoration England.*

Rachel Weil is Associate Professor of History at Cornell University in Ithaca, New York. She is the author of *Political Passions: Gender, the Family and Political Argument in England, 1680–1714* (1999).

Steven N. Zwicker is Stanley Elkin Professor of Humanities at Washington University, St. Louis. He has written on seventeenth-century politics and literature and on Dryden and Marvell, including *Dryden's Political Poetry* (1972), *Politics and Language in Dryden's Poetry* (1984), and *Lines of Authority* (1993). He is currently finishing a book on Marvell with Derek Hirst and coediting with Kevin Sharpe a collection of essays on early-modern life.

Photography Credits

Every effort has been made to credit the photographers and sources of all illustrations in this volume; if there are any errors or omissions, please contact Yale University Press so that corrections can be made in any subsequent edition.

Index